FROZEN PLANET II

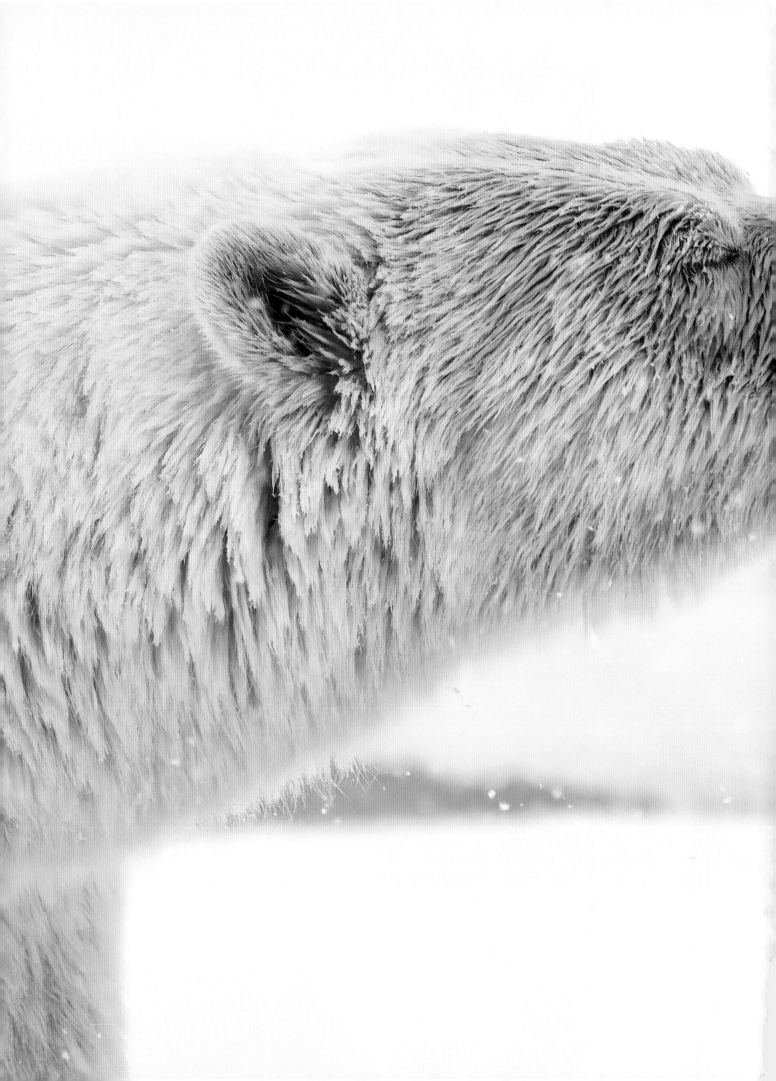

FROZEN PLANET II

A WORLD OF WONDER
BEYOND THE ICE

**MARK BROWNLOW AND
ELIZABETH WHITE**

BBC
BOOKS

Contents

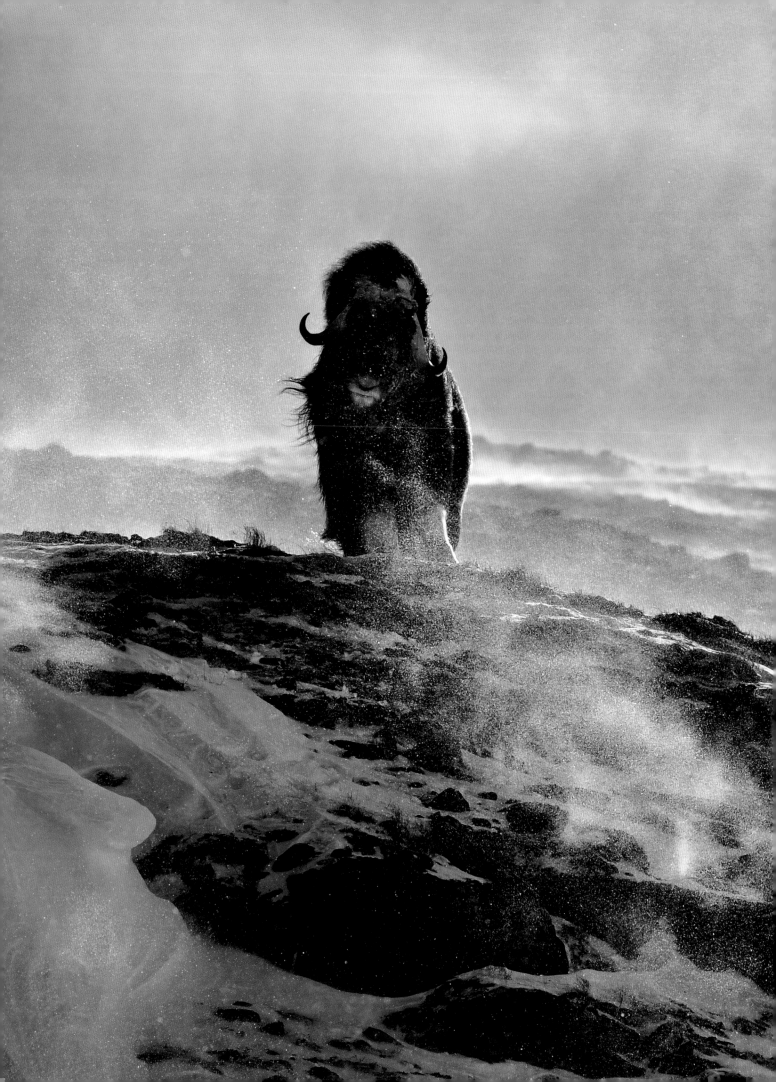

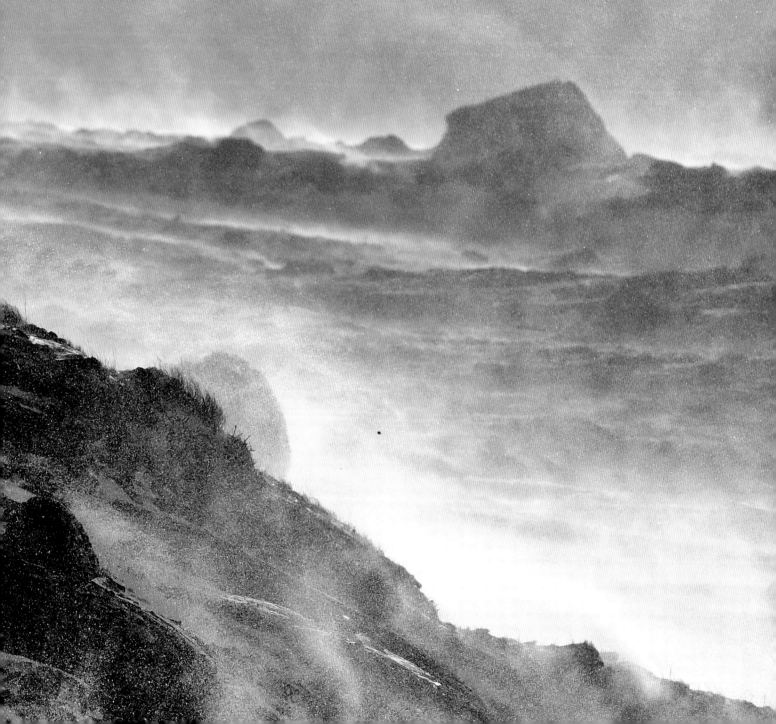

Chapter 1

FROZEN WORLDS

BELOW A drone's-eye-view of ringed seals on the sea ice off the coast of Alaska. It is the most numerous species of seal in the Arctic and a prime target for polar bears, as long as there is sea ice from which to hunt.

IT IS HARD to believe that one-fifth of the Earth is covered by snow and ice, but it is. Some of it is permanent, like polar ice sheets, where the ice can be a staggering 5 kilometres thick. The rest is ephemeral, like the snow that falls on Japan's Mount Ibuki in winter, where a record-breaking 230 centimetres fell in 24 hours, making it one of the snowiest places in the world; but it's all gone by spring. For the rest of us, we have to make do with a few flurries and a toboggan ride or two, but those moments – despite traffic grinding to a halt, power lines brought down, and villages cut off – most would agree are magical. There's something almost surreal about landscapes of snow and ice that makes us feel better for having seen and stood within them… but spare a thought for any life holed up on an East Antarctica plateau. In the depths of winter, the air temperature can drop to minus 94°C, making it the coldest place on Earth. And anything or anybody without a refuge on the steep slopes closer to the coast is battered by whiteout blizzards driven by 200-mph katabatic winds that put hurricanes in the shade. Winds, ice and snow mean something else entirely to any living thing bold enough to venture into such places. The frozen planet is, without doubt, the toughest place to live on Earth, for humans and wildlife alike; yet life, from the simplest bacterium to the largest whale, is so resilient that it survives and even thrives in these harsh conditions.

The Cryosphere

It's tempting to think of the frozen planet as the Arctic and the Antarctic, but there is more to it than that: think ice caves, permafrost, glaciers, high-latitude coniferous forests and high-altitude plateaus, along with frozen rivers, lakes and deserts; and climb any high mountain, even in the tropics, and at the top is a frozen wilderness on the roof of the world. They're all part of what science describes as the cryosphere, from the Greek word *krios*, meaning 'cold'. They are parts of the Earth where water freezes, whether they're on a mountainside in Africa or in the great northern forest in Siberia, the vast treeless tundra in Alaska, the frozen continent of Antarctica, or the frozen ocean of the Arctic. Each has its own species of plants and animals that have evolved to survive in the harsh conditions that prevail in each of those icy habitats. Today, though, they must master their particular frozen world at a time of unprecedented change.

RIGHT In winter, pancake ice forms on the Kitka River or Kitkajoki in northeast Finland, near the Russian border – part of the Earth's cryosphere.

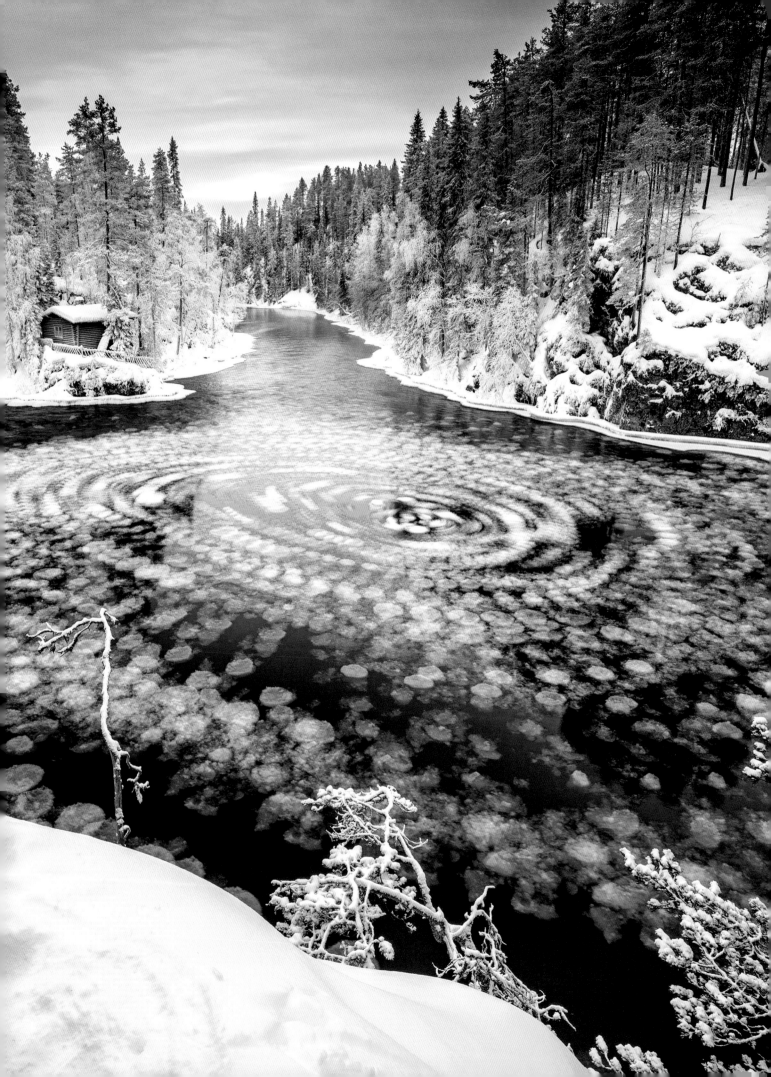

An Emperor's Maiden Voyage

BELOW In Atka Bay, Antarctica, emperor penguin chicks, each 20-24 weeks old, begin to moult their downy feathers.

OPPOSITE A male parent feeds its chick crop milk not long after the youngster has hatched from its egg. The hatchling balances on its father's feet and is protected by a warm, insulating pouch to keep it from freezing.

Antarctica is the ultimate cryo-continent. Most of it is covered by the largest single mass of ice on Earth. As a consequence, all resident plants and animals are small, the largest terrestrial animal being a flightless midge 6 millimetres long. Most larger animals are visitors and one of the most iconic is an enigmatic bird – the emperor penguin. Parents rear their offspring initially during the worst time of the year: not in spring, like most other animals, but in the depths of winter.

As the long, dark days approach, the female of the pair lays a single egg and passes it to the male. He balances it on his feet and covers it with a warm brood pouch to protect it from the bitter cold to come. The transfer is delicate and vital. If the egg touches the ground, the embryo will freeze. If successful, the female then heads to the ocean for two months to feed, leaving the male literally holding the baby. As the temperature drops to minus 40°C and the winds whip up to 120 mph, he joins a huddle of other abandoned dads. The formation is called a 'torque', and the birds shuffle around within it so, more by accident than design, none is on the outside for long. They do, however, have a little trick to keep warm: the birds minimise heat loss by keeping the outer surface of their plumage at a temperature slightly below that of the surrounding air. The key thing is to balance the heat lost by radiation (from the penguin's warm body to the outside air) and that recovered by thermal

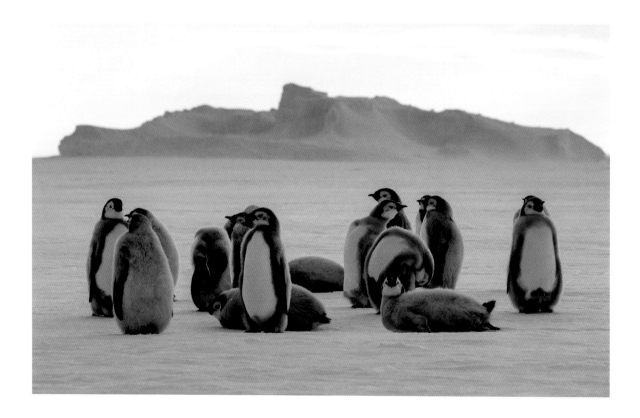

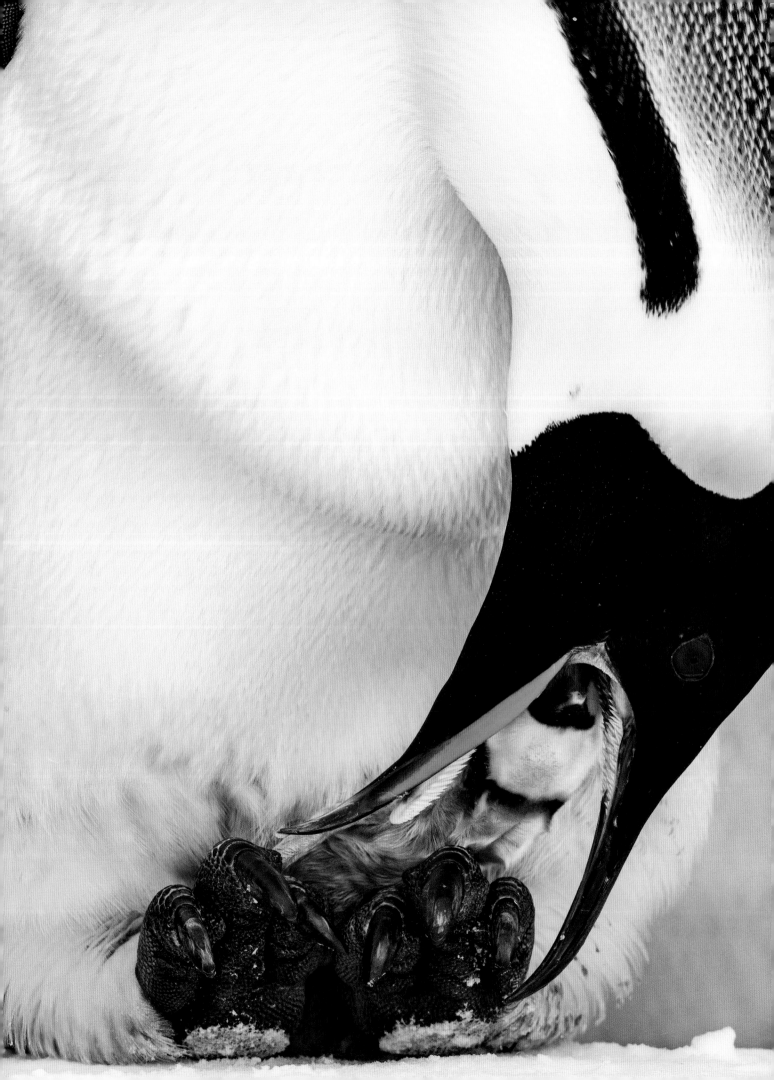

convection. As the cold air moves around the body, slightly warmer air comes into contact with the colder plumage and actually donates a tiny amount of heat back to the penguin. It is not much, but in such a forbidding environment even a minute gain could make a difference.

A little before mother returns, the chick hatches out, which takes maybe two or three days as the eggshell is remarkably thick. It is the first of many challenges that the young bird will have to face so early in its life. At first, its father feeds it a curd-like crop milk, from a gland in his oesophagus, an ability he shares only with pigeons and flamingos. If his partner's return is delayed, he can hold out for about a week, after which he can produce no more and the chick will die of starvation.

Most mothers return to the breeding site in early spring, when the weather is a little more clement. The mother coaxes the male to release the chick, and she takes over brooding and feeding duties, the male heading out to sea to replace the 20 kilograms he has lost during the winter. She feeds the youngster with a partly digested bouillabaisse of fish, squid and krill. The parents then take turns to look after the baby. If either fails to return, then the chick is abandoned, an early death sentence. There is also the risk of being kidnapped by a female that has lost her chick, with the victim facing the same fate, as a female without a partner cannot rear a chick successfully. In scuffles, chicks can be trampled, and southern giant petrels swoop in on breeding colonies and grab any bird standing alone. In some places, they account for a third of chick deaths.

Should they survive all this, the chicks gather into crèches for warmth and protection. As the youngsters grow, the demand for food increases, and so both parents go to sea. There comes a day, though, when they leave

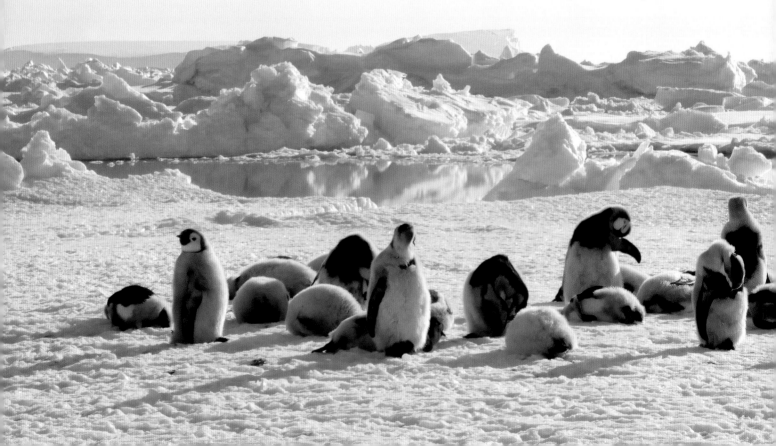

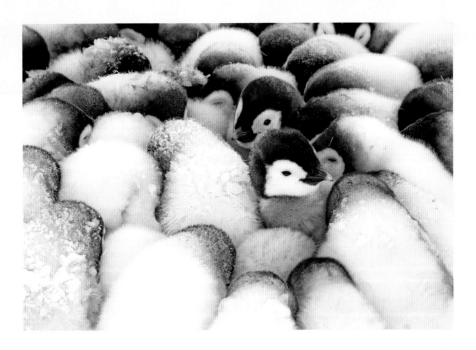

RIGHT Emperor penguin chicks huddle together in order to protect themselves from Antarctica's icy and often violent winds.

and don't return. The chicks have to fend for themselves, but how they get through this traumatic period in their lives, for which, aside from their plumpness, they are so ill equipped, is a mystery.

At just five months old, the fledglings have to waddle or toboggan across the ice to the sea, many still in their fluffy grey romper suits. The journey is not as long as that made by their parents earlier in the year, as the sea ice will have shrunk during the summer and so open water is likely

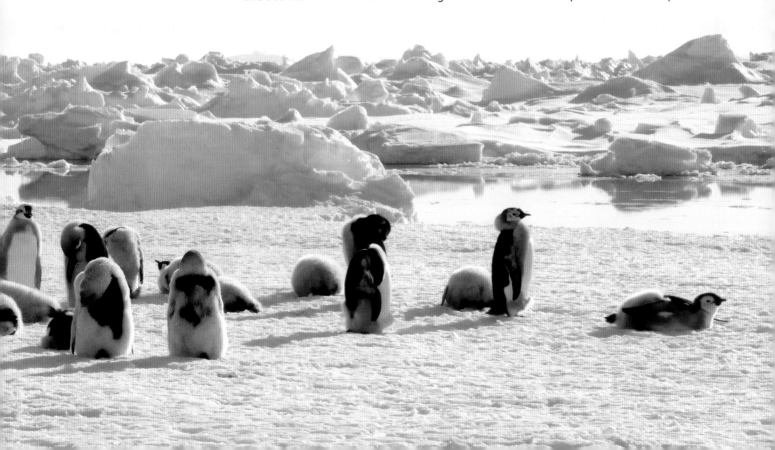

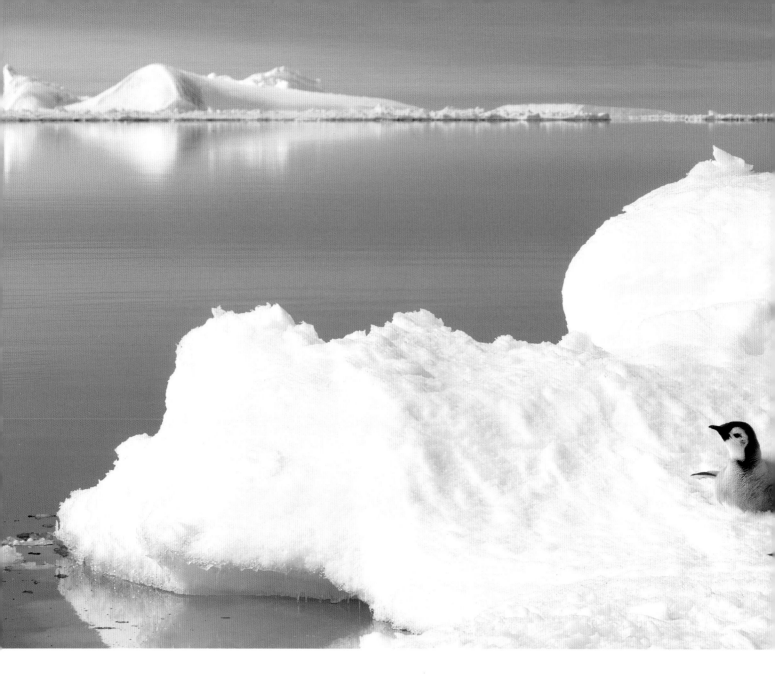

to be a little nearer, but it is, nevertheless, quite a hike and the terrain is not generally flat, so they constantly fall over. How they know which way to go, and not to walk into the centre of the continent, is another mystery. There is an element of 'follow-my-leader', when one bird strikes out and the others follow, until somehow they reach their destination – the ocean. Recent tracking research is beginning to reveal what happens next.

For starters, when the penguins reach the water's edge, a whole new bunch of dangers await them. Leopard seals patrol the edge of the ice and will quickly snaffle a naive bird foolish enough to jump in at the wrong moment. The seals know the best times to be present, and the birds seem to be unaware of the danger. They are also unbelievably clumsy and unsure of themselves in the sea: an easy target. They must first learn to swim, dive and hunt successfully, and stay out of the way of those powerful jaws, as this is not something they would have been taught by their parents – they really are in at the deep end.

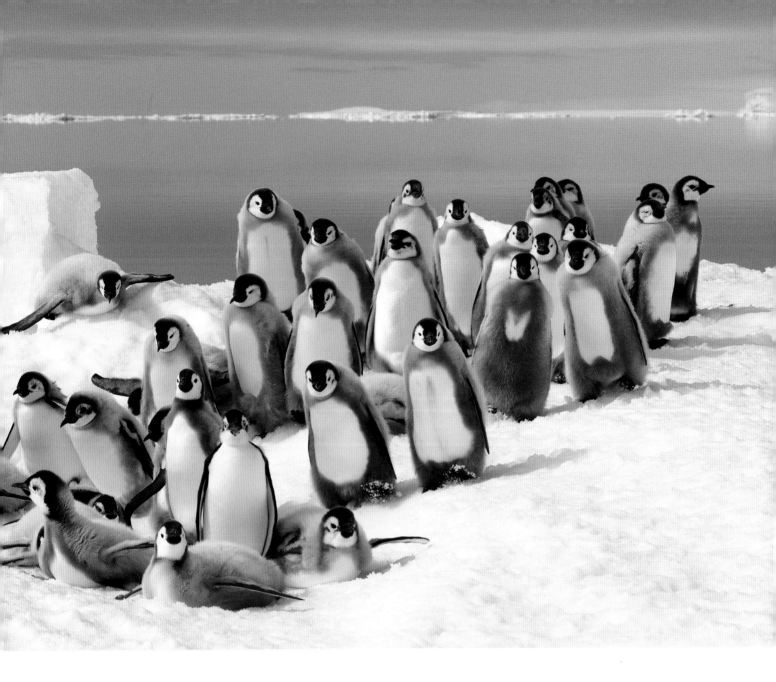

ABOVE Young emperor penguins hesitate at the ice edge in Atka Bay before taking the plunge and embarking on their journey northwards across the Southern Ocean.

In December and January, the young birds first head north, avoiding killer whales on the way. They swim considerable distances to reach warmer parts of the ocean, as far as 54° South, which could take them to the same latitude as the tip of South America. They need to be able to reach places where the thermocline, a transition zone in which warmer surface waters meet cooler deeper waters, is relatively close to the surface. This is where the food is concentrated. In April and May, when they have become proficient divers, they head back south again, to the sea ice, where they spend the winter making more confident dives. The thermocline will have sunk deeper in the autumn, so their prey, such as krill and small fish, will have moved to greater depths over the continental slope and into deep water. By this time, they can dive to 264 metres, as one did in a recent tagging study by French researchers. That's quite a feat for a young emperor penguin which, only a few months earlier, had been just a big ball of fluff.

OUT IN THE COLD
ATKA BAY, ANTARCTICA

'The most amazing thing is seeing the penguins making the transition from life on land to life in the sea,' says assistant producer Yoland Bosiger. 'At this stage, the penguins are moulting their down feathers and many sport mohawks and fluffy coats. Each day, they make their journey across miles of tricky terrain and cracks in the sea ice. They are so full of curiosity and come right up to us, pecking our gear and calling as if to say, "Who in the world are you?" When the penguins get near to the ocean, nobody wants to go first, but driven by instinct and an urge to feed, one bold individual eventually takes the lead, tumbling awkwardly into the ocean. As they swim off into the distance, I can't help thinking how little we know about their lives in the ocean.'

BELOW The *Frozen Planet II* film crew follows a line of moulting emperor penguin chicks as they make their way across the ice to the sea.

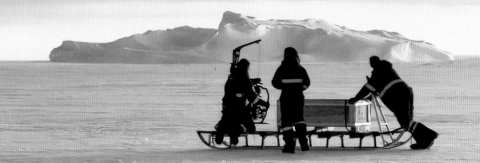

Wave-Washing

For the young emperors, the sea ice around Antarctica is a vital part of their life. Without it, they would be unable to do many of the things that they do, and it is the same for almost every creature that lives in the region. The ice comes in two basic forms: it can be attached to the land, when it is known as 'fast ice', or it can be 'pack ice', which is free-floating. While fast ice tends to remain intact during summer, the pack ice breaks up into smaller

ABOVE Off the west coast of the Antarctic Peninsula, a pack-ice killer whale spyhops to assess the chances of its pod washing a seal from the large ice floe on which it is resting.

ice floes, and these are vital haul-out sites, not only for emperor penguins, but also for Antarctic seals, such as Weddell and crabeater seals. As resting places, though, they are far from ideal.

Patrolling the fragmented pack ice are orcas or killer whales, the top predators in the region. They roam the Southern Ocean in small pods consisting of a matriarch, usually the oldest female, along with several younger females and calves and an adult male, recognised by his tall sword-like dorsal fin. There are several types, each categorised by its principal food:

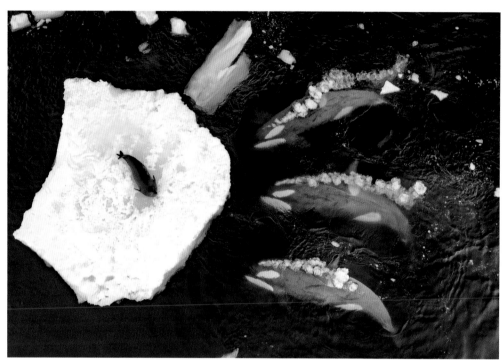

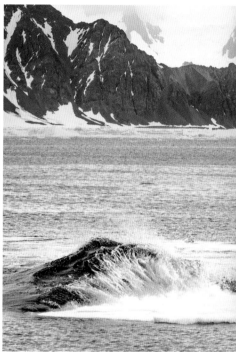

type A stays clear of the ice and hunts down minke whales; type B1 swims among the broken pack ice and prefers seals; type B2 is also in among ice floes but specialises in penguins; type C follows leads in the pack ice and likes fish, especially Antarctic cod; and type D is a sub-Antarctic killer whale that robs fishermen of their Patagonian toothfish catch. Type B1 killer whales, or the 'pack-ice killer whales' as they are sometimes known, are a small but highly specialised population, but they are not simply bullyboys; this bunch is clever. They hunt young Weddell seals resting on ice floes, and they do so in a remarkable way, a technique called 'wave-washing'.

First, the whales push their heads out of the water, a behaviour known as spyhopping, to check out not only if a seal is resting on the slab of ice, but also that it is an inexperienced seal that has clambered aboard the wrong type of ice floe, one that can be tipped or broken apart. Then, they disappear below for half a minute, during which time it is thought they are calling underwater for the rest of the pod. Shortly after, they all surface and begin to spyhop again. They seem to be working out the swimming depth and speed required to form the right-sized waves. After a couple of false starts, they line up alongside each other, up to seven whales in the formation, and swim about 30 metres away. They then turn abruptly and swim full tilt at the ice floe on which the seal is resting. At this point, they tend to be very close together in line abreast, with their tail flukes beating in synchrony. A small wave forms in front of their heads, with a trough above their tailstocks, and a second larger wave above their pumping flukes.

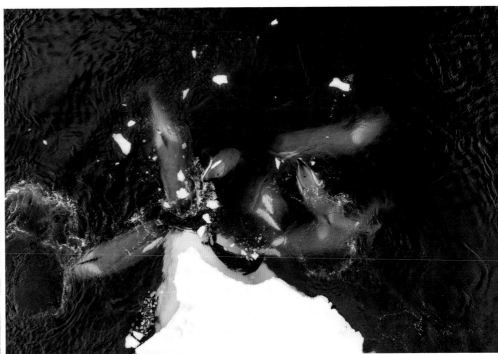

ABOVE RIGHT The wave-washing technique has not quite worked, but the seal is trapped on narrow ledge at the edge of the ice floe. The killer whales mill about, working how to get it off the ice.

At the edge of the ice floe, they give one last power stroke, creating a wave about a metre high that washes their target into the water. Under the ice they tilt to one side to prevent their dorsal fins from catching and double back to grab the seal.

Young whales learn this way of hunting from their elders, taking many years to perfect their technique, and one thing they are taught is what to do when an ice floe is too big for a successful wave-wash. The pod's matriarch knows how to crack it. A coordinated wave from below causes the ice to break apart, and if there are too many ice fragments in the way, they gently push away the piece with the seal on board, so they have a clear run. And if a seal jams itself in place, they have been seen to use their heads to flip over a floe and tip the seal into the water.

These marine mammals are clearly clever hunters, the adult females the most accomplished and the juveniles the most enthusiastic, but noticeable by their absence from wave-washing events are the adult males. With their tall dorsal fins, they do not make good wave-washers, so they tend to wait on the periphery of the action. The females basically feed them. Those females, though, are able to work out complex hunting strategies and then pass the knowledge on to the next generation. It is a hunting technique seen nowhere else on Earth.

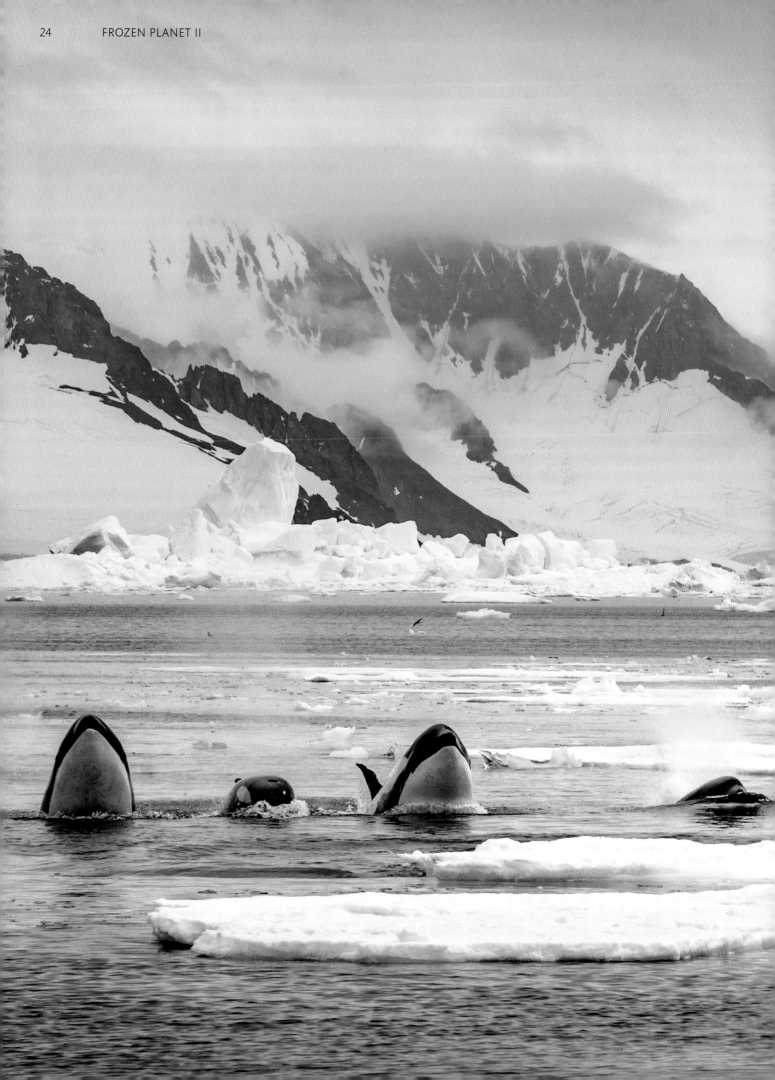

Killer Whales: All Washed Up

BELOW The pod of pack-ice killer whales heads towards a seal resting on an ice floe that is probably thin enough for the whales not only to break it up, but also wash the unfortunate seal into the water.

One major problem with this method of hunting is that it relies entirely on there being ice floes on which seals can haul out, but polar regions, more than any other part of the world, are undergoing rapid change. Although, according to the US National Snow and Ice Data Center, Antarctic sea ice extent in July 2021 was above average, the overall trend has been that the area of sea ice has been shrinking. The knock-on effect is that the normal behaviour of the Antarctic's inhabitants, particularly in the summer months when the ice is at its minimum, may have to change too. The pack-ice killer whales might have their ingenuity put to the test.

Firstly, there are possibly fewer Weddell seals, and this species is the preferred prey of type B1 orcas. In the first global count of its kind using many years of satellite images and published in September 2021, scientists have

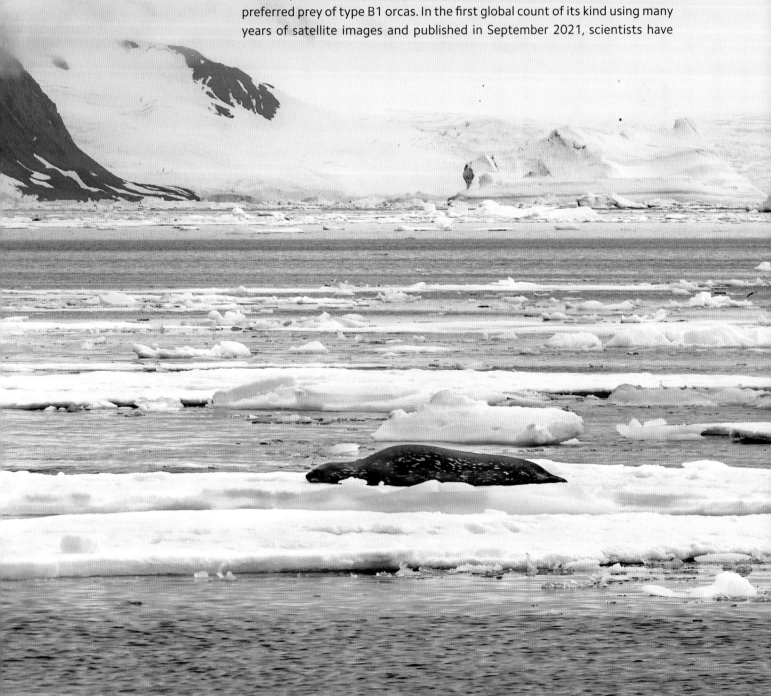

revealed that there are 202,000 sub-adults and adult females in the Antarctic (the males are under the ice defending territories at the time of the satellite pictures). A previous estimate suggested there were about 800,000 females. The discrepancy could be because the counting is more precise nowadays; on the other hand, it could also mean that there is a significant setback in the fortunes of this species, maybe because of the decline in fast ice.

Weddell seals prefer fast ice on which to raise their pups, so with this ice disappearing in the northerly part of their range, some maybe are moving further south. The killer whales also have special needs. They prefer near-shore waters, such as those close to Adelaide Island on the west coast of the Antarctic Peninsula, where the ice becomes choked up between the island and the mainland. Here, some of the pack ice remains in summer and the wind breaks it apart to form ice floes on which the seals haul out. The ice floes have to be just the right size for wave-washing to work, so if a warming climate is upsetting ice formation and the seals have shifted their range, then the killer whales must hunt further south too. They were once seen in areas just 150 kilometres north of Adelaide Island, but the changing ice conditions mean they no longer visit there.

Secondly, if the dynamic ecosystem of the pack ice is disappearing, eventually there will come a time when the seals cannot rely on having an ice platform on which to rest. There are already many reports of Weddell seals tending to haul out more on beaches and rocky shores, as new terrestrial habitats appear in summer, rather than on the shrinking pack ice, and that could have serious consequences for the orcas.

One option is for the killer whales to focus more on alternative prey and target the most common seal in the Antarctic, the crabeater, which will haul out on smaller floes. Some of the earliest observations of wave-washing involved crabeaters, but these are rather feisty beasts and could well injure an orca. They bare their teeth and advance in a threatening manner towards predators. They also swim faster and are more manoeuvrable than Weddells, using their more powerful front flippers for propulsion, so they can move rapidly over the ice and out swim an orca in the sea, and they've been seen doing just that.

If a crabeater is swept into the water by a wave-wash, it is able to keep a few centimetres in front of an orca's snout. The killer whale, the largest and fastest of the dolphin family, follows its every twist and turn, and the story ends with the seal torpedoing out of the water and onto a larger ice floe – a miraculous escape. The orca, meanwhile, will have wasted vital energy in an unsuccessful pursuit, so maybe crabeaters are not the ideal prey, although there are a lot of them: they're probably the most numerous large mammals on the planet.

Weddell seals, by contrast, have weaker front flippers, swim slower, tend to move with an undulating movement of their body on land, and generally appear more placid and naive to the danger from predators like orcas.

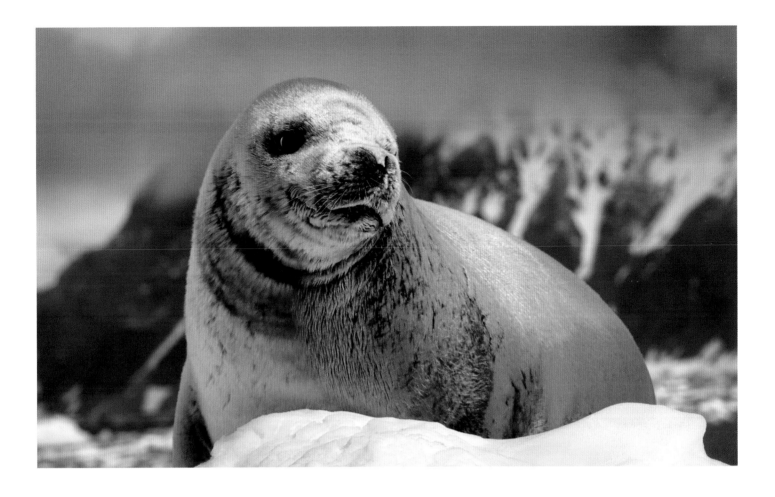

ABOVE Despite its common name, the crabeater seal does not feed on crabs. It has special teeth shaped to sieve out krill from the water. Being fast and feisty, it is less likely to fall prey to killer whales, but its pups are vulnerable to leopard seal attacks.

That's probably the reason orcas select them over other seals in the first place; they're easier to catch.

Another option is to hijack leopard seals. As apex predators, they might be foolish enough to think they're invincible; that is, until it's too late and they're washed off the ice and into the sea. It is a scenario that is unlikely to have a happy ending. A small pod of killer whales targets a leopard seal on a large ice floe. The whales create their wave, breaking the slab into four unequal chunks. The seal remains on the smallest piece of ice – bad mistake.

As a future hunting option, however, there is the real possibility that the crabeaters and leopard seals will not have any ice to haul out on either, so they too might head for the land. Both species already do so. This means that, with no ice, these orcas will have to change their hunting behaviour or go the way of the dodo. Already, scientists have noticed emaciated type B1 orcas in the Weddell Sea, and these wave-washers have been seen targeting elephant seals, minke whales and crabeaters in open water instead. They might well adapt to the changing circumstances, but their preference is for Weddell seals on ice floes. It's a real problem for animals that have become so specialised.

OUT IN THE COLD
ANTARCTIC PENINSULA

In order to film the type B1 pack-ice killer whales, the production team had to first reach the remote location near the Antarctic Peninsula, and then find the whales. After departing from the Falkland Islands, the first hurdle was the Drake Passage, a body of water between the southern tip of South America and the Antarctic Peninsula, possibly one of the stormiest sectors of the tempestuous Southern Ocean. The team was sailing, though, not in a luxurious cruise ship but with skipper Dion Poncet aboard the *Golden Fleece*, a relatively small motor yacht with a steel hull that can get in amongst the ice floes. In the open ocean, the turbulent passage across a stretch

ABOVE The *Golden Fleece* eases it way between scattered ice floes off the west coast of the Antarctic Peninsula, while the production team searches for any signs of the pack-ice killer whales.

of water 650 nautical miles wide has often been described as 'like being in a washing machine', and the film crew was seasick... all the way across. Wildlife cameraman Bertie Gregory compared it to 'the worst hangover I've ever had!' But when they reached the peninsula, the seas were calm as a millpond at first, and nausea was little more than a memory, so the search could begin.

Whale scientist Leigh Hickmott, of the Sea Mammal Research Unit at the University of St Andrews, was the guide on the expedition, and he revealed that the B1 population consisted of fewer than 100 individuals, so finding one of the pods that patrolled an area more than half the size of Wales was not going to be easy. Alerted to a sighting a month previously, they headed to the location and then simply looked. After three days of round-the-clock

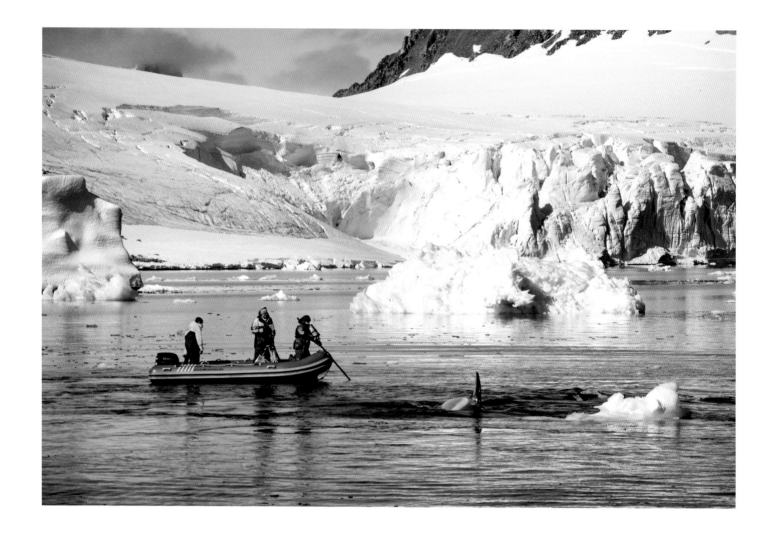

surveillance, staring constantly at the ice-strewn sea, they finally had some luck. The whales swam right below the boat. It was time to break out the cameras.

Bertie Gregory launched his drone to get a bird's-eye-view of the action, while wildlife cameraman Jamie McPherson set up his gyroscopically stabilised camera system on a precarious jib arm in one of the smaller inflatable RIBs.

'Using this set-up, we could get closer to the water,' says Jamie, 'rather than always shooting down from the deck of the mothership, and therefore we were right alongside the killer whales.'

One of their first encounters, though, was a little too close. Three young whales headed straight for the inflatable, followed by an adult male. At one-and-a-half times the size of the boat and less than a metre away it was a tense moment.

'I definitely felt I'd just been checked out by the male,' says director Mark Brownlow, 'and it was quite intimidating.'

ABOVE The film crew aboard the RIB follow the action under the water.

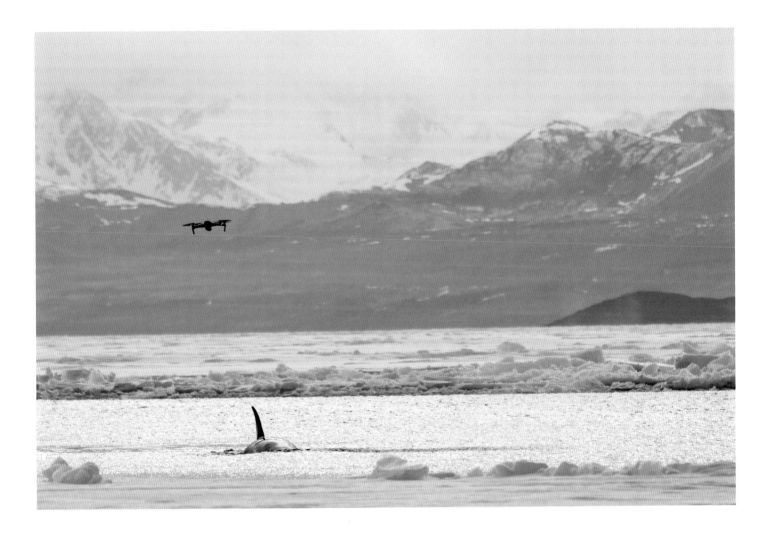

ABOVE **A drone follows the hunt from the air.**

However, what was even more disturbing was the way the climate of the region was changing and how it was affecting this population of type B1 killer whales. They were changes that Mark and the wave-washing film crew experienced for themselves.

'While we were off the Antarctic Peninsula, the weather changed for the worse. In the past, the peninsula was famous for perfect calms, sunshine, and clear blue skies, but now it doesn't happen so much, and snow cover and ice cover are reducing noticeably.'

It was also influencing the behaviour of Weddell seals, as Leigh Hickmott came to realise.

'It's a cruel irony really that, during the time we were filming, we found the largest group of Weddell seals on the beach and not on the pack ice, which meant the whales couldn't hunt them. I don't think it's too much to say that we *are* facing a climate emergency. This small population of killer whales could well be impacted. There's a real chance that as we lose this pack ice environment, this predator, which has one of the most complex hunting strategies on the planet, is going to be lost.'

House of Snow

A world away from Antarctica, mountains and other high-altitude topography are all part of the Earth's cryosphere, and here altitude rather than latitude determines the climate, vegetation and the ability of life to survive. The higher you go the colder it gets, until you reach a critical boundary between the snow-free surfaces below and the snow-covered ground above. This is the snow line, and it varies across the world: it is progressively lower with increases in latitude. Mountains close to the Equator, for example, have a snowline at about 4,500 metres above sea level, while in Norway's Svalbard, inside the Arctic Circle, it is much lower, at just 300–600 metres. It can also vary with the seasons, higher in summer and lower in winter.

The world's most spectacular snow-covered mountains are, perhaps, those which split Asia in two – the Hindu Kush–Karakoram–Himalayas (HKKH) complex of ranges, where the snowline can be on average at 4,500–5,000 metres. They are hosts to the world's two highest mountains – Mount Everest at 8,848 metres, where climbers queue to reach the summit, and the deadly K2 at 8,611 metres, where they don't. These mountain ranges are sometimes known as the 'third pole'. The highest peaks are in the 'zone of perpetual snow',

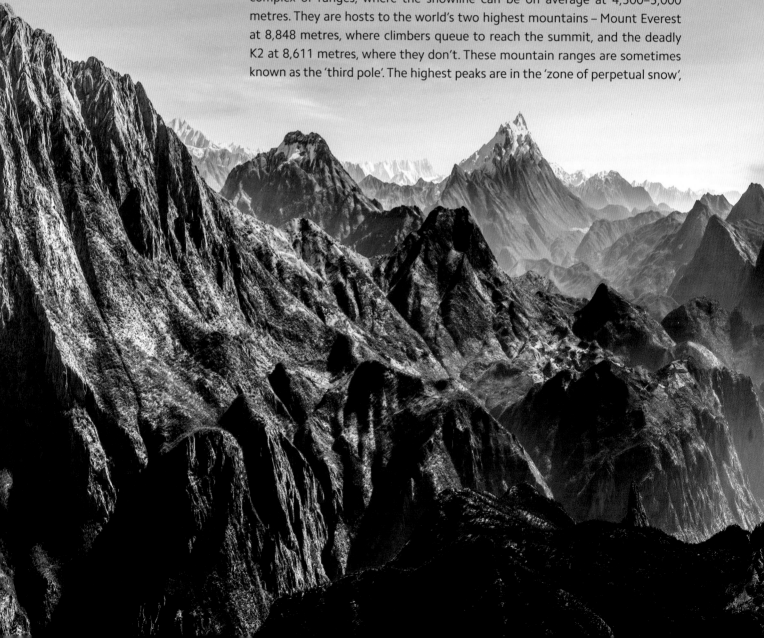

so more ice and snow can be found here than almost anywhere else outside of the polar regions; in fact, in Sanskrit *himalaya* means 'house of snow'.

The Himalayas separate the Tibetan Plateau in the north from the plains of the Indian subcontinent in the south, with more than 110 jagged peaks exceeding 7,300 metres and 15,000 glaciers that account for about 7.5 per cent of all the glaciers in the world. The Karakoram to the west of the Himalayas stretches for 311 kilometres and spans the borders of China, India and Pakistan and extends into Afghanistan and Tajikistan. It has four of the world's longest glaciers, including the Fedchenko Glacier – the longest glacier system outside of polar worlds. And finally, the Hindu Kush is an 800-kilometre range that stretches from Afghanistan to Pakistan and into Tajikistan. Its tallest mountain is the Tirich Mir, which at an elevation of 7,708 metres is the world's highest peak outside of the Karakoram–Himalayas.

All three ranges are important in ways you might not have imagined. Aside from being spectacular to look at and challenging to climb, these mountains are significant both geologically and climatologically. They are located in a geologically active region, where the Indian subcontinent is slamming into the underbelly of Central Asia and are the world's youngest major mountain chains. When they rose up about 40 million years ago, they may have been responsible for global climate change. The exposed

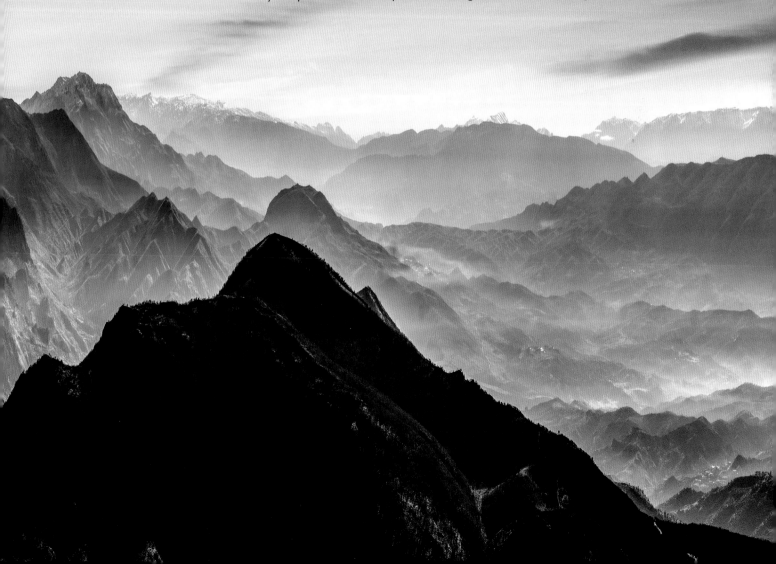

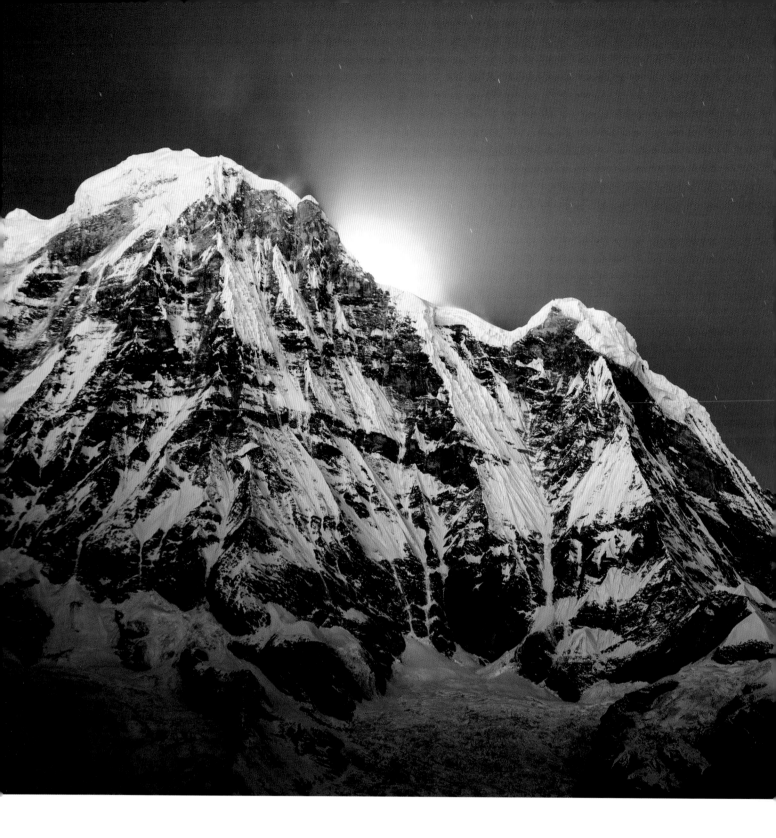

ABOVE The glow of the moon backlights Annapurna South and Annapurna Fang in the Nepal Himalayas at night in January.

limestone rock was weathered by a carbon-dioxide-rich atmosphere, which effectively removed the greenhouse gas from the air and caused the climate to cool, triggering the ongoing series of ice ages. Today, their glaciers may continue to serve as an indicator of climate change, the ice advancing and receding with long-term changes in temperature and precipitation.

Their glaciers are also important sources of water for millions of people. Meltwater from these HKKH mountain glaciers, along with rainwater runoff,

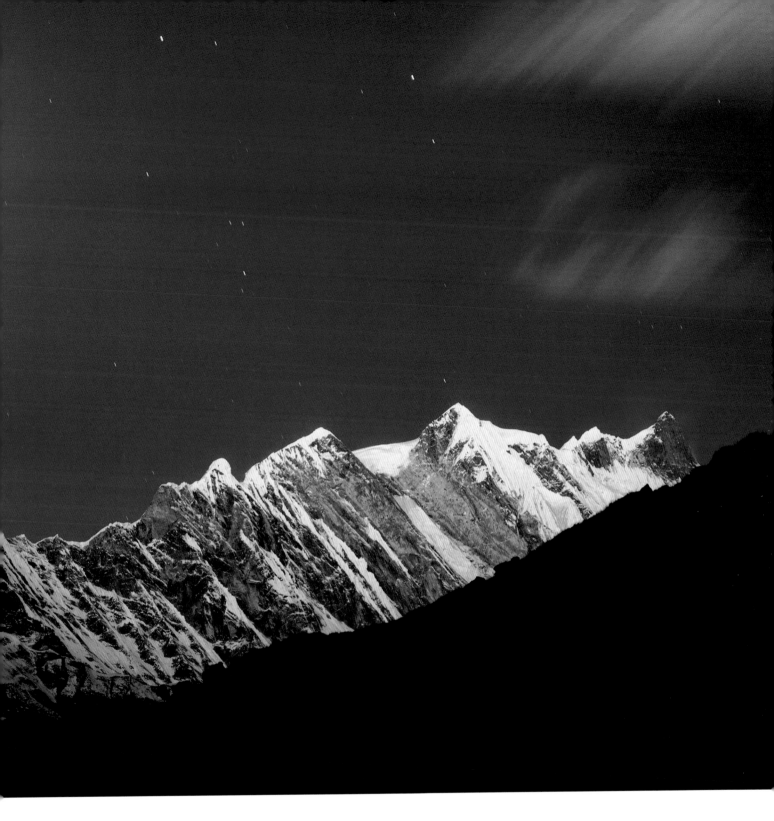

helps to fill ten major rivers, including the Indus and Ganges, which provide water for drinking and food production to more than a quarter of the world's human population who live downstream. They are also a barrier, preventing the moisture-laden monsoon winds from the Indian Ocean blowing further to the north, and so are partly responsible for the dry conditions that create landforms like the Gobi Desert and Mongolian steppe in Central Asia.

Grumpy Cat

BELOW Pallas's cat inhabits steppe, deserts and rocky mountain grasslands and scrublands. It can be found at high altitudes, even in the Himalayas. The highest recorded elevation for the species is 5,593 metres in Nepal's Shey Phoksundo National Park.

The Mongolian steppe can be icily cold. It is the most easterly section of Eurasia's grasslands and a land of extremes with especially cold winters, when the air temperature can drop to minus 30°C, and warm summers averaging 20°C. Snow is blown in from Siberia, but the steppes are remarkably dry, described as 'semi-arid' by climatologists, mainly due to the close proximity of the huge mass of ice-cold dry air known as the Siberian High, which is centred over Lake Baikal to the north. Animals here have to brave the cold and survive any summer heat, and one of the specialised steppe animals that lives here is Pallas's cat, an animal that, most observers would agree, must be the original 'grumpy cat'.

Slightly bigger than a domestic cat, it wears a perpetual frown and has flattened ears, as if the world is carried on its shoulders. In truth, this is part of its camouflage. The colour of its fur, the densest of any cat, blends in with the background of grasses and scrub, and, as its ears don't stick up like those of most other cats, it can peer out from behind or over a boulder or bush without its ears giving it away.

The problem is that Pallas's cat lives where there is limited cover, which makes creeping up on prey all the more difficult. There are also few places to hide from other predators, especially eagles that could easily carry off a small cat. Even so, at the best of times, the cat is hard to spot – a grey cat, amongst grey boulders, in a vast grey landscape.

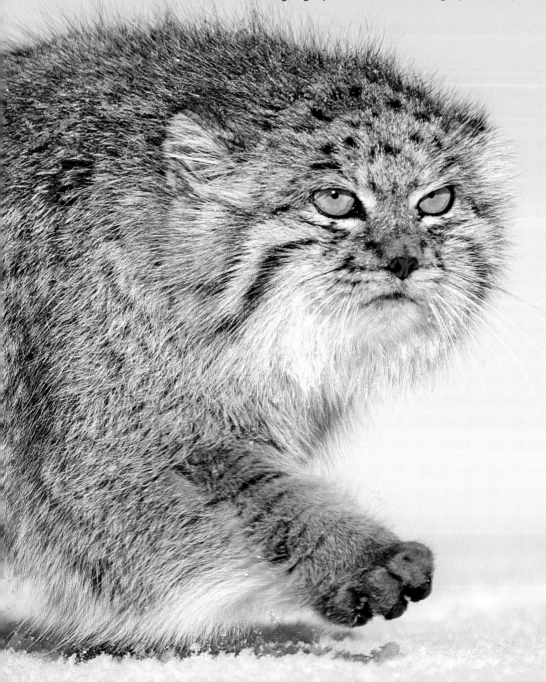

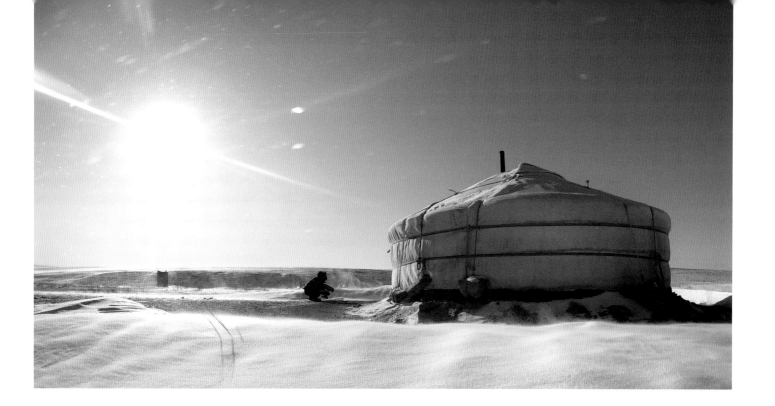

OUT IN THE COLD
MONGOLIAN STEPPE

Against all expectations, director Sarah Titcombe and cameraman Pete Cayless opted to film Pallas's cats in winter, when snow was on the ground.

'The experts told us not to bother to come in winter as the cats would not be tied to one burrow in the way they are in the breeding season, and so they would be very difficult to find in the vastness of the steppe, but we had a secret weapon: researcher and photographer Otgonbayar Baatargal and his wife Buyanaa, from the Mongolian Academy of Sciences. After a ten-hour drive to reach the village of Khalzan, where we set up camp in a traditional Mongolian ger or yurt, Otgonbayar took us to the top of a hill. More than a kilometre away was an unassuming pile of rocks, the only ones for miles around. Otgonbayar set up his scope and his camping chair, sat down, and placed his eye to the eyepiece. Within seconds, he beckoned us over to have a look. Through the scope and haze, I could see a small grey blob moving – a Pallas's cat, and it was only day one!

'It had snowed and, even though Pallas's cats have such a thick coat, they will conserve energy as much as they can, plus they really hate walking in deep snow. And while we watched this individual, Otgonbayar was surprised to see a second cat moving around the rocks, and then a third. Pallas's cats are generally solitary, so this was a first. He had never seen cats in winter cohabiting together. It was possible they were siblings that had been born in this rock pile during the summer just passed. They appeared to know each other, but if one got too close another, it would be given a thwap and a hiss.

'They would only appear when the sun was up enough to bask. They spent most of the day keeping their impressive coat in tip-top condition, as well as basking and sleeping. Often they would take time to ensure they had curled their huge tail underneath them, so that their paws weren't

ABOVE A traditional Mongolian yurt in a frozen wilderness was the film crew's base camp for the duration of the Pallas's cat shoot.

ABOVE The camera hide was a cramped box in which Pete Cayless, wrapped in a thick duvet to keep warm, had to wait patiently for the cats to appear each day.

in contact with the cold rocks or ground; but it was clear that they were hungry. The cold weather was eating into the fat reserves they had built up over the autumn. It was remarkable just how quickly they would switch to hunting mode, one minute sleeping, and the next out on the steppe.

'They eat mostly rodents. Brandt's voles, Daurian ground squirrels and Mongolian hamsters are the most common prey, and the cats have a variety of techniques to catch them. Sometimes they would hunker down and stalk slowly, before exploding into a sprint, other times they would take several short steps in a staccato, almost robotic way, all the time approaching slightly closer to the prey. Then they'd make a dash, accelerating rapidly to intercept it before it escaped. A third method was simply to sit in front of a rodent burrow, waiting to ambush an unsuspecting victim. It was never quite clear to us how they chose which to employ on each occasion.

'While most of the time the weather was clear and cold, the steppe could be hit by fast and bitter winds that would whip up the dry snow and sting your face. It was like taking a walk on a windy beach, and I have never been in such cold and dry conditions. It was so dry that any moisture in the air had frozen into beautiful sparkles that floated on the air; and each time you breathed in, the cold air sent prickles up your nose as the moisture froze. When moving from a warm car to the freezing cold, it often triggered a nose bleed.

'Although we had come prepared for everything, one essential thing we had overlooked was lunch. On our first day we were each handed a steaming bowl of Mongolian cuisine covered with foil, but despite keeping it next to hand-warmers, there was no way we could stop it from freezing. We sat for over ten hours at a time, watching and waiting for the cats, and to keep us warm, we had several layers of down. One particularly frigid morning my feet got so cold it felt like I was walking on stumps – I had lost all feeling in them. For two months after the shoot, I had no feeling in some of my toes. Now that was cold!'

Taiga Cat

To the north of the Mongolian steppe is the East Siberian taiga. Vast in itself, it is also part of the Great Northern Forest, or boreal forest, the largest forest in the world, which spans three continents – Europe, Asia and North America – and ten time zones. Like all elements of the cryosphere, the climate of the boreal forest is harsh. Winters are long and cold, while summers are short, warm and wet and the air is filled with mosquitoes. Spring and autumn are so short that you might wonder whether they exist at all, but the rest of the year, especially the winter, is a massive test for wildlife. During the long sub-Arctic winter, the temperature is well below freezing and the most northerly parts of the forest are often transformed into frozen landscapes of 'snow ghosts' – conifers encrusted with rime ice and snow. The ice forms from super-cooled water droplets that, as they lack freezing nuclei, remain liquid down to minus 40°C but which freeze when they touch an obstacle such as a tree. Living a little further south from them is a very special cat.

Few other animals exemplify the raw beauty of the taiga than the Amur or Siberian tiger, the most powerful subspecies of tiger and the largest of all the big cats. Mature males have a body about 2 metres long and weighing on average 190 kilograms, although one individual hit the scales at 306 kilograms and was 3.3 metres. The Amur tiger has a thicker and paler winter pelage than its more southerly cousins, and looks altogether shaggier, with a thick mane around its neck and extra fur on its back, belly and over its paws, useful adaptations to the cold. It has fewer black stripes than other tigers, but like them, each tiger has its own unique pattern, so no two tigers are alike.

They live mainly in the far east of Russia, where an adult female requires a territory of 250–450 square kilometres, so young tigers setting out on their

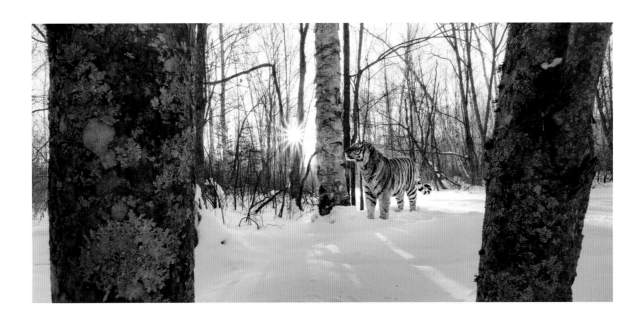

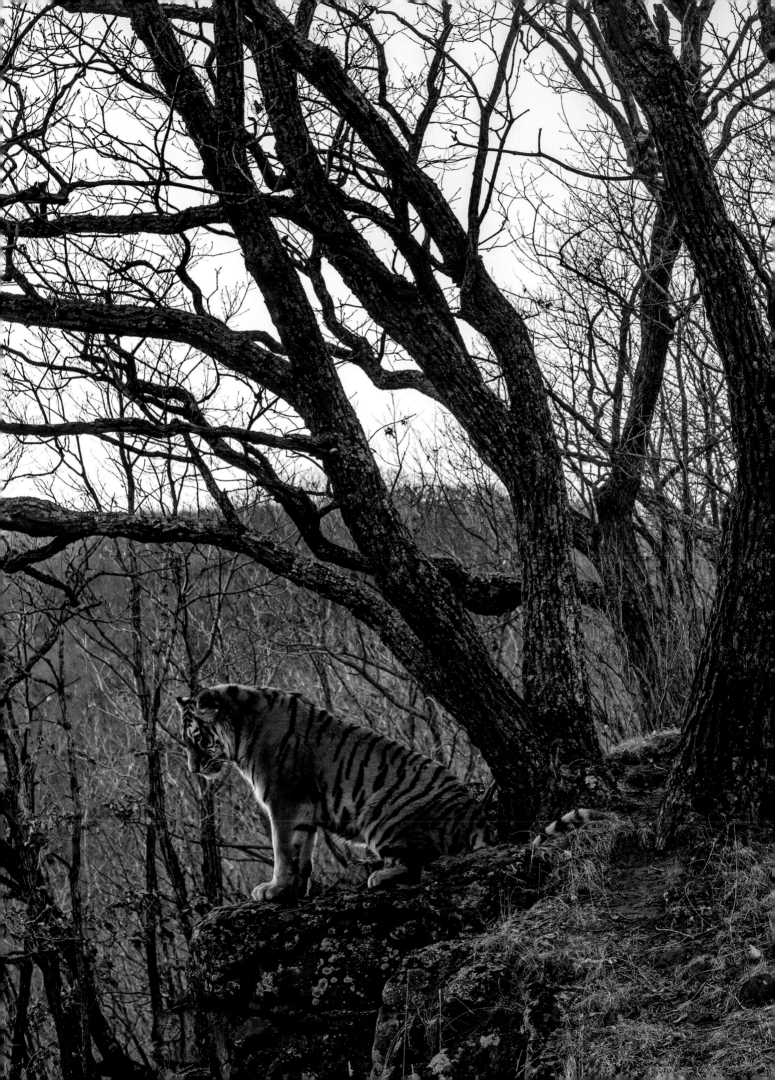

ABOVE An Asian black bear applies its scent marks to a tree trunk, an indication that this is its territory. But other scents on the tree indicate there is also danger here – tigers!

own have to explore far and wide, sometimes wandering for 200 kilometres or more to find a vacant space. Fortunately, in these northern lands, with low human density, space is not at a premium. Each tiger scent-marks its home turf and is aggressively protective of it. It hunts by stealth, creeping up on a target before a burst of speed, a pounce, and then grabbing the victim by the neck.

Such a large animal needs a fair amount of meat per day, depending on the season. In winter, tigers make a kill every five or six days, consuming 10 kilograms in one sitting. In summer, with no need to fight the cold, this drops to every seven days and about 8 kilograms. In total, that amounts to 50–70 deer and other large mammals, such as wild boar, per year, and they will even kill Asiatic black bears with whom they share the forest.

In winter, tigers have been known to attack and kill denning Asiatic black bears. In the northern parts of their range, these bears enter hibernation as early as October and do not leave until as late as the end of May. When other food is scarce, they are sitting targets. Many den in hollow trees, such as cottonwoods and, as black bears are good tree climbers, even on the inside of the hollow, it is difficult for tigers to catch them. Others opt for caves or

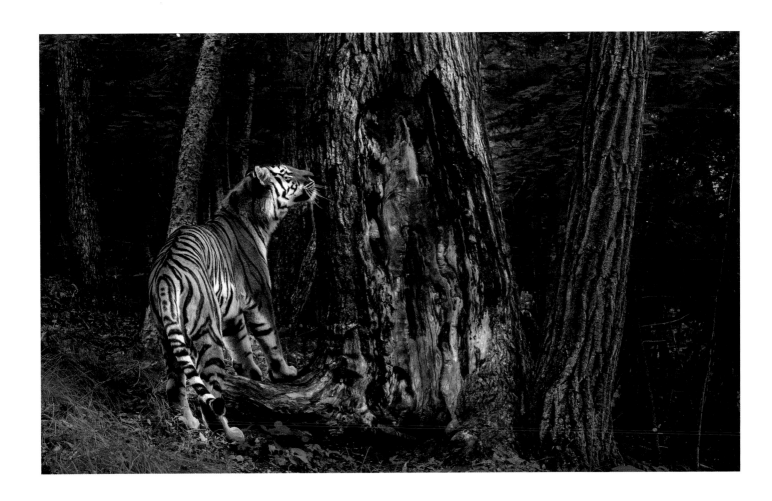

ABOVE **At the same tree, the tiger picks up the bear's scent, and tigers kill bears.**

under rocks and upturned trees, or excavate earthen dens, sometimes on flat dried-up river beds, and, where the entrance is big enough, these bears are accessible to tigers.

Both species are threatened due to trophy-hunting and for their body parts used in traditional Chinese medicine, the tiger listed by the IUCN as 'endangered' and the bear as 'vulnerable'. Poaching has been reduced in recent times, but it still remains a threat to both. Currently, there are about 500 Amur tigers in the wild in eastern Russia and a small number in China and maybe North Korea, although on occasion they might range more widely.

In October 2021, one individual – a male – went on a walkabout and its paw prints were spotted in Yakutia, the world's coldest permanently inhabited region and more than 1,300 kilometres further north of the species, normal range, evidence, perhaps, that Amur tiger numbers are recovering. Maybe the male was forced to seek a territory elsewhere. Curiously, this was the second unusual arrival in the region. In May the same year, a wayward polar bear had trekked over 3,000 kilometres south from the Arctic Ocean and wandered into Norilsk, an industrial town in northern Siberia, only 480 kilometres north of the travelling tiger.

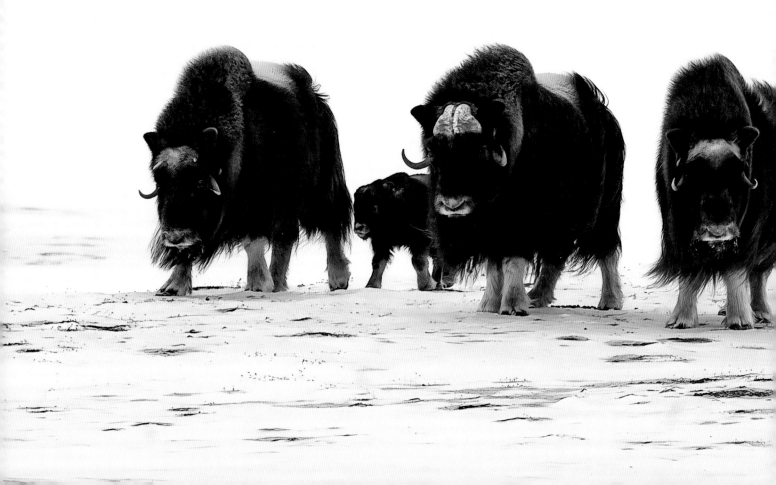

Tundra's Living Fortress

BELOW Musk oxen tend to confront danger by facing it, presenting a wall of horns to an aggressor, with the younger members of the herd tucked safely behind.

The land circling the top of the world is the tundra. It's too cold for trees to grow, and there is nowhere to hide from the relentless storms and minus 40°C temperature in the depths of winter. Life thrives, even here, but it has to have the best adaptations to the cold to survive. Such a creature is the musk ox, an Arctic mammal more closely related to sheep and goats than to cattle, a so-called goat-antelope. It's not a big animal; standing about 1.5 metres at the shoulder, but what *are* impressive are its large, curved horns with a broad base. When threatened, a herd will gather tightly together in a phalanx – a 'circle of wagons' formation – with youngsters at its centre and all the adults with their horns facing outwards. Like this, as long as none panics, their temporary fortress is impregnable.

A musk ox also looks far bigger than it really is because it has such a long and thick coat. It has long guard hairs that reach almost to the ground, like a skirt, and a dense underfur that, when moulted in summer, is collected and prized by northern people. It is called qiviut and is said to be the finest wool of all – the 'cashmere of the north'. It's eight times warmer than sheep's wool and is extremely soft and lightweight. A 1-ounce ball of 80-per-cent-qiviut yarn costs up to £80, about twice the cost of cashmere, mostly collected from semi-domesticated stock.

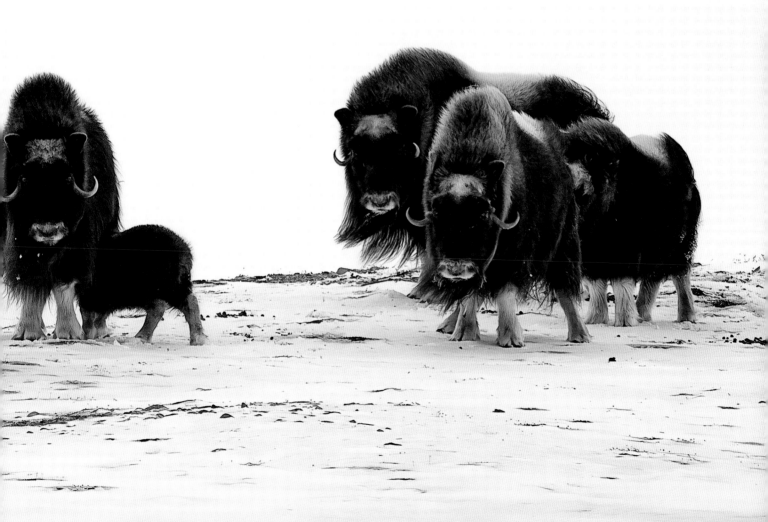

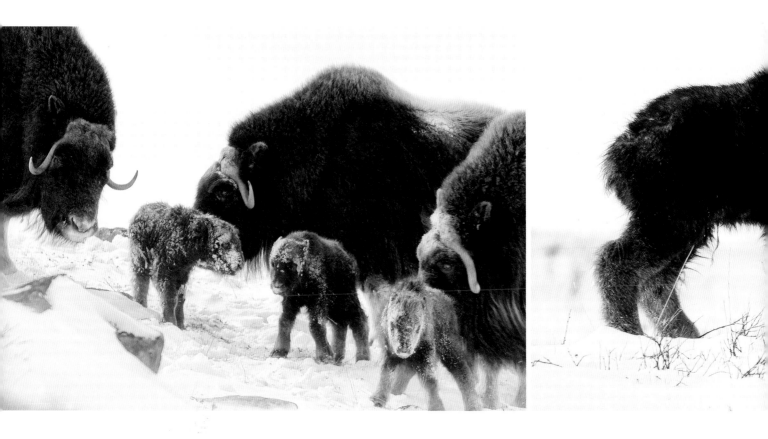

ABOVE **All these newly born musk oxen calves arrived at roughly the same time, so they are all at the same stage of development.**

ABOVE RIGHT **A young musk oxen is extremely vulnerable. It depends on its mother for food and the rest of the herd for protection and must be up and able to run from danger shortly after being born.**

In the wild, musk oxen roam the tundra in small herds, drawn to river valleys in summer, where nutritious herbs and grasses grow, but moving to higher tundra in winter to avoid deep snow. There is a distinct hierarchy, especially in winter. Wherever there are patches of grass, older animals displace younger ones; otherwise Arctic willow and lichens, dug from under the snow, are the staple winter foods.

At one time, musk oxen roamed freely across much of the Arctic tundra, but during an interglacial period about 20,000 years ago the warming world saw their range restricted. After the end of the last ice age, human hunters put paid to many of the rest so, eventually, they only lived in the wild in remote parts of Greenland and the Canadian Arctic. More recently, musk oxen have been reintroduced to Alaska, Siberia, and to Norway, with a small number moving into northern Sweden. Throughout their range, their main predator is the wolf, but in the Canadian Arctic there is one other carnivore that can wreak havoc amongst musk oxen herds.

The lives of the members of a herd are so synchronised that all the pregnant female musk oxen give birth within hours of one another, so every youngster is at the same stage of development. They are up and walking only minutes after they are born, but they are still unsteady on their feet and totally dependent on their mothers for everything, from encouragement to food and protection. With their thick fur, they can withstand the bitter cold,

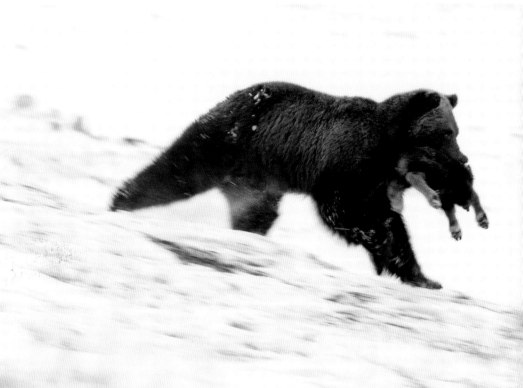

ABOVE RIGHT When confronted with a sudden glut of food, grizzly bears behave just like foxes in a chicken coop, seemingly killing for the sake of killing.

OVERLEAF The sense of smell is important in the bonding of a mother with her calf.

but there is something that they are not able deal with: in this area at this time of the year male grizzly bears emerge from their winter dens and, after a six-month fast, they are ravenous.

Bears have an extraordinary sense of smell so one can pick up the smell of the herd with ease, not helped by the dominant male's musk-like odour, which gave rise to the common English name of 'musk ox'. The bear runs at the herd at full tilt – close to 35 mph – but the adults, rather than form their defensive phalanx, simply run away, leaving their young calves behind. The bear slams into the first calf, but instead of settling down to feed, it starts after the others. Like a fox in a chicken coop, the bear kills indiscriminately. One after another the baby musk oxen are taken down. Just one survives the onslaught, but by now the adults are some distance away, and they don't turn back. This is nature red in tooth and claw, and the tundra at its most cruel.

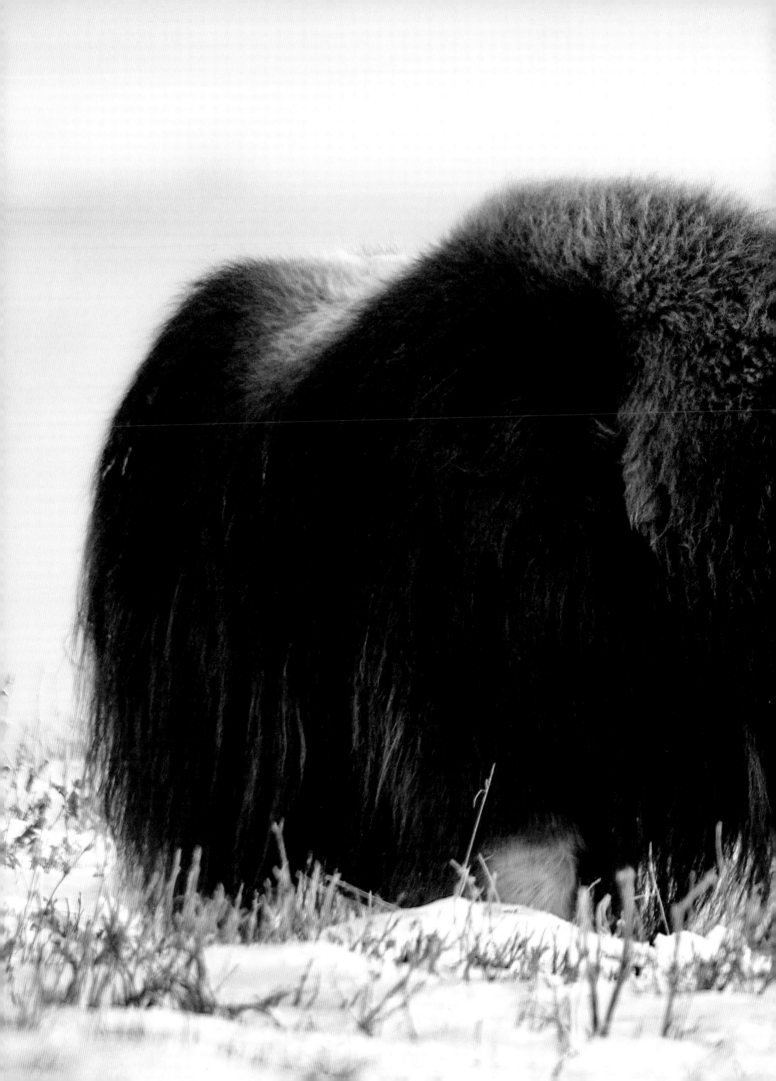

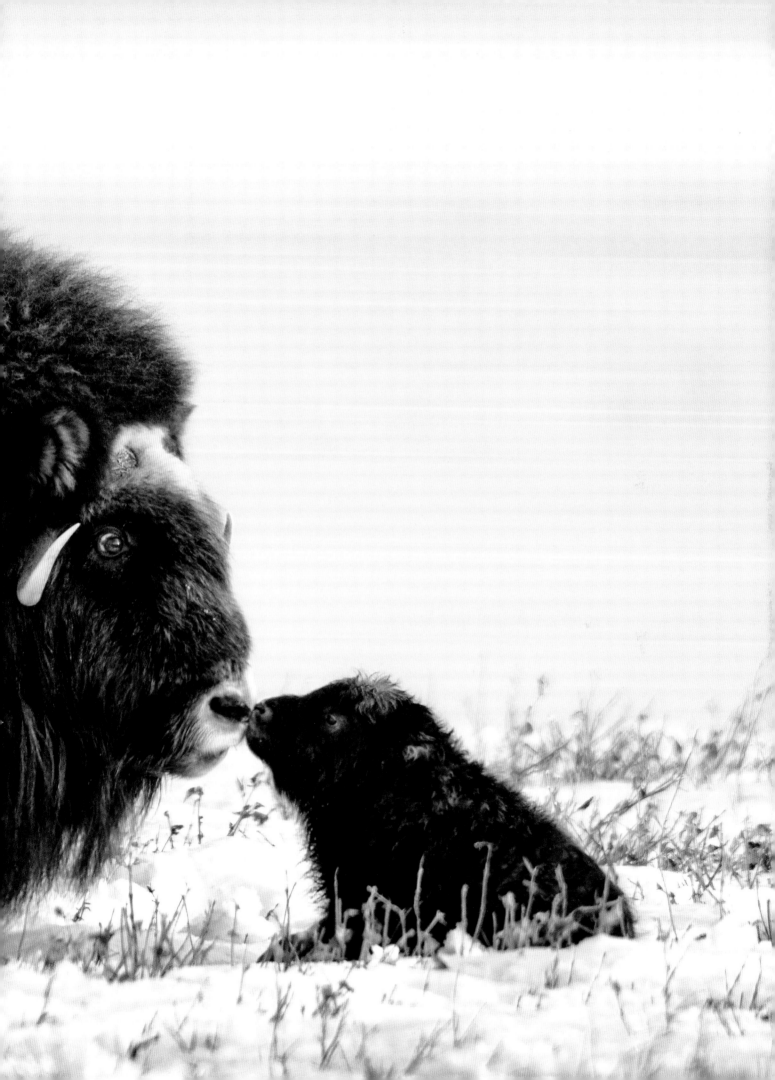

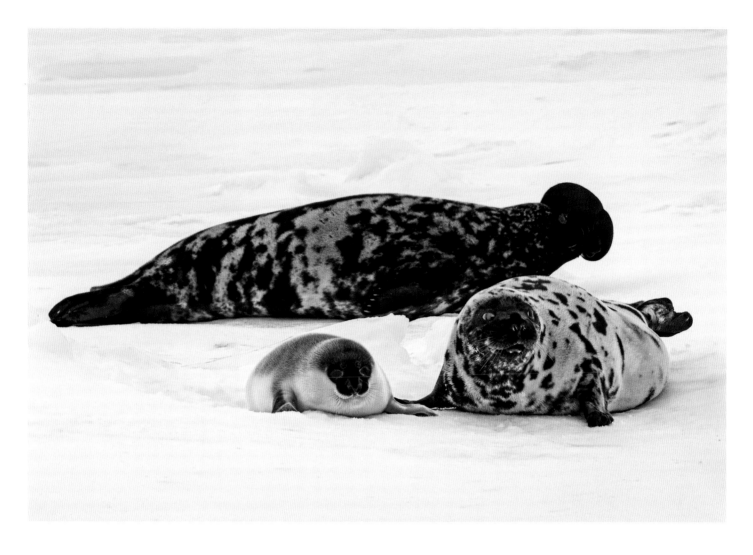

A Seal in a Hurry

ABOVE Even when the pup is just four days old, a male hooded seal, with one of his hoods inflated, is either scaring off a rival or attempting to attract the mother's attention, although she'll have none of it until her pup is weaned.

The tundra lands of Alaska, Canada, Greenland, Norway and Russia border the Arctic Ocean, which lies to their north. It is the only ocean that can freeze over almost entirely in winter, an icy world of constant seasonal change and shifting pack ice, and so several species of Arctic seals, especial those that gather at breeding sites on the edge of the ice, have to do things, such as birthing and weaning, incredibly quickly. The timing is critical. Just as the ice starts to thaw, polar bears are less likely to walk on the melting ice, but the pressure is on seal mothers to complete the entire process before the ice breaks up and is gone.

One of the fastest breeders is the hooded seal. When the time comes to give birth in late February or early March, pregnant females clamber onto the surface of the fragmenting pack ice and give birth to a single pup, about a metre long and known as a 'blue-back' on account of the blue-grey fur on its back. Its mother, however, barely sees the pup, as it is weaned 3–5 days after its birth, the shortest suckling period of any mammal. The pup gulps down about 10 litres of milk per day, its fat content about 70 per cent. It's the richest milk of any mammal, and it enables the pup to gain about 7 kilograms in weight a day.

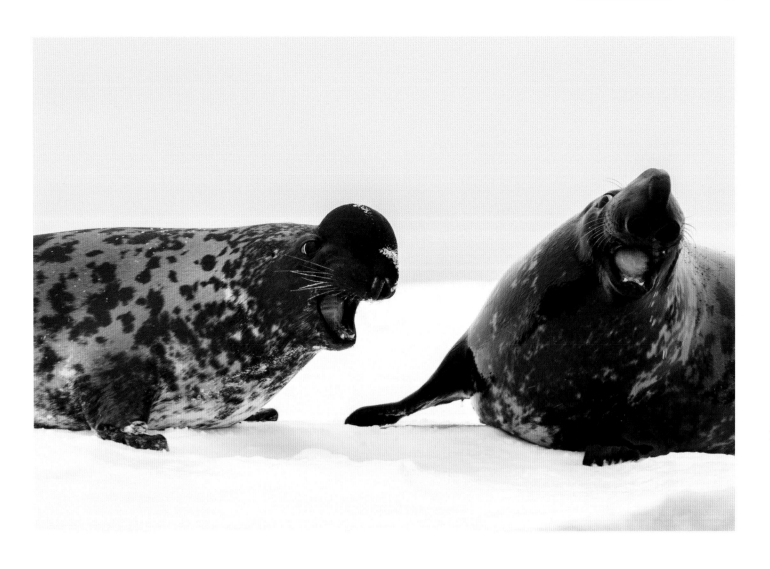

ABOVE Two male hooded seals are about to slog it out to be first in line to impress a receptive female.

Inevitably, waiting in the wings are male hooded seals, each one wanting to be first in line when the mother abandons her pup and is ready to mate again; but it's not so easy for a young pretender who is trying his hand maybe for the very first time.

The seal approaches the female, but the newcomer has jumped the queue, and it is at this moment that it becomes apparent why this species is called the hooded seal. The waiting males display to each other by inflating a bi-lobed nose hood, which when flaccid, hangs down in front of the mouth, but when inflated, forms a dark balloon. The males also emit 'bonging' and 'pinging' sounds, which turn to roars if a rival fails to back down. The ensuing fights become extremely noisy and very bloody.

Young males are usually chased away by the dominant 'ice master', but sometimes they get lucky. With both seals swimming at extraordinary speeds amongst the ice floes, against all the odds, the younger male succeeds in evicting his older rival. Winning over a reluctant female, though, might not be so easy. It is time to pull out the showstopper.

Males have a second visual display. They inflate a red nasal balloon formed from the nasal septum that is filled with air and pushed out of the left nostril. The male's size and, therefore, the size of his inflated hood and

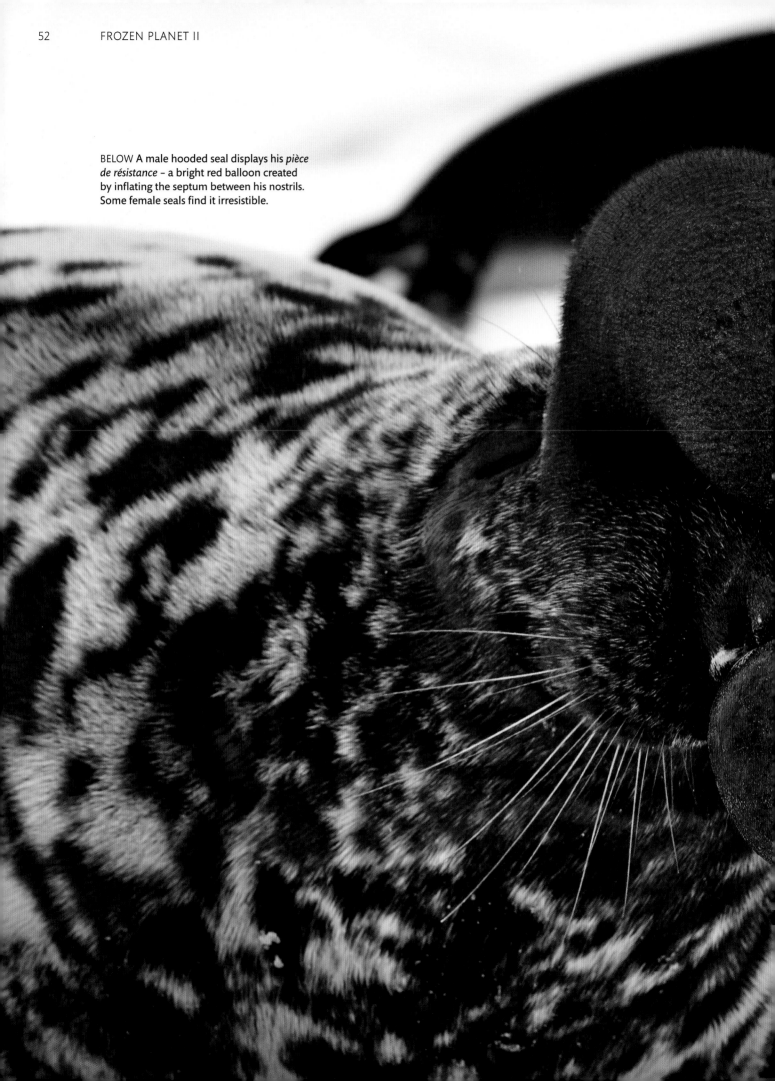

BELOW A male hooded seal displays his *pièce de résistance* – a bright red balloon created by inflating the septum between his nostrils. Some female seals find it irresistible.

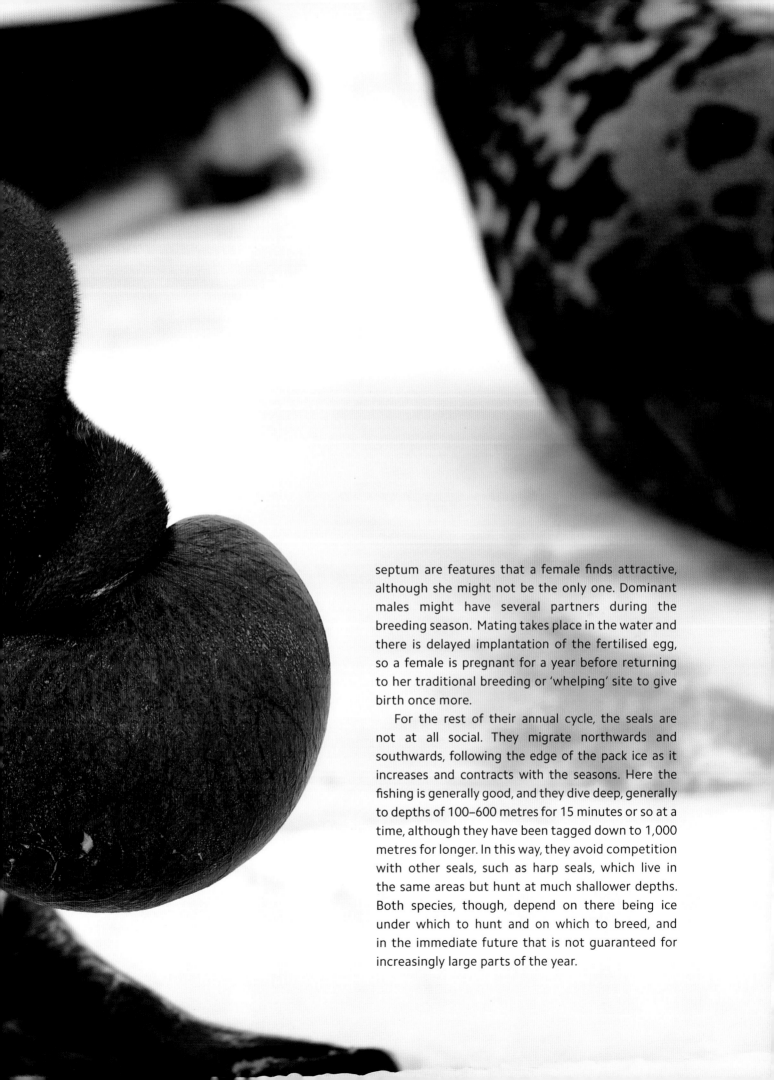

septum are features that a female finds attractive, although she might not be the only one. Dominant males might have several partners during the breeding season. Mating takes place in the water and there is delayed implantation of the fertilised egg, so a female is pregnant for a year before returning to her traditional breeding or 'whelping' site to give birth once more.

For the rest of their annual cycle, the seals are not at all social. They migrate northwards and southwards, following the edge of the pack ice as it increases and contracts with the seasons. Here the fishing is generally good, and they dive deep, generally to depths of 100–600 metres for 15 minutes or so at a time, although they have been tagged down to 1,000 metres for longer. In this way, they avoid competition with other seals, such as harp seals, which live in the same areas but hunt at much shallower depths. Both species, though, depend on there being ice under which to hunt and on which to breed, and in the immediate future that is not guaranteed for increasingly large parts of the year.

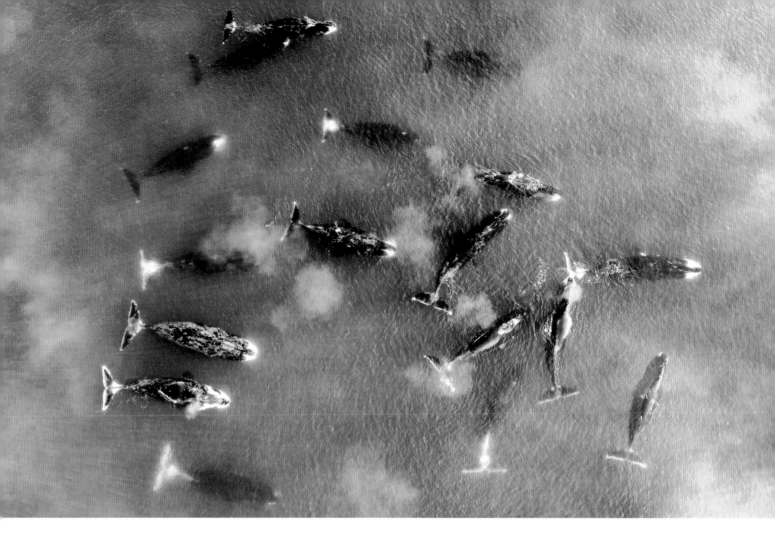

Big but Vulnerable

ABOVE A group of bowhead whales socialises in shallow water in the Sea of Okhotsk. They are part of a larger group of about 50 whales.

In summer, the Arctic Ocean is so rich in food that it attracts the largest mouths on the planet. They belong to bowhead whales, the Arctic's biggest animals. Bowheads are often the whales that forge ahead in the lead in spring, and smaller cetaceans, such as narwhals and belugas, follow them. They can use their large head – about a third of the bowhead's total length – to break through ice more than 20 centimetres thick, and they have a thick layer of blubber to keep warm. The superlatives continue with the way they feed: they have a mouth the size of a campervan – the biggest of any animal – and their comb-like baleen plates are the longest of any whale. When feeding in summer, they glide along at about 3 mph, sieving out about 2 tonnes of food a day, which includes krill, copepods and small fish. They also live for an exceptionally long time, a discovery that has an intriguing back story.

In May 2007, a group of Inuit hunters harpooned a bowhead whale off the coast of Alaska and hauled it ashore. Slicing the meat away, they found another, much older harpoon imbedded in the whale's neck. Whaling history experts examined it and found it to be a type of metal harpoon manufactured between 1879 and 1885. On its shaft were six notches, likely an ownership mark and an indication that it was probably an Inuit hunter and not a commercial whaler who threw the earlier harpoon. It also means the whale must have been swimming around for something like 115 years before it was

harpooned a second time, possibly by the descendants of the original hunters. More usually, scientists work out the lifespan of these whales by analysing the amino acids in their eyes. It's been estimated that they can reach the ripe old age of 200 years or more, making them the oldest mammals on the planet. By that time, they might have grown to 18 metres long.

Like many of the Arctic's animals, the whales migrate long distances, keeping pace with the ice edge northwards in spring and southwards in the autumn, but at some point in their annual schedule, some whales follow ancient pathways to shallow bays on the coasts of the Canadian Arctic and eastern Russia, where they socialise with others of their kind.

The bowheads come to feed on plankton concentrated by estuary and tidal currents, with the whales moving into waters sometimes as little as 3 metres deep. Watching scientists, though, have discovered that they're also here for something very different: the whales have what look remarkably like 'spa days'. Large boulders in the shallow water are used like pumice to scrape away dead skin and parasites, and it's likely the whales have been rubbing against these rocks for hundreds, if not thousands, of years.

BELOW A bowhead whale rubs its body against a large rock in shallow water, probably to remove dead skin and parasites. The rock has possibly been used for centuries.

OVERLEAF The film crew and its small skiff is dwarfed by whales that can be up to 18 metres long.

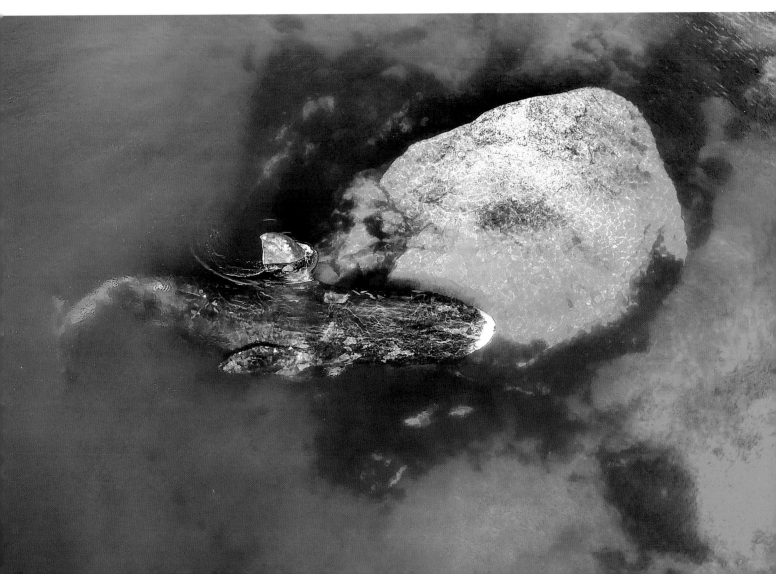

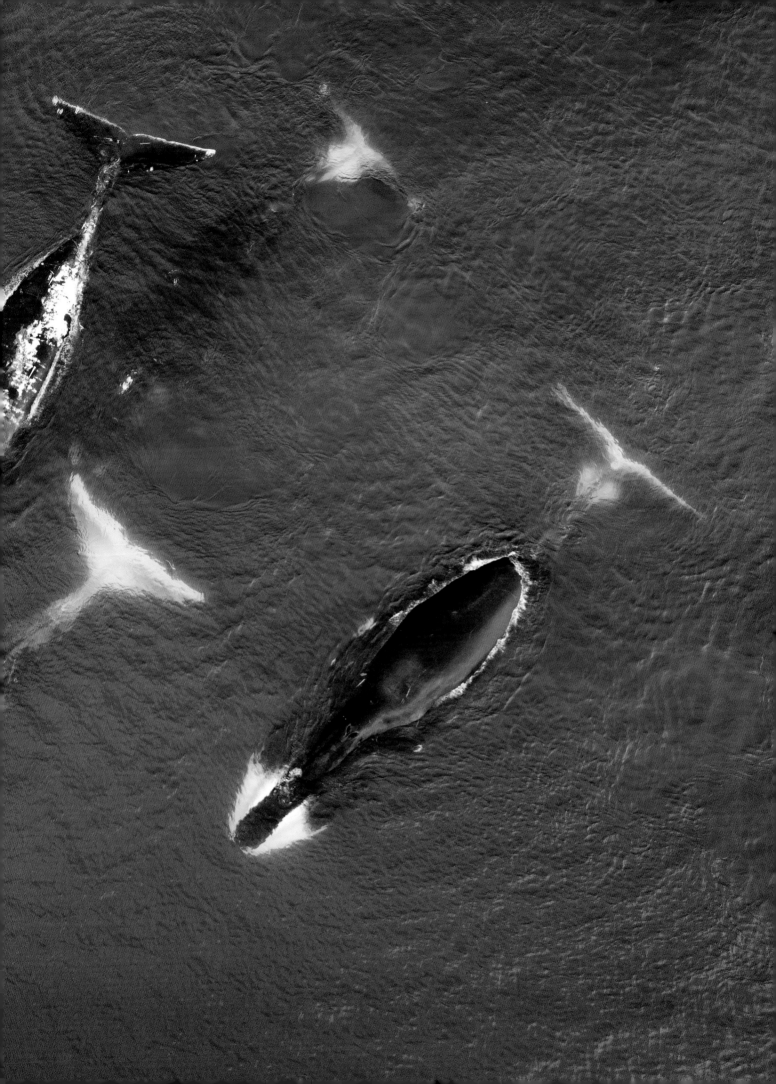

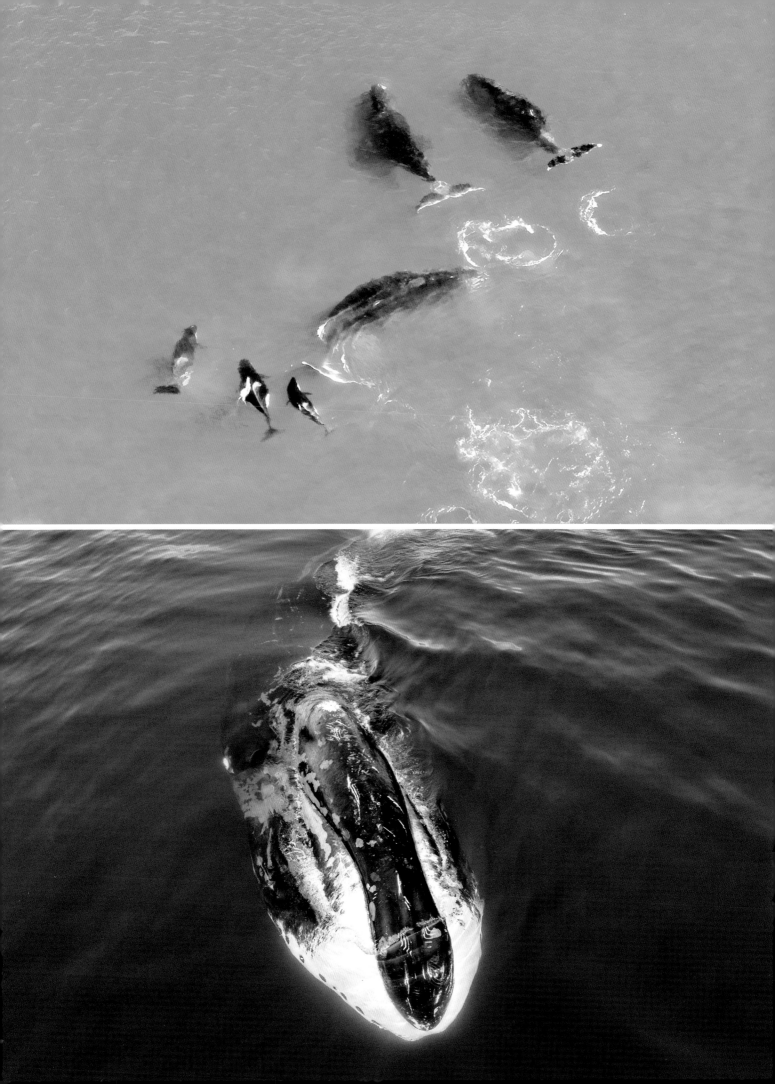

Where there are regular gatherings of animals like this, there are sure to be hangers-on, and some are unwelcome guests at the party. The Sea of Okhotsk plays summer host to the entire western sub-Arctic North Pacific sub-population of bowheads, but here they are often harassed by killer whales, some large pods having as many as nine individuals in their whale-hunting party. Killer whales can swim more than 20 mph faster than the bigger whales, and their sudden arrival would certainly cause considerable alarm among the bowheads. They are not entirely defenceless, for they can wield their enormously powerful tails, bringing them crashing down on the sea's surface. And, with an unexpected burst of speed, they can head for shallower water, where killer whales have less space to manoeuvre; but really, there is nowhere to hide.

At first, the killer whales size up their prey. The largest whales are usually too big to take down, although a pod has been known to attack whales up to 10 metres long, but the young and the weak are a better bet, so the pod would probably select a young bowhead and then start the chase. Killer whales, much like wolves, wear down their target, and they certainly have tenacity. They attack relentlessly, ramming into the bowhead's ribs, trying to sit on its blowhole and smother it, snapping at its jaws, and dragging it down into deep water. They can keep up the assault for over an hour, by which time the exhausted whale succumbs and the sea is filled with blood as the victors share the spoils.

The irony, though, is that, although killer whales kill young bowheads, you could say that many are actually the casualties of climate change. With the reduction in ice cover in summer, killer whales off the Canadian coast and in the Chukchi Sea, for example, are travelling further north and risking entrapment to spend longer in the Arctic and sub-Arctic, in waters that were previously locked in by pack ice but are now open. The impact on Arctic food webs is palpable, especially competition for resources, not only with the region's wildlife, but also local people who depend on marine mammals for food. The longer open-water season will inevitably make the bowhead, along with seals, belugas and narwhals, increasingly vulnerable to killer whale attacks, and already both scientists and indigenous peoples have been finding unprecedented numbers of tattered whale carcasses washed ashore. Bowheads may live for centuries, but for now their habitat is changing rapidly, and the big question is whether they will be able to keep pace with it.

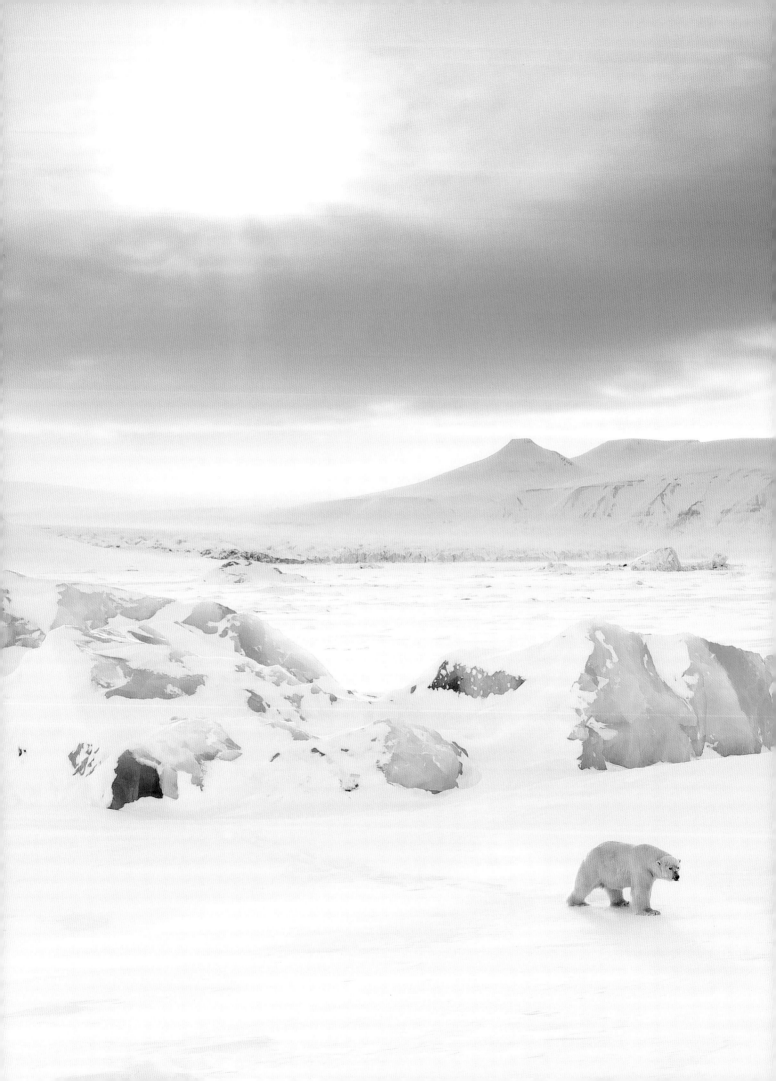

Chapter 2
FROZEN OCEAN

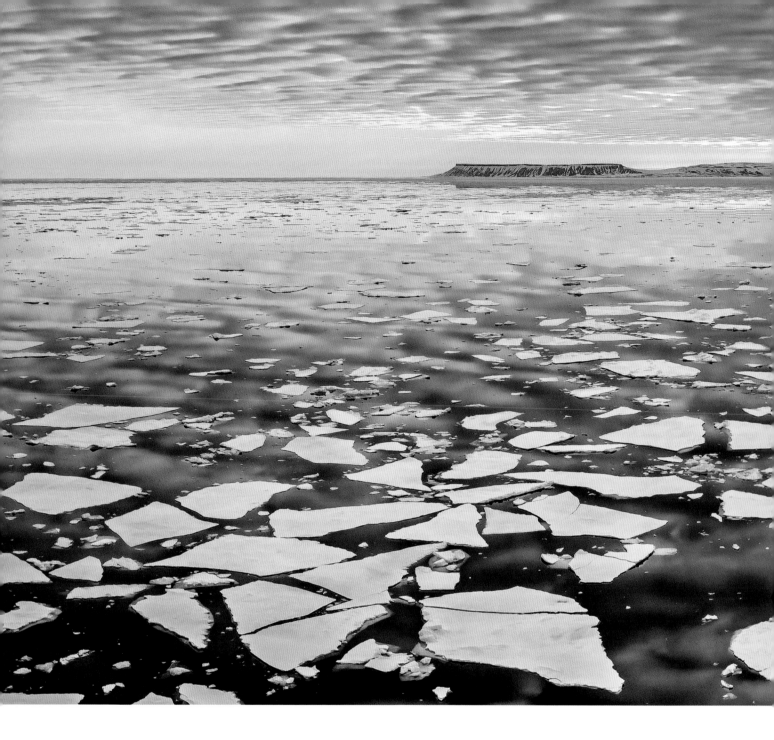

ABOVE A still day in spring, when large swathes of pack ice fragment into countless ice floes and melt away in the Svalbard Archipelago. The ocean's ice cover starts to shrink at the beginning of March and reaches its minimum in September.

THE ARCTIC OCEAN is a frozen sea surrounded by land situated over the North Pole. It is the smallest and shallowest of the world's five oceans, with 60 per cent averaging little more than 200 metres, but as deep as 5,550 metres in the Molloy Deep, an ocean trench located 100 kilometres west of the Norwegian archipelago of Svalbard and the deepest part of the Arctic Ocean. In midwinter, the region experiences 24 hours of darkness and, in midsummer, 24 hours of sunlight, both of which profoundly affect the lives of Arctic wildlife, above and below the waves, because with the change of seasons comes a change in the ice. In winter, about 90 per cent of the Arctic Ocean is covered by a lid of sea ice, which varies from year to year, but generally the area of sea ice expands and contracts with the seasons. It freezes to its maximum extent by March, at the end of the winter, while

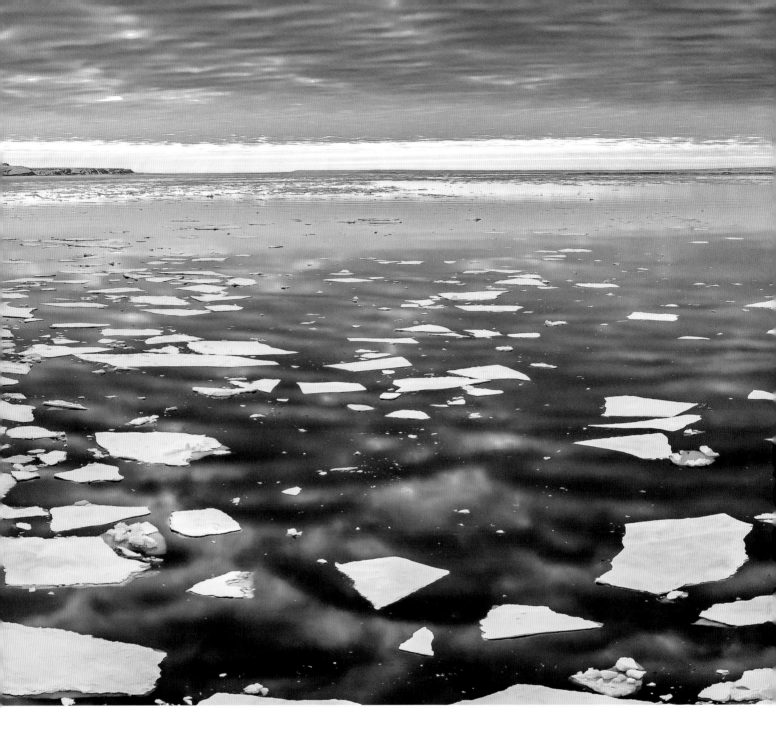

melting, breaking up and shrinking to its minimum size by September, at the end of the summer.

The average winter air temperature at the North Pole is a chilly minus 40°C, and in summer it can reach the dizzy heights of 0°C, while the water temperature below the ice is generally about 2°C, whatever the season. The water, therefore, is usually warmer than the air above, and this heat filters up through the ice to moderate the temperature close to its surface, so the Arctic Basin tends to be a little warmer than the Antarctic. Nevertheless, to survive here, life must adapt not only to the extremes of temperature – the perishing cold of winter and the relative warmth of summer – but also to the Arctic Ocean's shapeshifting world of water and ice.

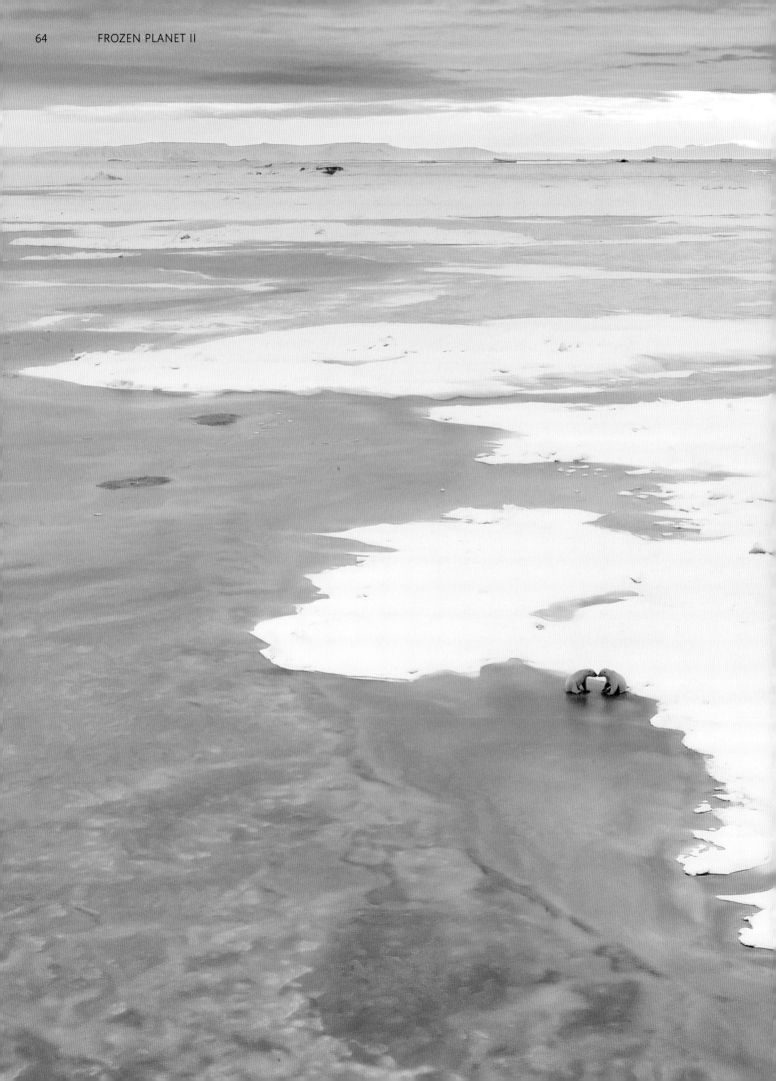

Ice-Skating Bears

OPPOSITE Young polar bears 'play' on the Arctic sea ice. What looks like a confrontation at first, surprisingly, turns into recreation.

The frozen ocean at the top of the world is home to that icon of the Arctic, the polar bear, and on the ice close to Svalbard is a young female about to go hunting. She will have spent the three dark midwinter months alone, patrolling the edge of the ice pack, while protected from the cold by a thick layer of blubber and a double coat of thick fur with hollow hairs that can trap the heat. She could withstand whatever conditions Mother Nature threw at her, but with the brief appearance of the early spring sun low on the horizon, conditions are beginning to improve and there are new opportunities to find food.

In the water beneath the ice swim ringed seals, the polar bear's most common prey. The seals catch fish and squid down to 90 metres but, having held their breath for 45 minutes, they must come to the surface to breathe. They make for holes or cracks in the ice, but their very presence in the air, no matter how momentary, alerts the bear that the hole is currently being used. She travels crosswind, using one of the most sensitive noses in the animal kingdom to detect smells in the different streams of air blowing across her track. It only works with low wind speeds and is especially useful in the long dark nights of winter, but in spring the bear can also use her eyes, so the young bear heads towards one particular hole in the ice. She sniffs close to the snow on the surface, for it is said she can pick up the smell of a seal even under the ice, and then she stops suddenly, looks pointedly ahead and, trying to make the least noise with her footfall, edges slowly forwards. Then, she makes a sudden dash, dives twice into the hole and

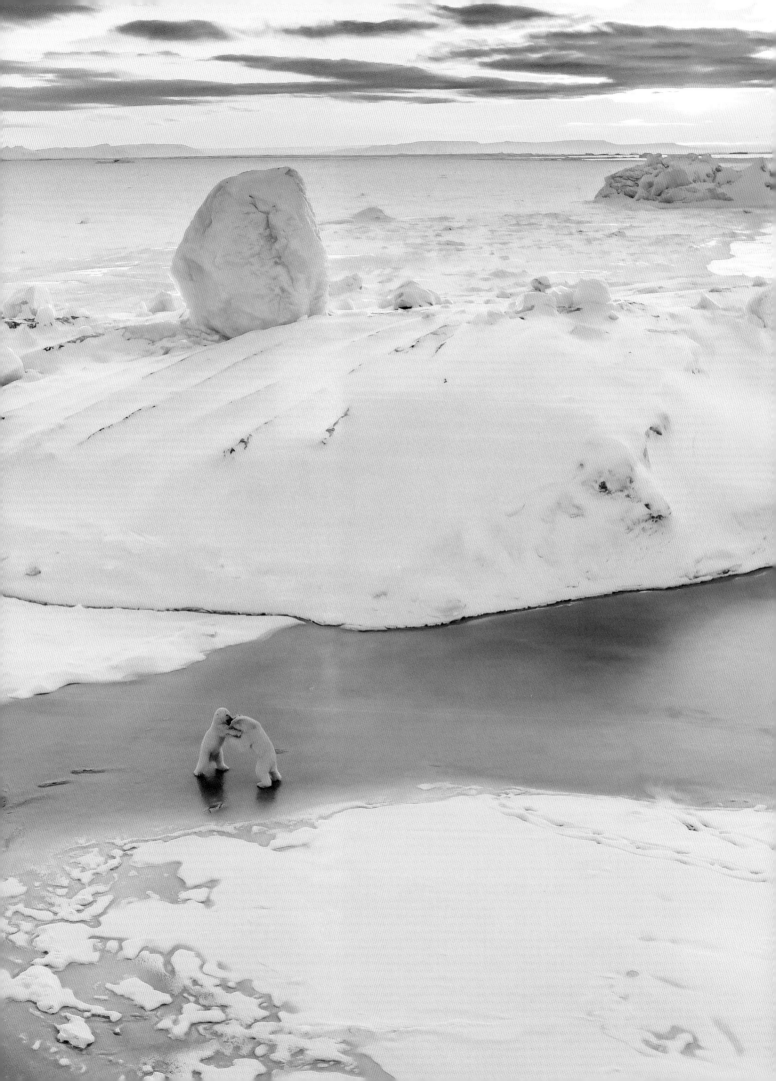

ABOVE A game of peek-a-boo has one of the bears swimming between two openings in the sea ice, while the other peers down from above.

OPPOSITE Having found a smooth stretch of sea ice without snow, the two polar bears begin to ice skate.

disappears briefly below the surface, only to reappear with a seal, which she devours slowly and deliberately, not wishing to leave even a morsel.

The reality, of course, is that only one in ten attempts result in a meal, so, with a male bear approaching, the female is ready to defend what remains of her seal carcass. Male bears tend to be larger and more powerful than females, but the male ambling towards her is not much bigger than she is. It would be an even fight, but then the two bears do the most extraordinary thing – after a brief rough and tumble, they start to play. They follow one another to an area of thin ice, have a game of peek-a-boo between two holes in the ice, and then they actually begin to skate. Yes, you read that correctly – these two young polar bears are dancing on ice.

After three hours playing together, they go their separate ways, returning once again to their solitary lives. It is an extraordinary piece of behaviour to have been captured on film.

Arctic Sea Ice

OPPOSITE TOP A pressure ridge is an angular block that pushes up from the sea ice. It has a sail above the ice that can be up to 25 metres tall, and a keel below that is four times the height of the sail.

OPPOSITE BOTTOM In spring, fast ice separates from the front of a Svalbard glacier, where a gap is starting to form due to the movement of the tides.

The sea ice on which these polar bears depend is present in two seasonal forms. The thin 'first-year ice' freezes in winter and melts during the warmer months, while the thicker 'multi-year ice' does not melt in summer, so it builds year on year. Unlike the ice from ice sheets and glaciers, which are composed of freshwater, sea ice is frozen seawater. The salt, though, does not freeze. As the water becomes frozen, most of the salt is squeezed out. Some is locked up in tiny vesicles of free water between the ice crystals, which drain out over time, but most of the salt remains in the water below the ice, which increases its density. As a result, the dense, cold water sinks down into the deep sea and flows across the floors of the Atlantic and Pacific oceans, only to be returned to the Arctic in warm currents, such as the Gulf Stream. It is a vital conveyor belt that determines climates across the globe, but there is a crisis looming. Sea ice in the Arctic is declining at a rate of 13 per cent per decade, with only 3 per cent of multi-year ice remaining currently. If it melts entirely and the conveyor stops, who knows what will happen? While the ice is there, though, it is surprisingly dynamic.

At one time, it was thought the ice just sat where it formed, but the Norwegian explorer and scientist Fridtjof Nansen had the notion that the ice moved around the pole, and he backed his theory with an expedition filled with danger. In 1893, Nansen was aboard the *Fram* and set out from Vardø, on the northern tip of Norway, heading for the ice front. When the ship was far enough north, he purposely let it be trapped, as the winter ice froze around it, but rather than sit still, it drifted across the Arctic Ocean between the North Pole and Franz Josef Land, emerging three years later off the north coast of Svalbard. Nansen had proved that the sea ice is very much on the move, and now, with the luxury of satellite technology, we know that two major ocean currents, generated by the prevailing winds, carry the ice around the Arctic Basin.

Like a great wheel, the Beaufort Gyre turns clockwise to the north of Canada and Alaska, corralling sea ice for several years and leading to the formation of thick, multi-year ice. The capture results in ice floes colliding and pushing up to form towering ridges, so the frozen Arctic Ocean is not a vast, flat, snowy desert, but can be a frozen seascape with peaks and valleys just like on land, and these vary from place to place and year by year. A second system – the Transpolar Drift – guides the sea ice from the Siberian coast of Russia, across the Arctic Basin, and exits into the North Atlantic. Some of this transpolar ice is pushed against the Greenland and Canadian coasts, forming the greatest thickness of sea ice in the Arctic. It averages 4 metres but has pressure ridges up to 20 metres high. In more recent times, this ice has gained the name 'Last Ice Area' because, if global warming persists, it will be the last sea ice in the Arctic and the only refuge for any species of Arctic wildlife that depends directly on the ice of the Arctic Ocean for food and shelter.

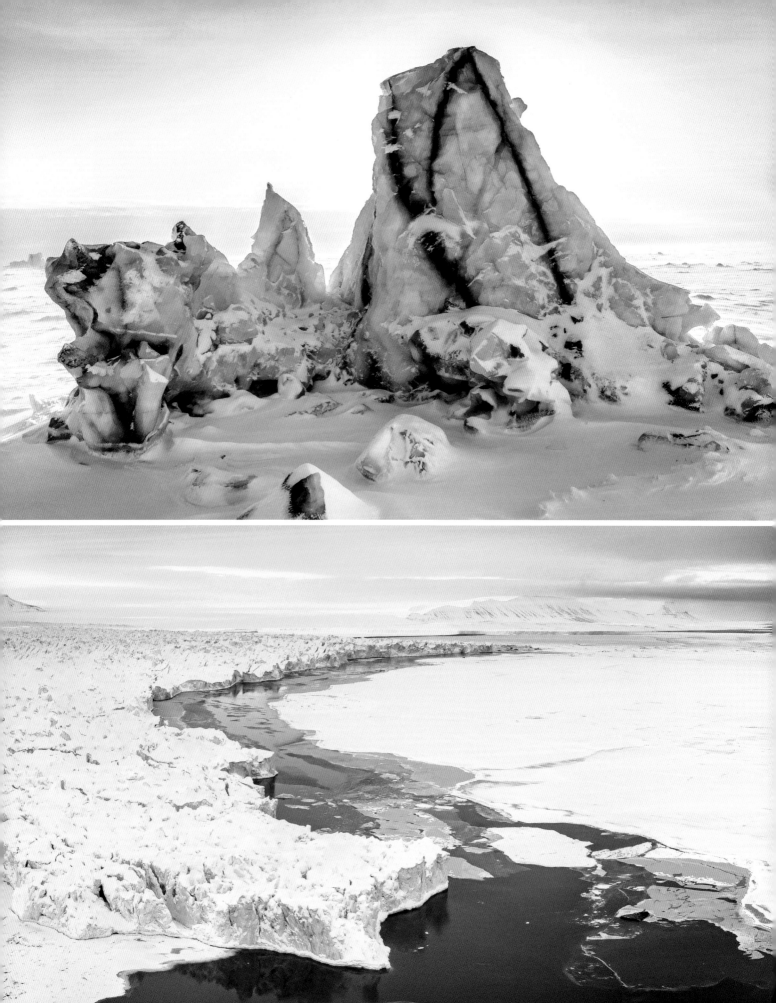

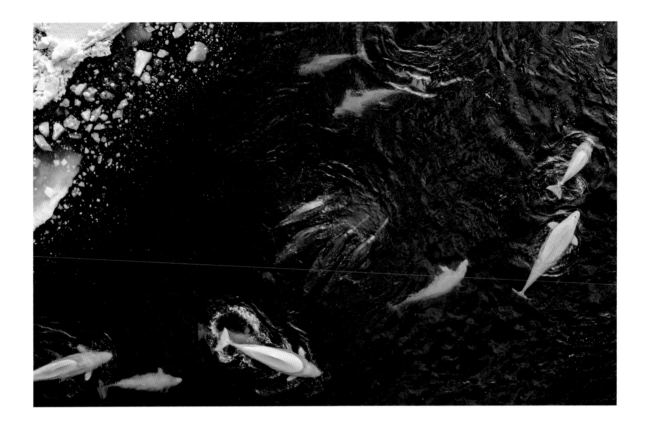

Follow the Lead

ABOVE Pods of narwhals
and belugas meet in a
cul-de-sac at the head of
a lead in the sea ice. Both
groups make clicking and
whistling sounds that give
the impression of two
types of toothed whales
communicating across
the species boundary.

OPPOSITE Belugas or
white whales are trapped
in the sea ice. They swim
in circles to keep the ice
from freezing, so they can
continue to breathe.

As the spring thaw takes hold, corridors of open water, known as 'leads',
appear in the sea ice. They tend to speed up its melting. The darker water
reflects a lot less light than the ice, so the sea in the vicinity of the lead
absorbs more solar energy and warms up, and they can form anywhere across
the Arctic Ocean and at any time. They are brought about when the wind or
ocean currents cause the ice to stress and crack, and the fragmented ice floes
to diverge. They are not permanent, lasting maybe only a few days, but they
enable Arctic whales – bowheads, belugas and narwhals – to probe deep into
the pack ice while still able to take a breath in open water.

Occasionally, a lead can close and trap the whales, especially the smaller
ones, and a pod of belugas has become trapped in a patch of open water
smaller than a basketball court, off the coast of Arctic Russia. As air-breathing
mammals, they need to return to the surface every fifteen minutes or so, and
by swimming continuously in a circle, the 30 4-metre whales manage to keep
the surface from refreezing. They have, though, been trapped here for the
several months of winter, and have eaten all the fish in the vicinity, so they are
clearly emaciated. They are, quite literally, starving to death, and the nearest
lead is 30 kilometres away, but as the spring thaw begins, the impenetrable ice
pack starts to fracture, and, just in time, the whales are released.

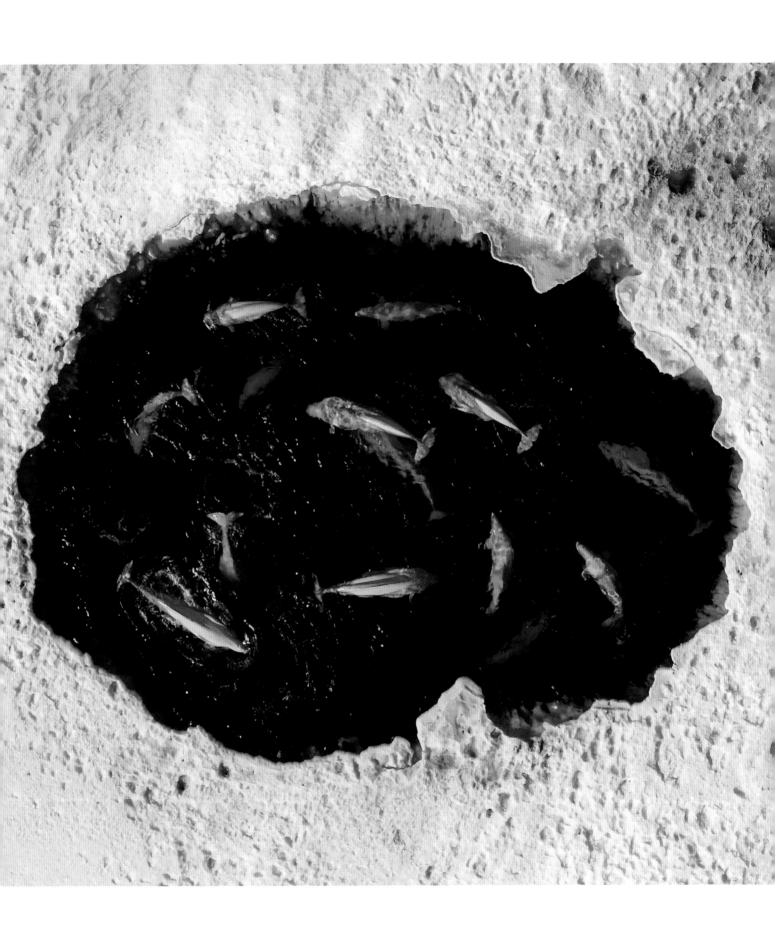

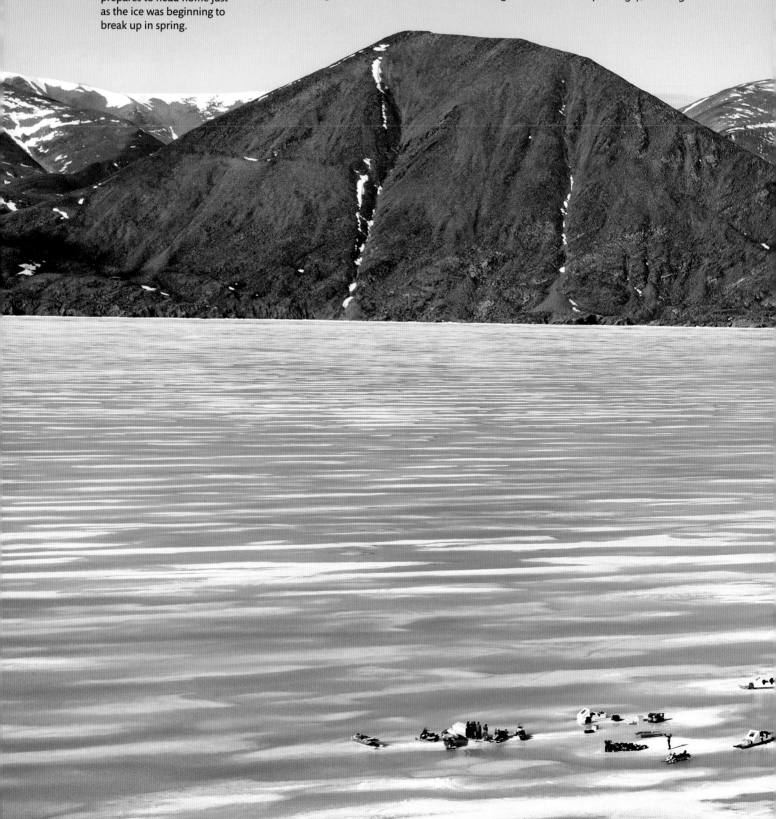

BELOW Having camped out on the ice for a month near Mittimatalik, meaning 'the place where the landing place is' (also known as Pond Inlet), the *Frozen Planet II* film crew prepares to head home just as the ice was beginning to break up in spring.

Another group of belugas heads along a lead, but eventually, it becomes a dead end, and milling about in the cul-de-sac is a group of four narwhals. The two species do not often meet like this, even though their habitats overlap. They are also not in competition for the same food because narwhals tend to catch fish, such as Greenland halibut and polar cod, deep underneath the ice, and belugas hunt in shallow areas along the coast. Surprisingly, during

OVERLEAF Male narwhals, recognised by their long spiral tusks, follow a lead in the sea ice off the coast of Arctic Canada.

this very rare encounter, the whales socialise and appear to be 'talking' across the species boundary. Underwater microphones reveal that both species seem to be communicating with a repertoire of buzzes, clicks and whistles. What they are saying, though, must remain a mystery.

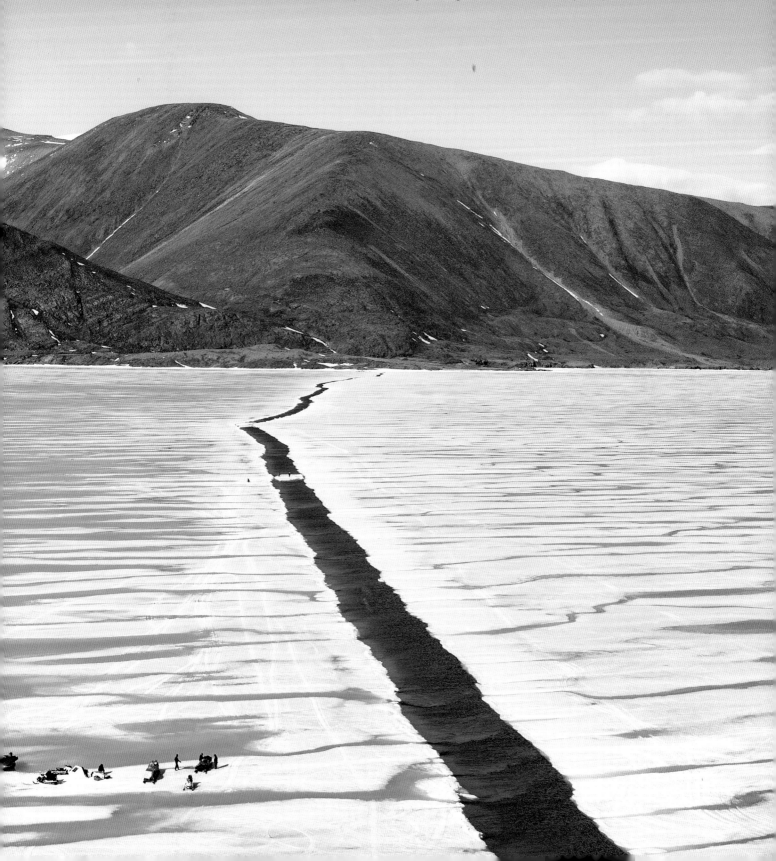

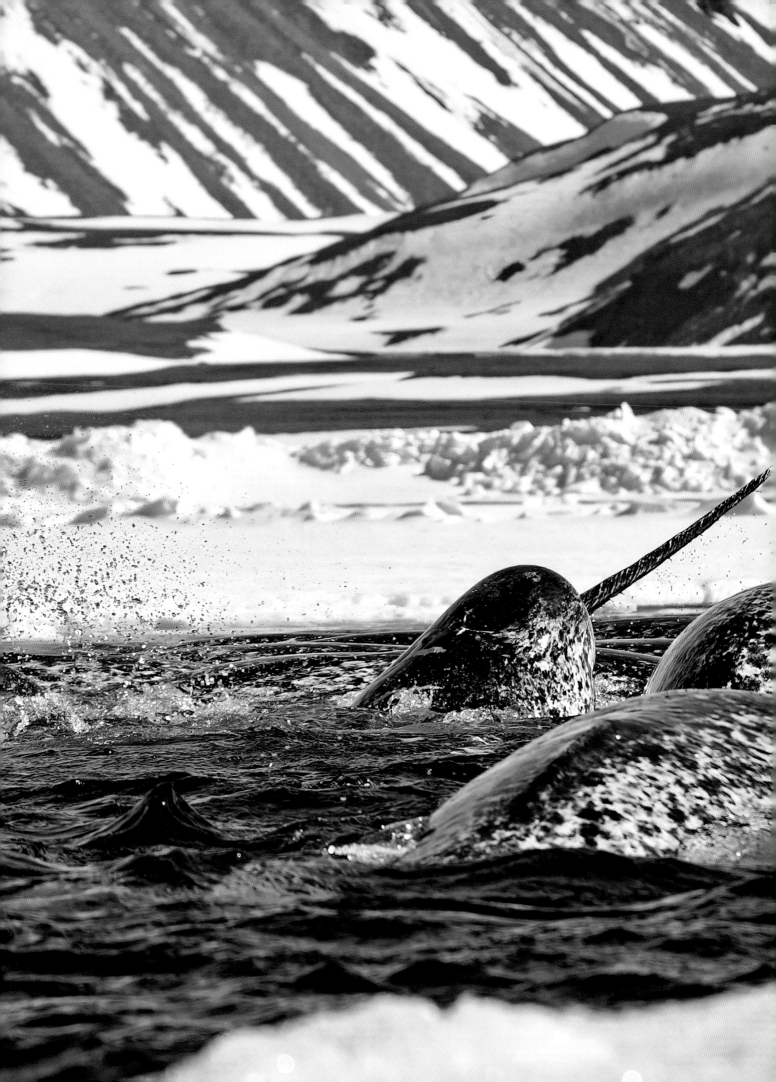

New Life at the Edge

In spring, large parts of the Arctic Ocean's pack ice fragment into countless ice floes, and the area of sea ice gradually shrinks. After the perpetual darkness of midwinter, the lengthening days of early spring bring with them the promise of new life. One species that needs to stay ahead of the game is the harp seal, especially mother harp seals, as they drop their pups on top of the ice, where they're easy targets for predators. Like the hooded seals we met in the previous chapter, timing is critical: pup too early and the tightly packed sea ice can be negotiated easily by hungry polar bears; pup too late and the ice will have gone before the pup has had time to develop the wherewithal to survive. It's a delicate balancing act, and harp seals have it timed to perfection; at least, they did.

Looking at such factors as bird migrations and flowers blooming, scientists at the University of California, Davis, determined that spring in the Arctic is arriving at least 16 days earlier than a decade ago, and for the harp seal a 16-day shift in its annual cycle could be devastating.

Harp seals are wanderers. You can find them anywhere in the extreme North Atlantic and Arctic Ocean, from Hudson Bay in the west to Franz Josef Land in the east, but they don't stay in one place for very long. Each year, the seals follow the pack ice northwards in summer and then south in

BELOW A baby harp seal on an ice floe in the Greenland Sea. At four or five weeks old it will shed its white coat, having grown a grey one underneath.

winter, an annual round trip of more than 5,000 kilometres. In late February, they gather at traditional breeding sites across the Arctic, and in March the females give birth. There are four main pupping sites: the 'Front Herd' congregates off the coasts of Labrador and Newfoundland, the 'Gulf Herd' around the Magdalen Islands archipelago in the Gulf of St Lawrence, the 'West Ice Stock' off eastern Greenland, and the 'East Ice Stock' in the White Sea on the north coast of Russia.

On the West Ice , the pups are born usually on the edge of the pack ice. The birth is quick, maybe as little as 15 seconds, a pace that continues for the first few weeks of their life. To cope with the sudden drop in temperature from womb to ice, they have to rely first on solar heating and shivering, and then insulate themselves with blubber… and do it fast. The nursing period is very short – just 12 days, during which the mother does not hunt – but she does watch over her youngster as it teaches itself to swim.

The crash course in swimming, lack of food, and a demanding pup mean that the mother loses on average 3.1 kilograms of weight per day, but her pup rapidly puts on the pounds, about 2.2 kilograms a day during the nursing period. The milk is 50 per cent fat and 11 per cent protein, so the pup triples in weight in less than two weeks. Then the little white-coated character is abandoned. It'll not see its mother ever again.

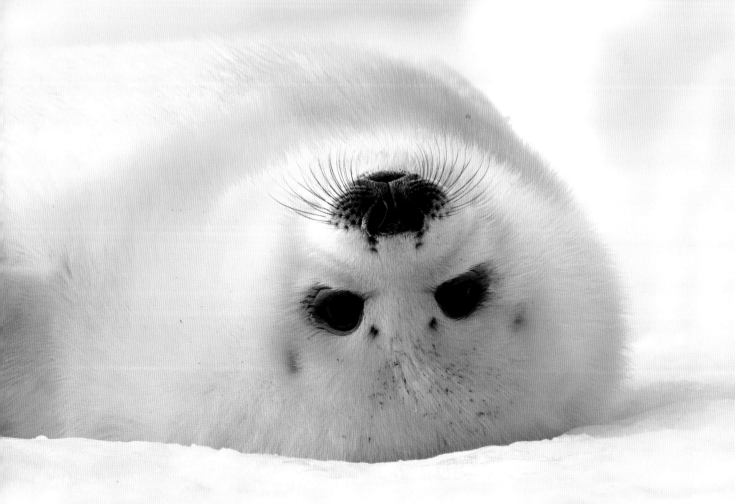

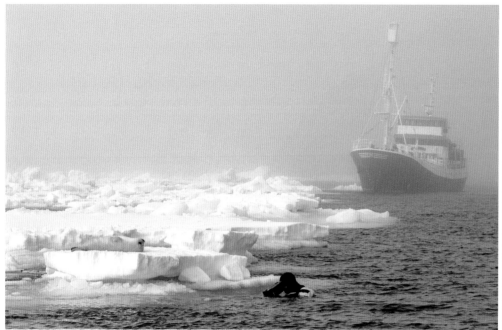

OUT IN THE COLD
GREENLAND SEA

Reaching the remote location of the West Ice Stock to the west of Greenland and finding any signs of seals was surprisingly difficult. Producer Rachel Scott was with the production team.

'We set out from Norway, taking about a week to reach the pupping site: and then, finding the pups was very challenging. We were in a very remote area of pack ice and expecting to see thousands of seals hauled out on large pieces of ice. Storms and thinning ice, though, had broken the pack into very small fragments, so the seals were scattered very thinly over a large area.'

For Norwegian skipper Bjørne Kvernmo, it was a new reality.

'The ocean used to be covered in ice as far as 200 miles from the coast,' he recalled. 'Every time we go now, we are surprised by the weather and ice condition. You just have to handle it all from experience. That's all you can do.'

Wildlife cameraman Jamie McPherson, himself a polar veteran, had worked with Bjørne many times in the past, and was in awe of the way he navigated the moving pack ice.

'He has more experience in sea ice than anyone I have ever met. He was once a sealer and the boat we were on was an ex-sealing vessel – the *Havsel*. He had done more than 40 seasons at West Ice, and it's a trip that sailors young and old dread. It may not seem it, but the frozen waters off the east coast of Greenland are incredibly dangerous and remote. Very few ships pass and so, if you get into trouble, you are on your own for days or even weeks. You are also working in heavy drift ice, so if you lose power or read the tides or swell wrongly, a boat can sink easily. Storms occur regularly between mainland Europe and Greenland, and even on a calm day the swell is a couple of metres, or at least it was when we were there! But there seem

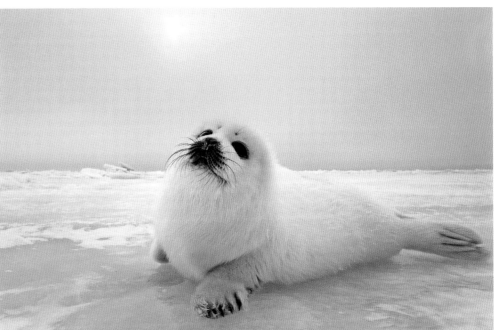

ABOVE LEFT Underwater cameraman Hugh Miller approaches a weaned seal pup resting on a small ice floe. In the background is the expedition's ship, the *Havsel*, meaning 'sea seal'.

ABOVE A mother harp seal watches as her pup learns to swim and dive.

ABOVE RIGHT The youngest harp seal pup is called a 'whitecoat'. It becomes a 'grayback' when it sheds its white coat, a 'beater' from the way it slaps the water when learning to swim, and then a 'bedlamer' after its second moult.

to be more storms than ever before, breaking up the ice and having an immediate impact on the number of pups. Bjørne said he hadn't seen so few pups in 40 years on the ice.'

At first, this lack of extensive areas of pack ice and few pups meant Rachel and her team had not filmed anything for a week. They simply had to keep searching, pushing further into the broken pack ice along the Greenland coast to where no film crew had been before.

'We launched small boats from the icebreaker and negotiated the labyrinth of ice floes in our search for the pups. The greatest risk was when the wind shifted, and we could become trapped in the ice. We had to be rescued several times by the mother ship.

'The air temperature was generally about minus 10°C, although, on one day, it did drop to minus 22°C. Even so, when we were there in 2019, it was Greenland's warmest year on record, which gave rise to big storms; in fact, there were days when the weather was too rough, so we had to leave the pack ice for fear of the ship becoming stuck. The team had to sit it out in open water, where we were bobbing around in an angry sea and feeling very sick. Water froze on the bow and on the winches that lowered the small boats into the water, so we had to hammer off the ice before we could continue. Any delay ate into our short window to film. We had just 16 filming days, before pupping was over.'

When the team finally encountered the pups, all the hardships were quickly forgotten.

'I can't quite put into words how adorable harp seal pups are,' says Rachel. 'They are the epitome of a gorgeous vulnerable baby animal with their fluffy white fur, huge eyes, and sweet little calls. They would roll around biting their fins and playing, then sleep for long periods, cry for mum, feed, and then do it all over again. Filming them learning how to swim was a real

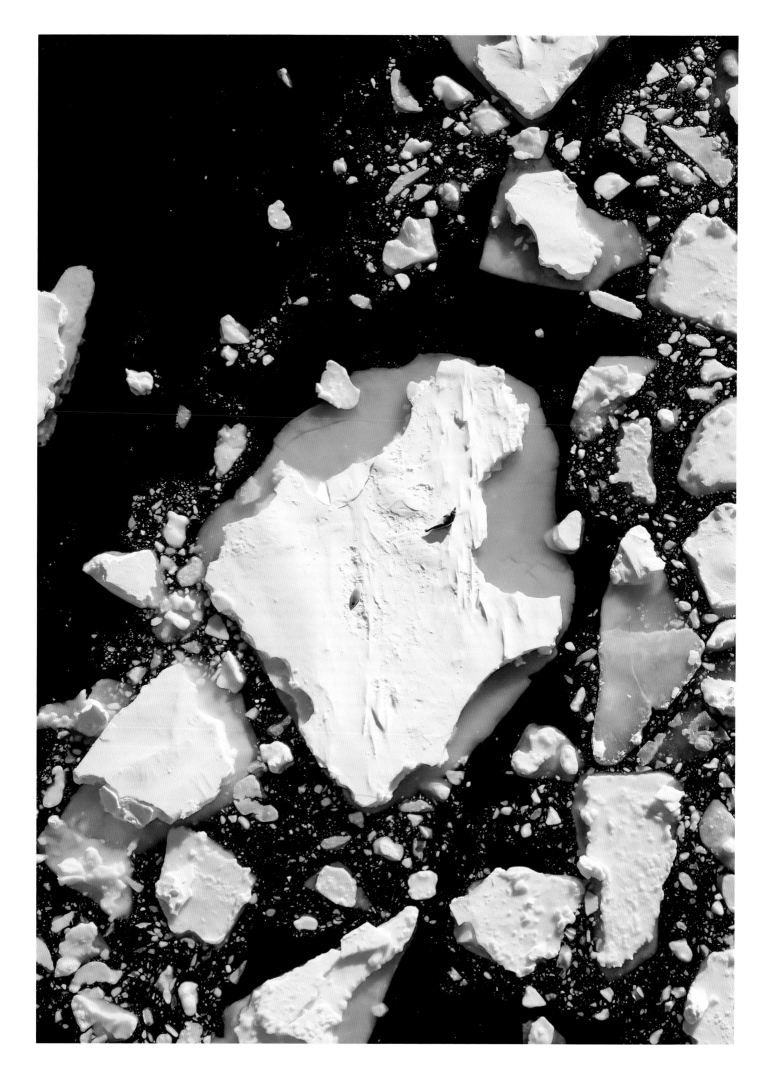

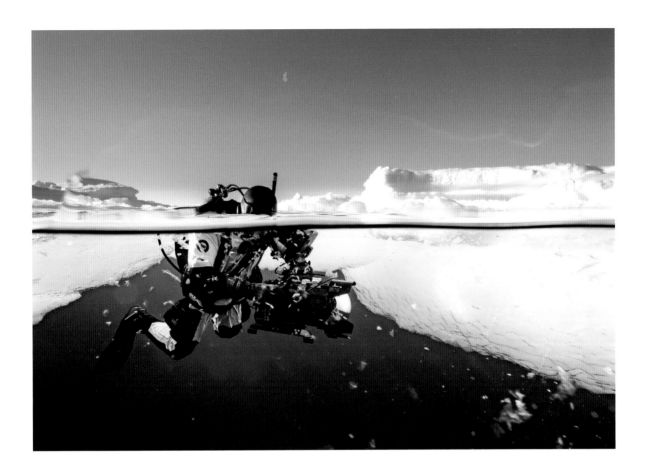

OPPOSITE A mother and baby harp seal are on a sizable ice floe that should last until the pup is competent in the water.

ABOVE Hugh Miller negotiates the labyrinth of ice floes to catch pups learning to swim.

delight. It was amazing how fast they went from very basic doggy-paddle, with heads out of the water and fins flopping all over the place, to becoming agile, deep-diving experts in a matter of days.'

Filming the pups learning to swim, though, was a challenge for the two cameramen. Jamie was covering events on the ice.

'What you don't realise when you see the film on the screen is that, although it seems calm and tranquil, the ice floe is actually rising and falling with a swell of over 2 metres, so to keep the pup in frame I had to pan wildly.'

In the water, underwater cameraman Hugh Miller had problems of his own. The temperature below the surface was about minus 2°C, and ice formed on the dome of the underwater camera. Buttons froze, water leaked into the housing, batteries died quickly, and Hugh's fingers quickly became uncomfortably numb.

'Conditions were really hard,' says Hugh. 'The cold made it very, very difficult to operate the camera underwater.'

But when seal pup and cameraman were in the water at the same time, the results were pure magic.

'The pup was even playing with the camera,' says Rachel, 'and I could see Hugh's smiles from far away.'

But, when the time came for a mother to leave her pup, it was almost more than Rachel could take.

'It's hard not to feel such sadness for the poor tiny things when they're abandoned at just 12 days old in a big deep ocean. They still called out for

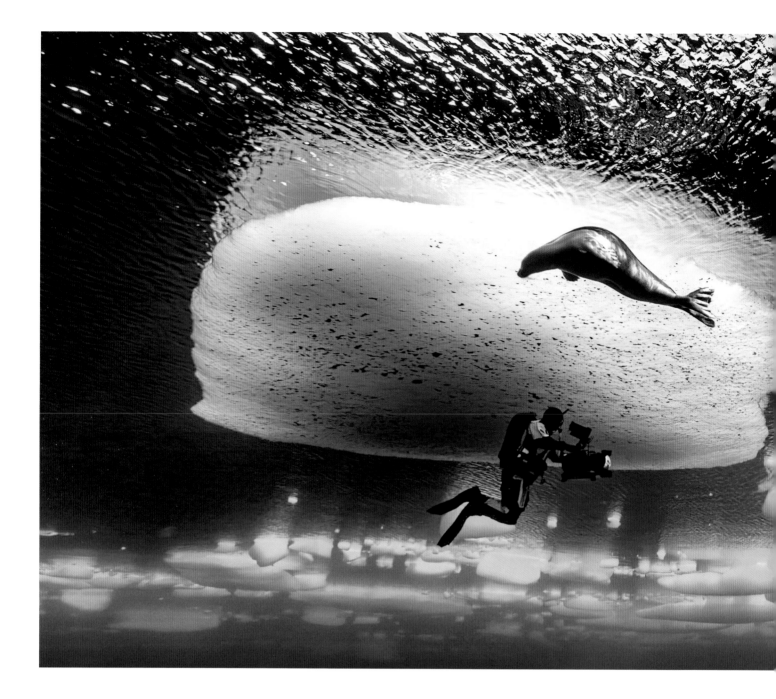

their mum for a day or so after she left, with no answer, of course. This was so hard to watch.'

With its mother gone, each pup is dependent on its ice platform. It must moult its stark white coat and don a grey one, and also strengthen its muscles so it can swim without drowning. Then, it can remain for longer periods in the water and hunt for itself; but thinning ice and an increasing number of storms plague the warming Arctic Ocean. Captain Kvernmo has seen what happens first-hand.

'In the wind, the pups roll into the water. They are not yet ready to survive in the sea. Many seal pups die because of bad weather. The ice is broken up and they are falling into the water before they are able to handle it. It's terrible to see.'

But see they did, and for Rachel, it was not the image they would have liked to take away from that shoot.

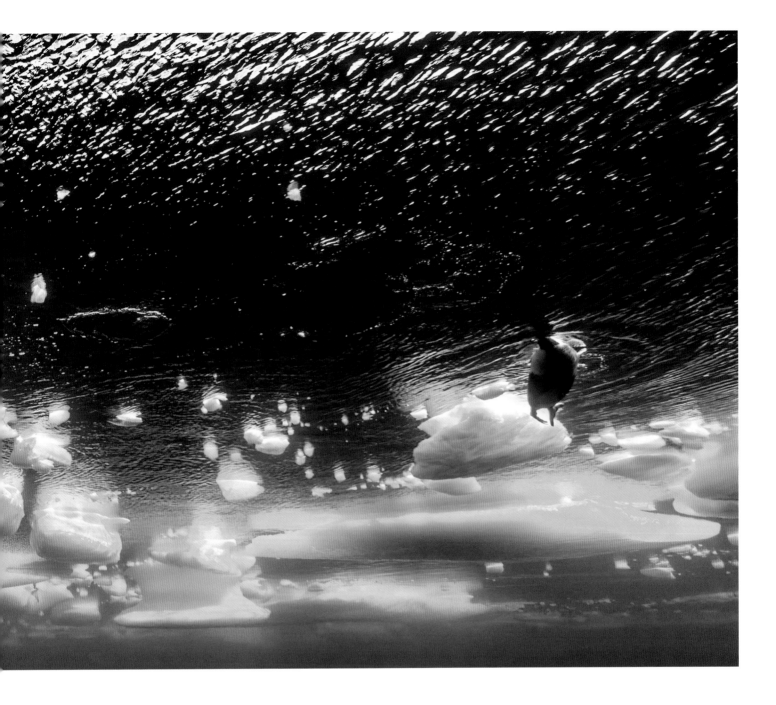

ABOVE Hugh in remarkably clear water in the Greenland Sea, with a couple of harp seals.

'Observing this new threat of climate change was heartbreaking. With the rough seas, we saw many pups being thrown into the water, and felt powerless to do anything. I just hoped they were strong enough to make it back onto ice, and that it persisted long enough for them to become fully confident in the sea.'

Many, though, do not make it. At one of the pupping sites in Canada's Gulf of St Lawrence, pup mortality has been as high as 75 per cent of the population in recent years, and, in the breeding area visited by the film crew off eastern Greenland, at least 40 per cent of pups are not making it to their first birthday. Populations are decreasing, and this in a species that is considered to be the most abundant marine mammal in the North Atlantic... but for how long?

Ghosts and Jellies

ABOVE **A bloom of ice algae covers the underside of Arctic sea ice.**

OPPOSITE **With the sea ice gone for the summer, sunlight reaches the seabed and life proliferates.**

A huge transformation occurs in the Arctic in early summer. Aside from the ice breaking up, there are stirrings in the ocean below. First up are the microscopic green algae that spent the winter within or on the underside of the sea ice. These are the ice algae. They grow slowly in the semi-dark conditions during winter, but they are rich in fats. Their awakening is dependent on the snow cover on top. Too much snow and not enough light penetrates, so turnover is small, but as the snow disperses and sunlight pierces through, the sea ice algae are released, and they grow and proliferate early in the season. This is followed by a second mid-water bloom of the rest of the phytoplankton, when the zooplankton and other tiny creatures, such as skeleton shrimps, step up their rate of feeding.

Skeleton or ghost shrimps are aptly named. They're a type of amphipod crustacean, whose threadlike bodies, a couple of centimetres long, blend in with seaweeds and bryophytes on the seabed, so they are almost invisible. They can be found at all depths, and in spring they move up through the seaweeds, such as kelp in glacial fjords, to get closer to the organisms on which they feed. They are tiny omnivores, consuming algae, zooplankton, and marine snow – the constant rain of zooplankton faeces and dead plankton that sinks down from the surface – as well as hydroids and

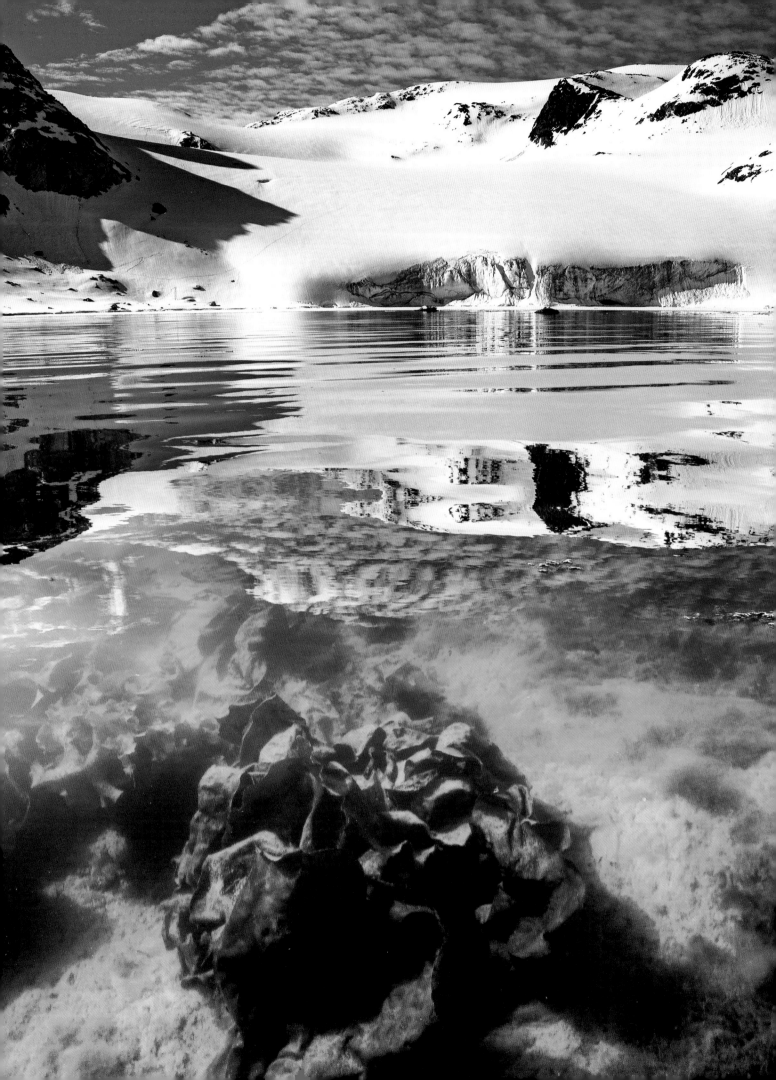

ABOVE Skeleton or ghost shrimps sit and wait for diatoms and tiny zooplankton to drift by, catching them with raptorial appendages, called gnathopods, in a similar way to the preying mantis.

bottom-dwelling creatures, although goodness knows how they find time to catch anything: they all line up along the edge of, say, a kelp blade and constantly fight with their neighbours. They're just one species among a wealth of creatures – sea angels, sea butterflies, comb jellies, true jellyfish, soft corals, sea anemones, clams and mussels – which take advantage of such an abundance of phytoplankton that it colours the ocean green… and initially, it all depends on the ice.

The sea ice is the foundation of the Arctic Ocean food web. The big question now, of course, is what happens when the ice is no longer there. Without it, the ice algae and maybe the rest of the phytoplankton might not bloom in the way that they did in the past, but nobody is sure what might happen. Many organisms in the zooplankton, such as copepods rely on the lipid-rich ice algae to nourish their young. Without sea ice there would be no ice algae, but in the short term there would be a bloom of the less nutritious phytoplankton. For the copepods, it would be like going from a well-balanced meal to fast food, with the inevitable consequences for body condition – and not only that. As the water temperature rises, copepod metabolism would go into overdrive, using up the lipids from the algae they eat more rapidly than before, which would mean that the whales

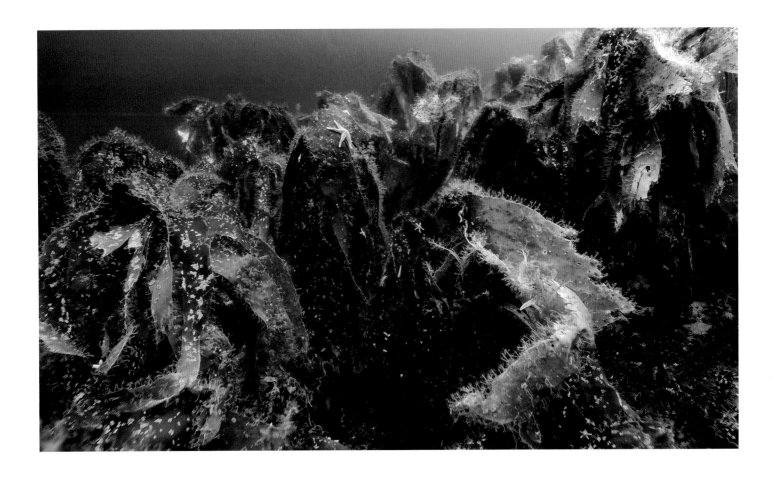

ABOVE Kelp on the seabed grows up towards the light. The 'fur' on its fronds consists of countless numbers of skeleton shrimps, all reaching into the upper layers of sea where most food is concentrated.

and other organisms, which feed on copepods, would be consuming sub-standard fare. Also, in an ice-free Arctic Ocean with no ice algae, there would be pulses of phytoplankton blooms in April and May and little else for the rest of the year. Ice algae in pockets beneath the sea ice keep ecosystems ticking over in the winter. Without the ice, this wouldn't occur.

Already, there are signs that warming temperatures and melting ice are causing these spring blooms to occur increasingly earlier, and this advance of spring has been pronounced especially during the past decade. Scientists at Scripps Institution of Oceanography, working with an international team of colleagues, have determined that the one-to-two-week peak of the spring bloom can be up to 50 days earlier in some parts of the Arctic, which means animals that time raising a family to coincide with the sudden seasonal increase in ocean productivity could find themselves failing to take advantage of the opportunity: they simply arrive too late, and that could impact the entire food chain, from the zooplankton that graze the phytoplankton right up through to the top predators. It's sobering to realise that 87 per cent of a polar bear's diet is derived originally from the algae under the ice.

A Return to Seabird City

With the sun rising high in the sky and those long winter nights having given way to long summer days, the visitors flock in. By July, tens of millions of seabirds will have arrived from lands and seas further south, transforming barren coasts and islands into noisy, smelly and overcrowded breeding colonies, some of them the largest in the world. Every ledge on towering sea cliffs is packed with eager parents-to-be, but the summer is brief, so there's an urgency to court, mate, lay eggs, rear chicks, and have them fledge before the weather chases them away again. One species – the crested auklet – will have spent the previous nine months at sea but, in July, the boulder slopes of St Lawrence Island in the Bering Sea draw in half a million at breeding time. They're here because the Anadyr Current brings cold, nutrient-rich waters from the deep and so the continental shelf is filled with life, especially the krill and copepods on which the birds mainly feed.

In July, the breeding season is well under way, but there are still birds looking for a partner. One of the many that are making their debut is a young male, no bigger than a starling. He is probably another first-timer, and he is quick to learn that there is fierce competition on the slopes. For his starting gambit, he shows off his drooping forward-arching crest and bright orange bill set against pure black plumage, but, as both males and females sport the same quiff and bill colour at breeding time, he fails to stand out from the crowd. He tries a serenade instead, but a neighbouring male's voice is deeper and louder, and it drowns out his feeble attempt to impress. What's more, the rival has commandeered a higher perch, so he is more likely to be seen and checked out by the watching females.

The audience at such performances are late-breeding females and even other males, and they all gather round not only to watch, but also to smell. The auklets release a heady tangerine scent from a gland at the back of their neck, the first bird species found to send fragrant signals.

While the birds are performing, the dominant individual proves to be irresistible. The females come flocking in, but then it is time for the females to impress the male, as mate choice in crested auklets is mutual. Eventually, he finds a partner and is gone, so the display rock becomes free. The younger male seizes the opportunity, a young female shows interest, and a whiff of tangerine seals the union. The partnership might last for four years, if they're lucky, but these auklets are not too good at staying the course. It could be just a matter of time before another catches his or her eye. The divorce rate in crested auklet society is thought to be close to 50 per cent.

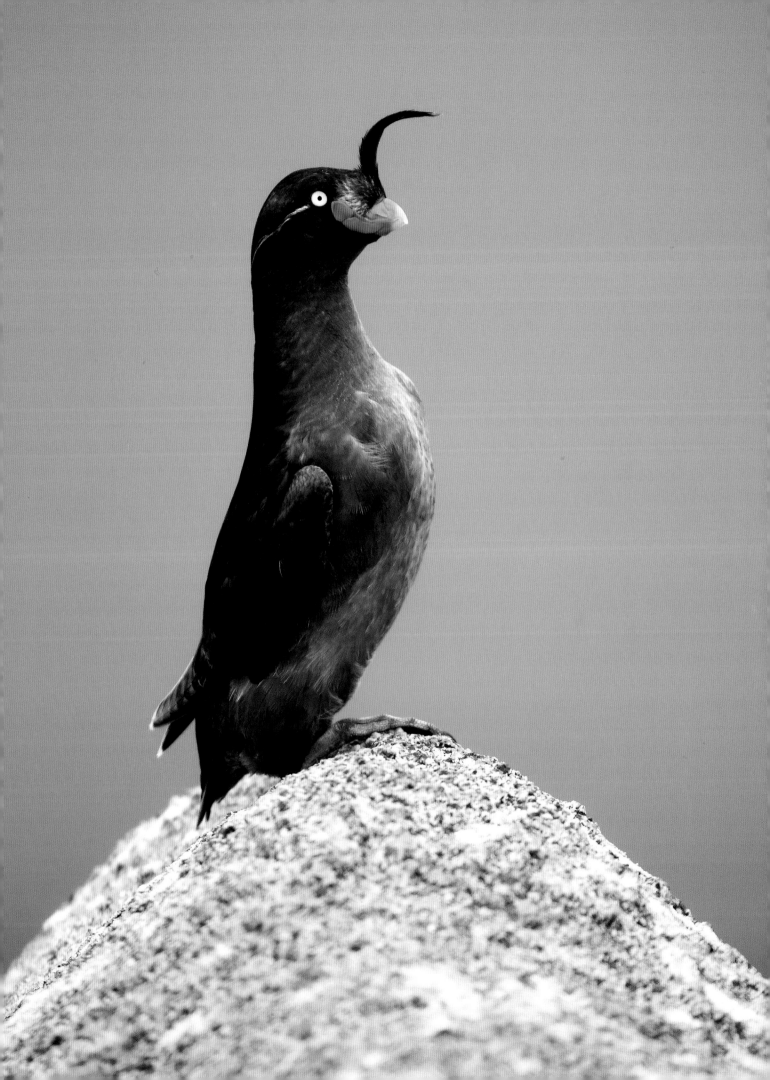

OUT IN THE COLD
ST LAWRENCE ISLAND

Among the new arrivals on St Lawrence Island was wildlife cameraman John Aitchison, along with researcher Erin McFadden and field assistant Paul Lawrence. Not only did their destination prove to be an awkward place to get to, but also local conditions were tricky. The island is remote and often fogbound – not the best kind of weather for filming – but when they arrived, there was an unexpected heatwave, with temperatures hitting 35°C. Undaunted, the production team pressed on in a procession of quad bikes from Gambell at the island's northern tip to the filming location at Kongkok Bay to the south, passing swathes of tundra flowers in full bloom and skirting white sand beaches with sparkling blue water.

'In the distance, you could see Russia, which is not that far away,' John logged in his diary, 'and all around were dunlin and turnstones nesting, along with long-tailed skuas, tundra swans, and sandhill cranes, each of them summer migrants, and there were meltwater lakes where kittiwakes

ABOVE Quad bikes are the main mode of transport on St Lawrence Island in summer.

OVERLEAF Thousands of crested auklets swarm around the cliffs before dropping down to the rocks and their nests below.

came to drink. When we reached the nesting areas of the crested auklets, we saw that they were not on sheer cliffs, like other seabirds, but on steep slopes with a scree of large boulders that had fallen from the crumbling cliffs above. The auklets occupied the gaps between the rocks, but they were feeding at sea during the day, so we had to film when they returned in the evening. They would gather on the water and, at about 9 o'clock, they would start to fly around in large flocks like starlings, before dropping down to the ground.

'The male birds were either alone or in small groups. They would crouch down and point their heads at the sky, and then pump their chests energetically to produce an odd chugging sound, which, at first, I didn't realise was coming from them because you don't see their beaks moving. And they had striking eyes. The iris is white and, when they display, they constrict the pupils until they are just pinpricks, so the entire eye looks white, like a zombie's.

'What they really want to do, though, is smell each other's necks. One would scuttle over to the performer and stick its beak into the back of his neck, really snuggling in, and then another would come and do the same, and then a third and a fourth, so you had a kind of conga of auklets all sniffing each other's necks. It might end when they were disturbed by a glaucus gull, a raven, or perhaps an Arctic fox, and the whole lot would take off in a whoosh, not just those displaying, but the entire colony, and then it was suddenly silent.'

However, all is not well with the crested auklets of St Lawrence Island. John learned that the occasional fox or gull was the least of their worries.

'The local Yupik people told us that no chicks at all had survived the previous year, and they put it down to extreme weather due to climate change – although predators, such as rodents, ravens and skuas probably took their fair share. These are people who know their environment so well that they are in no doubt that climate change is happening. They know very precisely what "normal" is, and what is happening now is not normal. In Gambell, people were telling us how the sea ice had left in February, rather than more usually in June. They described how hundreds of seabirds and several grey whales washed up along the shore. They put it all down to shortages of food, which not only affects wildlife, but the people themselves. Even though they have typical American fast food at the store, everybody depends on what they can gather from the sea, anything from seabirds to whales and walruses. You might have bizarre conversations with people who would have to break off to tend a fermenting walrus, as it had to be frozen before the worms got too long! Talking to one of the young men, I asked, "What's your favourite food?" and he replied, "The clams in the stomach of a freshly shot walrus," but for how much longer will he be able to enjoy such a delicacy? The lives of these people are already changing dramatically.'

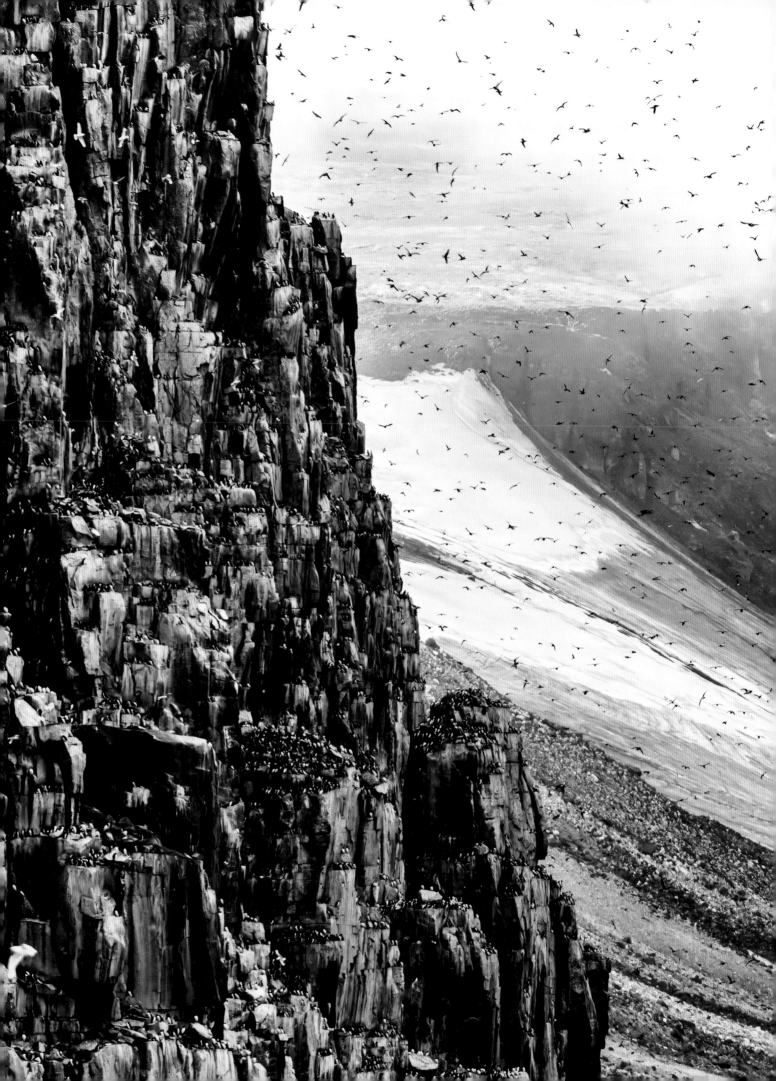

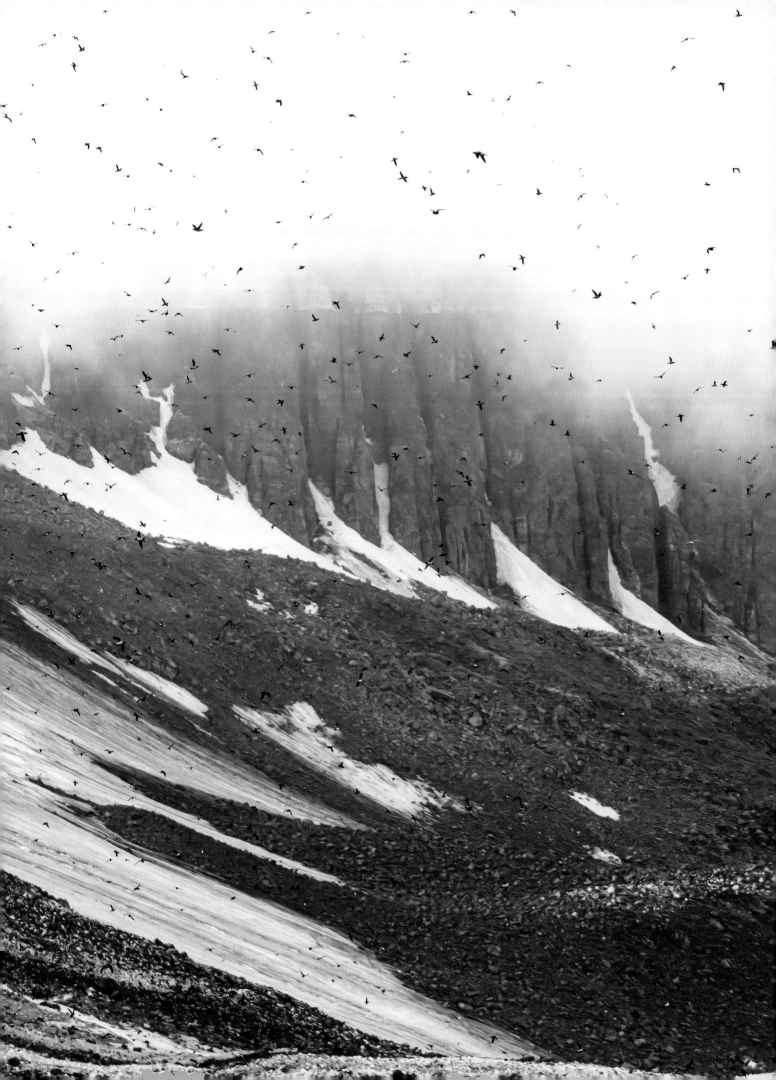

Blubber Brothers

Walrus births begin in spring, so mothers have growing calves by summer. Ice cover is important to them, as females and their offspring like to haul out on drifting ice floes, where they are isolated from the rest of the community, as well as predators, such as polar bears. With an ice floe to themselves, the family is much safer than if it were on a beach, but in summer these days, more and more walruses are forced to haul out on land.

Apart from the odd vagrant like Wally, who swam as far south as the Bay of Biscay, the two species – Pacific and Atlantic walruses – live their entire lives in the Arctic where, for an animal that's 3 metres long and weighs 1,700 kilograms, they feed in an unexpectedly delicate way. They dive down to the seabed and, using their thick, bristly whiskers, probe for clams, worms and other creatures buried in the bottom sediments. They can gather over 50 clams in a single dive that can last for up to 30 minutes, and foraging can go on for up to 17 hours during the long summer days. Generally, they spend eight to ten days foraging in the water, and when they've had enough, they

BELOW Like playing a game of roly-poly, a walrus rolls down the beach to reach the sea.

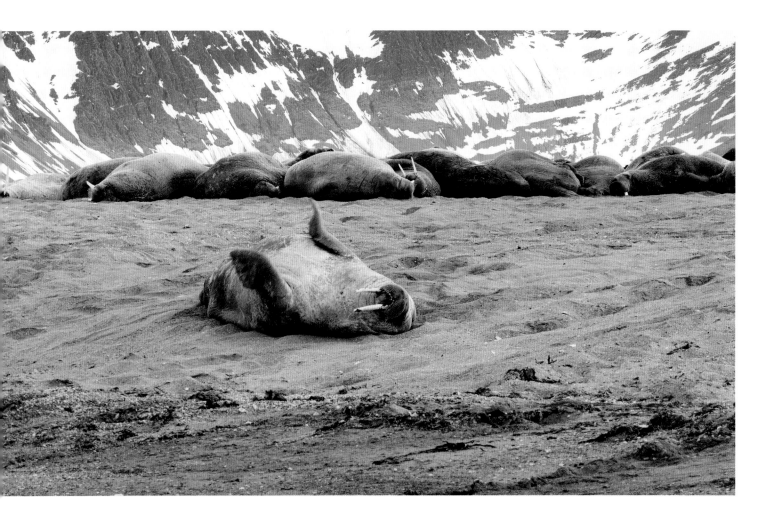

haul out and rest for about the same length of time, unless there's a high wind blowing. Walruses don't like wind. Anything in excess of 30 mph seems to be avoided. If they are hauled out, for example, biologists have noticed that they get quite skittish if the wind is up.

Haul-out sites are usually close to foraging sites, and ice floes are most definitely favoured places to rest. Walruses forage all year round and are noticeably more active when sea ice is available, especially in winter when the ice edge is further south. When only land is available to haul out, traditionally in late autumn, they tend to spend less time feeding in the water, and this becomes significant in a warming Arctic when the summer season is extended.

In the North Pacific, thousands of walruses are crammed together at newly acquired haul-out sites. On both sides of the Bering Sea, hundreds of thousands haul out on the Russian side and, since 2007, there have been huge haul-out sites, such as Point Lay in Alaska. The reduction in sea ice is having an unfavourable impact on the local walrus population. The reason that there are so many is that the continental shelf on which they feed is

BELOW There's little room on a walrus beach in Svalbard, and any new arrivals tend to be a pale shade of pink.

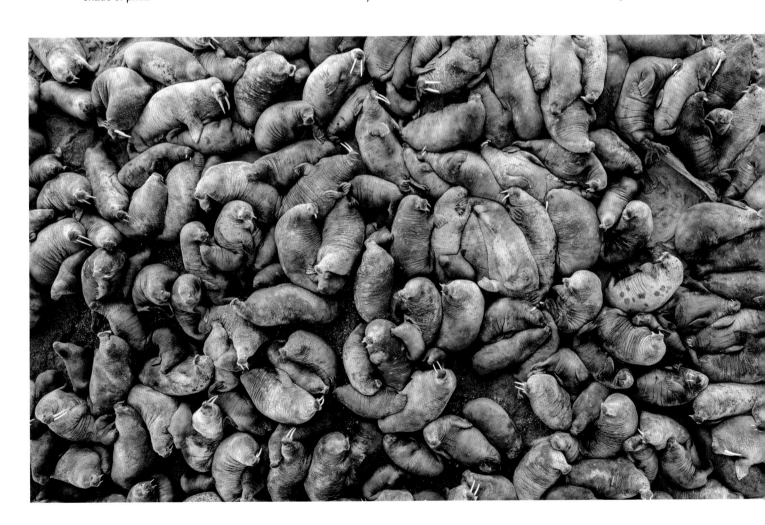

BELOW Walruses are quite
chilled when people are
about, barely bothering to
move, but if a polar bear
appeared you wouldn't
see them for dust!

wide, and so accommodates a large feeding population. In between feeding bouts, they used to haul out on ice floes, but the sea ice is now much further north, so they must rest on land some distance from where they feed.

Males often head for beaches where they are in male company, and on Spitzbergen, in the Svalbard Archipelago, a male walrus hauls out on his favoured beach. He undulates in a wobbly fashion over the sand and gravel, shifting his weight from one side to the other in order to raise the front flipper on the opposite side. It must be quite an effort and a strain on the forelimbs, so he stops for a brief rest after four or five 'steps'. Using this ungainly gait, he places himself at the centre of the crush, even though there is plenty of space elsewhere. There he sprawls out with an audible sigh and begins to change colour.

While in the water, the walrus tends to be white or dull brown, as all his blood is shunted to the core of his body to reduce heat loss through the

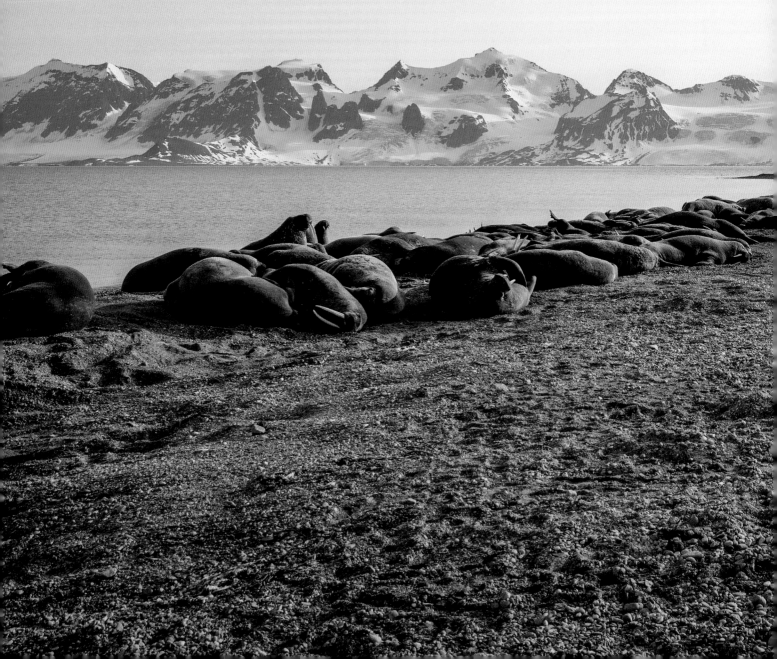

skin. In order to keep cool on land, his body pumps warm blood into the blood vessels of the skin to lose heat, so he turns a brighter shade of pink.

Reassuring though it is, being cheek-by-jowl with the mob has its disadvantages: you do eventually get hot, for the air temperature can be 22°C and the moulting skin is an irritation. This calls for a dip in the sea, but the walrus is so big and blubbery that it is a huge effort to make it to the water's edge. Instead, the animal literally rolls down the beach, like a child playing a game of roly-poly down a hill; and once one walrus has started, the rest follow, so they are all rolling down the beach to the sea. It is a convenient, low-energy way to reach the water, especially if there is a gradient, and they appear to enjoy it.

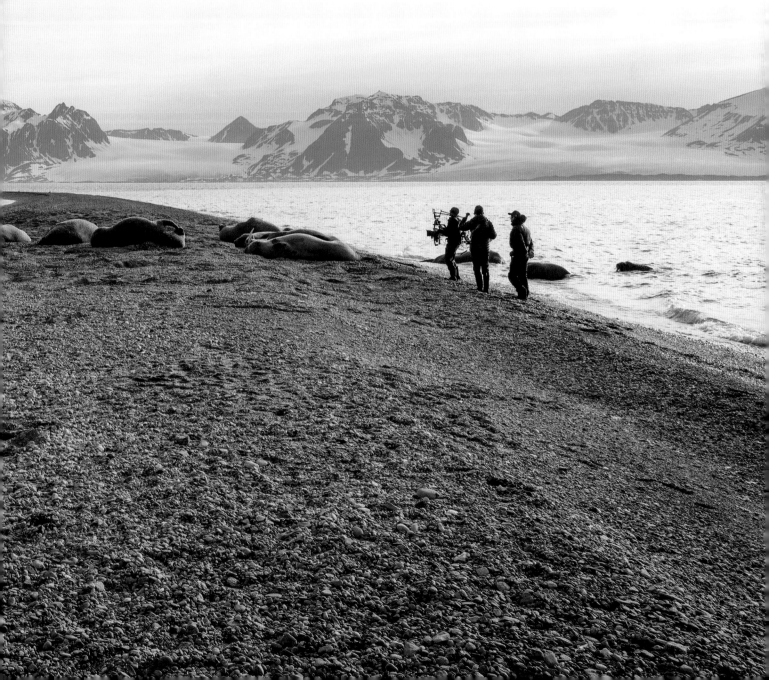

Ice-Free Arctic

A theme that we return to time and again is the impact of climate change and a warming world on ice cover in polar regions. Each summer in the distant past, the area of sea ice shrank quite naturally, but in the last 40 years that which remains has halved. Some scientists are warning that it could disappear in summer completely in as little as 15 years. In both the Arctic and the Antarctic, sea ice is turning out to be not simply a layer of ice on the surface of the ocean, but something that underpins almost all of life in the region, from the tiniest phytoplankton organisms that hide beneath it to the largest whales that take advantage of the superabundance of food at the edge of the ice pack, one of the most productive places in the world's oceans. Without the sea ice, it's hard to imagine how many of the Arctic's iconic creatures have a future. However, while animals like the beluga, narwhal and bowhead may or may not be able to adapt to an ice-free Arctic, other animals see the changing conditions as an opportunity.

Northern populations of killer whales, as we have seen, are moving increasingly further north, but they're not alone. Pacific salmon are appearing where Arctic char once swam, brown bears have been seen on the shores of the Beaufort Sea, and polar bears are mating with them to create so-called 'pizzlies'. And all these southerners could be bringing diseases to which their Arctic cousins are not immune.

It was discovered recently that narwhals and belugas lack the antibodies to fight Phocine morbillivirus, which causes distemper in seals. It was first discovered in the marine environment in 1988, when tens of thousands of harbour and grey seals died in waters around northwest Europe. Since then, it has reached the seals in Lake Baikal and dolphins in the Mediterranean. All it takes is for a pilot whale, harbour seal or dolphin that is carrying the virus to make contact with belugas or narwhals, and the consequences could be disastrous for both species; and these kinds of interactions are more likely to occur because of the loss of sea ice.

RIGHT In the Svalbard Archipelago, like elsewhere in the Arctic, the sea ice is breaking up increasingly earlier in the year, leaving few places for animals like polar bears to hunt.

Great White Bear

BELOW Having swum from some distance away and arrived at Wrangel Island, a mother polar bear and her two six-month-old youngsters are desperate to find food.

An animal that depends on the sea ice for its very survival is the polar bear, but with considerable uncertainty about how much of it will remain in the future, the prospects for the great white bear are not looking particularly good. One place to see the fallout is Wrangel Island, 140 kilometres off the coast of northern Russia. It is quite a large island – the size of Crete – but it is a cold and forbidding place, often hidden under dense fogs.

And if it is not foggy, it can be very windy and that means high seas. At the base of its dark cliffs, narrow beaches of black sand are pounded by surf driven by the high winds. It's here that both walruses and polar bears wash up, some of the bears having swum great distances across an often-angry ocean, something that has become all the more common in recent years. One female bear, fitted with a satellite tracking device, swam non-stop for 232 hours and covered a distance of 687 kilometres in the Beaufort Sea. Her cub did not survive the epic journey, and almost half of all the cubs in the same study also perished. In better times, they would have swum short distances between ice floes, but with less summer ice, the journey times are getting increasingly longer.

Wrangel has become a summer refuge for wayward bears from North America as well as Russia, and so many now make landfall on the island – roughly 3,000 at the last estimate, with many more arriving each year – that it is home to the largest concentration of polar bears in the Arctic (along with the largest number of dens in winter). In the 1980s, the bears here arrived in September, but in the present climate, they now come in July.

At one time, 100,000 Pacific walruses also hauled out at Wrangel. It was the largest number anywhere in the world, but now there are just 3,000. Even so, space on the narrow beaches is still at a premium, just like in Svalbard, so there's plenty of argy-bargy to bag the best spots. Walruses, though, are generally chilled. They're very tolerant of tourists, for instance, but when polar bears come sniffing around, the panic that ensues means, inevitably, there are casualties. The larger male walruses are not too concerned about the bears. Their hides are too thick for teeth to penetrate, and the bears could well get stabbed. Females with calves, however, are vulnerable, not only to predation by bears, but also because their offspring can easily be crushed or drowned in a stampede. Polar bears seem to rely more on causing alarm – in about 80 per cent of feeding opportunities – than by direct hunting.

Arriving among the mayhem is a mother with two cubs who have survived their long swim and made it safely to the beach, only to find it crowded with bears scavenging for scraps, including large males that are fighting fiercely for access to the meagre rations. They rise up on their hind legs and smash into each other, swiping out with their large claws. It is not a place for cubs to be. They are probably no more than six months old, and a large and hungry male could make short work of them: the mother is on high alert. She would normally go out of her way to avoid confrontations with other bears, but these are strange times, and, like all the other bears that pitch up here, she needs to find food.

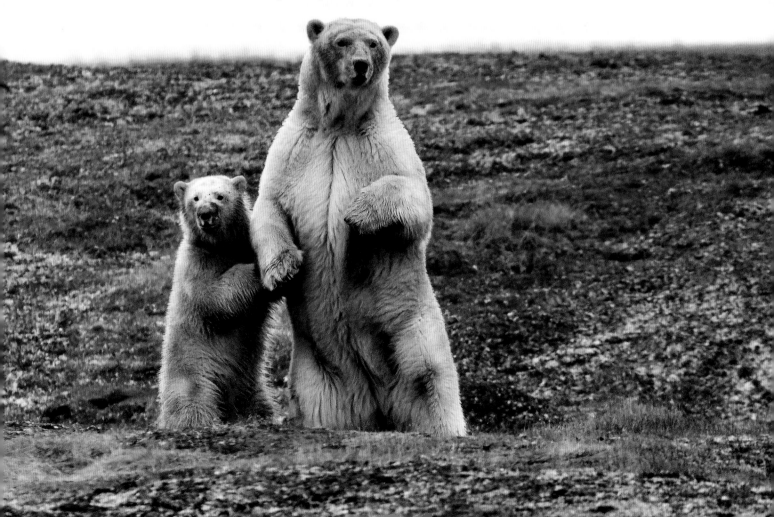

ABOVE Polar bears face an uncertain future (and a long swim) as the Arctic sea ice disappears.

OPPOSITE Walruses pack narrow beaches below cliffs that are crumbling due to thawing permafrost on Wrangel.

A stampede at the water's edge causes a walrus pup to drown, and a bear drags it out of the sea and begins to devour the carcass. Several others join in. The mother and her two cubs look on, desperate for food. Starved though they are, she cannot take the risk. She moves on.

Then she picks up the scent of another carcass, but this time it is being dragged inland and away from the crowded beach. Could this be a chance to feed? Driven by her hunger, the mother takes a huge gamble. She warns her cubs to stay back at first, and then makes her move. She eases her way between two bears, too intent on feeding to notice her arrival, let alone the cubs. She seems dwarfed by a male at the same table, but suddenly, the cubs call out. Another male, its face and fur stained red from walrus blood, picks up the call and begins to approach. Immediately, the mother runs to their defence, potentially risking her own life to protect her offspring. The male's interest fades, and he turns back. The mother quickly races back to the carcass, but again the bloodstained male sets off towards the cubs. This time the mother goes for a full-blown attack, biting at the male's rump and chasing him away, the cubs following close behind. With the male gone, the three bears return to the food and the cubs are able to feed for the first time in several weeks.

In fact, there is food in summer at Wrangel, but not enough. Walrus, bowhead and gray whale carcasses wash ashore, with up to 20 bears feeding together at the same time, and there is some foraging for shellfish and hunting lemmings and snow geese. They can scavenge dead musk ox and reindeer and try to catch salmon, but it's a good supply of seals that they need, and they are slow to adapt physiologically to the changing circumstances. The bottom line is that there's just not enough food to sustain them on land.

OUT IN THE COLD
WRANGEL ISLAND

To get a handle on what all this means to a young polar bear family, in September 2019, our film crew went to Wrangel. On the team was wildlife cameraman John Aitchison, fresh from St Lawrence Island, but Wrangel was even more difficult to reach. Instead of the short, direct, as-the-crow-flies hop of only 975 kilometres, John had to travel right around the world, via London, Moscow, Magadan on the Sea of Okhotsk, the Siberian gold mining town of Bilibina, and then by Russian transport helicopter to Wrangel.

'Having waited for some time for a weather window, we finally took off, but as we approached, fog obscured Wrangel and we thought, "Well, that's it, we'll have to abandon the shoot," but then the pilot spotted a tiny gap and he could see the water, so he dropped down and there was just enough height between the sea and fog for him to fly to the island, and then very low over beaches to Doubtful Bay. From, there we were taken across country in a six-wheel tundra buggy at cycling speed to the other side of the island.

BELOW On a bleak Wrangel Island cliff top, the film crew captures the moment polar bears stampede a group of walruses.

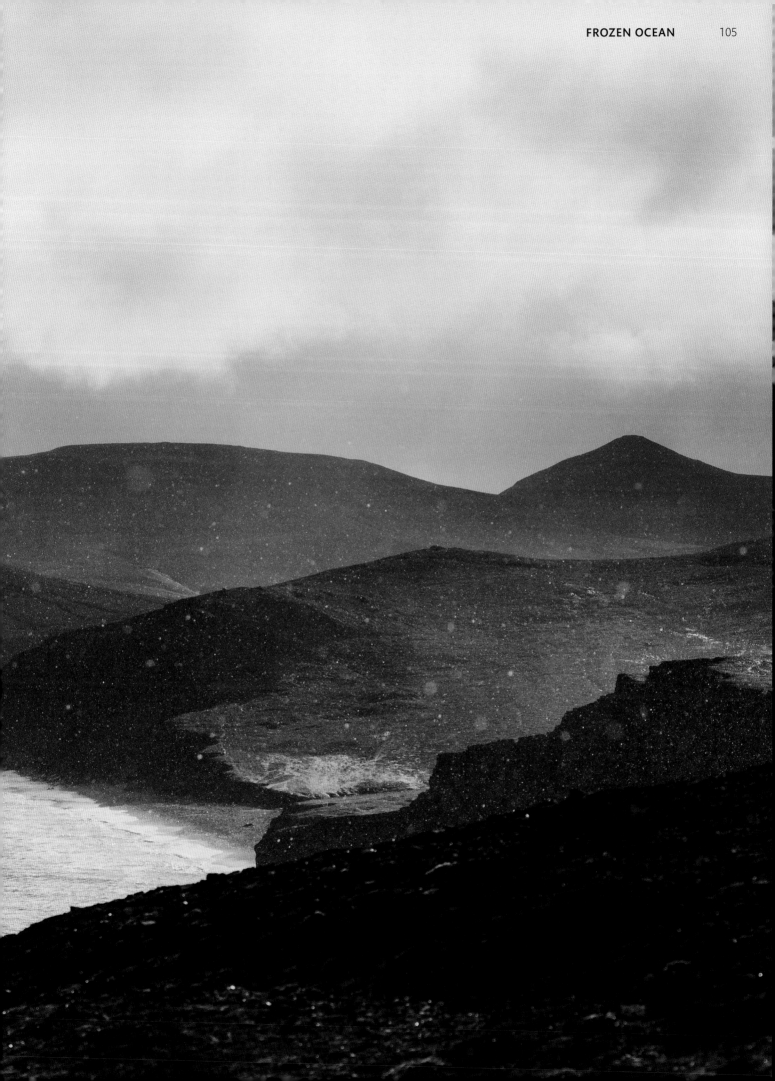

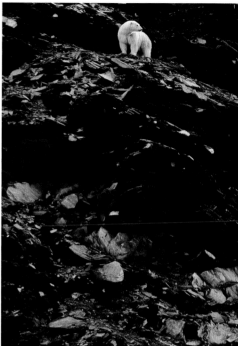

'It's a very bleak place, a grey shale landscape with patches of snow on the hills, and you'd see something pale on the ground and it would be a mammoth bone or tusk, as Wrangel was the last place in the world to have mammoths, but the fog made it a difficult kind of place in which to film.'

When John and the team could see, there was plenty of action, especially when polar bears went after walruses.

'We found a large number of walruses that had hauled out on a narrow beach below a big cliff, and the bears approached them from the water. They didn't actually catch the walruses but tested for weak individuals. When the walruses saw the bears coming, they would panic. Those that had started to climb the cliff to escape would fall and land on others, and if they rushed into the water, calves would be crushed, so often there was a dead or injured walrus left behind.

'When a large walrus washed up, a lot of bears arrived. You could see them with their noses in the air, and they came from very far away. Many of them were large and dangerous male bears, and, under other circumstances, they would certainly eat a cub. The cubs, though, didn't appreciate the danger, and we could see a mother having a hard time, because her cub wanted to feed at the carcass. It was in the surf, and an enormous male turned up and chased away the other adults to dominate the carcass, but curiously he didn't mind the cub. He let it feed alongside him, but the mother looked as if she were standing on hot bricks and seemed undecided what to do.

'The thing is that the mother will have been in a den all through winter,

ABOVE LEFT A hungry mother polar bear and her cub eye up wildlife cameraman John Aitchison as a potential meal.

ABOVE A mother polar bear and her two growing cubs scavenge for scraps of food on the rocky slopes, away from the boisterous feeding activity on the beach.

ABOVE RIGHT A hungry polar bear finds that piercing the tough skin of a dead walrus is not as easy as it looks.

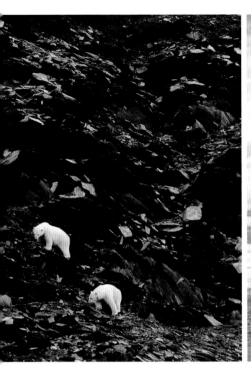

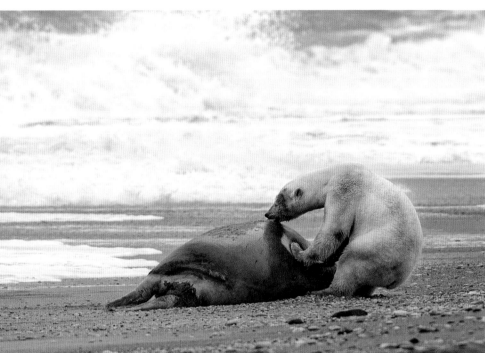

feeding the cubs and, as there was no sea ice, she could not hunt for much of the summer, so by September she would have been ravenous; and it would be months before she could get on the ice and start hunting seals, so she had to scavenge.'

On Wrangel, scavenging opportunities are turning out to be particularly good. Most bears – about 60 per cent – are healthy and well fed. While this is not true throughout their range, in some parts of the Arctic bears are proving to be more resourceful and resilient than we had previously given them credit for. On a geological timescale, this is not the first time that similar conditions have occurred in the past couple of million years, and these sources of fat and protein, especially whale carcasses, have sustained bears during warm interglacial periods. Scientists at the University of Washington did the maths: in summer a hypothetical population of 1,000 bears, they calculated, would need eight large whales, while in spring, when polar bears tend to eat more, the figure would be 20. Russian data indicates there would be enough whale carcasses for the bears from local Chukchi Sea population to survive, but elsewhere there are not so many whales. In the southern Beaufort Sea, for instance, polar bears are not doing so well. The loss of sea ice is taking its toll, and the subpopulation is seeing signs of stress. Anyway, scientists are unsure that whale carcasses are going to be a long-term solution for most subpopulations. In a warming world, overcrowded beaches, scavenging food, and literally fighting for survival are the new realities for the great white bears of the Arctic.

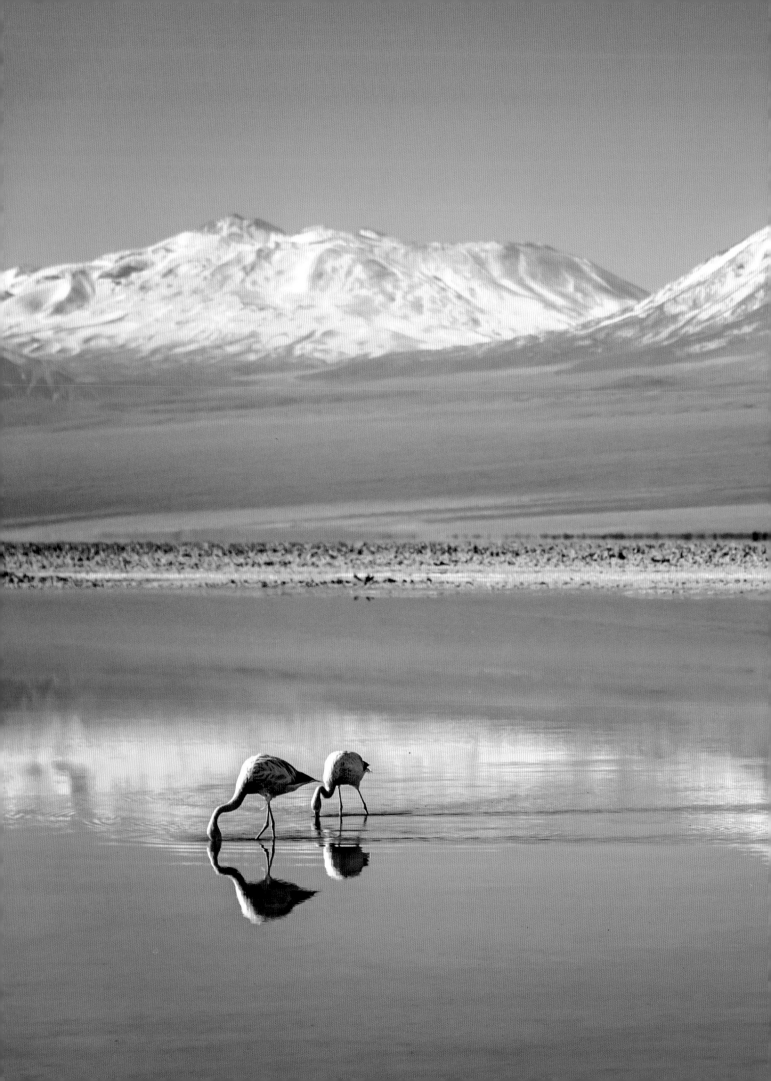

Chapter 3

FROZEN PEAKS

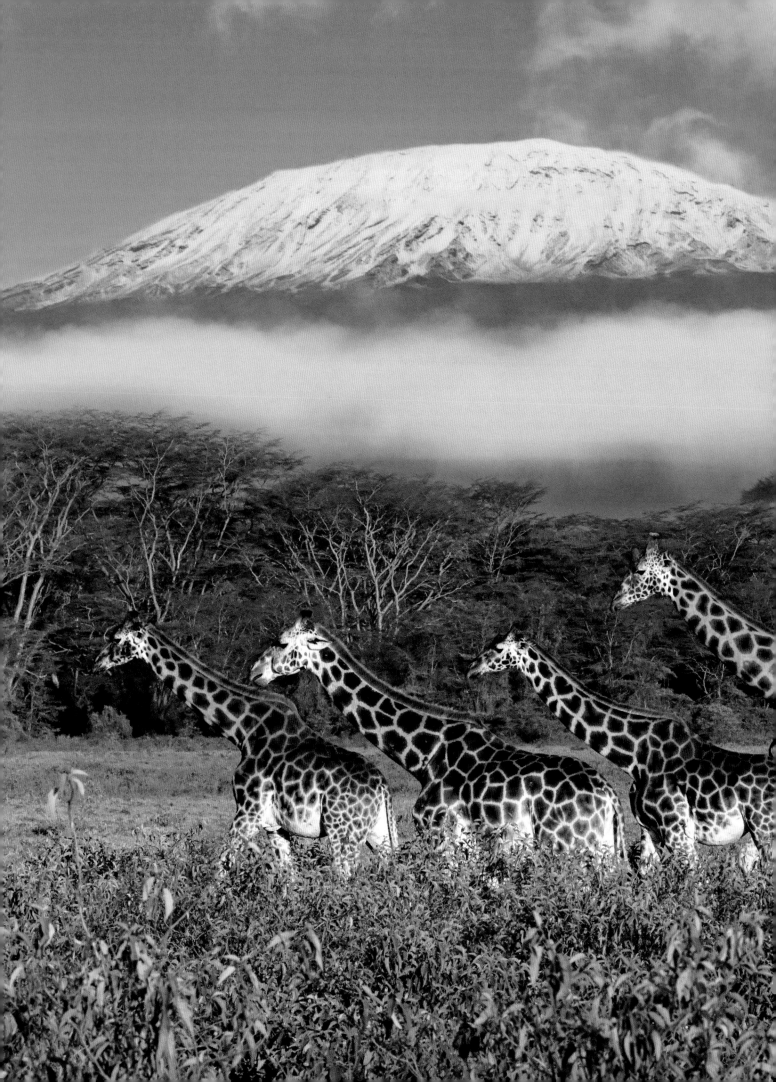

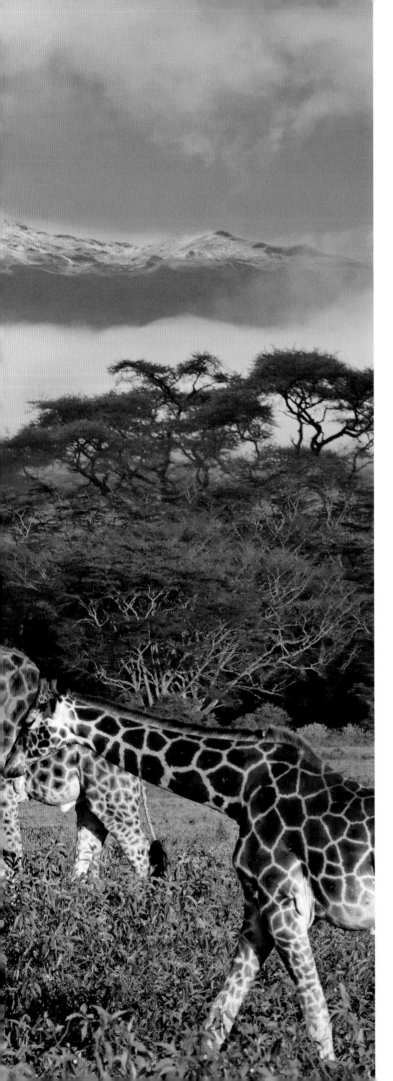

THE FURTHEST POINT you can get from the poles is the Equator, and it cuts through the heart of Africa, Asia and South America. In many places, the average temperature at sea level, even in the early morning, can be 23°C and by the afternoon more than 30°C, with high humidity, torrential rain and frequent electrical storms. So what, you might ask, has this to do with the frozen planet? The answer is 5 kilometres or more upwards. The highest mountains, even those at the Equator, have ice at the top. East Africa's Mount Kilimanjaro, for instance, is just 330 kilometres south of zero degrees latitude and rises to 5,895 metres, the highest mountain in Africa. The kind of wildlife that you would expect to see in East Africa lives around its base, yet at the very top is a permanent snow cap, where snow can fall at any time during the year and little more than a few lichens grow. It is popular as a hiking destination, and for those who trek to the top, the air temperature decreases by about 6.5°C for every 1,000 metres they climb. In a similar way, the air thins and the temperature falls with rising altitude on every mountain on the planet, and whilst the topmost level might be a stark landscape of bare rock, ice and snow, on the slopes immediately below there are many opportunities for life to thrive, each plant and animal perfectly adapted to these high-altitude, ice-cold worlds.

LEFT Mount Kilimanjaro is a dormant volcano close to the Equator with wildlife, like this tower of giraffes in Amboseli National Park close to its base, yet it has permanent snow and ice on the summit and a wealth of different habitats in between, including wildlife living even on its freezing upper slopes.

Chameleons in the Cold

OPPOSITE A chameleon is not a creature you'd expect to see near the top of a high mountain, but the high-casqued chameleon is a highlands specialist, inhabiting sites up to about 4,000 metres above sea level.

Mount Kenya is Africa's second highest mountain, after Mount Kilimanjaro, and its plants and animals experience a whole range of weather conditions. At its base, the annual temperature is on average 12°C, while at the top it's minus 4°C, and rainfall is 870 mm at the bottom, but 1,970 mm on the upper slopes. This steep climate gradient has resulted in dramatic changes in vegetation with altitude. Low montane forests dominate the lower slopes, followed by a bamboo zone, upper montane forests of conifers and African redwood, heathlands, an alpine zone with giant groundsels and lobelias, and, above 4,500 metres, very little vegetation at all, just rock and ice. It's almost like travelling from the East African savannah to the north of Svalbard, except the journey is considerably shorter, and you experience summer every day and winter every night.

ABOVE A newly born chameleon must seek shelter in the centre of bushes before night descends and the air temperature drops significantly.

OPPOSITE There's a striking contrast between the bare rocks, ice and snow at the top of Mount Kenya and the alpine zone below, with its giant lobelias and groundsels. Plants thrive even to an altitude of 4,500 metres, and, as the climate warms and glaciers recede, plants are colonising ground increasingly higher.

Hidden away in vegetation on the slopes of the alpine zone, if you look very carefully, lives the high-casqued chameleon. Its world of extremes yo-yos daily between ice-cold nights and brief windows of warmth by day, and so, when it is time to give birth, there is pressure to get things done before the weather closes in.

At night, frosts invade the slopes, but being a 'cold-blooded' creature, a pregnant mother must warm up before she can give birth. The morning sees a great transformation, with the temperature soaring in just a few minutes. It's vital that, if she is to have any chance of a successful birth, the rising sun must warm up her body and then maintain it before the frosts return, but first it's time for breakfast.

Accelerating at an astounding speed – from 0 to 60 mph in a hundredth of a second – her tongue shoots out twice the length of her body to catch a cricket on the sticky suction cup at its tip. Then, it's down to the task in hand, but she has to be quick. The mountain only thaws out for a few hours each day. She climbs higher to be in the full glare of the sun and, to speed up the process, does something quite remarkable: she changes colour. The darker she is, the quicker she'll reach a working temperature.

The result is six fully formed but miniature youngsters, and they must rush to find a safe place to hide, not just from predators, but also from the night. They head for the centre of their bush, where it's a few degrees warmer. It's been a busy first day on the roof of the world. Living at high altitudes comes with very short windows of opportunity, whether they are twice a year for giving birth, or the daily task of simply feeding; but equipped with the right tools, like a skin that can change colour, it is possible to beat the odds.

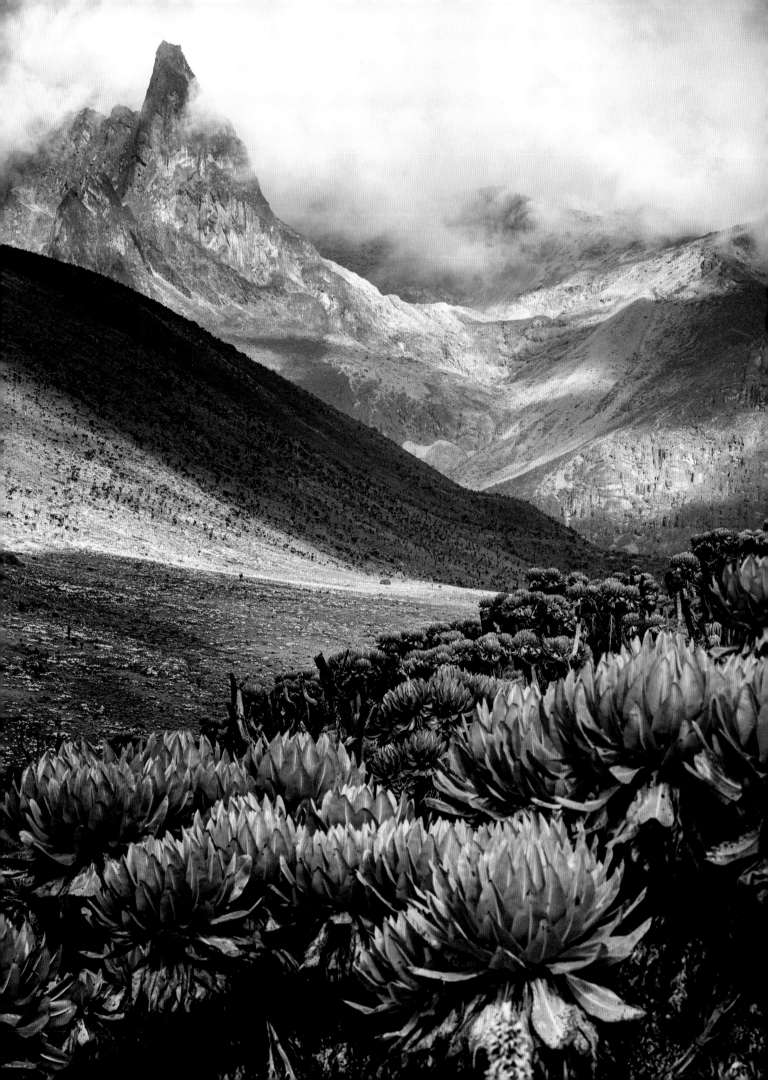

OUT IN THE COLD
MOUNT KENYA

Finding and filming that tiny reptile at an elevation of about 4,000 metres resulted in one of the most high-altitude filming trips undertaken by the *Frozen Planet II* team. The director on location was Usha Amin.

'There were four of us in the film crew: wildlife cameraman Simon de Glanville, time-lapse specialist Freddie Claire, mountain chameleon expert Jan Stipala, of the University of Exeter, and me. We drove up to the foothills and pitched camp in the shadow of the mountain. We knew the following day would be tough going so it was important to get a good night's sleep. We drifted off to the sounds of the forest, although the chorus of loud and raucous grunts from troops of colobus monkeys didn't help!

'The next morning, we set off on foot, led by mountain guide Elijah Ndunga, and it was quite a procession. More than 60 porters were needed to get our filming equipment and camping gear up the mountain. They carried everything on their backs, including large cases with the heavy cameras and

BELOW The film crew negotiates stands of giant lobelias in Mount Kenya's upper alpine zone on their way to the chameleon location.

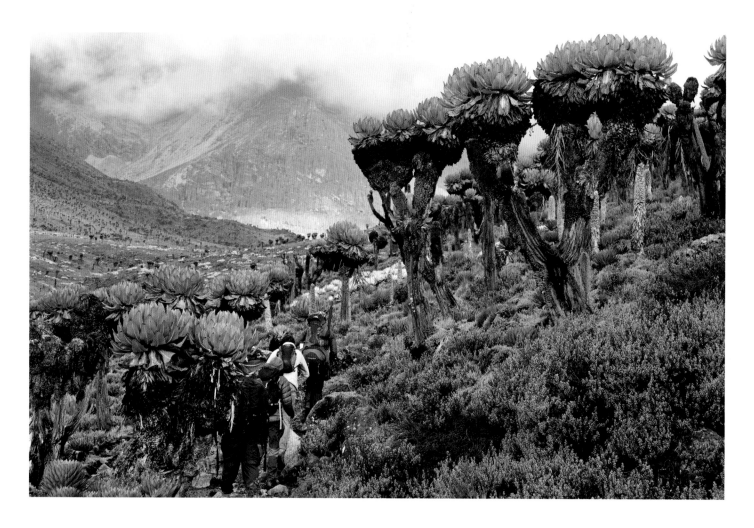

monitors. It was amazing to see them speed past us in their wellies, while the four of us plodded up slowly, feeling very much the effects of exertion at high altitude. The trek took nine hours, which included navigating a stretch of moorland above the tree line ominously named the "Vertical Bog". It was akin to the spongy peat bogs on the moors at home, where you have to hop between clumps of vegetation and try not to sink in.

'By the time we reached our next camp, it was getting dark and altitude sickness kicked in. Two of the team were laid low, and we were close to getting them evacuated off the mountain, but they were carefully monitored by Elijah, who is a trained mountain rescue ranger and wilderness first responder, so we were in safe hands. After some food and rest, their condition improved rapidly, which was just as well; otherwise, the porters would have had to take them down on stretchers in the dark. With the sun gone, though, the temperature dropped dramatically, so we all took to our tents and climbed into warm sleeping bags.

'When we came to film the chameleons the following day, the local Kenyans were very surprised that we were so interested in such creatures.

BELOW Camping beneath the stars of the Milky Way on a cold and frosty night on Mount Kenya.

Chameleons feature a lot in their folklore. They're treated with great suspicion and are generally thought to bring bad luck.'

And, curiously, bad luck was what greeted Usha and her team. Aside from the altitude sickness, they had scheduled their visit to coincide with the dry season in January, with the expectation of cloudless skies and cold, frosty nights, but like many *Frozen Planet II* expeditions, they were subjected to unexpected weather conditions.

'Instead of icy nights and sunny days, for the first few days we got nothing but rain. The guides said they had never seen anything like it, but then things perked up, and in came the sun and the cold.'

'By coincidence, my grandfather and my uncle, who lived in Nairobi, had climbed the same route back in 1970, and just before we set out my uncle showed me photographs he had taken on their expedition. What struck me was how much less ice and snow there is now. The glaciers, which are expected to disappear completely by 2050, were much smaller, and the rain had replaced the snow my family had experienced. It was a very personal and sad reminder of how much change there has been over the course of one generation.'

ABOVE Usha with the photographs her uncle took of the glaciers, from roughly the same spot more than 50 years ago.

OPPOSITE Filming took place in the alpine zone, in the shadow of the three main pyramidal peaks of Mount Kenya.

Where Eagles Dare

While mountains in the tropics experience extremes of weather in a single day, in more temperate regions, the climate varies more with the seasons. In the European Alps, the climate is influenced by several factors: mild, moist air can flow in from the Atlantic, icy-cold polar air drifts in from the north, and from Eurasia in the east, continental air masses are cold and dry in winter and especially hot in summer, so wildlife must be able to seize any opportunities when conditions are favourable.

The Alps are golden eagle country and, in spring and early summer, a golden eagle pair will have a youngster or two in the nest, their eyrie usually on a ledge high on a rocky cliff. Finding food for their offspring is their top priority, and they have the wherewithal to do it. These birds have eyesight capable of spotting prey from 4 kilometres away and can swoop down at speeds of 150–200 mph to catch it, making them one of the world's fastest animals, but this is all to no avail if the mountains are shrouded in fog or lashed by driving rain. Even a morning mist or low cloud will reduce visibility significantly, so the birds would find it difficult to spot prey from a distance. While adult birds are capable of surviving several days without food, their

two chicks need to be fed many times a day. It sometimes means that the first born, which is dominant over the other chick, receives the lion's share of the food and the runt dies. In order to satisfy the appetite of the survivor, the parents need to hunt fresh meat.

Golden eagles are big birds. With a wingspan of up to 2.2 metres, a body length of almost a metre, and weighing close to 6 kilograms, the golden eagle is one of Europe's largest and most formidable birds of prey. Getting such a large body into the air, though, is not without its problems. When operating from the nest, they can simply swoop down the mountainside, but if they land, say, in an alpine meadow after a failed attack, they are surprisingly laboured getting back into the air: six to eight deep wingbeats followed by two or three second glides until they find an updraught to give them lift. Then they can soar effortlessly, with an unhurried cruising speed of about 30 mph.

When soaring, golden eagles have access to two types of updraught: thermal and orographic. Thermal updraughts are rising columns of warm air, while orographic updraughts occur where the wind is deflected upwards by a cliff. In the Alps, the orographic updraught is more likely to be used, and it's not only helpful in soaring. The steep-sided alpine valleys and rocky cliffs give rise to updraughts that subsidise an eagle's normal flight and enable it to airlift larger prey than it would normally be able to tackle, and early summer is the lambing season for ibex and chamois. They are not easy targets. Parents are ever watchful, and each species has formidable horns that could be lethal should an eagle be caught out, but that doesn't stop a golden eagle.

It hunts mainly in the day, although during the eagle breeding season it can be out and about an hour before sunrise and be heading back to the

ABOVE The eagle uses air currents, deflected upwards by the vertical cliffs, to help it soar.

nest an hour after sunset. With offspring to feed, the bird must maximise its hunting time. Flying into the wind, the eagle can course slowly over vegetation and quarter the ground around cliffs, pouncing on anything that moves and gives itself away, maybe an alpine marmot or alpine grouse.

Sometimes a pair of eagles works as a team, a behaviour known as 'tandem flying'. While in search mode, the smaller male bird tends to fly ahead of the female, and also flies higher. One of them diverts the prey's attention, while the other attempts the kill.

When tackling the ungulates, such as chamois, the birds occasionally use a bit of avian nous to outwit the larger animals. If attacked, chamois mothers gather their kids together in a tight bunch and try to protect them using their bodies as shields. They are so closely knit that mothers will defend the kids of other females and, if the eagles fly too close, they'll try to hook them with their horns. To gain the upper hand, the birds try to outmanoeuvre the herd.

One eagle – the 'beater' – swoops in and panics the herd, while the other watches for a kid to be separated from its mother. Should that happen, the eagle is on it in an instant, gliding down at speed and grabbing the unfortunate kid in powerful talons that can exert twice the pressure of human jaws, and then, aided by updraughts, fly with it back towards the nest. On the way, however, the birds do something quite unexpected. A parent bird dare not take a kicking animal back to its chick, lest it knock it

out of the nest. Instead, it flies to a precipitous cliff and simply lets the kid fall. The victim drops like a stone and smashes into the rocks below. Gravity is the killer – a kid feeds a chick. How often these eagles take young chamois is not really known. There are plenty of other prey animals available, such as marmots, squirrels and hares, but should they try again in autumn, when their youngster will have left the nest and they need to feed well themselves to help them through the winter, the chamois kids will have grown and will weigh far more than the eagle. At this time, the eagle must take more risks. It watches and waits for a kid to walk close to the precipice, then grabs it and drags it over the edge, to be smashed on the rocks below.

By being a generalist and adaptable predator, the golden eagle can take advantage of whatever prey is readily available at different times of the year and under different weather conditions. It is, however, a tough place to bring up a family. A large number of chicks don't make it to fledging. Even so, in the Gran Paradiso National Park, where the extraordinary chamois-killing behaviour has been observed, there are 31 pairs; that's one pair per 32 square kilometres, a density that is one of the highest in the world, so some fledglings must have made it.

BELOW A fully grown golden eagle has incredibly powerful talons that have ten times the grip of human hands and twice the pressure of human jaws.

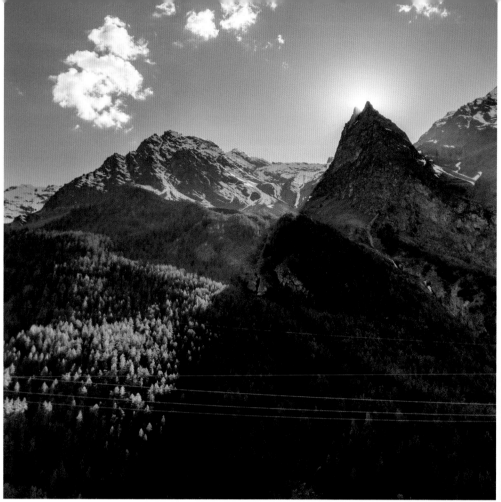

OUT IN THE COLD
EUROPEAN ALPS

ABOVE Gran Paradiso Mountain, seen here in the background, gave its name to the national park.

ABOVE RIGHT As with any films about mountains, the crew were required to do a lot of climbing with heavy backpacks!

The golden eagles are on our screens for less than ten minutes, yet to capture this dramatic behaviour took several years and a lot of ingenuity. Central to its success were French filmmakers Erik, Anne and Véronique Lapied, who were more than willing to share their knowledge of the animals, which they had built up over the years. Their home is close to the Gran Paradiso National Park. Here, they have been filming the wildlife of the park, including golden eagles, with great success due to a combination of local knowledge, perseverance, exacting field craft, and, let's be honest, an element of good luck. They were the linchpins in a series of filming expeditions set up and monitored by *Frozen Planet II* production coordinator Jane Greenford, who had the daunting task of organising these excursions in the middle of a global pandemic, with all the restrictions that this implies.

'Throughout this time, the normal setbacks of getting teams out were magnified so much that it felt like an achievement just to get them to the location, let alone film anything. For the eagle sequence, we had three main expeditions. The first was with Italian wildlife cameraman Marco Andreini and his assistant Irene Giorgini, and the second, which was subjected to the unpredictable travel rules at the time, was with a truly international team, so it required an extraordinary amount of paperwork.

ABOVE RIGHT Chamois are such nimble animals on these precipitous cliffs that it looks almost as if they've been glued there.

'German wildlife cameraman Rolf Steinman and director Joe Treddenick from our team at the BBC joined the French and Italians in the field. The main reports coming back focused on the challenging hike every day, and long days when not very much happened. I thought that they were exaggerating until I went there myself.'

Jane joined a third shoot, which was divided into two teams: one below a cliff edge where the eagles were nesting, and the other partway up Alpe Levionaz Dessous. She and cameraman Olly Jelley were at the lower site, where they had to climb steep mountain paths with heavy backpacks containing the camera equipment.

'We were very much reliant on Marco's relationship with the local rangers to obtain the latest news on the eagles and chamois. Even so, we would sometimes have to wait for hours for chamois and their kids to appear. I worked as eagle spotter with Olly. In the hide, his view was limited so I would tell him when the eagles headed his way. At first they looked at us suspiciously, but eventually they got used to us being around and not a threat. It reminded us just how keen their eyesight is.

'One memorable day, all the planning and hard work paid off. An eagle swooped down and grabbed a chamois kid and flew off with it in its talons. The entire hunt, including flying back to the nest, occurred right in front of our eyes. I really never expected to see that!'

Mountain Monkeys

Imagine a landscape in which the main highway is flanked by 10-metre-high snowdrifts, fruit and vegetables are deliberately frozen outside to retain their flavour, trees are transformed into gigantic 'snow monsters', and, because the snow is so deep, people enter their houses from their top-floor windows. Imagine no more, for in the Hakkōda Mountains of Japan, this is the reality for half of the year. In winter, more snow falls here than almost anywhere else on Earth. It's a fluke of nature. Moisture-laden winds blow in from across the Sea of Japan and dump more than 2 metres of snow in a day, yet there is a monkey that lives and even thrives in such conditions. Most monkeys are found in tropical or subtropical climes, but the Japanese macaque is a remarkable exception. With its thick furry coat, it is able to live in a colder climate than any other non-human primate – down to minus 15°C – and it lives the furthest north, the most northerly population living on the Shimokita Peninsula, the axe-shaped northernmost tip of the island of Honshū.

A macaque troop generally spends the night in the trees, rather than on the ground, to protect it from being buried in snow, and the monkeys huddle together for warmth. They have also learned to bathe in hot springs in a volcanically active area as another way to not only keep out the winter chill, but also to lower their stress hormones, and they roll snowballs just for fun. It just goes to show how the Earth's cryosphere extends to places and to creatures that you might never have imagined existed. Away, from the mountain spa, though, life is not quite so luxurious.

Snow falls upon snow up here in the Northern Japanese Alps, and the biting winter wind is relentless; you could easily freeze to death, and this is a real danger for a young male macaque that has recently left its mother.

When his younger sibling is born, the juvenile is shunned by his mother, so he is facing his first winter alone. While the new baby is enjoying fresh warm milk, the ostracised male has to make do with the bark from trees and foraging for grubs in the river; but that means putting his hands in freezing cold water. Having stepped into another troop's territory and been rejected again, the youngster is at his wits' end. Then the young monkey discovers another individual hit by the same difficult circumstances, and the two outsiders unite by grooming each other, a move that will give them a better chance to survive.

When snowstorms roll in, all macaques in a troop usually gather together in their own huddles, but now they are outcasts the young males are excluded. Through the new relationship they have with one another, however, they are able to huddle too, raising each other's body temperature by a few vital degrees. Small margins like this mean the difference between life and death in the mountains, and several others come to join them – a band of brothers that keep each other alive until the snows melt and spring arrives, by which time some find a troop of their own to lead, while the unlucky are resigned to another year of having to find ways to beat the cold.

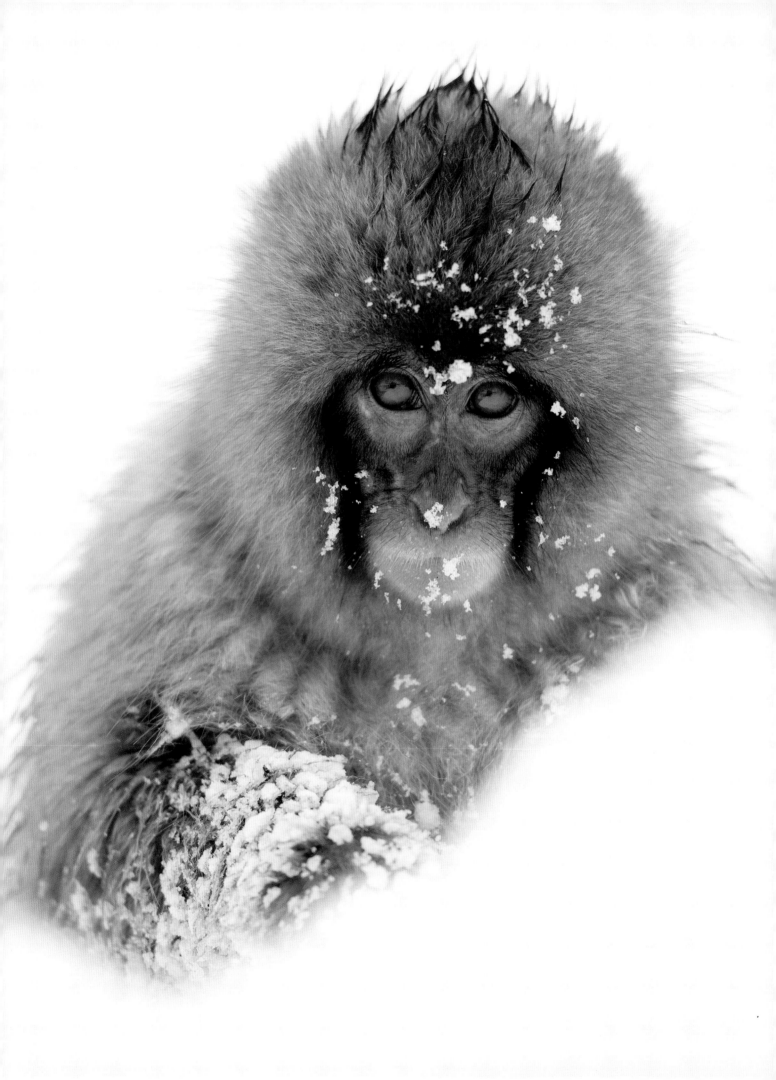

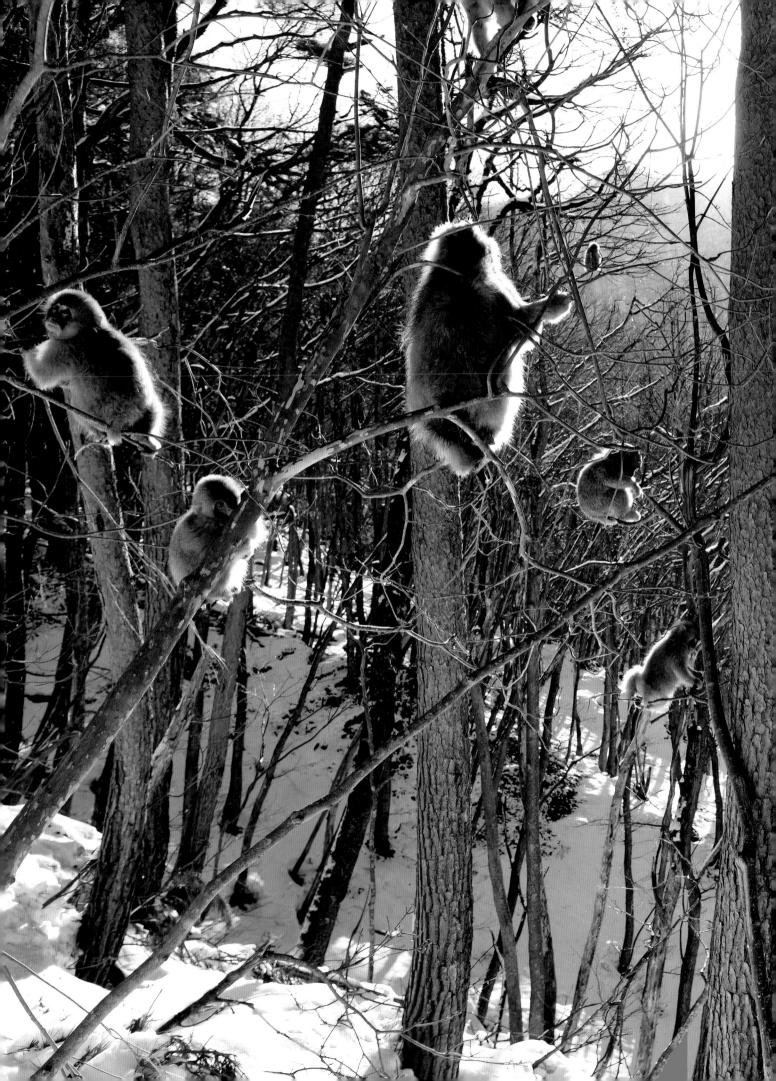

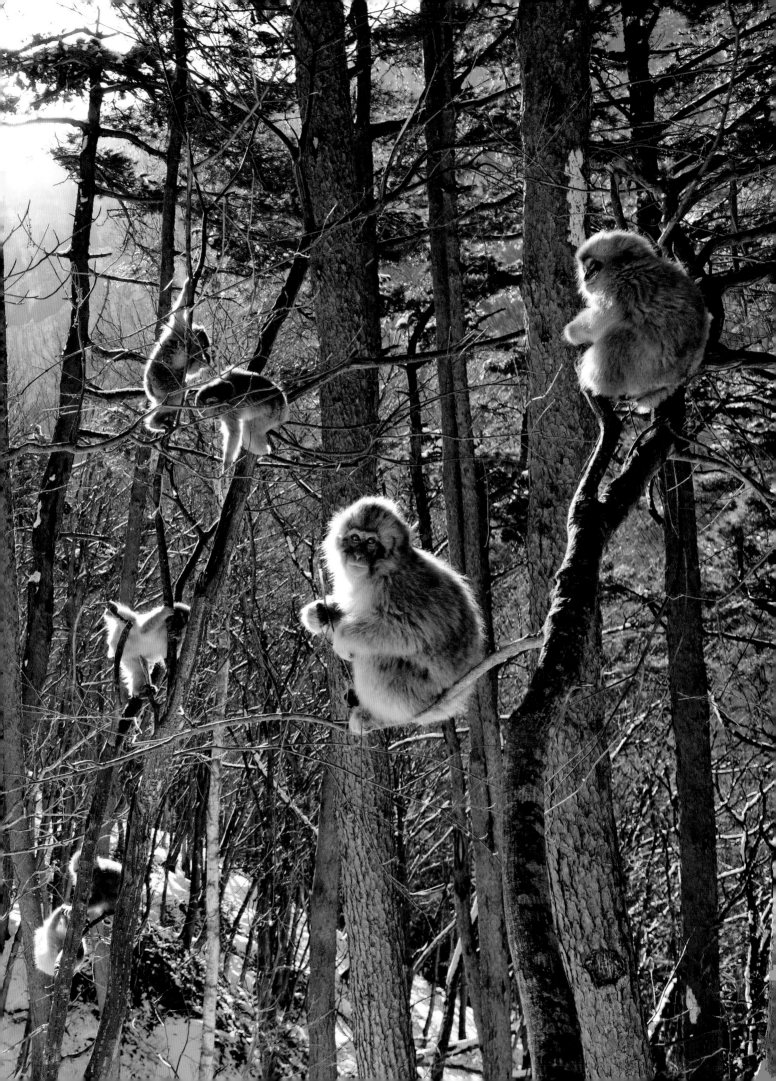

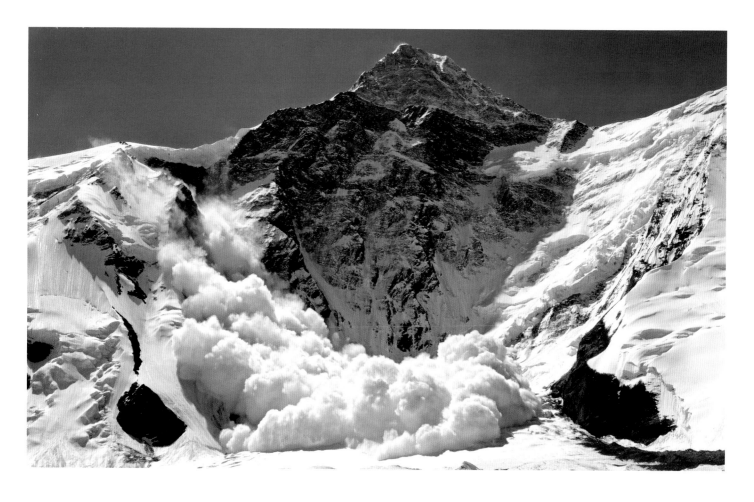

Avalanches

ABOVE Even though avalanches are no more than flowing snow and air, they can move rocks, trees and ice down the mountainside.

Aside from the piercing cold and falling over a cliff, the greatest danger to people and wildlife in the mountains is an avalanche. It is one of two ways in which frozen water finds its way from the top to the bottom of mountains. The other is the slow grind of the glacier. Both start out as fallen snow.

Snow is so prevalent on mountain peaks because warm water vapour from below is funnelled up to meet the cold air above. Water condenses and, as it is so cold, it falls not as rain but as snow, each snowflake showing its own pattern, as no two snowflakes are alike. Layer upon layer of snow builds on the mountain slopes, and should they become unstable, they are transformed into powerful avalanches that bury everything in their path.

Avalanches occur where the snowpack, terrain and weather conditions work together to destabilise the snow. They can occur virtually anywhere in the mountains given the right conditions, but they are more prevalent at certain times of the year, such as late winter or a warm spell in midwinter when snow starts to melt. Some places are more prone to avalanches than others. A south-facing slope in the northern hemisphere, for example, is more likely to have avalanches than one that is north-facing. The avalanche itself is like the snow on a car windscreen. While it is icy cold, it sticks to the glass, but when the temperature rises, it slides or 'sluffs' down, often in slabs. These are miniature avalanches.

Large mountain avalanches might contain more than 100,000 tonnes of snow and tumble down mountain slopes at close to 100 mph. They are surprisingly frequent. There might be as many as a million avalanches a year worldwide. Large ones tend to occur naturally, but skiers often trigger smaller ones, and they tend to be the more deadly.

An avalanche has three main parts. The starting zone is often higher up a mountain slope, where unstable snow fractures from the rest and begins to move downhill. The second part is the avalanche or slide track – the route that it takes. Large swathes of forest with no trees might indicate a frequent route for avalanches. The third part is the run-out zone, where the snow and any debris the avalanche has picked up, such as splintered trees, comes to a halt.

An avalanche is, without doubt, destructive, what ecologists call a 'disturbance', but it can also have a positive impact on the immediate environment. It can redistribute water and nutrients and open up a habitat. An alpine meadow, for instance, can appear in a montane forest, boosting the diversity of plants and animals. Plants that could not grow in the shadow of conifers can suddenly germinate, providing food for herbivores, and then, in turn, for animals further up the food chain. The slide tracks are also clear of deep snow, and so mountain goats and deer, such as mountain caribou, often wander into the area to feed on any low-growing plants that have been exposed.

But can animals predict an avalanche and move away? There is some evidence to suggest they might be able to. Many animals can detect ultrasounds, very low-frequency sounds that we cannot hear. They sometimes use that channel for communication. They can also detect Rayleigh waves, a surface wave that travels through the ground at ten times the speed of sound. An avalanche can spawn both, and so animals might well have a warning. On the other hand, few animals are likely to be looking for food in such deep snow. They will already have been looking for it elsewhere. Even so, in the USA, it has been estimated that about 15 per cent of mountain caribou die in avalanches, so they clearly didn't receive the warning. Avalanches are, though, another source of food. It has been found that wolverines regularly patrol avalanche slide tracks looking for fresh carrion, and they dig their breeding dens in the run-out zone among the piles of snow and boulders at the bottom.

In spring, the slide track also attracts grizzlies. The snow here melts before that in the woods, so when the bears awake in early spring, they mainly eat starchy avalanche-lily roots dug out of slide tracks. About 40 per cent of bears in the Columbia Mountains of North America, for example, adopt this springtime habit, and they spend about 60 per cent of their waking hours there. And that's not all: in the Swan Mountains of northern Montana, a study has found that female grizzlies hang out regularly at avalanche tracts and wait for the males to show up. The avalanche creates a dating site for bears!

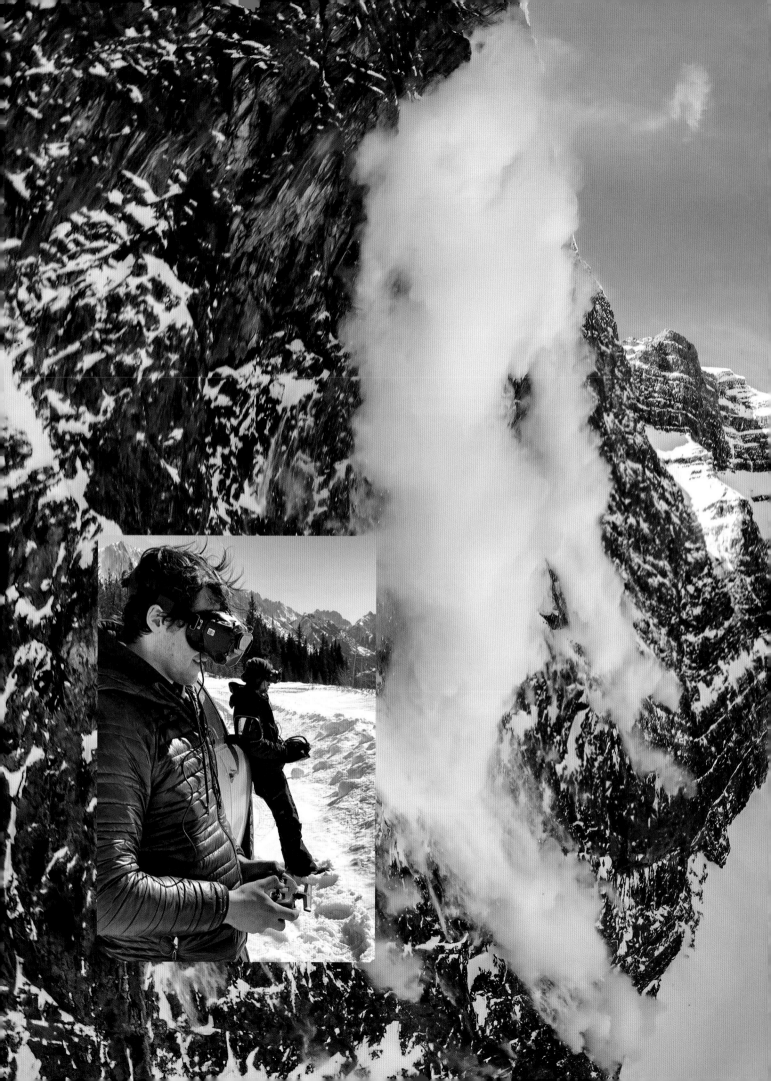

OUT IN THE COLD
CANADIAN ROCKIES

BELOW In a test, the team flies the 'racer' drone as close as they dare to the falling mass of snow.

INSET Drone operators Raphael Boudreault-Simard and Matt Hobbs wear virtual-reality goggles to guide their drones.

To get a more immersive view of an avalanche, the producer of this episode, Alex Lanchester, wanted to be able to travel alongside the falling avalanche, an event that lasts for little more than two minutes. Drone operator Raphael Boudreault-Simard welcomed the challenge, working alongside field producer and cameraman Matt Hobbs. Matt coordinated up-to-the-minute meteorological data and field logistics, as well as filming the avalanche from the ground. Raphael piloted the drone, opting to use a first-person-view (FPV) or 'racer' drone.

'The pictures from FPV drones are monitored with virtual-reality-style goggles,' explains Raphael, 'offering the pilot a much better sense of proximity of the terrain and subject from the aircraft. This allows the drone to be flown much closer to the action, creating some of the most immersive and seemingly impossible images.

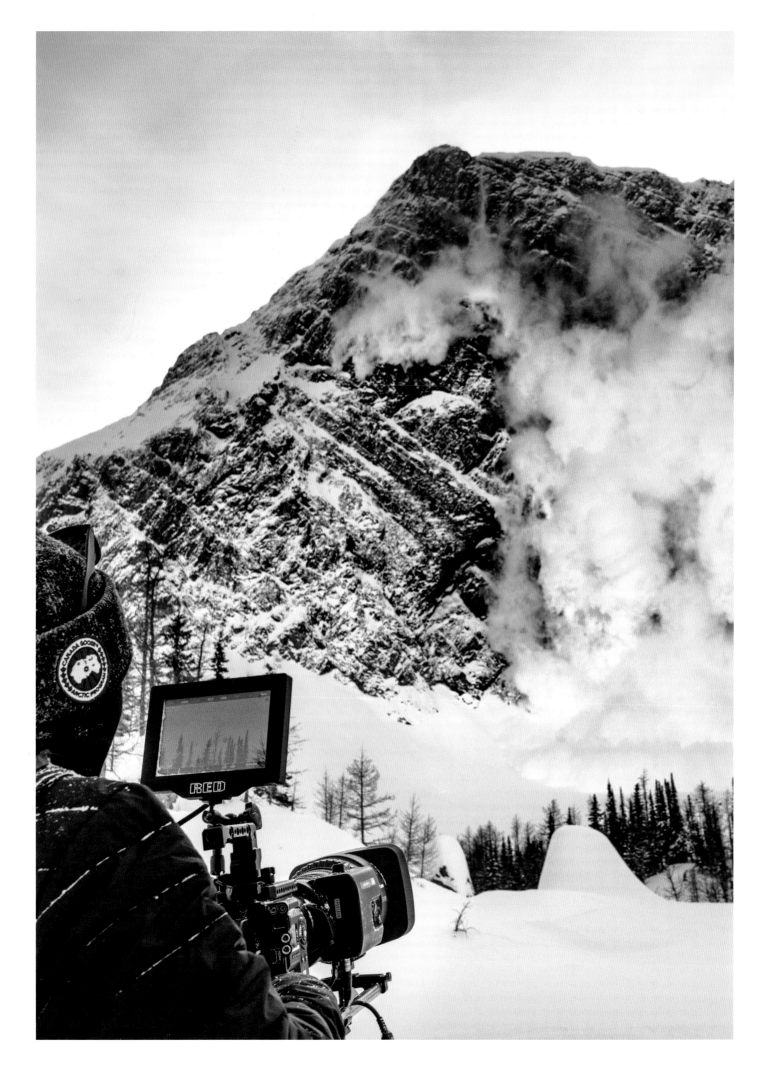

OPPOSITE More conventional cameras are used to record the avalanche from some distance away.

ABOVE As an avalanche accelerates, it gathers increasingly more snow, and, if it travels fast enough, the snow mixes with air, forming a powder snow avalanche.

'When I first started looking into the mountains we were going to be filming, I quickly realised we were going to be operating at the edge of where FPV technology is at currently. Before even thinking about flying with avalanches, distance and flight time were going to be challenging. Using more efficient propellers, bigger batteries and more powerful antennae, we managed to get enough flight time and secure a strong video connection. Another concern was the fast and turbulent air found at the front of avalanches, and the only way to find out if the drones were going to be up to the task was to try it out, starting conservatively and getting closer and closer to the snow cloud as we built confidence. Luckily, we had an amazingly talented crew on this shoot, and we all know how it goes: teamwork makes the dream work!'

'The team produced some truly extraordinary shots,' says Alex, 'and they enabled us to really demonstrate the terrifying power in an avalanche and how mountains can be very unpredictable.'

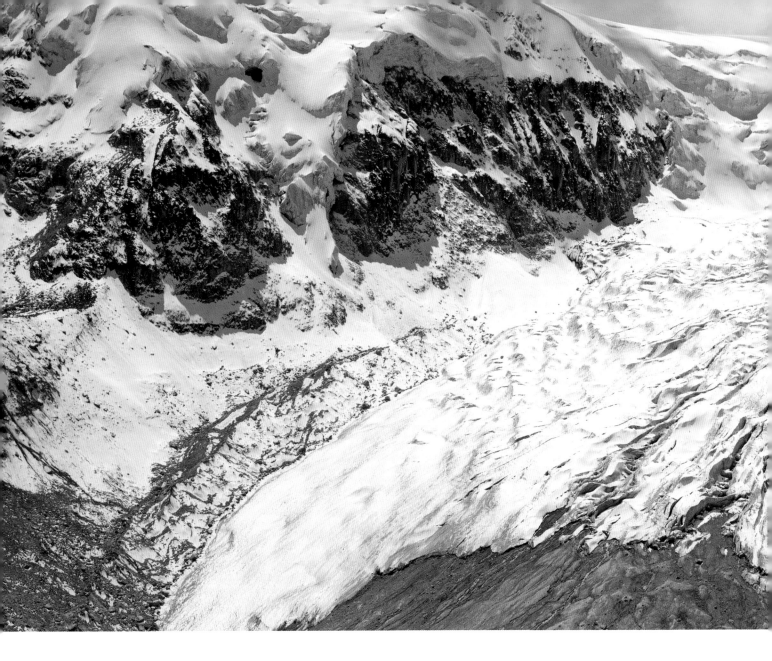

Rivers of Ice

ABOVE Mountain glaciers generally flow out of ice fields that span several peaks. When they pass down valleys, they become, appropriately, valley glaciers.

Where the annual snowfall exceeds the rate at which it melts, so great masses of snow accumulate over time and glaciers form. The enormous weight of snow on top compresses the snow underneath so it becomes solid sheets of dense ice. Snow from avalanches can contribute to their formation, and these ribbons of ice are also on the move. At first glance, they look to be stationary, but time-lapse recordings reveal that they are very much in motion, sliding along at up to 50 metres a day like rivers of ice, and, wherever they go, they have such an immense power that they change the shape of the landscape.

Mountain glaciers, like avalanches, move downhill, often following the route of a mountain valley. Inevitably they pick up debris – rocks and boulders – and it is this, and not the ice directly, that carves out different landforms. A steep-sided V-shaped valley, for instance, is eroded to become a broader and deeper U-shaped valley, and any side valleys entering it are left high up on the valley sides, so-called 'hanging valleys'.

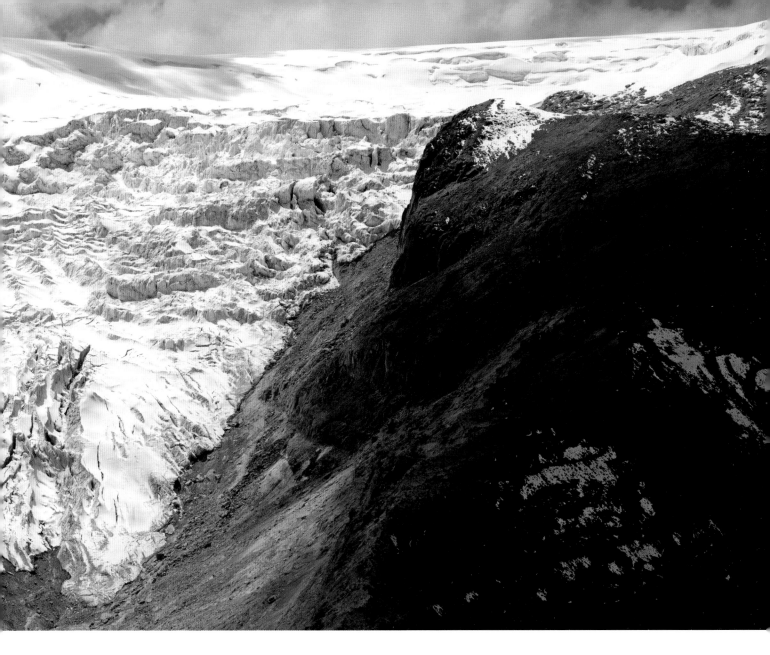

OVERLEAF **An ice cave in the Breiðamerkurjökull Glacier, Iceland.**

Recent research has shown that the speed at which glaciers move and the climate in which they exist control how quickly they cut down into the bedrock, and it turns out that precipitation is the great leveller. If the ice is frozen to the bedrock, its movements are constrained and there's little erosion, but, if it can slide more freely, then more erosion will result. The most erosive glaciers are those in warmer climates where there's a lot of snowfall and the air temperature can hover around zero, such as in Alaska. Where there's little snowfall and the temperature is way below freezing, such as in the Antarctic, there is less erosion.

One feature of glaciers that has intrigued scientists is the ice cave. Wherever water runs through or under a glacier, a cavern or tunnel is formed. Most are dynamic and move with the ice, with the danger that they will collapse. In many, the ice has a vivid blue colour. This is the result of extreme compression, when most air bubbles have been squeezed out, so the ice absorbs all visible light except blue, which it scatters.

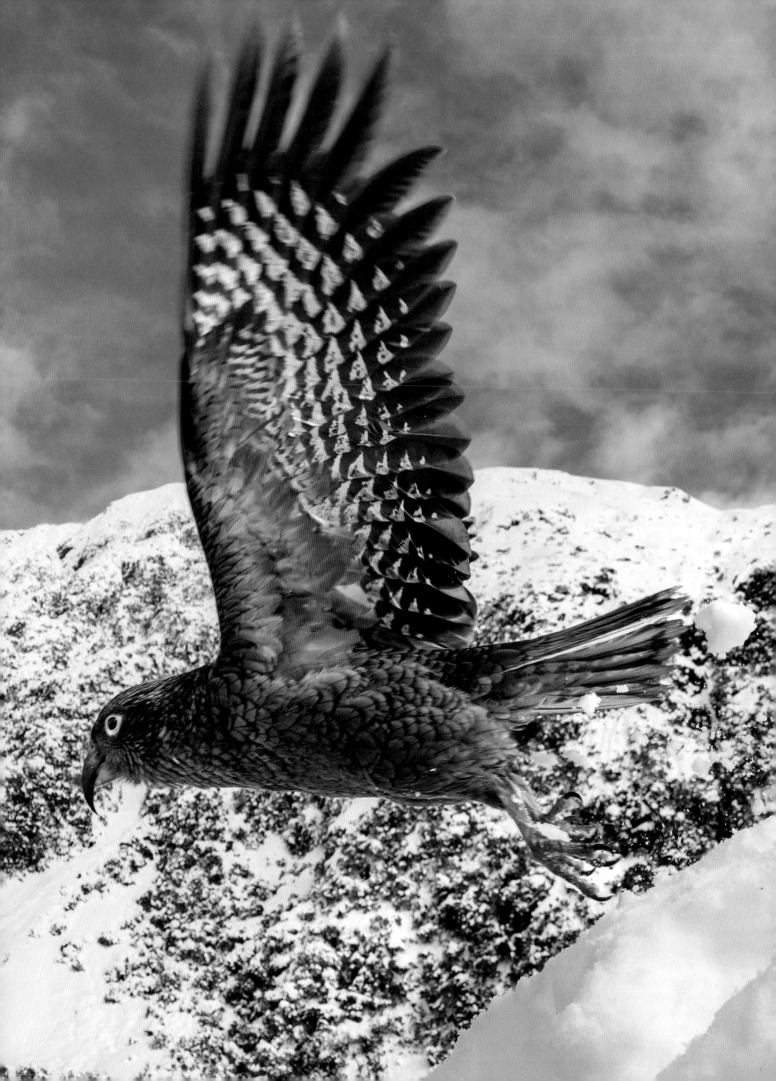

A Mischievous Bird

New Zealand has glaciers, about 3,155 of them, and, with a length of 23.5 kilometres, the Haupapa or Tasman Glacier on South Island is the largest, although it too, like glaciers the world over, is disappearing fast. But this glacier and a few others in New Zealand are notable for something else entirely: they have unusual neighbours. The world's only alpine parrot – the kea – lives here, a mischievous bird with a lot of character, and the only species of parrot that occurs above the snowline.

Keas are remarkably intelligent. They need to be. They must be adaptable to survive in these mountains, so they purloin anything remotely edible, including carrion and the contents of a skier's rucksack. In their relentless search for food, they've been known to strip down cars, pulling out rubber seals, and a few individuals have learned how to successfully open the lids of

OPPOSITE When an olive-green kea takes flight, it reveals a startling flash of brightly coloured feathers on the underside of the wings.

OPPOSITE The kea's body feathers have a lining of black, giving them the appearance of scales.

rubbish bins at ski resorts for the scraps inside. Once one bird got in, several others watched and learned and now several do it. And, if a bird chances upon food, such as the carcass of a tahr, a goat-like animal introduced to New Zealand from the Himalayas, a whole bunch of birds are likely to fly in. Squabbling is reconciled by a warbling 'play' call, which is the kea equivalent of a laugh. It seems to whip them up into a play frenzy, during which one bird might lie on its back, like a puppy, and the others jump on top of it.

When the opportunity arises, these parrots also become predators. They listen for the calls of shearwater chicks in their nest burrows and then break in and grab them. They became famous (or more accurately infamous), however, for some very odd behaviour. In the early 1860s, reports circulated that the wounds found on the rumps and sides of domestic sheep were due to attacks by keas. At first, it was considered an old wives' tale but, in 1868, a sheep farmer and his colleagues caught keas in the act, and the scientific community reluctantly accepted it was true. Alfred Russel Wallace, who came up with the theory of evolution at the same time as Charles Darwin, referred to it in his book *Darwinism* (1889), citing it as an example of behavioural change in nature, but was it that much of a change?

In a fossil site on North Island, where keas once roamed, the fossil bones of a 4,000-year-old moa, a large flightless bird that rapidly went extinct when people arrived, had scars in the pelvic area that fitted the bill of the kea. Could the kea just have switched prey? The kea has a long, curved, hawk-like bill and powerful claws, so it is quite capable of inflicting serious wounds, and, with the moa gone, the target now is sheep, especially the fat from under a sheep's skin. A natural source of fat is important to birds, especially living in such harsh conditions, and it's significant that most attacks have been seen in winter, when food is hard to come by. Back in the 19th century, this behaviour made the kea public enemy number one, and they were shot or poisoned almost out of existence. Now, they are protected, but these 'clowns of the mountain', as they were once described, show far from clownish behaviour. Some even use tools.

Remote cameras have revealed that the birds whittle sticks to trigger stoat traps. They might try several sticks before settling on one that will do the trick. The traps are baited, and it's thought this potential food source is the reason for the behaviour. The bait, though, is often left. It seems the loud bang of the trap shutting startles the birds so much that they fly off in alarm and leave the food behind.

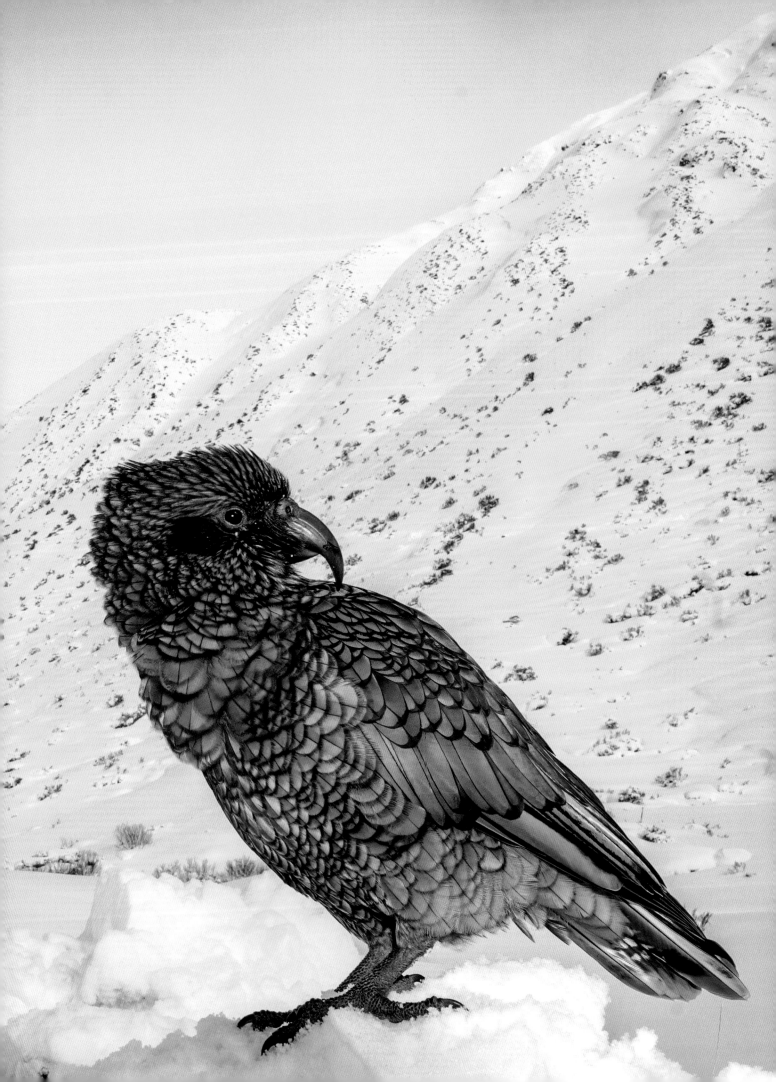

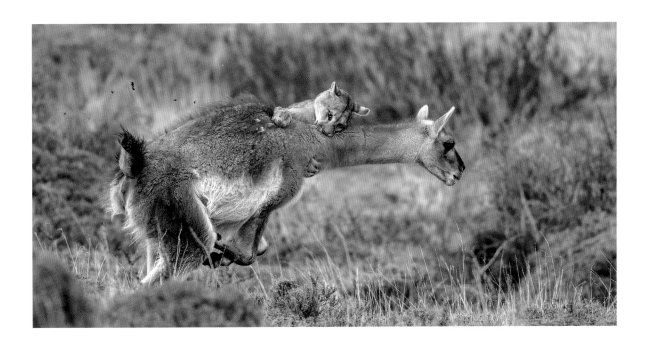

Big Cat of the Andes

OPPOSITE AND ABOVE
The disparity in size does
not stop a puma from
trying to bring down an
adult guanaco.

OVERLEAF Guanaco travel
in herds. Females and their
young stick together, while
young males and bachelor
adults form their own herds.

The Andes Mountains effectively split the South American continent in two from north to south. Top predator, throughout their length, is the puma, and its target in the southern part of the range is the guanaco, a New World member of the camel family and a wild relative of the llama. Both are well camouflaged, but in the darker days of winter, when the night can be 15 hours long, the cat has a distinct advantage. Pumas have more rods and fewer cones in their eyes, so they work well in low light conditions, when colour is less important. This is when pumas are out hunting, and on the mountain slopes there are few places to hide.

Guanacos combat the danger by huddling in groups and select upslope sites to spend the night. When threatened, they just run, the explosion of movement confusing the predator momentarily, but giving them just enough time to escape. They can reach speeds of 40 mph, about the same as a thoroughbred horse, and their soft-soled hooves give them good traction on the rough terrain. They also swim well, so that's another escape route. They're basically very athletic animals.

Pumas, though, are accomplished ambush predators, using rocks, boulders and any vegetation to hide behind, and they can take the guanacos by surprise. A puma can accelerate to about 50 mph in a short burst, and it has long hind legs, which enable it to leap over 5 metres into the air and 12 metres horizontally. The guanaco is much larger than the puma, yet the predator can jump onto its back, grab it by the neck and then simply hang on and, with the help of its powerful forequarters, eventually bring down the quarry. Guanacos, though, are powerful beasts themselves and they put up a formidable fight, so these life-and-death struggles sometimes end with the prey getting away.

OUT IN THE COLD
CHILEAN PATAGONIA

To film these secretive cats in action, director Joe Treddenick and his film crew, including camerawoman Helen Hobin, headed to the Estancia Laguna Amarga, a privately owned ranch bordering Torres del Paine National Park, which has a large population of pumas. On their first evening in the field, not 30 minutes had passed when they heard on the radio that the guides had spotted a cat feeding on a guanaco kill.

'Standing at a respectful distance,' says Joe, 'I was able to see a puma in the flesh for the first time – and close up! Typically, when filming life in the mountains, animals are incredibly shy. Weeks can go by with only fleeting glimpses of them. However, this individual was completely at ease with us, content to carry on feeding while we stood there.'

Most of the filming for this sequence was at night, when the cats were out hunting, and working in a part of the world renowned for the darkness of its nights was not without its problems.

'We used the thermal cameras [which pick up body heat] to scan miles away,' recalls Helen, 'looking for heat signatures and checking the shape and gait of the animal to determine whether it was a fox, hare or puma. It was quite eerie. With the thermal vision, we could watch hunting pumas and

ABOVE **Wildlife cameraman Dawson Dunning stands in the pitch dark of a Patagonian night. The only way he can see and record puma behaviour is with a thermal camera that picks up the warmth of an animal's body.**

wary guanacos move unknowingly within metres of each other, because the wind was almost constantly howling, diminishing their sense of smell and hearing.'

Most nights, though, as Joe points out, were not plain sailing.

'Unlike the first night, we didn't immediately find our cat early in the evening. More commonly it required hours of searching and we often didn't find a cat until after midnight. The call of "Cat!" producing a curious mixture of excitement and relief, but there were nights when we didn't find a single cat and, I can tell you, that spending up to 16 hours hiking in 50 mph winds and rain, and scanning in the pitch dark, is not much fun.

'The weather in this part of the world is extremely unpredictable. We went from setting up a time-lapse to film a pleasant sunset to taking it down 20 minutes later in the middle of a blizzard! However, it was the wind that was the most extreme. The guides referred to it as like someone opening and shutting a window, and they were right. The speed at which it could go from calm to 50 mph was astonishing. It took seconds. The wind, once in full flow, would keep up all through the night until the temperature differential stabilised, and it calmed down. It was just one of the perils of working between the cold High Andes and the vast yet warm Pacific Ocean, and the people living there were well used to it. We were advised by the guides to always park our vehicles into the wind. If we didn't, when you

opened the doors they would be ripped off. On the flip side, though, the wind cut just as abruptly as if someone really had shut a gigantic window.'

And that powerful wind played havoc with the camera equipment, both on the ground and in the air, as Helen discovered.

'One of our trackers described a day so windy that his car windshield had simply shattered from the sheer force. He told us that the saying goes in Chile: "If you don't like the weather, just wait five minutes." So we'd form team hugs to shelter the camera on the ground from the wind, using our backs to stop it from shaking. Flying a drone in such conditions wasn't easy either. Not only do you have to worry about unpredictable downpours and battling the wind, but you also have to keep up with an often constantly moving big cat. The thermal camera on the drone is your only way to understand where you are flying in the terrain, beyond the tiny flashing lights on the body of the aircraft, and thermal depth perception in a rolling landscape can be confusing. You never know quite when the pivotal moment of a hunt will unfold, and so you're always having to land, change battery and relaunch from the slopes, and all on the move and in the dark.'

Despite the wild weather, Joe and his team were fortunate to witness something quite remarkable. It unfolded during the course of one night, when they were following a newly independent female puma, which had consistently failed to bring down a guanaco and was undoubtedly hungry. She led them to another kill, made by a more mature female. Settling down in the long grass, and carefully avoiding dangerous black widow and recluse spiders that tend to live there, the team had a grandstand view of some unusual behaviour.

'Our immature cat approached the older female feeding on the kill and initially received short shrift, but she held in there. Settling down just a few metres away, she waited for the older female to eat her fill, and eventually she became less hostile. Slowly but surely, our cat was able to approach until she was finally close enough to take a mouthful. They then settled down to feed together. At around 3am, a third female joined in, and, just after that, a large male came in to have a feed too. To be surrounded by so many pumas was extraordinary. Of course, we could only see them through the camera and our thermal spotting scopes. If you were to stare into the darkness the only indication that they were close was the slightly disconcerting sound of bones being crunched. The final spectacle of the night happened just before dawn. One of the females and the male broke away and after a brief (and very loud) courtship ritual, they began to mate. This was a once-in-a-lifetime experience, not only for all of us, but also for the guides, and the emotion showed. As dawn came round, the cats dispersed to sleep off their meals and we, completely out of camera batteries and food ourselves, thought it was probably time to call it a day and return to base too.'

What Joe and the team had witnessed was something relatively new to science. It turns out that the solitary puma has a secret social life, and

neighbours might well share their food. They are more likely to do this with individuals that have shared their kill in the past. Older males and females are the most gregarious, and females will share food if offered protection by a male, as well as letting them be first in line when the time comes for courtship, as the team saw. And these are not brief encounters. During winter, the cats will dine together at a carcass for a week or until the food has run out and meet up with other pumas every ten to 12 days. All in all, it was a remarkably successful assignment, and all down to the forward-thinking brothers Tomislav and Juan Goic Utrovicic, current owners of Laguna Amarga.

'The ranch itself is remarkable,' says Joe. 'There is a healthy population of pumas living there, and this reflects both a positive and negative reality of puma conservation in the south. The fact that there are so many living together in this ranch is for the simple reason that they're not persecuted by the ranch owners and that wild herbivores are also given space to graze there. This doesn't affect their livestock business too greatly, and they're also doing well from ecotourism. The negative aspect comes from the fact that this is a healthy but quite isolated population of pumas. When they leave this ranch, other than to cross into the adjoining national park, where they're protected, they are at very high risk of being killed as pests. The ranch, therefore, is an island of safety surrounded by a sea of danger.'

BELOW Wildlife, including guanacos and pumas, around the Laguna Amarga ranch are remarkably tolerant of wildlife film crews.

Freezing Firebirds

Flamingos are birds we would normally think of as inhabiting the warm places on Earth, but three species live high in the Andes, at 4,000 metres above sea level in one of the highest, driest and coldest deserts in the world – the Atacama high desert – where they are surprisingly resilient. James's and Andean flamingos are here all year round, while the Chilean flamingos are summer visitors, but why do they come to such an inhospitable place? Well, for the food, of course.

The birds dip their upside-down beaks into the water, their tongues pumping at six times a second, to skim off brine shrimps, diatoms and cyanobacteria, and different species have different-shaped bills to filter out different foods – James's and Andean flamingos have deep-keeled bills, James's with 54 lamellae or filter plates to the inch and Andean with 23 to the inch. The first two eat mostly diatoms 0.6 and 0.8 millimetres across respectively, while Chilean flamingos have shallow-keeled bills, with 13 lamellae to the inch, and eat much larger brine shrimps and other invertebrates, so the three species can share the same feeding grounds yet not compete. It also seems the mobility of their respective prey items affects the way they move. The 0.6

diatoms are clearly slow movers, so adult James's flamingos stride about at a stately ten to 15 steps per minute. Andean flamingos up the ante to 20–30 steps per minute, but the Chilean flamingos race about at 40–60 steps per minute in order to stir up the invertebrates in the bottom sediments.

They are gregarious birds that do everything together – feed, nest, procreate and sleep, but as many in the colony as possible have to be in the mood for a particular task, such as reproduction, before they settle down and get on with it. It takes a lot of energy to rear a chick, and flamingos are most successful if they all rear their chicks at the same time, then, when the parents mysteriously abandon them, they gather into crèches for safety and to help keep warm. These youngsters, like most birds, need to roost at night. The safest place for them is in the middle of the shallow lake. Predators are less likely to surprise them while they sleep, although they do have only one half of their brain asleep at a time, so they are super alert. Even so, as winter advances, night temperatures drop below freezing, and the surface of the lake freezes solid. In the morning, the birds find that they cannot move their legs. They are not only trapped, but also cut off from their food supply. There's nothing for it: they just have to wait until the ice melts and they can extract their legs.

But, at this moment in the early morning, when the lake is finally thawing, the feathers of the young birds are caked in lumps of ice, and they have a distinct loss of regal composure. They struggle to break free, the ice in their plumage weighing them down and preventing them from becoming airborne; but when the temperature rises, the wind begins to blow, and their icy shackles melt away, the birds are lifted into the air, and they can escape their icy prison.

Another reason for being here is that flamingos flock to these kinds of alien and remote habitats, from alkaline soda lakes in Africa to lakes that freeze over in the Andes, because in both cases there will be fewer predators about. Their long necks are not only useful for feeding, but also when standing upright flamingos have a grandstand view of a salt lake and can spot a predator approaching from several kilometres away. They are undoubtedly remarkable animals, but the ice in the mountains catches them out. When their lake freezes, an aerial predator could swoop in or any four-legged beast could skate across and gnaw on the birds trapped in their icy stocks. It is a big price to pay, but curiously, the predators seem not to have caught on. The remoteness really does work.

OPPOSITE A flamingo fledgling has been able to break free from the ice, but large icicles hang down from its feathers, making it difficult to lift off.

BELOW Flamingos huddle together at night to keep warm, but there is always the danger that the water freezes and the birds are trapped.

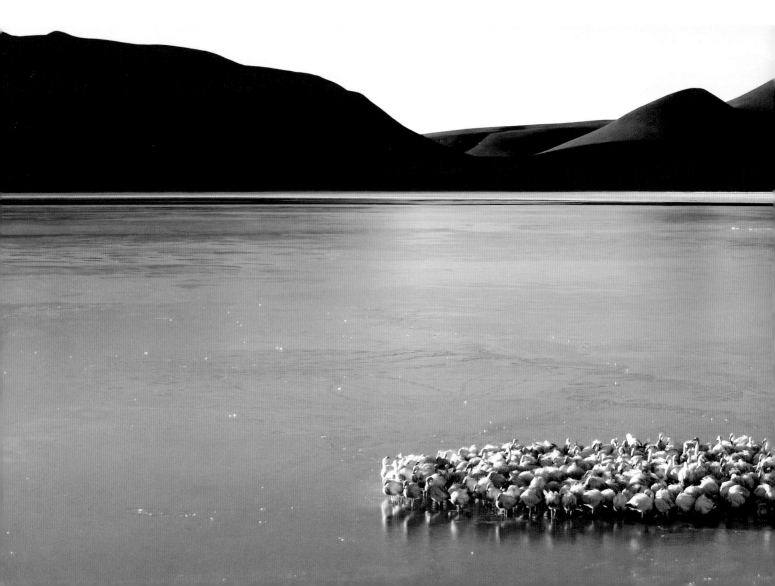

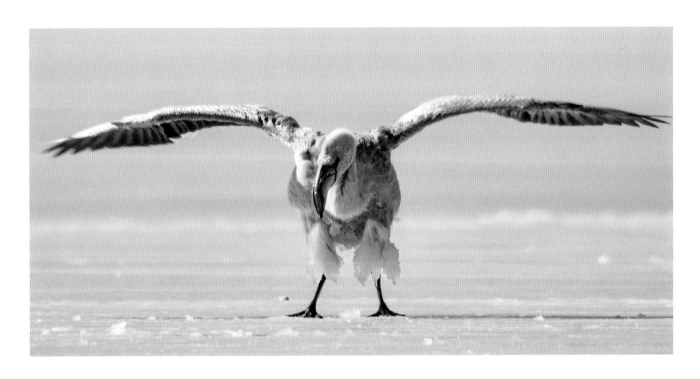

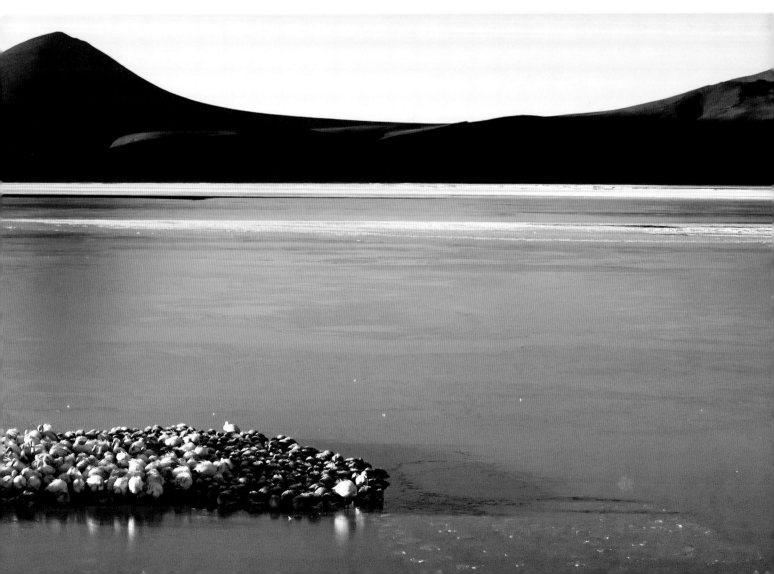

The Big Melt

The Andes are relatively young and impressively high, the longest and tallest terrestrial mountain chain outside of Asia. Their highest mountain is the extinct volcano Aconcagua, which at 6,961 metres above sea level is the highest mountain in all of the Americas. Several glaciers grace its slopes, as they do in the cryosphere throughout the rest of the Andes, including the North and South Patagonian ice fields that hold the greatest contiguous areas of ice in the southern hemisphere outside of Antarctica, but, like glaciers almost everywhere, many of those in the Andes are receding at an alarming rate.

A melting glacier is quite normal. It is part of the natural water cycle. Water evaporates from the ocean and forms clouds which are blown inland, and rain or snow falls on the mountains and forms glaciers. The glaciers melt and, along with the rest of the runoff from the mountains, the water eventually reaches the sea, and the whole things starts over again.

The problem now is that more snow and ice is thawing than is replaced, so many glaciers are gradually shrinking. It means that, as glacier meltwater is freshwater, we must add melting mountain glaciers to the melting Greenland and Antarctic ice sheets when thinking about rises in sea level. There is, however, one place in the world where the glaciers are less at risk.

Many of the giant glaciers in the Karakoram range are in surprisingly good shape. One reason for their survival is that they tend to be covered in very thin layers of debris, which appears to insulate them from melting. This is unlike the neighbouring Himalayan glaciers, which are coated in a layer of dark soot from industry in the south, and this is causing them to absorb more heat and melt more rapidly. Declassified spy satellite pictures have revealed that, during the past 40 years, these glaciers – unlike those of the neighbouring Karakoram – have lost about a quarter of their ice, and that the ice loss is accelerating. In recent years, Himalayan glaciers lost twice as much ice between 2000 and 2016 as they did between 1975 and 2000. Even up here, in these remote and inaccessible mountains, the impact of human activity is having a profound effect.

Wildlife aside, loss of glacial ice threatens the water supply to hundreds of millions of people right across southern Asia. Major rivers, such as the Indus and Yangtze, start as meltwater from glaciers, but the melt of the near future could be catastrophic, not necessarily because of too little water, but because of too much. While the normal drip of melting glaciers feeds first gurgling mountain streams and then mighty rivers, providing drinking water and water to irrigate crops, the rapid melt is more devastating. Outbursts from glacial lakes have already washed away villages in Nepal, where people have been killed due to the sudden impact of swirling floodwaters. Now there is evidence the glaciers are warming internally, and large volumes of ice are close to melting point. According to one report, if there are no substantial cuts to fossil-fuel emissions, the Himalayas could lose 66 per

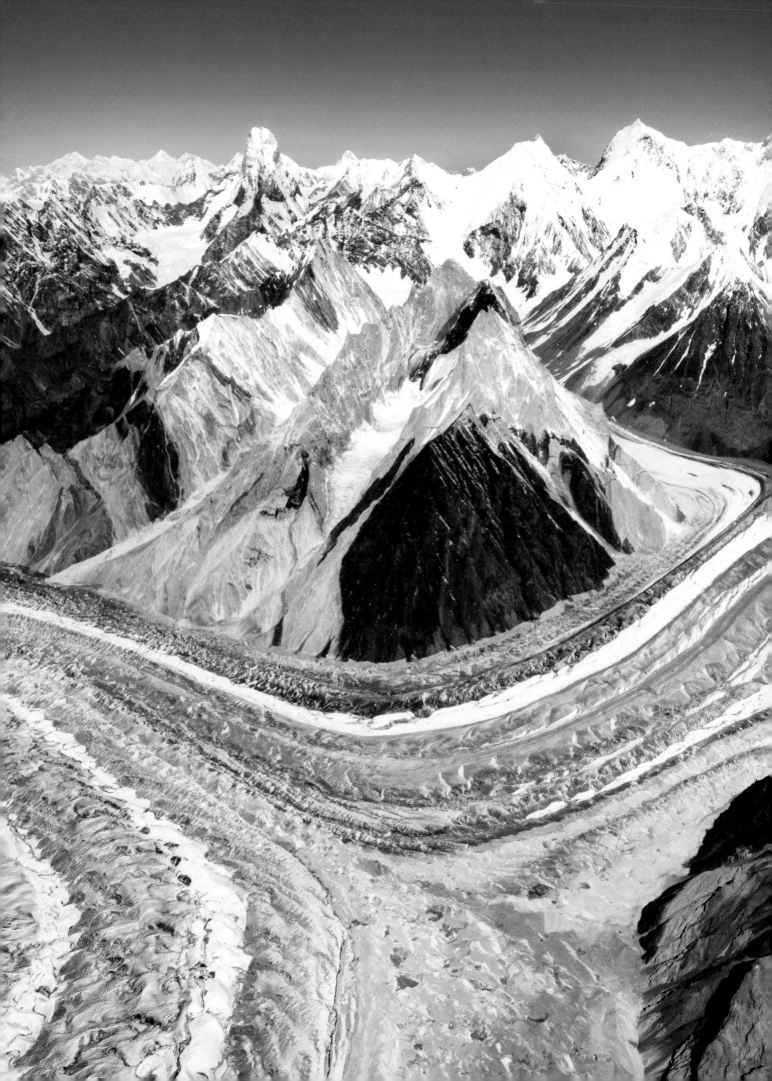

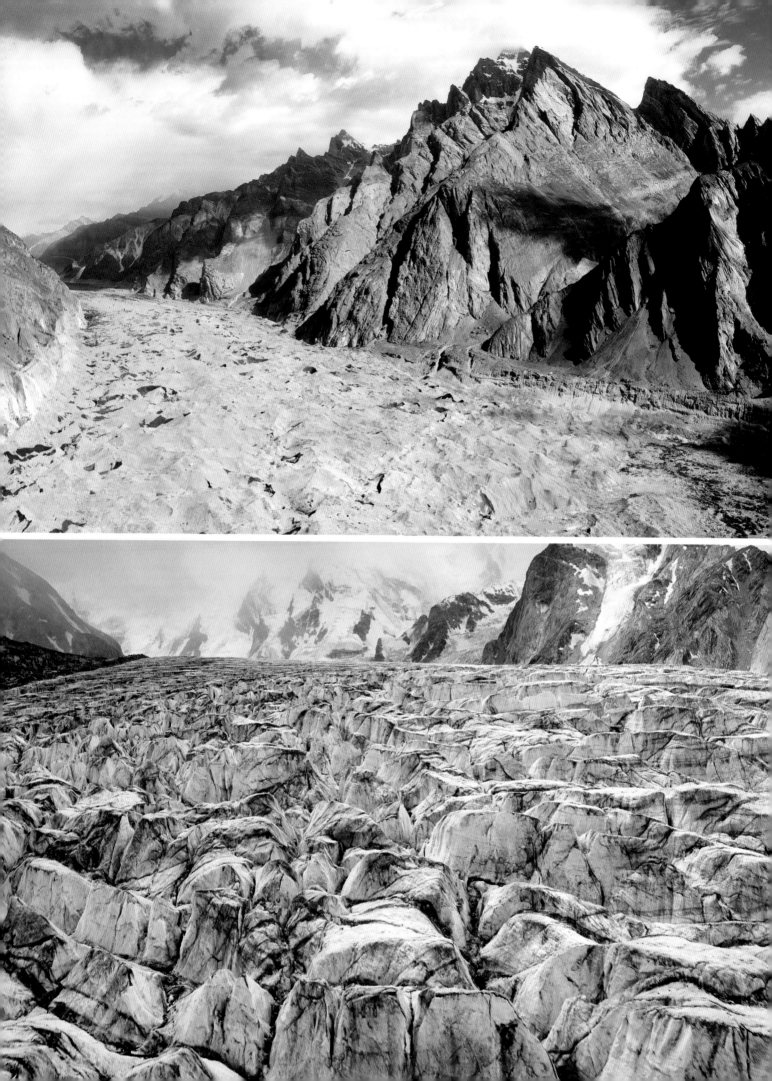

OPPOSITE TOP The Baltoro Glacier has a covering of dust that helps stop it melting in a warming climate.

OPPOSITE BOTTOM
A glacier in the Concordia area of the Karakoram is crisscrossed by crevasses.

ABOVE
An ice stupa for water storage in a village in Ladakh, in the Karakoram-Himalayas mountain region of Kashmir.

cent of its ice by 2100. Snow- and ice-covered mountain peaks will become bare rocks.

There are close to 200,000 glaciers in the world, covering about 10 per cent of the world's total land area, but many glaciers, like those in the Himalayas, are on the wane. In a low-to-no-snow future, some smaller glaciers, such as those on the summits of African mountains, could disappear altogether within as short a time as two decades, reports the United Nations. Africa contributes little more than 4 per cent of global greenhouse-gas emissions, yet Africans are going to pay the price. The loss of glacial regions on Mount Kilimanjaro, Mount Kenya and the Rwenzori Mountains bordering Uganda and the Democratic Republic of Congo could bring drought, food insecurity and displacement from their homes for 100 million people.

It is not all gloom, though. People living in the cold deserts of Ladakh and the Chilean Andes share the same problem. Their glaciers are melting so fast, they already have little water during the summer months. The solution: an artificial glacier. In winter, they spray water at night to build up tall heaps of ice, called 'ice stupas', named after Buddhist mound-shaped buildings. These artificial glaciers melt slowly in the summer, providing them with water for crops and drinking. Although it is on a small scale, it is, nevertheless, a simple but effective way to deal with potential water shortages.

A Very Special Bear

On the snowy, forested mountain slopes in south central China, where there is an understory of bamboo, lives a celebrity among animals. Ever since 1961, when the then World Wildlife Fund adopted this black-and-white bear as its logo, it has been the icon of conservation. It is, of course, the giant panda.

It was always thought that the panda was a highly specialised animal with particular dietary needs, i.e. primarily a herbivore, but now we know that there are grounds for it to be considered, at least in part, an omnivore, a bit like other bears. When the opportunity arises it will snaffle a bird's egg or catch insects and other small animals, such as rodents, and even forage

for farm produce and domestic pig food, but camera traps in a nature reserve in China's Shaanxi province have revealed that giant pandas eat carrion.

Even so, the panda mainly has a fondness for bamboo. Unlike other bears that forage widely, a giant panda will sit in a stand of bamboo and happily eat it for hours at a time. In fact, it depends on just two or three species of bamboo. Strong jaw muscles and large molar teeth are able to crush the tough bamboo shoots, and a special 'pseudo-thumb', formed from a modified wrist bone, holds them steady. Its digestive system, however, is still like that of a carnivore, rather than a herbivore, so a lot of food is passed out as undigested waste. To compensate, the giant panda must consume about 20 kilograms of bamboo a day in order to extract sufficient nutrients to stay healthy. It spends, therefore, ten to 16 hours a day foraging and eating, with the rest of its time assigned to resting or sleeping.

In spring, between April and June, when the bamboo starts to grow, pandas prefer bamboo shoots, rather than leaves or culm (stalk). They have higher concentrations of nutrients and lower fibre content, and, as the cell walls have not yet fully developed, the shoots are easier to digest. However, as the season progresses the lower parts of the shoot become more fibrous, but, by following the delayed growth of bamboo shoots with increasingly higher elevations, the panda migrates each spring from the lowest to the highest parts of its range to acquire the best food as it become seasonally available.

The panda's mainly bamboo diet also has other implications. Unlike, say, the grizzly bear, the panda cannot acquire sufficient fat stores to hibernate in winter, but, when the temperature is below 8°C, it does have the ability to raise its metabolic rate, so it keeps warm in its chilly montane forests, where the temperature regularly drops below zero. According to Chinese research on wild pandas, they also roll in fresh horse manure to help them tolerate cold ambient temperatures down to minus 5°C. Conversely, in summer, they become uncomfortable at the critical air temperature of 28°C but can lower their metabolic rate to compensate.

Since the early days of the conservation movement, the giant panda has symbolised vulnerable species, it being an animal that was brought back from the brink of extinction. Numbers are currently increasing slowly, but for how long? Until now, the main threat has been the spread of agriculture, resulting in the loss of the animal's wild habitat, but now there is this new danger: climate change and its impact on the giant panda's main food plant.

As the planet warms, bamboo could be left behind other plants. Its reproductive rate is so slow that, down the generations, it may not be able to adapt to the changing environment, and while giant pandas currently are doing fine, any changes in their mountain habitat that impacts bamboo could affect them too.

Chapter 4
FROZEN SOUTH

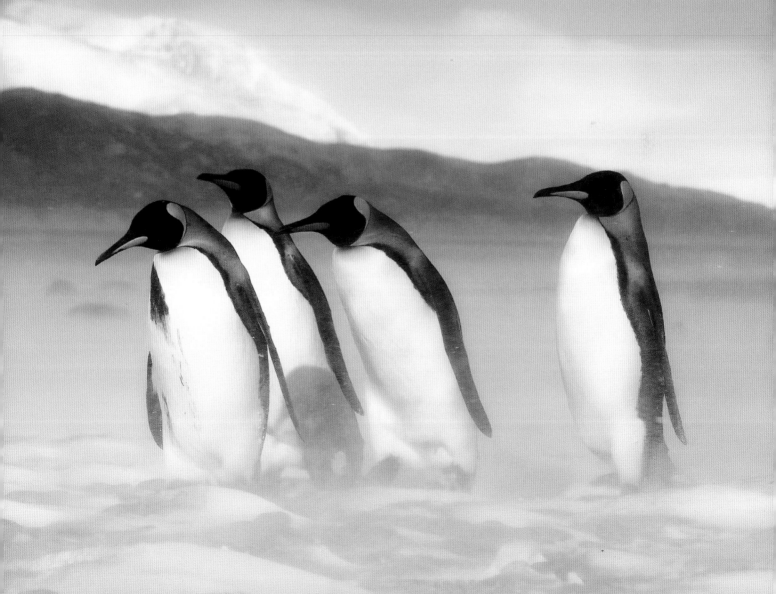

ABOVE During the southern spring, a group of emperor penguins takes a stroll on the ice in front of an iceberg in Atka Bay, Queen Maud Land, Antarctica.

IT MAY COME as no surprise to learn that Antarctica is the coldest place on our planet, but what might raise an eyebrow is to find out that it is also the windiest, driest, highest and most isolated continent on Earth. More than anything, though, as any polar scientist or wildlife film crew will tell you, the Antarctic can be unimaginably cold. On 21 July 1983, the world's lowest ever air temperature was recorded at Russia's Vostok Station, about 1,300 kilometres from the geographic South Pole. The mercury bottomed out at a staggering minus 89.28°C, which is pretty cold if you compare it with your freezer at home that is only set at minus 18°C; more recently, Earth-observing satellites have recorded even lower temperatures. They revealed that clear skies and dry air, during the long southern polar night on the polar plateau of East Antarctica, give rise to land-surface temperatures (that's how cold the surface would feel to the touch, rather than the air temperature) that plummet to minus 98°C, a temperature thought to be as cold as it is possible to get on the Earth's surface.

Continent of Snow and Ice

While the Arctic is a frozen ocean almost surrounded by land, Antarctica is land surrounded by a frozen sea. At its heart is the polar plateau, a vast area of ice and snow with an average elevation of 3,000 metres in East Antarctica. It encompasses the geographic South Pole, the southernmost point in the southern hemisphere, and is the site of the United States Amundsen–Scott South Pole Station. The summer here, though, can be a very different story from the winter, for the centre can be a balmy minus 12.3°C, as it was on Christmas Day 2011 at the height of the austral summer. That may sound cold, but it was the highest ever temperature recorded at the South Pole.

These exceptionally low temperatures occur because the centre of the continent is unexpectedly calm, with an average annual wind speed of just 12 mph – a 'gentle breeze' on the Beaufort scale, although there can be many blustery days with 58-mph 'storm force' winds. The weather at the coast, though, can be even more boisterous. At the bottom of slopes at the edge of the polar plateau, Antarctic research stations are regularly hammered by 60-mph katabatic or down-slope winds, and 100 mph is not unusual – that's 'hurricane force'. Cape Denison at the head of Commonwealth Bay in George V Land is considered the windiest place on Earth, where many days have ferocious and persistent winds that thunder down from the plateau.

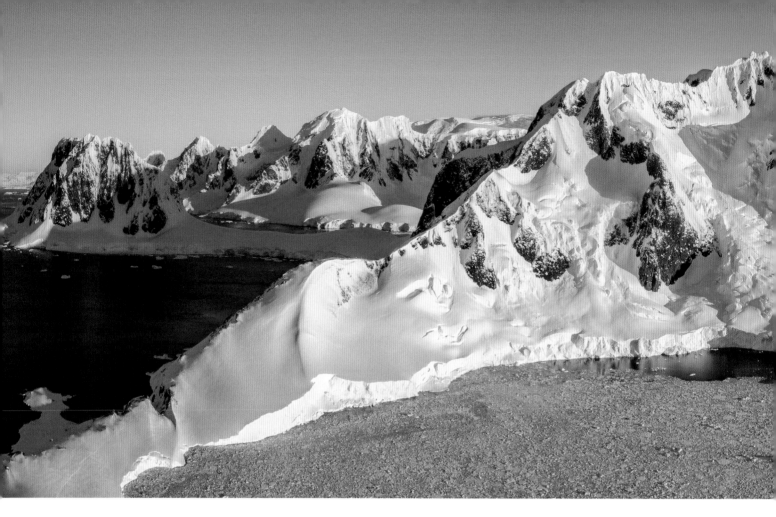

In July 1972, the highest wind speed of 203 mph was recorded nearby at France's Dumont d'Urville Station, on the Île des Pétrels in Adélie Land. It means raging blizzards can keep researchers holed up for days.

Another astonishing revelation is that Antarctica is technically a desert; in fact, the biggest desert in the world. Any place with less than 250 millimetres of rain or snow a year is considered a desert; you might think that with all that snow and ice the Antarctic couldn't possibly be a desert, but you'd be wrong. Annual precipitation is surprisingly low – less than 50 millimetres in the interior – but blizzards driven by the gale-force winds whisk the snow about, so it looks as if it snows more often than it really does.

Temperatures are generally below zero, so frost and snow crystals that accumulate on the surface fail to melt, even in high summer. As a result, layer upon layer has accumulated and compacted into glacial ice, a process that started here 35 million years ago, forming the Antarctic ice sheet, which is divided into West and East. It is 4.774 kilometres thick at its deepest point, holds 60 per cent of the world's freshwater, and covers an area the size of the USA and Mexico combined to form the largest single mass of ice on the planet. Its weight is so great that parts of the continent underneath have sunk, with some of the land below the West Antarctic Ice Sheet more than 2.5 kilometres below sea level. If it all melted not only would the continent slowly rebound, but also the global sea level would rise by close to 60 metres, so goodbye London, New York, Sydney and any other city by the sea, along with all low-lying countries and islands.

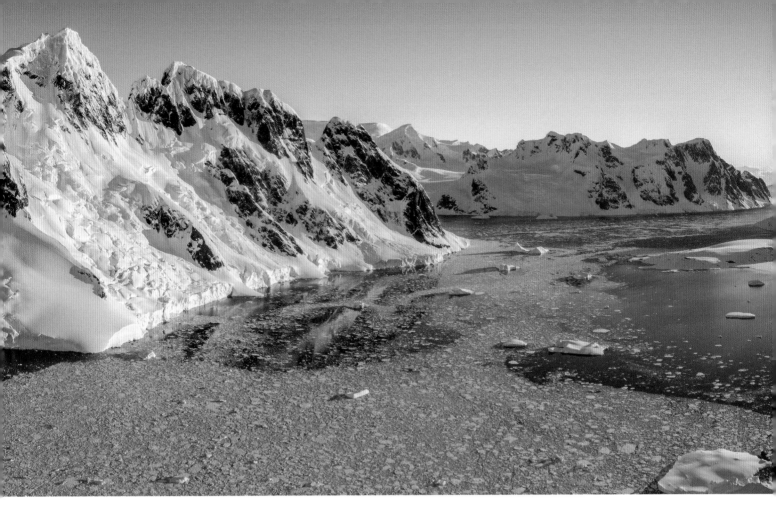

The two main ice sheets are divided by the 3,400-kilometre-long Transantarctic Mountains, which stretch across the entire continent. Many peaks are 4,000 metres or more, the highest being Mount Vinson in the Ellsworth Range, which at 4,892 metres is a little higher than Mont Blanc in the European Alps. Along with the polar plateau, the rest of the continent looks white and flat, with dark mountaintops, known as nunataks, protruding from the ice, but, because the average altitude of the entire surface of Antarctica – rocks and ice – is about 2,000 metres above sea level, Antarctica is recognised as the Earth's highest continent.

One of the more obvious features in Antarctica is the Antarctic Peninsula, usually top left in map projections, in what sailing folk would know as the northwest quadrant, i.e. longitude 0–90° West. Like an extension of South America to its north, the peninsula pushes out into the Southern Ocean, where, uninterrupted by land, the winds blow clockwise around the Antarctic mainland. This quadrant is one of the stormiest parts of the world, especially the notorious Drake Passage, where violent weather systems are squeezed between the northern tip of the Antarctic Peninsula and the southern tip of South America. On average a gale a week occurs south of latitude 50° South, and there are 5-metre-high ocean waves for half the year, which, in an instant, can transform into a wild and foaming cauldron with 20-metre-high waves blown up by 90-mph winds. To visiting film crews, the storms are the most brutal they are likely to experience anywhere in the world, and seasickness inevitably is the most common malady.

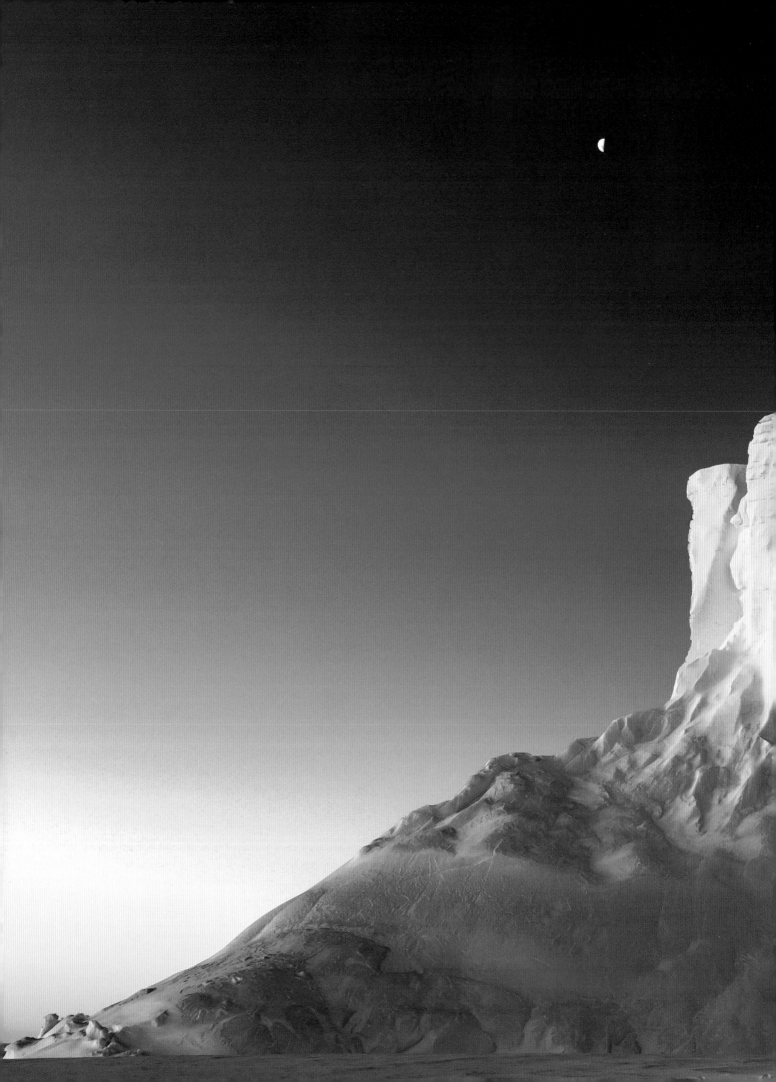

OUT IN THE COLD
SOUTH POLE

The South Pole is a surprising 2,835 metres above sea level, a touch taller than Mount St Helens in Washington state so, when visiting the area, producer Orla Doherty found that it was like climbing a mountain.

'We flew with the US National Science Foundation from McMurdo Station at sea level on the Antarctic coast all the way to the South Pole. We wanted to film the polar plateau to show this great white desert that covers so much of the continent, but first, I had to get over the altitude sickness and the cold.

'We landed at about 1am and, after our briefing, were shown to our rooms at the incredible Amundsen–Scott South Pole Station – the closest I will ever come to living in a spaceship. Sleep, though, was impossible. This is how the altitude hit me – a headache and an inability to sleep. Striding out onto the plateau the next morning, we filmed with drones to capture the endlessness of the ice sheet. I had an urge to keep walking out across the ice, but the altitude made me breathless. Instead, we all watched as a sundog – a patch of sunlight to the left and right of the sun – formed over the station.'

ABOVE The Amundsen–
Scott South Pole Station is
a United States scientific
research station on a high
plateau at the South Pole.

RIGHT Director Orla
Doherty stands beside the
pole marking 90 degrees
South, the geographic
South Pole. It has a specially
designed marker at the top
that is replaced at the start
of each year. Orla was on the
most southerly shoot of the
entire series.

A Pageant of Kings

OPPOSITE TOP Having been at sea for several weeks, a parent king penguin searches for its chick in a tightly packed crowd. It will be recognised by its call.

OPPOSITE BOTTOM A meal of semi-digested fish, squid and krill is regurgitated to the chick, before the parent returns to the ocean to hunt for more.

OVERLEAF While their parents are at sea, the brown-coated youngsters gather together in enormous numbers for protection from predators and the weather.

Facing the wrath of the unrestrained winds of the Southern Ocean is a group of remote and inhospitable islands – South Georgia and the South Sandwich Islands. They lie some distance – two days in a cruise ship or a five-day sailing-yacht journey – to the northeast of the Antarctic Peninsula, where they qualify as sub-Antarctic islands. The climate is slightly milder than further south, although the weather is highly variable – howling gales and blizzards one minute and a splash of sunshine the next; in fact, you can experience the four seasons in one afternoon.

The islands are not far from the Antarctic Convergence, a narrow zone about 50 kilometres wide where icy-cold northerly-flowing Antarctic waters of the Southern Ocean meet the warmer South Atlantic, producing upwellings and mixing in the water column that create one of the most productive areas in the ocean. It means many sub-Antarctic islands are magnets for wildlife, and none more so than South Georgia, temporary home to an estimated 30 million breeding seabirds.

In late winter, with snow still on the ground, close to 450,000 young king penguins – the world's second tallest species after the Antarctic's emperor – gather in huge groups or crèches as they wait for their parents to return from the sea. Each has a thick overcoat of brown down, and looks so unlike the sleek black-and-white adult that early explorers thought it was an entirely different species.

Kings have an odd breeding cycle too. From hatching to fledging, it spans ten to 13 months on average, and maybe even more, so chicks in the colony can be at different stages of development, some having recently hatched while others are well on their way to being fully grown. Tending to their every need are their long-suffering parents, on whom the youngsters depend entirely for food.

Most chicks will have hatched between January and April and are guarded closely for a month. Both parents go to sea and, on their return, they regurgitate a soup of semi-digested seafood to their single offspring. The chick takes in the calories and lays down fat to help keep it warm during the coming winter. By the time it's about four months old, it'll be bigger and heavier than either of its parents, so when winter sets in, parents can leave their chick temporarily to fend for itself. Many chicks tend to cluster together in a crèche, which gives a modicum of protection from the wind and any inquisitive predators.

The parents then spend much of the austral winter at sea. They dive down to depths of 240 metres catching fish and squid, especially lanternfish: small, bioluminescent schooling fish that live during the day in the ocean's twilight zone, but which swim up closer to the surface at night, a behaviour known as diel vertical migration. They are part of the greatest migration of Earth and are so plentiful that they are thought to be one of the world's

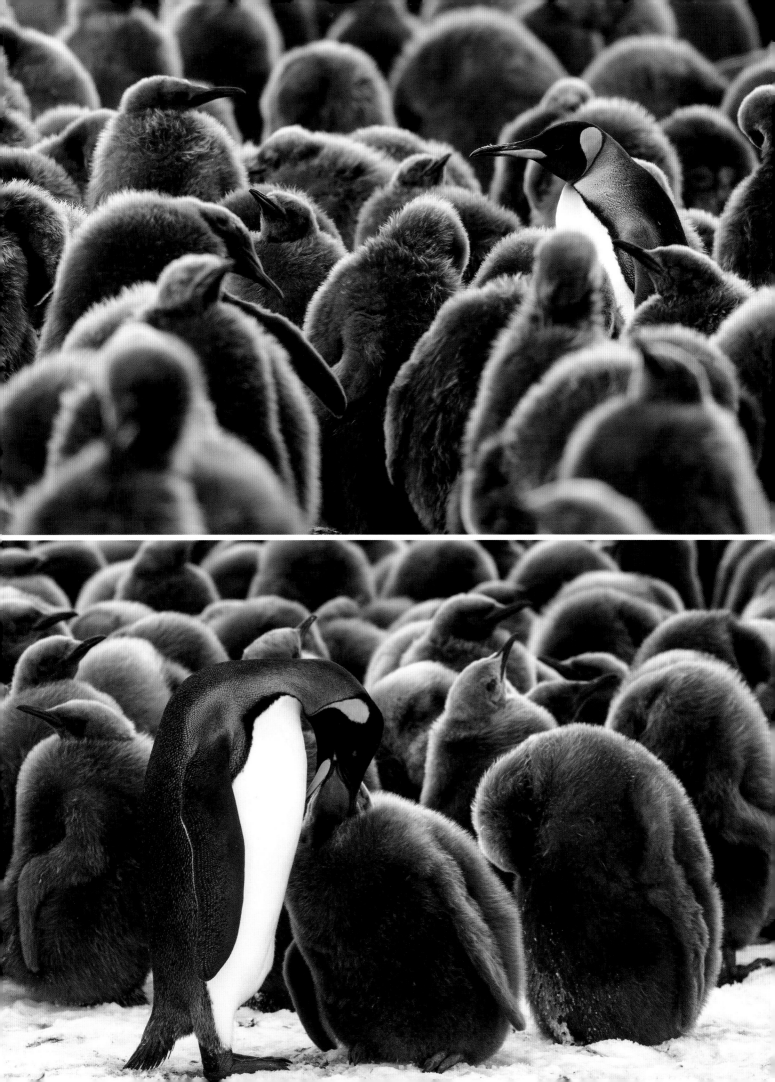

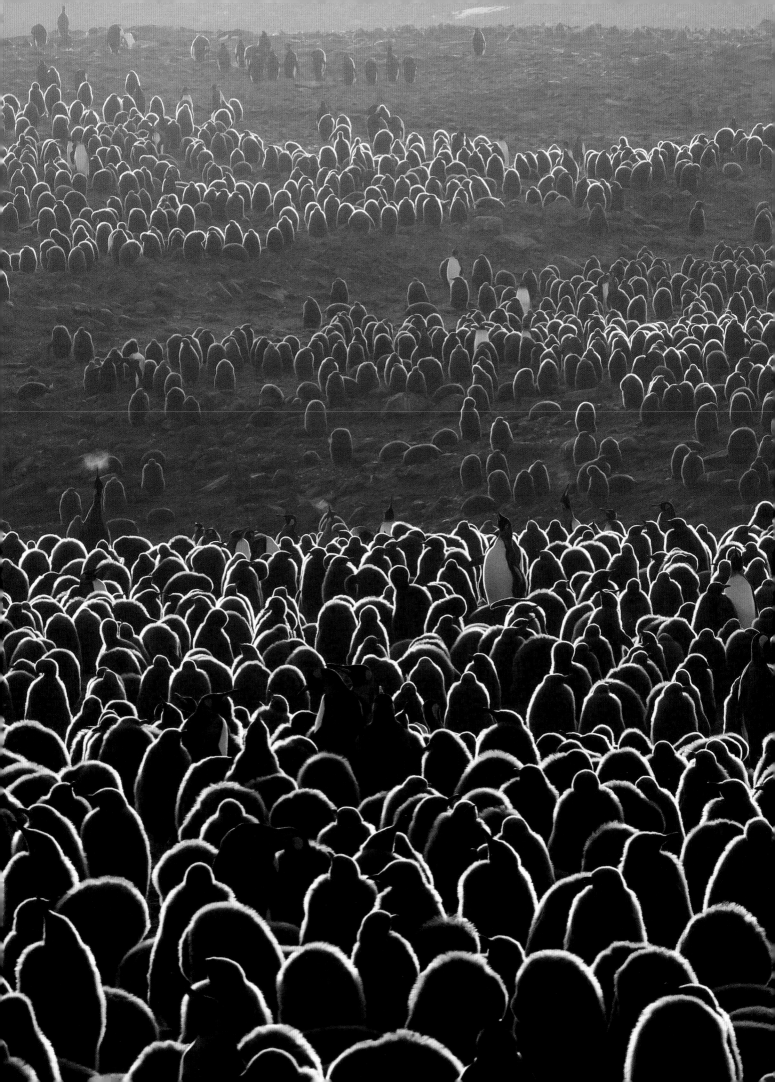

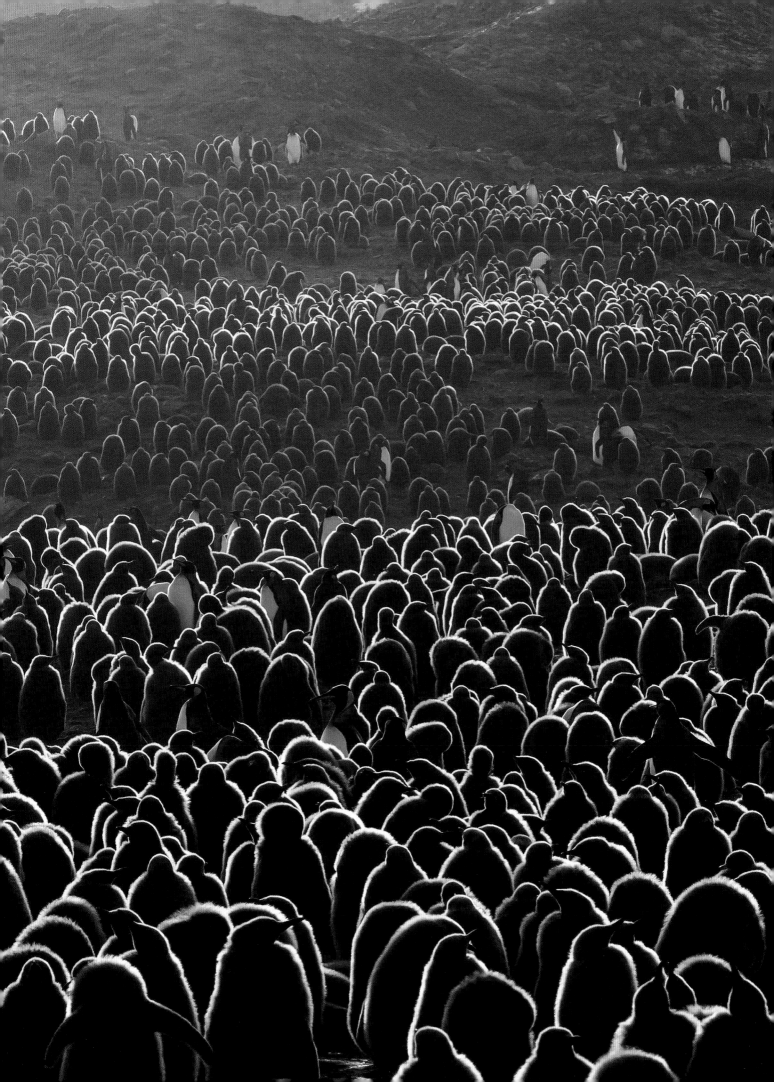

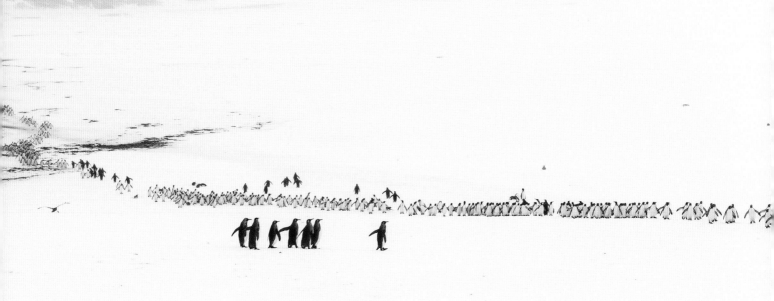

most populous vertebrates (second only to mesopelagic bristlemouths), which is of some benefit to king penguin chicks in winter.

Chicks are fed erratically during the dark winter months, as the parents only collect food in daylight. Less food is caught each day, so journeys can be all the more extended. At this time, the young birds receive sufficient food to keep them ticking over, with chicks that hatch early in the season faring better than late arrivals. They are better prepared for the winter. Without sufficient body mass, the latecomers can starve or freeze to death. The rest inevitably lose weight, only to put it on again when the adults get back and the chicks undergo a second phase of growth.

With spring in the air – or what passes for spring on this cold and desolate windswept island – the parents increase their rate of to-ing and fro-ing. When they reach the colony, though, they must first find their chick, and, as they all look so similar, it's thought their offspring is recognised by its distinctive call, so parent and chick eventually reunite. The chick is fed, and then it's back out to sea again, with hundreds of birds on the move at the same time.

In one remote bay, the parade of parents is an extraordinary sight. For as far as the eye can see, a thin winding trail of penguins, their dark bodies

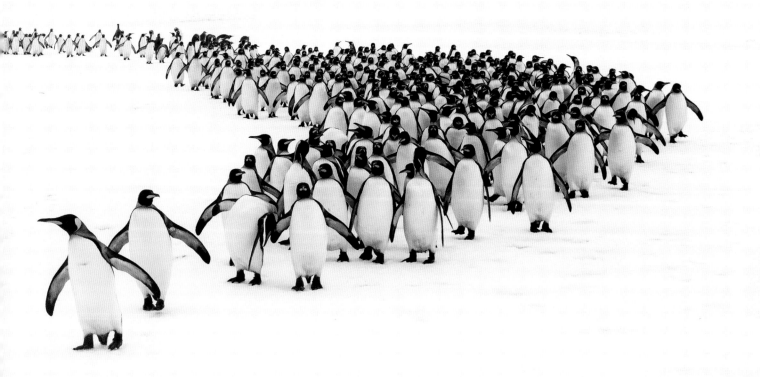

stark against the white snow, stretches for 1.4 kilometres from the breeding site at Right Whale Bay on the north coast to a nearby beach that has been nicknamed 'the Cove'. Most waddle along in a slow but purposeful way typical of the larger penguins, while a few toboggan across the snow on their bellies. Some trek side-by-side, but many walk one behind the other. It's thought they are following a 'tested' path, and by tagging along behind the bird in front they reduce trip hazards. It also ensures, of course, that they keep one another in sight. A steep and snowy pass between two mountains slows the procession, some birds using their bills as ice picks to help them climb. Progress is slow, the arduous trek taking the best part of three hours to complete.

At the beach, though, there's a bottleneck. Penguins at the water's edge hesitate, while hundreds of others are slowly piling up behind. Something's wrong. None wants to enter the sea. Just beyond the surf line the reason is plain to see: the reptile-like heads of several leopard seals, and they're here because the penguins are here.

At up to 3.8 metres long and weighing 500 kilograms, leopard seals are hefty predators. They usually hunt alone, but the promise of a steady stream of kings attracts several opportunists into the bay. Up to eight might hide

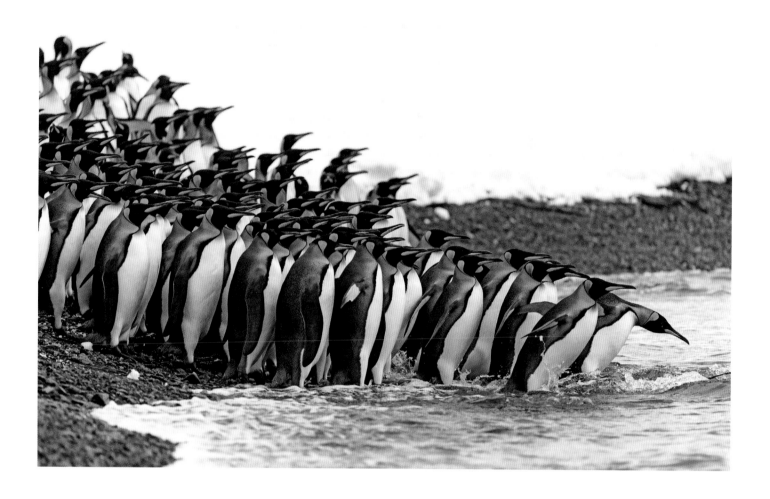

ABOVE **When one brave soul starts to move, the others follow. By heading out en masse, some have a chance of running the gauntlet without being seized by leopard seals.**

in the kelp beds, ready to intercept the birds, and, on one occasion in the recent past, at a time when many young birds were fledging, 36 leopard seals were spotted offshore. Even one leopard seal would spook the birds, but a handful of them must be the ultimate nightmare for a king penguin. The birds have walked straight into a trap, but what can a parent do? The parents must go to sea, or their chicks will starve. There's nothing else for it: they must run the gauntlet of these wily predators. Giant petrels and gulls gather around, waiting for the inevitable feast. Leopard seals, like foxes, sometimes kill for the sake of killing. There could be plenty to go around.

First one brave bird makes a move and then others follow. They stop momentarily, almost as if nothing untoward is happening, wash their feathers ready for the journey ahead, and then they go for it. As the birds pile into the shallows, the water churns: there's safety in numbers. King penguins are large animals and agile swimmers, able to make tighter turns than the seals, so they're difficult to catch; at least, that is true in the open ocean, but, in the confines of the bay, the largest and most experienced seals are sure of a prize. A leopard seal can accelerate to 25 mph and is the most streamlined and nimble of the true seals, while the king penguin can only manage 6 mph. One seal makes a lunge, and, as one, the penguins retreat, but another seal surges onto the beach and grabs a victim. It's unmitigated chaos, but with a conveyor belt of penguins in the water at the

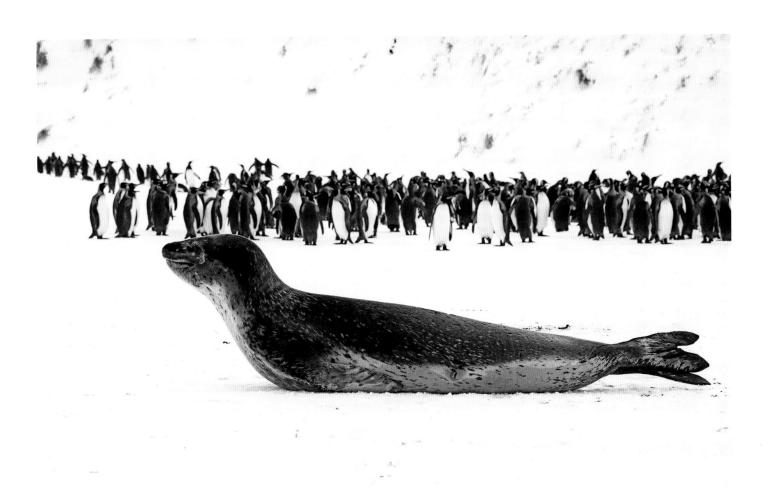

ABOVE The leopard seal, with a head more like a reptile than a mammal, is able to catch penguins on land as well as in the sea.

same time, the predators are swamped, so while a few penguins make the ultimate sacrifice, the rest can make it through unscathed.

In the relative safety of the open ocean, where they have room to manoeuvre, they embark on a 300-kilometre hunting excursion, no mean feat in itself, and then return once more to feed their chicks. During spring and summer, they make the same extraordinary journey over land and sea every six or seven days, and each time they leave or arrive in the bay, leopard seals are hiding in the kelp beds ready to ambush the less cautious or the unlucky.

Out at sea, small hunting parties of king penguins seem to 'fly' through the water, porpoising in order not only to breathe, but also to reduce drag and swim more efficiently. The Right Whale Bay contingent, though, are a mere drop in the ocean. Millions of other parents are out fishing too, and they are concentrated in this part of the world because the Southern Ocean is so rich in food, especially in key areas of high productivity, such as by the ice edge and downstream of islands. Curiously, though, not everywhere in the Southern Ocean is very productive. The reason is that there is a lack of micronutrients, such as trace elements like iron, and, without iron, phytoplankton cannot grow.

Single-Sex Partners

Among those millions of seabirds breeding on sub-Antarctic Islands and feeding in the Southern Ocean is the wandering albatross. It is a giant. It can stand over a metre tall and has the longest wingspan of any living bird – up to 3.5 metres – and it really does wander. Tagged birds have been known to circumnavigate the globe in their relentless search for food, yet they expend little energy on these epic flights. They use a technique called 'dynamic soaring', in which the bird extracts propulsive energy from horizontal winds over the ocean. In a sequence of half-turns connecting upwind climbs with downwind glides of about 100 metres, the albatross is, in effect, a flying sailboat and is most efficient when it remains in a crosswind. It is not simply being blown along, though. It can fly faster than the wind, up to 67 mph,

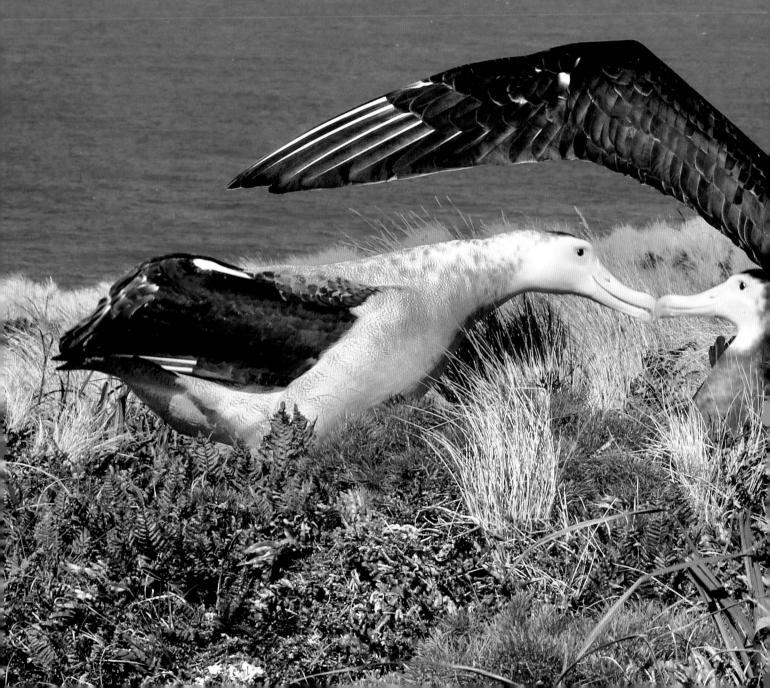

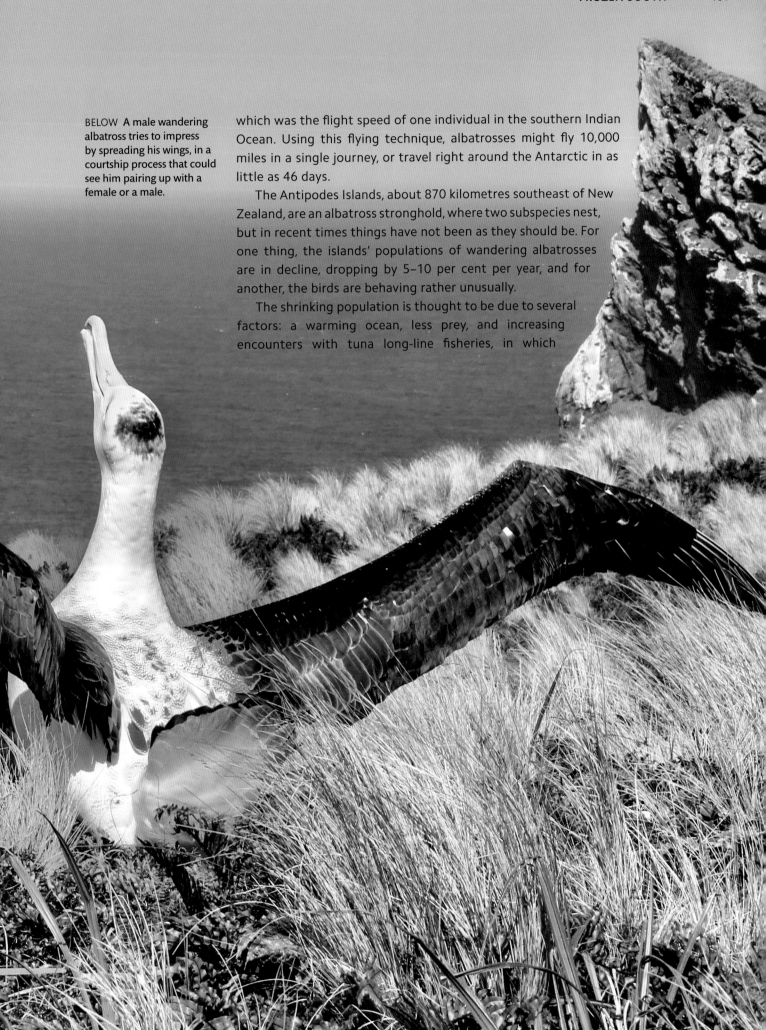

BELOW A male wandering albatross tries to impress by spreading his wings, in a courtship process that could see him pairing up with a female or a male.

which was the flight speed of one individual in the southern Indian Ocean. Using this flying technique, albatrosses might fly 10,000 miles in a single journey, or travel right around the Antarctic in as little as 46 days.

The Antipodes Islands, about 870 kilometres southeast of New Zealand, are an albatross stronghold, where two subspecies nest, but in recent times things have not been as they should be. For one thing, the islands' populations of wandering albatrosses are in decline, dropping by 5–10 per cent per year, and for another, the birds are behaving rather unusually.

The shrinking population is thought to be due to several factors: a warming ocean, less prey, and increasing encounters with tuna long-line fisheries, in which

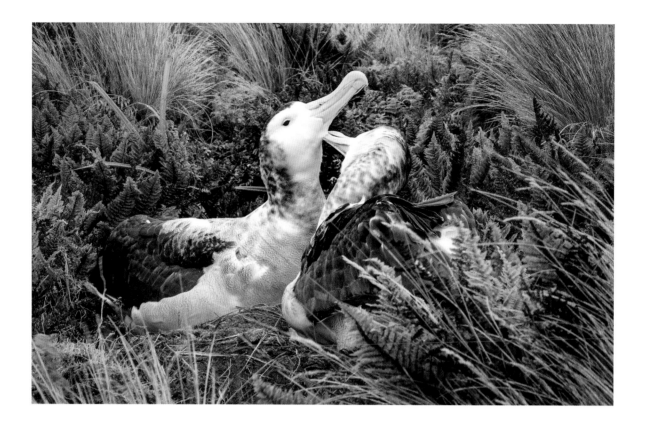

ABOVE These are the
Antipodes Island sub-
species of wandering
albatross, slightly smaller
than their more common
cousins. Once a pair
develops a rapport, they
could be together for
life, always meeting at
roughly the same spot
on the same island each
year at breeding time.
Allopreening is usually
performed by birds that
have paired.

many birds are accidentally hooked and killed. The fishing lines deployed by these boats can be more than 100 kilometres long, with several thousand baited hooks on each line. The birds try for the bait, get hooked, and drown. Satellite studies have shown that the problem in the Indian, Atlantic and Pacific oceans is that only 15 per cent of fishing boats adopt the internationally agreed method of 'night-setting', during which the lines are set at night when the birds are less likely to be feeding. They could also attach heavy weights to take the hooks rapidly down and streamers to discourage the birds from diving on the baits. The result, published in a scientific paper in 2011, is that globally at least 160,000 and maybe as many as 350,000 seabirds – mainly albatrosses, petrels and shearwaters – are killed annually. An albatross is killed every five minutes, says the RSPB and BirdLife International, with the wandering albatross having lost half of its global population since the 1960s. In some locations this has led to an imbalance in the sex ratio at breeding sites because, when foraging at sea, female birds tend to travel further than males, so it is thought they are more likely to interact with long-line fisheries. In the Antipodes Islands, a young male bird experiences first-hand the problems that come with this one-sidedness.

After many years at sea, he returns to the islands and finds a pitch, where he has his first stab at attracting a mate. Albatrosses tend to be partners for life, so it is important for females, especially, to get the selection right. This is achieved by an elaborate courtship display. When a female flies in and shows some initial interest, the male first points his bill skywards, and when she approaches closer they double-head bob, followed by the wings

stretched open to their maximum. Males with the greatest wing span tend to win the day but, on this occasion, the commotion attracts in a whole bunch of other males. The female has none of it and flies off, as do the other males, leaving the young suitor all alone. Then, another bird flies in. The display starts again, but this time, it is another male. It seems males without female partners prefer a single-sex relationship and companionship to the alternative – loneliness. With fewer females arriving at breeding sites and so fewer typical mating opportunities, a small proportion of males are changing their behaviour. Scientists are seeing males teaming up with males, something they had not seen before.

BELOW The sky-point is often accompanied by a low gurgling sound, while the sky-call lets rip with a loud scream.

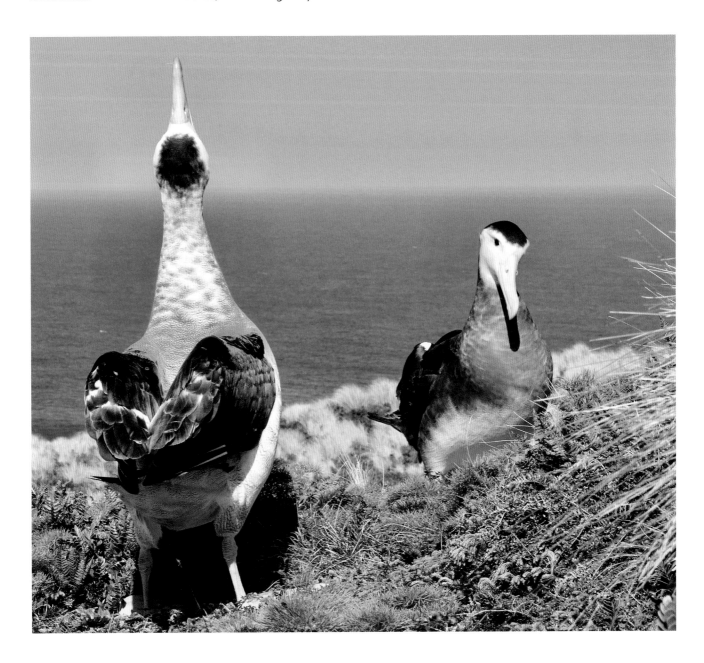

Ubiquitous Krill

Push further south and the main hazard is not stomach-churning storms, but ice. Huge icebergs, some the size of entire countries, break away from glaciers and ice shelves and drift about in the Southern Ocean, but, like the Arctic Ocean, the main ice cover is sea ice – moving pack ice out to sea and locked-in-fast ice attached to the land. During the austral winter, sea ice around the Antarctic continent extends to about 18.7 million square kilometres – about twice the size of Europe. It doubles the size of Antarctica, and hidden away on the underside of the ice are tiny marine creatures that are probably the most important in the entire ecoregion.

Underpinning the food web in many (but not all) parts of the Southern Ocean is the shrimp-like Antarctic krill, a small translucent crustacean with black eyes, which is bioluminescent in the dark. Krill have an unusual life cycle that starts with the mother krill dropping her eggs in the water column. They sink rapidly into the depths as far as 1,000 metres below the surface, where the youngsters hatch out. It's relatively safe down there in the dark, but they must return to the surface to feed on phytoplankton in sunlit waters. The vertical journey can take the baby krill up to three weeks to complete, its success dependent on whether the mother deposited sufficient lipids in her eggs so her babies can travel without having to feed. At this time, surface waters are still open, and so they gobble up algae and small particles of detritus and develop rapidly. In the autumn, the sea ice forms and expands so the areas frequented by krill are covered, and the habitat becomes an icy krill nursery. The youngsters scrape algae from the underside of the ice, the ice cover giving some protection from predators, so sea ice in winter is vital for krill. Without it, krill would decline in some areas and food webs collapse.

Krill are food for a large number of Antarctic animals. The developing larvae fall prey to other crustaceans and jellyfish, while the adults are consumed by mid-water fish, squid, the smaller penguins, crabeater and leopard seals, fur seals, baleen whales and even seabirds, such as black-browed albatross, prions and Antarctic petrels.

Most of these animals can catch krill when they are in surface waters, in the top 100 metres of the ocean, although krill do follow a diel vertical migration, closer to the surface at night and lower down in the day. There is also evidence to suggest that when their food is in short supply at the surface they will forage close to the seabed at depths down to 2,000 metres, where detritus and copepods are their main source. It seems vertical migration between the surface and deep sea is an integral part of krill ecology, and because of its habit of gathering in dense swarms containing astronomical numbers of individuals, it is like a magnet for the ocean's giants.

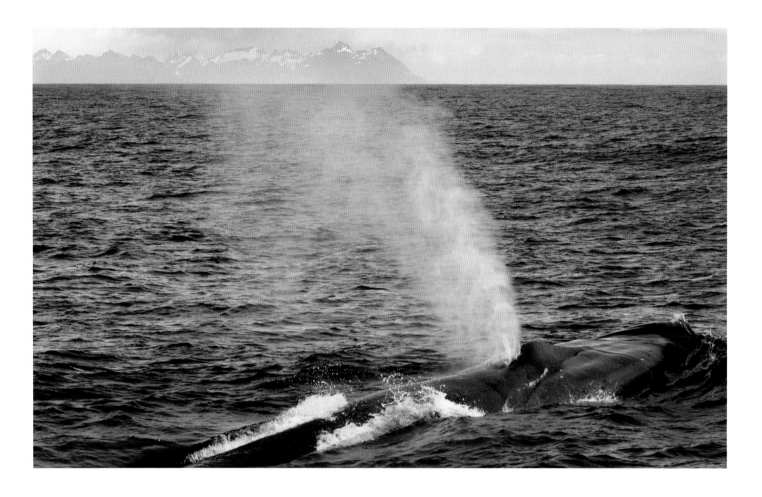

The Biggest Ever

ABOVE The blow of the blue whale is a cone-shape spray that can be up to 12 metres tall and visible from some distance away. The height and shape of the blow depends on the strength of the wind and the behaviour of the whale: the more active the whale, the greater the blow.

The Antarctic subspecies of blue whale is not only the world's largest living animal, but also the largest animal that has ever lived, surpassing the largest dinosaur or ancient marine reptile. In the past, the longest accurately measured were a little over 30 metres, but today 26 metres is a respectable maximum length, the Antarctic whales being the longest and heaviest of the three living subspecies – a good 2 metres longer than the others. The heart alone is as big as a small car, and it beats four to five times a minute, pumping 10 tonnes of blood through arteries so wide that a small child could crawl through them. They grow this big, it is thought, so that they can take advantage of the seasonal blooms of krill and then store sufficient blubber reserves to fuel prolonged periods of not feeding during the breeding part of their annual cycle. In places, the layer of blubber beneath the whale's skin can be more than 50 centimetres thick.

A blue whale that's not in a hurry cruises at about 4 mph, but it can steam along at 18 mph for several hours if necessary, and is capable of bursts of 20 mph, especially when being pursued by killer whales. A brief burst of

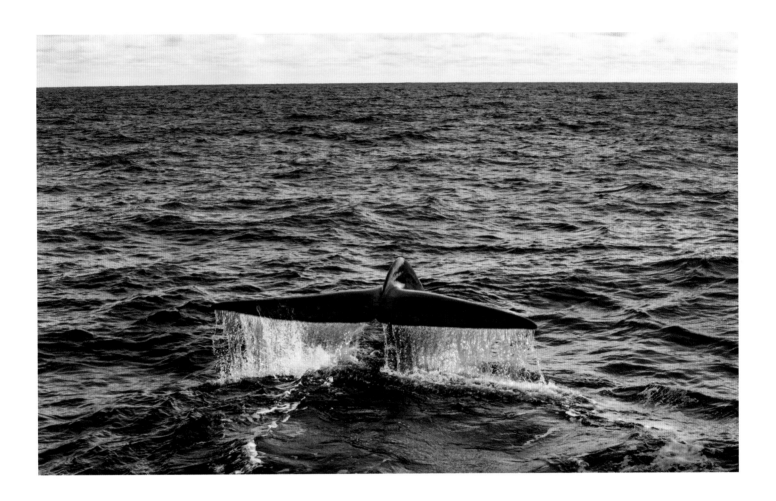

ABOVE A blue whale raises its tail flukes, as it dives below to hunt for swarms of krill. The flukes are relatively slender for an animal its size, and are more than 7 metres across on a mature whale.

speed – about 6 mph – is required while feeding. The whale glides down towards a dense swarm of krill, lunges forward, and opens its mouth, so its lower jaw is almost at a right angle to its upper jaw, which brings it almost to a halt. Its throat distends, fills with a thick broth of water and crustaceans, and then it uses its throat and tongue muscles to force out the water through the comb-like baleen plates that filter out the food. With such a large maw, it can ingest enough food in a single lunge to provide it with around 480,000 calories, which is about 90 times as much energy as it uses in the dive. Each dive lasts between 3 and 15 minutes, during which time the whales may lunge up to six times. If prey density is low, a whale won't bother to dive. It waits and conserves oxygen and energy. If there is plenty (krill swarms can be up to 2 kilometres long), a large whale can gulp down about 16 tonnes of krill in a day, the equivalent weight of a city bus, and it must keep this up for the four vital months of summer to gain enough blubber to tide it over in the face of less dependable feeding opportunities in tropical and temperate seas in winter. Its faeces help helps to fertilise the ocean, maybe even supplementing the iron important in plankton development.

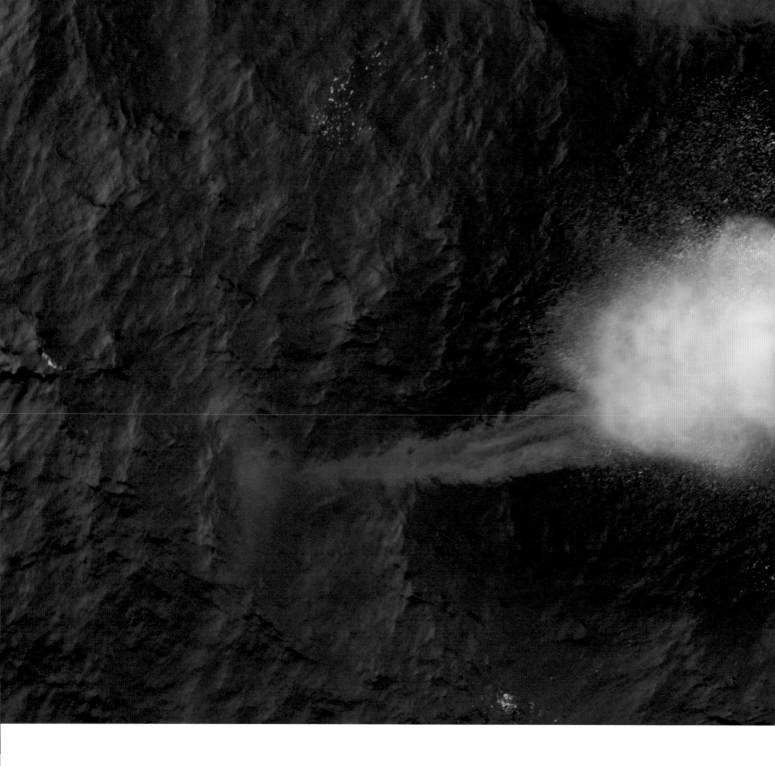

ABOVE The blue whale's broad, flat head appears U-shaped from above. The blowholes and the pronounced, raised splashguard in front of them are on top of the head.

During winter, it is thought that most whales migrate to warmer parts to breed, although the breeding grounds of this subspecies are unknown for now. However, there appear to be three distinct subpopulations, with whales making for breeding sites in the ocean basins of the South Atlantic, South Pacific and southern Indian Ocean. If observations of mother and calves in the offshore waters of Brazil are anything to go by, breeding and nursing sites are likely to be in deep water. In spring, they return south, heading for feeding sites close to the summer pack ice over the continental shelf where krill is most abundant. Not all migrate. Some remain in Antarctic waters all year round, and some stay north in summer. Antarctic blue whale calls, for example, have been recorded off Samoa in summer.

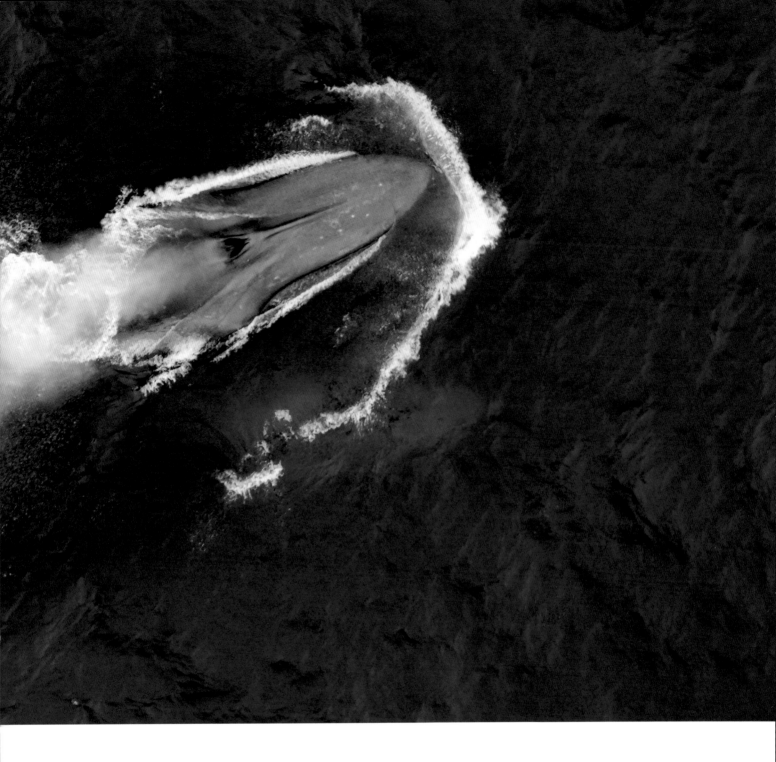

That the whales are here at all is surprising. During the early 1900s, with the introduction of modern commercial whaling methods, they were hunted almost to extinction; in fact, by 1973, when the illegal Soviet whale hunt came to an end, there were thought to be just 360 individuals. Today, the population has bounced back, with the most recent survey taken during the 2003–2004 austral summer, when it was estimated that there were 2,280. If the population has been increasing at the same rate of 7.3 per cent per year, it could be that there are over 9,000 now. These whales, without doubt, have come back from the brink.

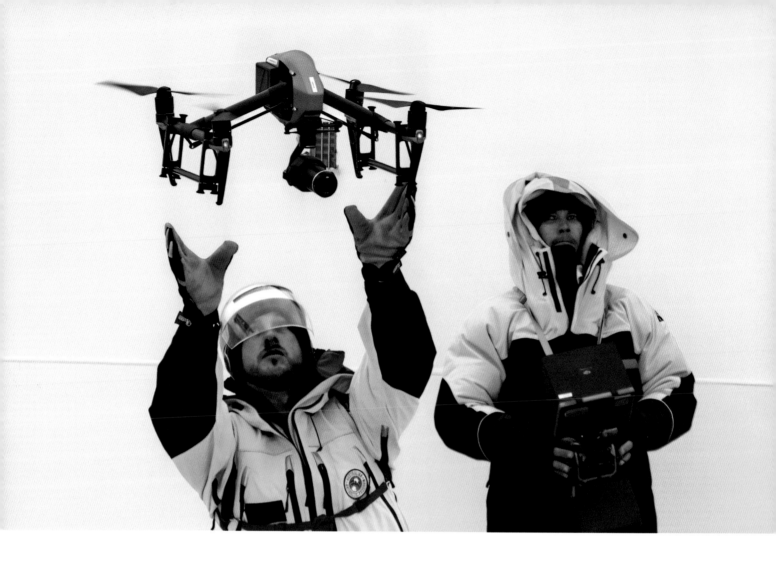

OUT IN THE COLD
SOUTHERN OCEAN

As you can imagine, filming blue whales on the storm-tossed Southern Ocean is never going to be straightforward. On drone duty was wildlife camaraman Alex Vail, and the first challenge was to find a whale.

'We were aboard the MV *Investigator* with an international team of acousticians who use military technology known as sonobuoys to find whales. They can detect their calls from hundreds of kilometres away. We were mostly filming from drones off the deck of the ship and its many instruments wreaked havoc with the drone's directional systems. Also, the wind was usually strong, and it was bitterly cold. I had to wear thin gloves in order to operate the drone, and the pain in my fingers from the cold was sometimes quite intense. Coupling this with 3-metre-plus swells and an animal you're never quite sure where it's going to pop up meant we certainly had a challenge on our hands. Nevertheless, we had some magical encounters. One I remember particularly vividly is when the ship stopped, and a blue approached us at very close range while I was filming. I saw the ship come into frame as the blue slid past and gave an almighty blow. There's something pretty special about being showered with snot from the largest animal that has ever lived!'

ABOVE James Cox and Alex Vail launch their drone in the very windy, drone-unfriendly conditions that are common in the Southern Ocean.

OPPOSITE TOP A drone's-eye view of a blue whale. A large Antarctic blue whale can be the length of three double-decker buses.

OPPOSITE BOTTOM The team's base for the blue whale shoot was the MV *Investigator*, an Australian marine research vessel operated by the Commonwealth Scientific and Industrial Research Organisation (CSIRO). It has been engineered to operate very quietly in order to boost its research capabilities.

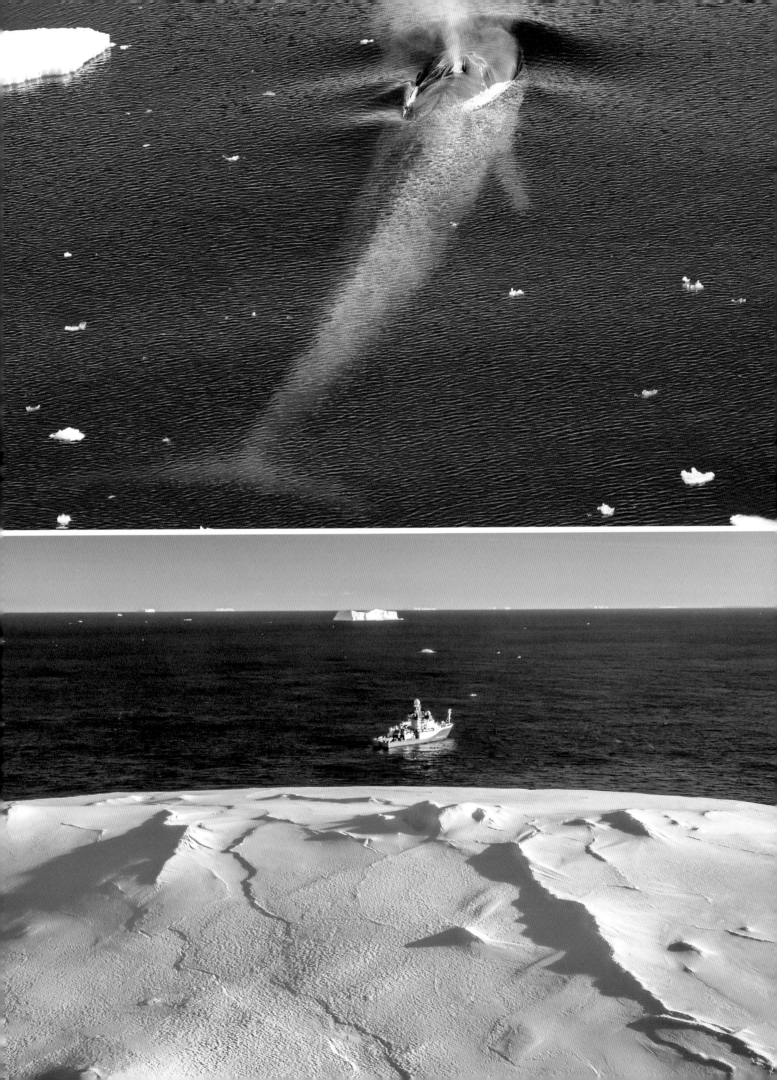

Home Is Just a Hole

Closer to the Antarctic mainland, fast ice forms a barrier that most whales cannot break through, but there is one marine mammal that can: the Weddell seal. It makes breathing holes in the ice and keeps them open using its teeth. The upper canine teeth and incisors project forwards for reaming the ice. It enables this species of ice seal to breed further south than any other mammal. The fast ice is a haven, as predators, such as killer whales, cannot reach here without the risk of being trapped, so they don't try.

Female seals give birth on the ice between September and November, and their newborn pups might face temperatures of around minus 20°C. Putting on blubber will effectively protect them against the weather, but a greater challenge will be getting into the water, where the youngster has to learn not only to swim, but also to navigate through the labyrinth of constantly changing caverns of ice below the surface in order to forage in this topsy-turvy world independently of its mother.

BELOW A Weddell seal pup remains with its mother for six to seven weeks in order to learn how to swim and navigate under the ice.

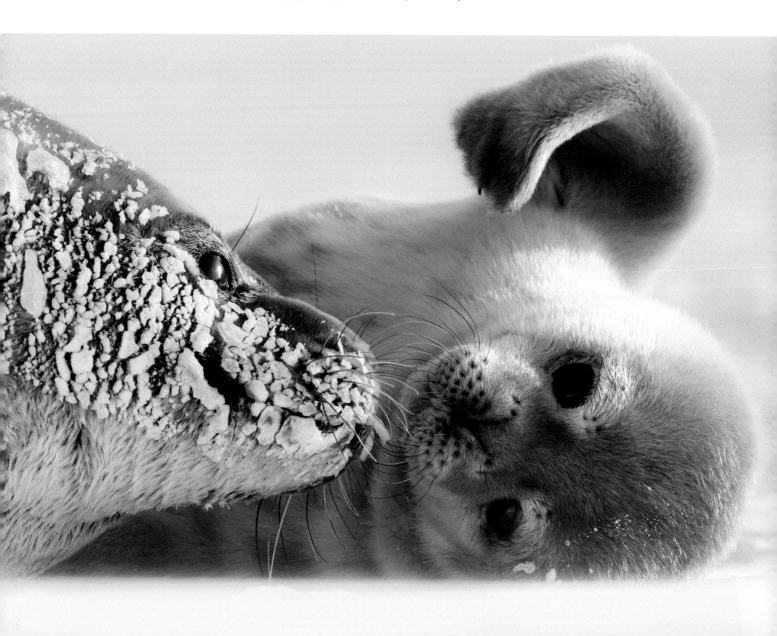

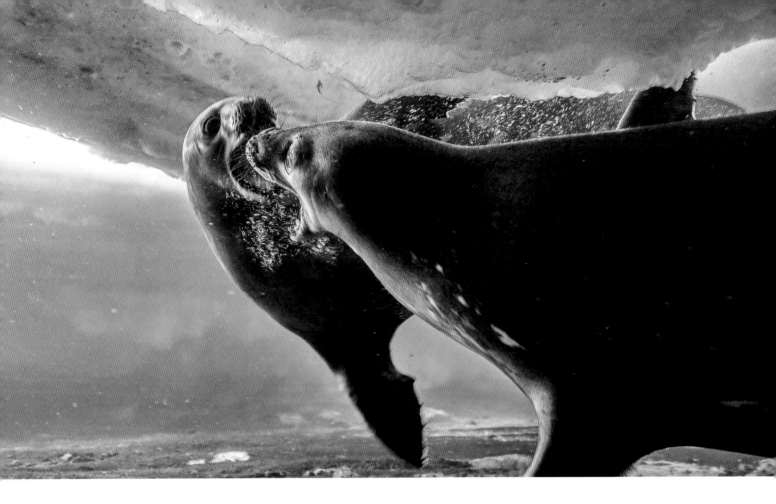

ABOVE A female seal not ready to mate can be quite feisty and attack an over-amorous male.

A pup generally does not enter the water for its first seven days, and, even then, it seems reluctant to get wet, with mother having to cajole it into swimming. One mother was seen to wrap her front flippers around her unenthusiastic youngster, and gently pull it below. Having overcome its initial fear, swimming lessons might start with a quick one-minute dip, but, as it gets used to the water, the pup stays for longer. It is more likely to swim late at night and in the morning, rather than in the afternoon, with the deepest and longest dives during the morning. A pup will dive down on average to less than 2 metres, but, if it feels brave enough, maybe to 15 metres. It will dive deeper and longer as it gets older; with the number of dives per day increasing as it heads towards weaning. Eventually, it seems reluctant to leave the water at all, although at this point in its life, it will spend up to 21 hours a day honing its swimming and diving skills, rather than focus on foraging.

At the same time, the pup's red blood cell count increases, so it can hold its breath for longer. As a young pup, it can stay down on one breath for no longer than eight minutes, and about 20 when a juvenile, but by the time it is adult, an individual will be able to dive for up to 90 minutes. Weddell seals are, in fact, superb divers, reaching depths of more than 600 metres, although most foraging is at 100–350 metres, the dive routinely lasting about 30 minutes.

A key thing they need to learn at this time is the ability to navigate, because they have to know where breathing holes are located or drown, and it is thought that part of the curriculum at swim school is how to find

OPPOSITE Most pup deaths are from drowning, so it is important that a pup learns from its mother the whereabouts of the nearest breathing hole.

their way about under the ice and how to locate those breathing holes; one reason, perhaps, that they spend so much time with mother. Most seal pups are with their mothers for less than four weeks – far less for some species in the Arctic – but a Weddell seal pup is with its mother for six or seven weeks.

One danger the youngster will encounter, apart from getting lost, is the threat from over-amorous male seals. As soon as the pup is born, they come a-courting, and they make a heck of a racket. The calls of the male Weddell seal are as loud as a gunshot, and these 3-metre-long seals are intent on mating with the female – except that, until her offspring has weaned, she has no interest. She will rebuff any approach. If the male commandeers her breathing hole, however, she becomes part of his territory, but she does not have to accept it.

Females, in fact, can be very aggressive and protective of their pups, and a male can come out of the encounter worse off, literally nursing his wounds. Pups do get bitten, but not often. Weddells are good mothers. The survival rate is high while mother is around – about 80 per cent. When she has gone, only 50 per cent of young Weddell seals make it to their first birthday, 35 per cent to their second, and only about 20 per cent of female pups will eventually have pups of their own.

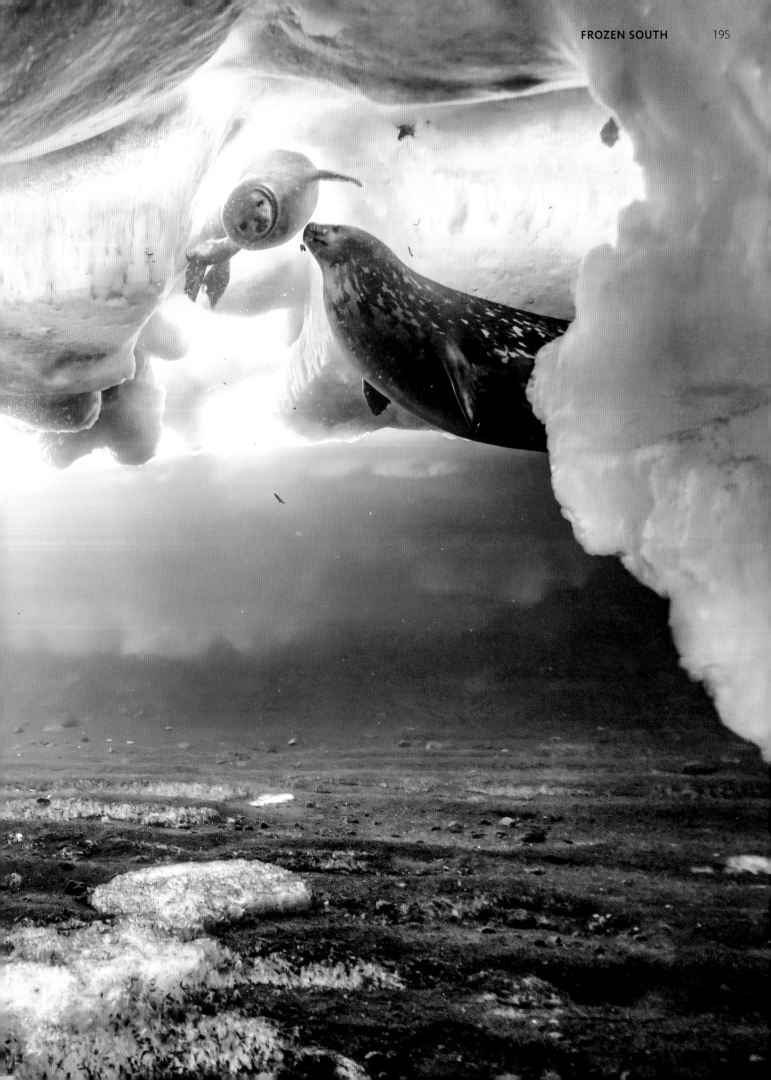

OUT IN THE COLD
MCMURDO SOUND, ANTARCTICA

Filming the interaction between female and male seals was only possible by using a type of underwater breathing apparatus known as a 'rebreather'. Its main feature is that it does not release bubbles when breathing out. It had not been used in polar waters before, but tests at the US Antarctic Program revealed that it could be, and it was the only way the production team could have witnessed the seals' natural behaviour. Blowing bubbles is part of a male Weddell seal's aggression display, so the seals would not have behaved normally with a breathing apparatus emitting bubbles. With the rebreather, the team could get much closer to the action. Yoland Bosiger was the director.

'Underwater cameraman Hugh Miller and I were under the ice in McMurdo Sound, and we discovered that female Weddell seals will engage in brutal fights with the males to ensure their pups remain out of harm's way. This is the first time that details of this behaviour have been filmed, and it was only possible with the rebreathers.'

ABOVE Underwater cameraman Hugh Miller is down in the cold again, this time at the other end of the world, under the ice in the Antarctic.

RIGHT With a rebreather, Hugh was able to remain with the seals without his bubbles interfering with their behaviour. Even so, this female seal is a little unsure what this alien creature could be.

OVERLEAF Hugh, like the seal pups he was filming, had to learn how to navigate under the ice.

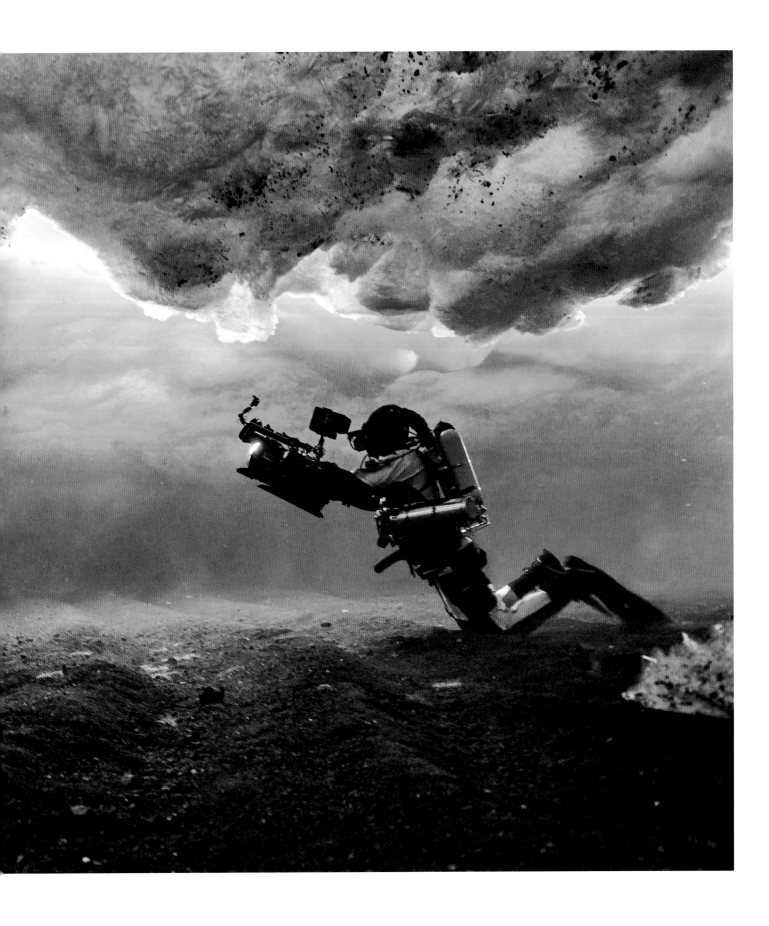

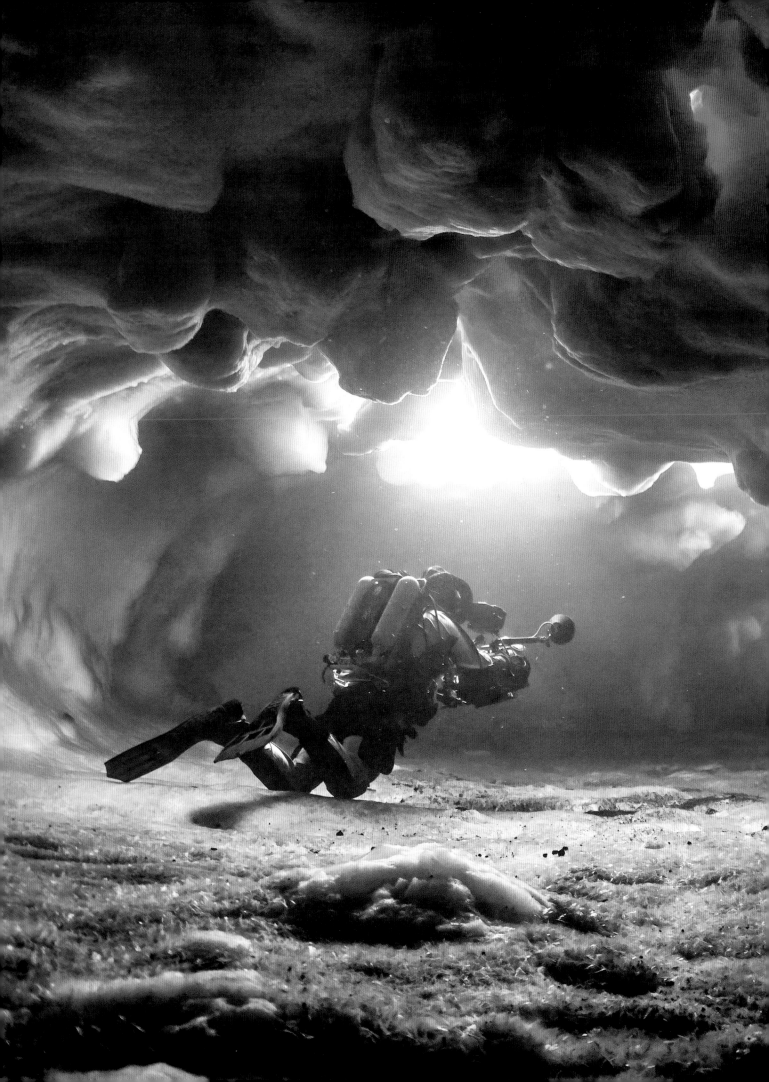

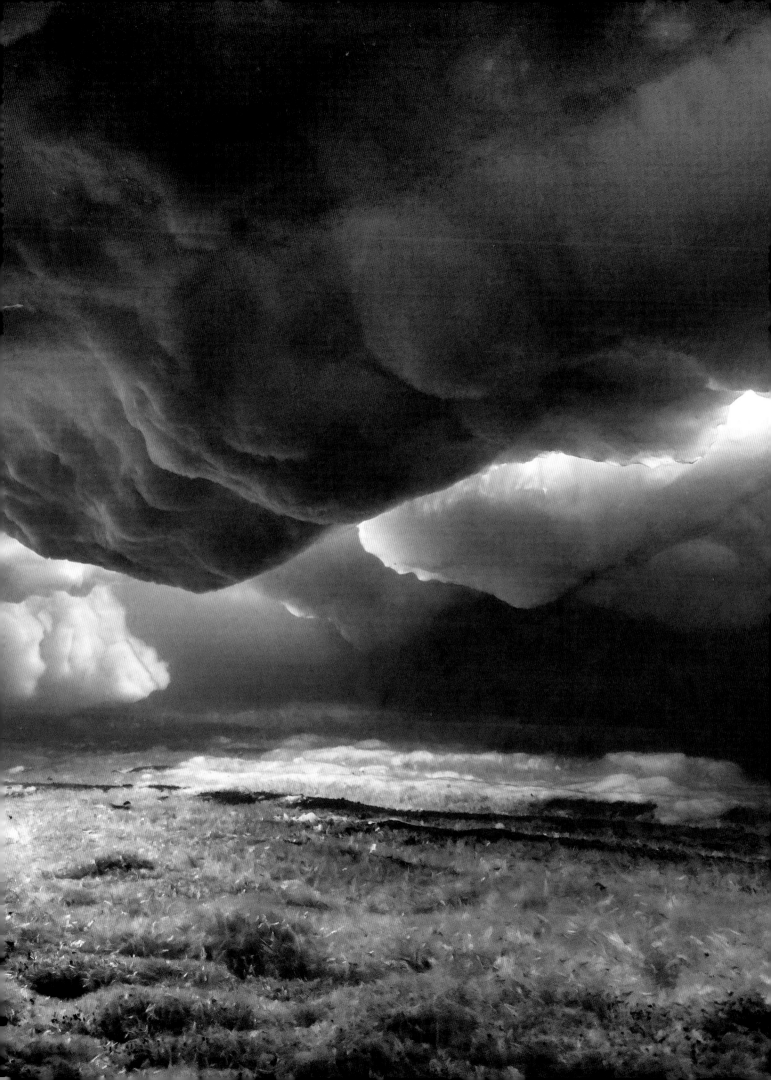

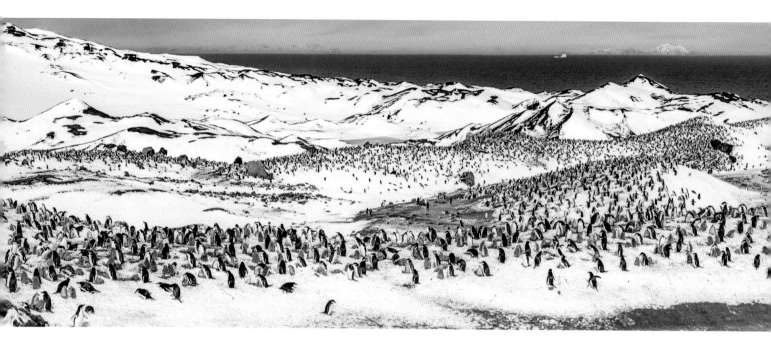

Pilfering Penguins

ABOVE The chinstrap penguin rookery on Vapour Ridge Col is located on the west side of Deception Island, off the Antarctic Peninsula.

OPPOSITE From a drone, the penguins can be seen to bunch together onto the most suitable sites for building their stone nests.

In spring, much of Antarctica's sea ice begins to melt, and by midsummer only about 15 per cent of the winter ice remains. On the coast, bare rock appears, attracting another species intent on procreation: the chinstrap penguin.

Chinstraps spend the winter at sea, but in the spring, they head for relatively ice-free breeding sites, returning almost always to the same place where they hatched as a chick many years before. Some of those sites are on Deception Island, close to the Antarctic Peninsula, an island instantly recognised as the horseshoe-shaped caldera of an active volcano in the South Shetlands archipelago. It is the biggest volcano in the area, and it erupts occasionally, as it has done several times during the past 10,000 years, most recently in 1970, with a significant impact on local chinstrap populations.

One of the world's largest chinstrap breeding sites is in the southeast of the island, but there are other smaller colonies, such as that on Vapour Col, a ridge on the west side, where 19,177 breeding pairs were counted in a survey in December 2011. There used to be more, but during the past 50 years, the number of breeding penguins has halved across the entire island, although they have stabilised more recently. Scientists believe it is a consequence of climate change. Apart from the reduction in sea ice during winter, which has resulted in a change in the distribution of krill and maybe even its abundance, there is also competition from recovering populations of whales and seals, and from commercial krill fisheries. Krill is the chinstrap's main food.

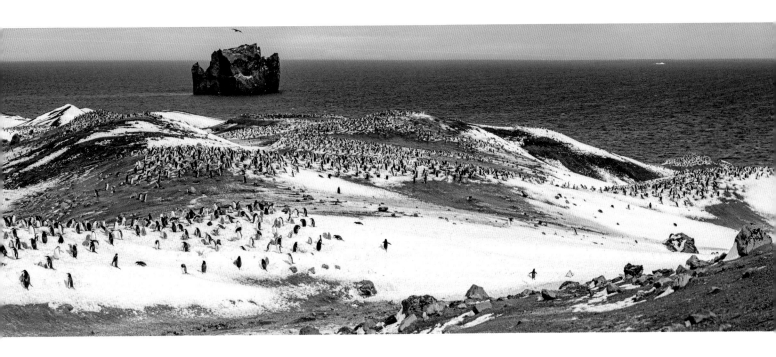

ABOVE Chinstrap nests are built outside their neighbours' liquid guano splat distance, but sometimes there are 'accidents'.

ABOVE RIGHT The nest of stones is an attempt to keep first the eggs and then the chicks from being flooded.

For the current visitors, the race is always on to find the prime nest sites. Slopes are favoured so that meltwater or rain will flow away, but failing that any flat surface will do, in fact, anything but a pocket where water can accumulate. Often as not they will make for the same nest site they used the previous year. The penguins also do a bit of civil engineering: they make a fresh scrape in the ground and build a small nest mound of stones. On slopes, just a couple of stones are enough to stop an egg from rolling away, but a small pile will keep eggs, and later the newly hatched chicks, high and dry. As the chicks grow and become mobile, the raised platform is less significant, and so the nest falls into disrepair. Until that time, though, suitable stones are in short supply, usually buried in mud during the winter, so penguins steal from the others; and they're all at it, so the same stones are probably being recycled throughout the entire colony.

Social distancing is the norm for these penguins, with each nesting pair not only out of pecking reach from its neighbour, but also at a distance to avoid being hit by projectile defecation. As a result, each nest site is surrounded by a pattern of white lines of guano, like the spokes of a bicycle wheel. It means less faeces in your own nest, but if they accidentally splat a neighbour, they really don't care; it's collateral damage. The chicks, meanwhile, depend on their parents for food, warmth and protection from predators, and there are plenty of those around. Antarctic skuas, for example, nest nearby to take full advantage of occasions when eggs or chicks are left alone.

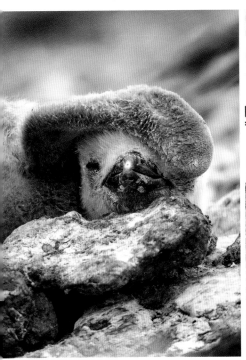

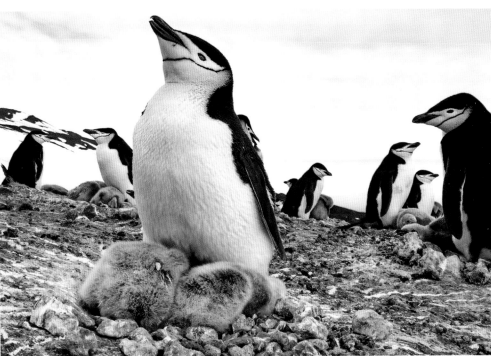

ABOVE RIGHT Chinstraps generally have two chicks, which will remain in the nest with their parents for up to a month.

The biggest threat to a youngster's survival, though, is rain. The warming climate means that it rains here twice as often as it did 60 years ago; soaking a chick's downy feathers so they fail to insulate the little one's body against the bitterly cold winds. The chicks shiver violently to generate some heat, in a bid to battle hypothermia, but they inevitably lose heat, and, if there's no let-up in the weather, they eventually die. It's a double whammy: less krill and wet weather, with mortality so rife that even the larger sites on the island are showing a decline in the population of almost 60 per cent over 35 years, and some of the smaller traditional breeding sites are actually empty. And it is not just chinstraps; the Adélie penguin is facing the same fate on the nearby Antarctic Peninsula, where US biologist Bill Fraser, head of the Polar Oceans Research Group has been studying them. He has been witnessing first-hand the extraordinary changes taking place, and, on what was his last trip to the Antarctic, he visited Torgersen Island, on the western side of the Antarctic Peninsula,. Historically, it was the site of one of the largest penguin colonies with which he had ever worked.

'I arrived here for the first time in 1974, and it felt like the edge of the world. It's hard to describe, but it felt like you had landed on another planet. It just captured me, and I've been here roughly 45 years – a long time. What fascinated me was the incredible hardiness of these penguins – feisty, determined, and beautiful little animals.

'Adélie penguins return to their breeding colonies every year. In that respect, they are extremely hard-wired, and you can see the advantages of

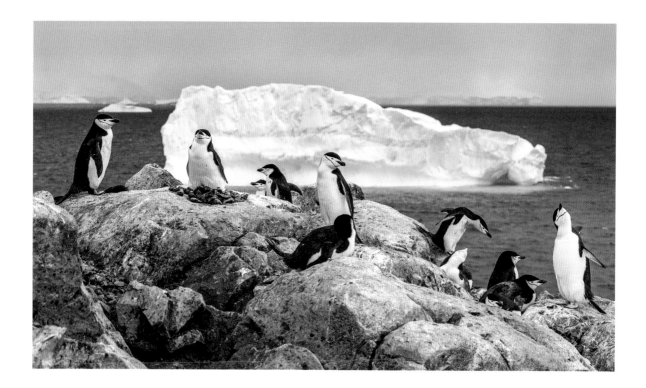

that behaviour, but it is a cost to them now, because their environment is changing. Their habitat is not suitable any more.

'During the past 45 years, the tremendous warming has had an incredible impact, and the changes have been very rapid, more rapid than anyone anticipated. Four decades ago, this area contained 20,000 adults, but currently we have somewhere in the order of 400 breeding pairs.

'One of the issues these Adélie penguins are clearly experiencing right now is the increase in rainfall. Adélies are creature of the High Antarctic. They evolved in a dry, polar system. They simply cannot tolerate being continuously wet. The chicks are soaking. The rain is penetrating their down, breaking down their ability to insulate themselves. That's why you see they are shivering, because they are trying to maintain their body temperature, but they can't. A tiny chick has zero chance of surviving. We are standing, looking at climate change killing off these Adélie penguins, one at a time.'

On nearby Litchfield Island, Bill found that the Adélies had fared even worse.

'This is where we recorded the first island-wide extinction of Adélie penguins. When we used to walk onto this island, you could immediately hear the penguins. They were everywhere. The silence that exists now is pretty overbearing in its own way. There are small stones here that were used on former nest sites by the Adélie penguins that bred on Litchfield Island. It's very sad. It's very emotional. This is the last week of my last season here, working in the region. There are no words that can really describe what I'm feeling. We have been working with the canaries in a coalmine. Adélie penguins are, without a doubt, the indicator species that are telling us the globe is changing – the globe is getting warmer.'

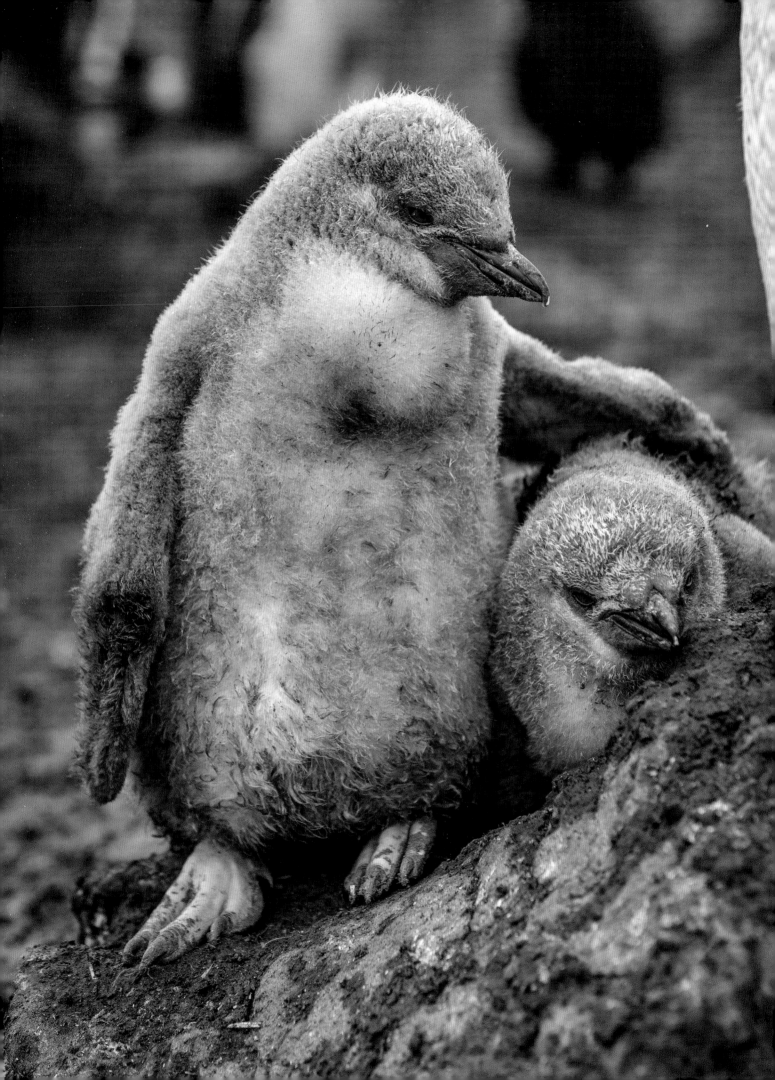

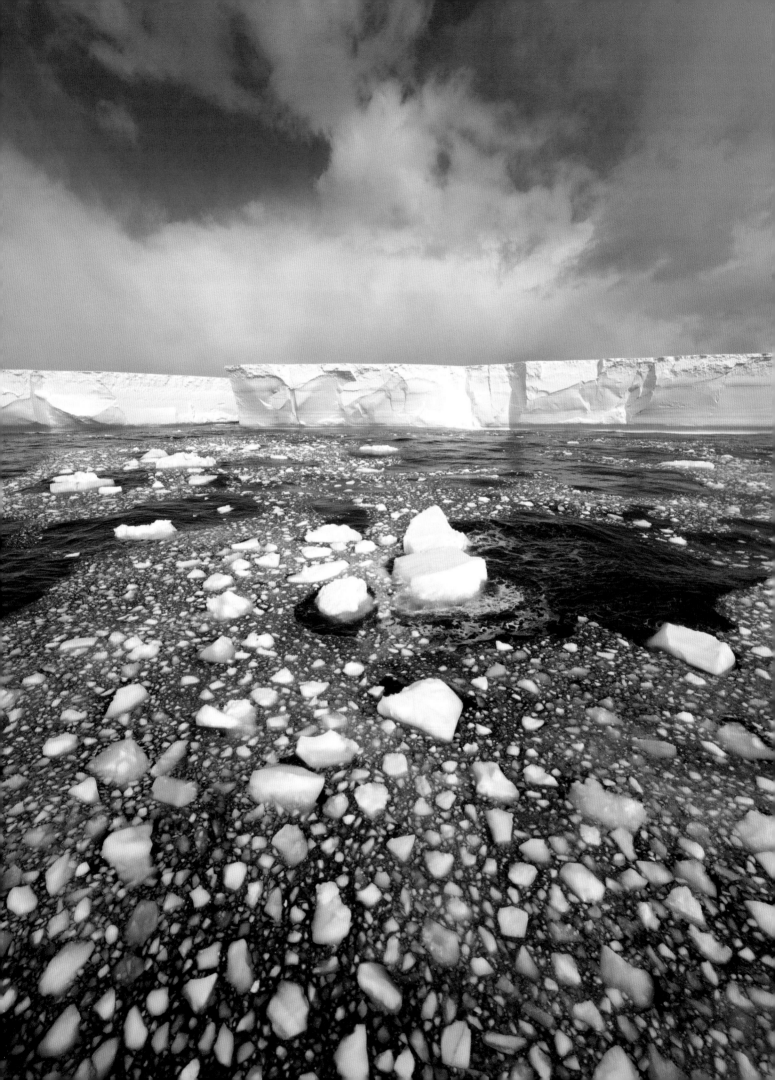

Ice Loss, Storms, and a Place in the Sun

One of the problems of a warming world is that Antarctica is losing the very thing that defines it – ice. A survey of 40 years of satellite views of Antarctic sea ice cover by NASA's Goddard Space Flight Center has found that although there had been a decades-long overall increase in Antarctic sea ice, this trend was reversed in 2014 and the decline surpassed the widely publicised decay rate in the Arctic.

A complication is that parts of the continent are warming at a faster rate than anywhere in the Southern Hemisphere. On 6 February 2020, a staggeringly high temperature of 18.3°C was recorded at Argentina's Esperanza Base on Hope Bay at the northern tip of the Antarctic Peninsula, and all around the Antarctic, weather patterns are changing dramatically and precipitation has increased significantly. More frequent rainstorms, rather than snowstorms, are the result, and, as the region warms, even more rain is forecast for the future.

It was once thought that the South Pole itself was relatively immune to the current spate of global warming, but recent research has revealed that over the past 30 years, the interior of Antarctica has warmed more than three times faster than the rest of the planet, the result, it is thought, of a combination of natural cycles of warming and cooling with manmade climate change. Scientists have been tracking temperature at the Amundsen–Scott South Pole Station since 1957, and figures show a 1.8°C rise between 1989 and 2018, with 1°C of that attributed to an increase in greenhouse gases. The trend is the result of low-pressure weather systems and stormier weather in the Weddell Sea area, which carry warm, moist air onto the Antarctic plateau, a weather phenomenon linked to unusual warming in the tropical Pacific. Surprisingly, over the same period, warming in West Antarctica slowed, and even stopped on parts of the Antarctic Peninsula.

Even so, scientists are documenting a general loss of sea ice along the western side of the Antarctic Peninsula. There is a year-on-year variability, but the overall trend since the middle of the last century is a significant loss – up to six times faster now than it was 40 years ago, which coincides with a marked increase in global atmospheric and sea surface temperatures. While the exact mechanisms for these changes are still being studied, one thing is clear: if global warming progresses as it is currently, the sorts of changes being seen along the Western Antarctic Peninsula are likely to become widespread in other parts of the Antarctic, and on a timescale of not millions, thousands or even hundreds of years, but in several decades.

Already, the Glenzer–Conger ice shelf – about the size of Rome – collapsed in March 2022, and that was in an area of East Antarctica that was thought to be stable. At the time, the air temperature in some spots in the region had soared to 40°C higher than normal. The concern is not that it happened, but where it happened.

Close to the Pole

On the Antarctic continent itself, despite the rising temperatures, climate change seems to have had less impact so far because the ice is so thick. Sticking up through it are great towering blocks of dark rock, the peaks of mountains whose lower slopes and ridges are buried beneath the snow and ice, and, although they might look bleak, they are a refuge for the world's most southerly breeding bird – the snow petrel.

They're tough little characters, not much bigger than a rock dove. Like most polar birds, they have dense plumage and lay down a lot of fat to keep out the cold, but, amazingly, they nest up to 440 kilometres from the coast and so are a very long way from where they feed. Nest sites are tucked away in hollows and crevices among the rocks, which offer some protection from the biting winds. The birds are in such an extreme environment probably because they cannot lay their eggs where there is ice or likely to be liquid water. It is also remote and away from predators, but the nunataks are not entirely predator-free, for south polar skuas swoop in. Nevertheless, shelters are at a premium and birds will fight for the right to occupy one… but they don't fight fair. When two come to blows, one might vomit its oily

BELOW Having been on the receiving end of projectile-vomited stomach contents from an adversary, this snow petrel cleans up with a bout of snow-bathing.

ABOVE A pair of snow petrels have found the perfect nest site under a rocky ledge, where they have some protection from the weather and any intruders, such as predatory Antarctic skuas.

stomach contents over the other. If it can't be removed from its feathers a bird could die, but more usually a snow-bath will get rid of the stain and the bird is ready to find its mate.

Snow petrels mate for life, so it is a simple matter of locating the spouse, but male newcomers looking for a partner must undergo a scary initiation ceremony, for, in snow petrel society, it is the female who selects her mate. She flies at breakneck speed, and he must follow her closely, never knowing what her next move will be. She flies straight at the rock face, turning at the very last moment, and if he's not agile enough, he could easily plough into the mountain. If he's an accomplished flyer, though, he might pass the test, although other factors could also be involved, such as smell and voice. If he passes muster, he grabs the female by the tail, and they flutter down to the ground and mate.

The nests are lined with pebbles and feathers, and once the single egg is laid, the father takes on the first incubation duty, which is generally the longest. He'll then fast until the female returns from sea. Then they swap over. Shifts decrease in length, usually down to one or two days, as the chick grows and can be left on its own, but the journey the parents undertake each time is a killer. The round trip, including foraging out at sea, can be in the order of 1,500 kilometres.

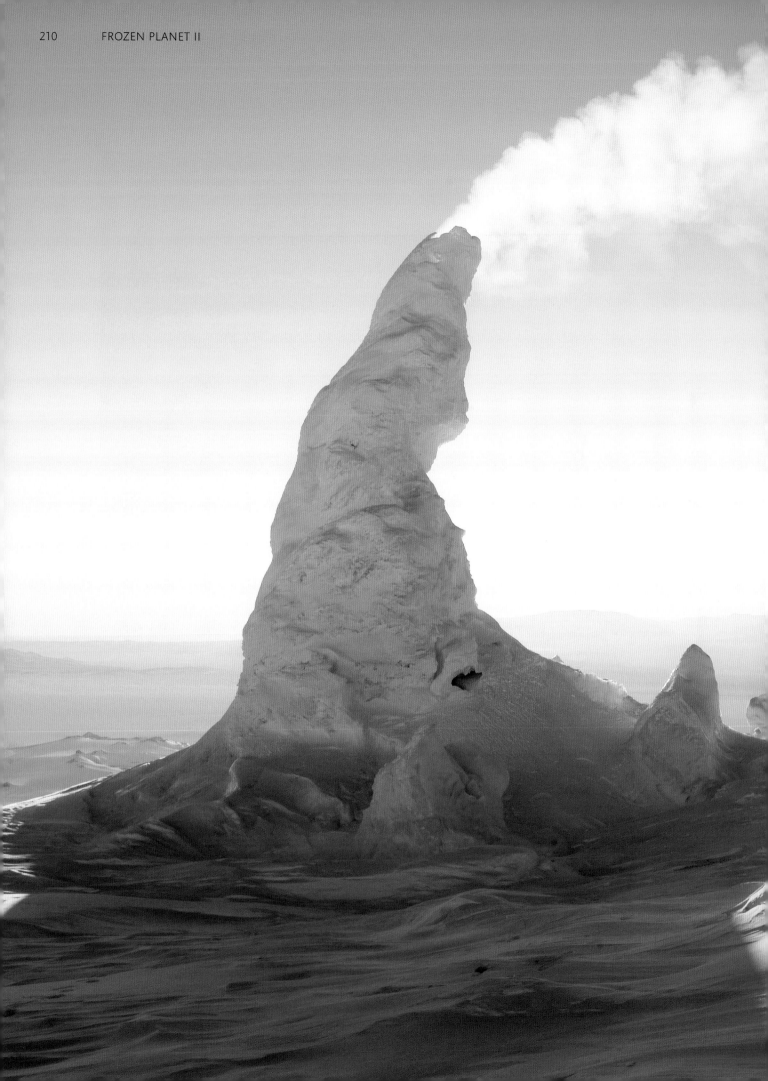

Strange New Worlds

BELOW An ice fumarole above 'Sauna Cave' on the slopes of Mount Erebus has formed where gases escape from vents in the volcano's surface and water vapour freezes into towers of ice.

BELOW INSET The crater of Mount Erebus in McMurdo Sound is one of only five in the world to have a permanent lava lake. It is the southernmost active volcano on Earth and the most active in the Antarctic.

Apart from the snow petrel's nunataks and mountain chains like the Transantarctic Mountains, much of the continent is a stark white landscape. However, newly discovered geological features directly underneath the ice sheets are proving to be exciting finds.

First up are volcanoes. In recent years, several volcanoes – at least 21 confirmed, and possibly more to be discovered – have been found hidden away under the ice of the West Antarctic Ice Sheet, some still active, others more ancient, but how much they are contributing to ice melt is not clear. A magma plume deep below West Antarctica, for example, could be triggering melting underneath the Pine Island Glacier, the fastest-melting glacier in the Antarctic. Scientists monitoring its progress, though, feel that volcanic activity is not a major contributor to its demise; rather, it is relatively warm water eating away at the underside of the glacier's ice shelf that is the cause.

Elsewhere in the Antarctic, volcanoes are more visible. Antarctica's second highest (after Mount Sidley) and the world's most southerly active volcano is Mount Erebus, on Ross Island in McMurdo Sound. It is one of only a handful of volcanoes on the Earth's surface to have a permanent crater lake of molten lava, which has been bubbling away, on and off, for at least 50 years. The lava is unusual in that it is phonolite; a rare fine-grained igneous rock that splits into thin, hard plates that ring when struck by a hammer, hence the name.

On the volcano's upper flanks are great hollow towers of ice with ice caves below. They build naturally over fumaroles. When carbon dioxide degasses, the warm ground first melts the ice and snow, hollowing it out like a cave, then vaporises the water. Finally, the water condenses and freezes again, accumulating as ice crystals in chimney-like towers.

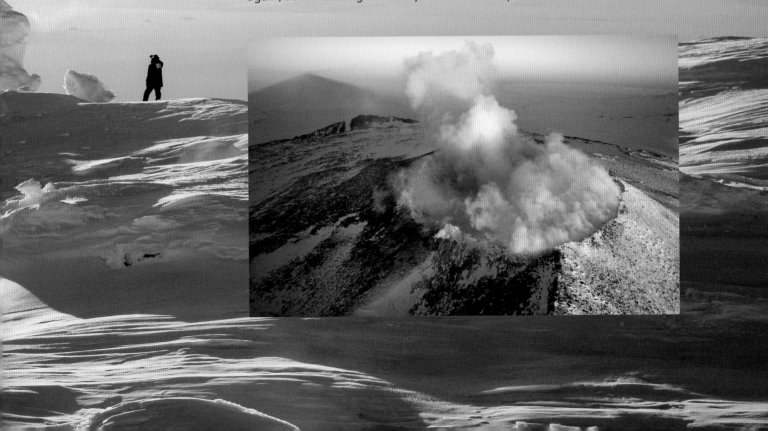

Dry Valleys

Antarctica's Dry Valleys are a strange and unexpected landscape on this frozen continent. Located to the west of McMurdo Sound, there are three types, a thaw zone, an upland dry zone and an intermediate zone, each zone with its own microclimate. Those close to the coast have a summer temperature that can rise above zero, and there can be some snow and even rain, although no more than 100 millimetres a year. The upland zone, however, has the most extreme desert climate anywhere on Earth, with a mean temperature of minus 23°C (and an extreme low of minus 69.07°C recorded recently), low humidity, and little rain for a very long time. What little precipitation there might be – no more than 10 millimetres of snow a year – evaporates within hours.

The valleys are dry and largely without ice because the surrounding snow-capped mountains are sufficiently tall to block the seaward-flowing ice of the East Antarctic Ice Sheet from reaching the Ross Sea. The valley floors are covered with gravel and sand, and what looks superficially like a snow-blown ridge in remote Victoria Valley is actually one of several barchan (crescent-shaped) sand dunes, the valley having the greatest accumulation of sand in Antarctica. Where the strong and persistent easterly winds have moved the dunes along at about 1.5 metres per year and have cleared the sand, parts of the valley floors are seen to be crisscrossed with polygonal, pavement-like permafrost, produced by repeated freeze-thaw cycles. The ice comes from vapour deposition rather than liquid water, which has cemented the frozen soil. The polygons are more similar to features on Mars than anything on Earth. Because of this, the area is protected, with restricted access.

The highest wind speed recorded here to date is 111.18 mph, and so sand and ice are blown about, leaving the valleys littered with extraordinary wind-blasted sculptures, known as ventifacts. They're polished smooth by wind-blown particles, with one ventifact carved into the shape of a giant swan. There are also the freeze-dried, but very fragile, mummified bodies of Weddell and crabeater seals. How they got here, many kilometres from the sea, must be speculation: maybe they took a wrong turn about 2,000 years ago.

One of the first pioneers to enter the dry valleys was the British polar explorer Robert Falcon Scott, who, together with William Lashly and Edgar Evans, stumbled on the valley when heading for the coast in December 1903. They stopped off for a few hours and observed many of the features that have been described formally only recently, including a mummified Weddell seal. 'It is certainly a valley of the dead,' Scott wrote later, although Lashly broke the magic with the comment that it would make 'a splendid place for growing spuds!'

Lashly's potatoes might well have a chance to grow in summer because, when the sun strikes the Wright Lower Glacier and the meltwater builds in

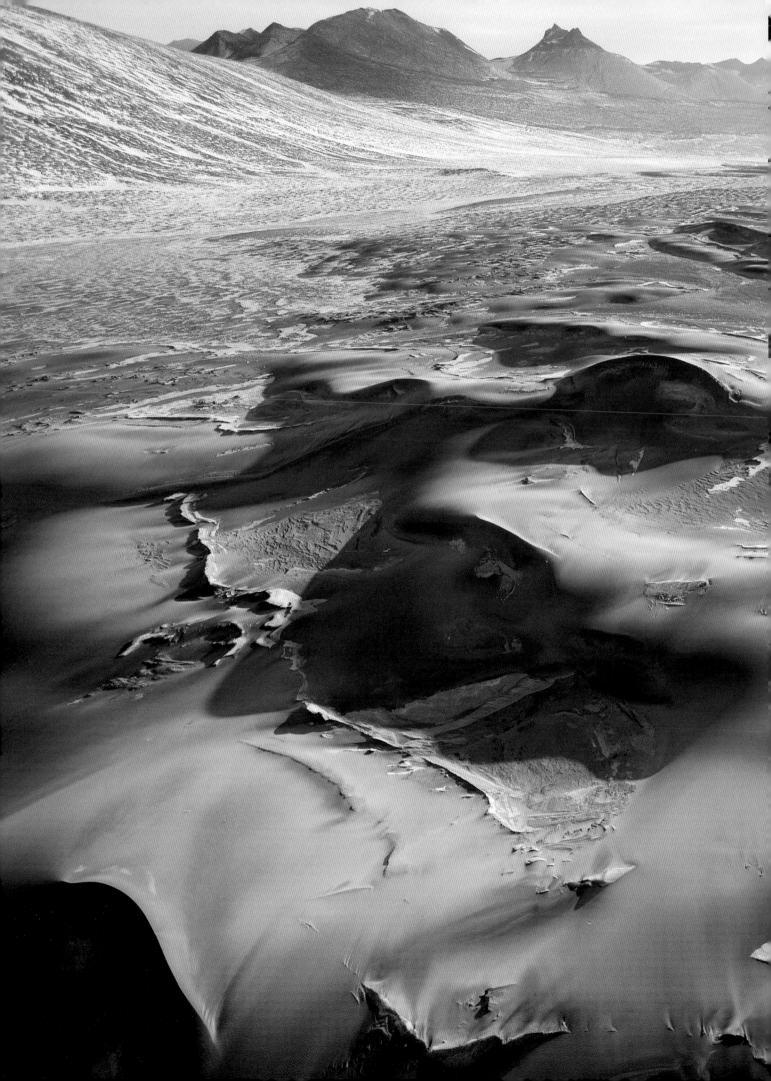

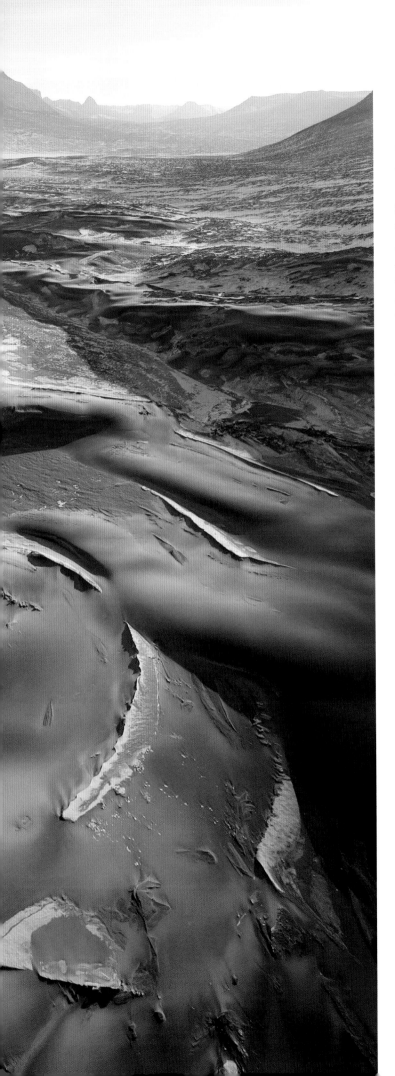

Lake Brownworth to its west, it can trickle across the floor of the Wright Valley forming the Onyx River. It flows away from rather than towards the sea, following a braided river pattern of water channels separated by temporary gravel islands. Along the way, tributaries bring in the meltwater and sediments from several other glaciers to join the flood (at least in 'flood years'), the whole lot eventually entering the permanently frozen Lake Vanda, which is said to have the clearest ice of any lake in the world.

As you might expect, there are no fish in the Onyx or the lakes, but there is life here. There are many species of diatoms present, and cyanobacteria and diatoms form mats of different colours depending on what photosynthetic pigment is present, so they are hotspots for life in an otherwise barren landscape. Rotifers, tardigrades, and nematode worms are the largest permanent residents. Mosses grow nearby and skuas fly in occasionally, but there are no vascular plants so there is little organic detritus in the water.

The main river system is about 28 kilometres long, making the Onyx the longest river in Antarctica, but its size and flow varies from year to year. Some years the river and streams might flow for up to ten weeks, while other years the river doesn't flow at all – so maybe not so good for spuds, after all.

LEFT According to satellite pictures, the surfaces of frozen sand dunes move across the floor of Victoria Valley at a rate of about 1.5 metres a year.

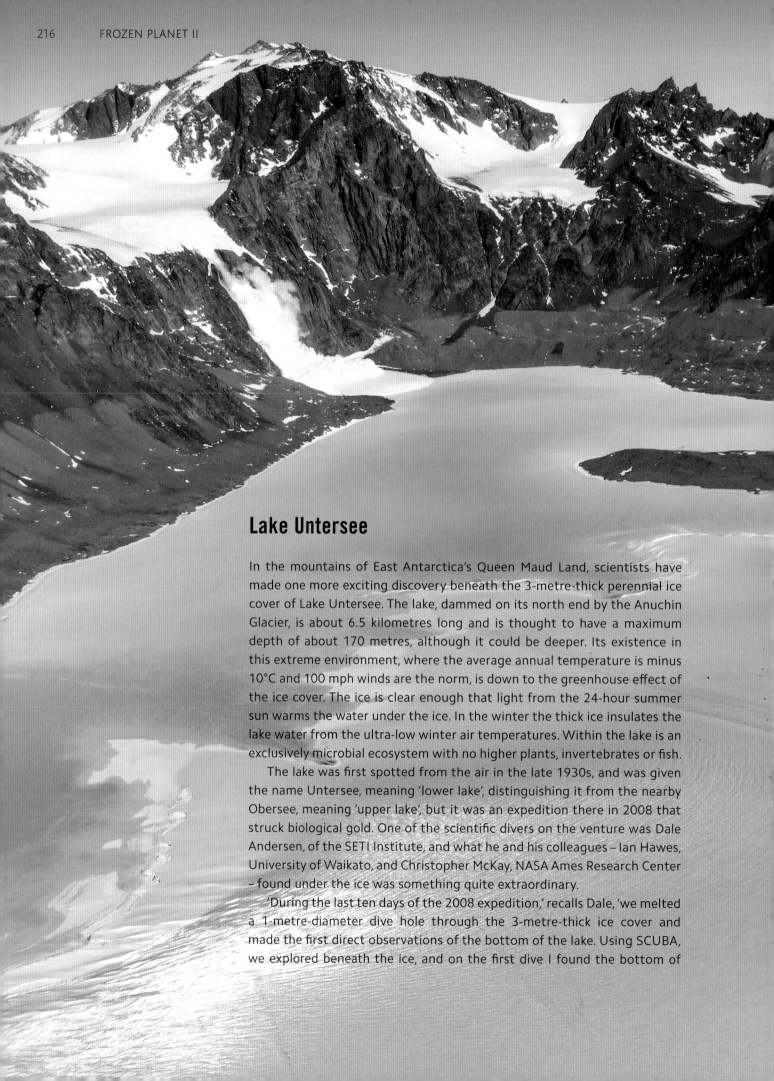

Lake Untersee

In the mountains of East Antarctica's Queen Maud Land, scientists have made one more exciting discovery beneath the 3-metre-thick perennial ice cover of Lake Untersee. The lake, dammed on its north end by the Anuchin Glacier, is about 6.5 kilometres long and is thought to have a maximum depth of about 170 metres, although it could be deeper. Its existence in this extreme environment, where the average annual temperature is minus 10°C and 100 mph winds are the norm, is down to the greenhouse effect of the ice cover. The ice is clear enough that light from the 24-hour summer sun warms the water under the ice. In the winter the thick ice insulates the lake water from the ultra-low winter air temperatures. Within the lake is an exclusively microbial ecosystem with no higher plants, invertebrates or fish.

The lake was first spotted from the air in the late 1930s, and was given the name Untersee, meaning 'lower lake', distinguishing it from the nearby Obersee, meaning 'upper lake', but it was an expedition there in 2008 that struck biological gold. One of the scientific divers on the venture was Dale Andersen, of the SETI Institute, and what he and his colleagues – Ian Hawes, University of Waikato, and Christopher McKay, NASA Ames Research Center – found under the ice was something quite extraordinary.

'During the last ten days of the 2008 expedition,' recalls Dale, 'we melted a 1-metre-diameter dive hole through the 3-metre-thick ice cover and made the first direct observations of the bottom of the lake. Using SCUBA, we explored beneath the ice, and on the first dive I found the bottom of

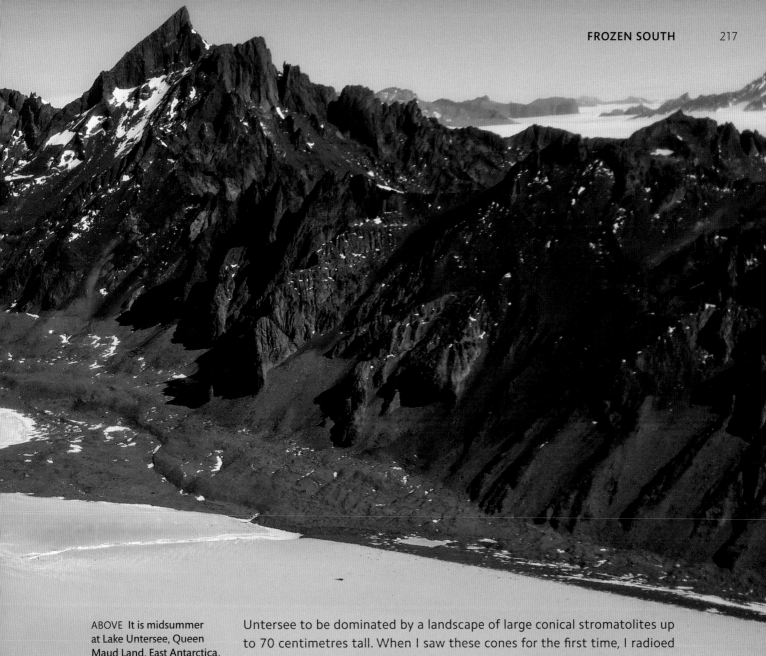

ABOVE It is midsummer
at Lake Untersee, Queen
Maud Land, East Antarctica,
and the lake still has its
4-metre cover of ice.

Untersee to be dominated by a landscape of large conical stromatolites up
to 70 centimetres tall. When I saw these cones for the first time, I radioed
up to the team on the surface that there were large cones of bacterial mat
everywhere. At first, they didn't understand so, to help them visualise it, I
said the bottom looked like it had been littered with large traffic cones.'

The presence of large conical stromatolites like these was unexpected.
While there are other examples of living stromatolites around the world with
a wide range of shapes and sizes, such as the well-known examples at Shark
Bay in Western Australia and Exuma Cays in the Bahamas, there have not
been good examples of modern living, microbial communities forming very
large conical stromatolites as they did billions of years ago. In previous years,
Dale and other scientists studied the lush cyanobacterial mats – modern
stromatolites – in other Antarctic lakes, such as those in the McMurdo Dry
Valleys, but the Untersee stromatolites are something else entirely.

In Untersee, the mats of photosynthetic cyanobacteria form two basic
structures: small light-coloured finger-like pinnacles up to 15 centimetres
high, which is a shape found elsewhere in the world, and the much larger
conical stromatolites that Dale describes. These larger structures are a
darker reddish hue as a result of an abundance of cyanobacteria rich in

the pigment phycoerythrin, used to absorb the dim blue light available for photosynthesis, and they rise up to more than half a metre above the lake floor. The pinnacles and cones are dominated by their own consortia of cyanobacteria and other microorganisms, and these biofilms trap and bind very thin layers of fine silt or clay, with the structures growing at a rate of a few tens of microns per year.

It is thought that the stromatolites are able to grow here because the water is so transparent, allowing light to penetrate into the depths to facilitate photosynthesis. It is one of the clearest lakes in the world, and although the divers could only go down to 40 metres, their remotely operated vehicles revealed that the cones are present at depths of more than 100 metres, and the photosynthetic mats are present even in the very dimmest light at 160 metres. The lake also has some unusual properties. Most of its water is supersaturated with oxygen, all except one end that is anoxic, and the pH is high.

'Although the pH is around 10.6, the water is not alkaline as in a soda lake,' says Dale. 'Untersee is poorly buffered freshwater. The high pH is due to two things. Weathering of the local parent rock can release hydroxyl ions (OH) into the water, driving the pH upward, but more importantly, the cyanobacterial mats consume carbon dioxide (bicarbonate) in the water, which also drives up the pH. If you removed the ice cover and allowed the atmosphere to mix

BELOW Large cone and small pinnacle stromatolites grow unbelievably slowly on the floor of Lake Untersee. The living cones are seen nowhere else on Earth.

ABOVE The stromatolite ecosystem of Lake Untersee could be similar to the biosphere of the Earth 3.43 billion years ago, the date of the oldest known fossil stromatolites discovered in Western Australia.

with the water, the pH would drop to neutral very quickly. The tight seal of ice means there is little to no mixing of the lake water with the atmosphere.'

Another remarkable revelation is that the stromatolites on the lakebed are unlike anything else living today, but, as Dale points out, they are remarkably similar to stromatolites that were once very common in the distant past.

'When we collected one of the small cones and sliced it, so we could see the internal laminations, we realised that this was something we'd seen before in the scientific literature. Large conical stromatolites, like those at Untersee, are present in the preserved fossil record in the Strelley Pool Chert Formation in the Pilbara region of Western Australia. They date back 3.43 billion years to the dawn of life on our planet, a planet whose sun was 30 per cent less bright and with an atmosphere, lakes, rivers and oceans nearly devoid of oxygen. But cyanobacteria had evolved photosynthesis – how to use the sun by harnessing its light energy and splitting water, and then using the released hydrogen in combination with carbon dioxide captured from the atmosphere to form carbohydrates (sugars) and, in the process, releasing oxygen back into the environment. This began an event that over geological time transformed our planet to a world capable of sustaining multicellular life and leading to the great diversity seen across the world we live in today.'

In fact, those Strelley Pool fossils are among the oldest records of life on Earth, and Dale feels that this unique ecosystem in an Antarctic lake could not only be a useful tool with which to study Earth's earliest biosphere, but also, perhaps, to envisage an early biosphere in ice-covered lakes on Mars. Even more exciting, he suggests that, if life can thrive in such a hostile environment as Lake Untersee in Antarctica, maybe similar life forms could live in oceans tightly sealed by ice on the frozen moons of the outer planets. Now that really is an exciting prospect.

Chapter 5
FROZEN LANDS

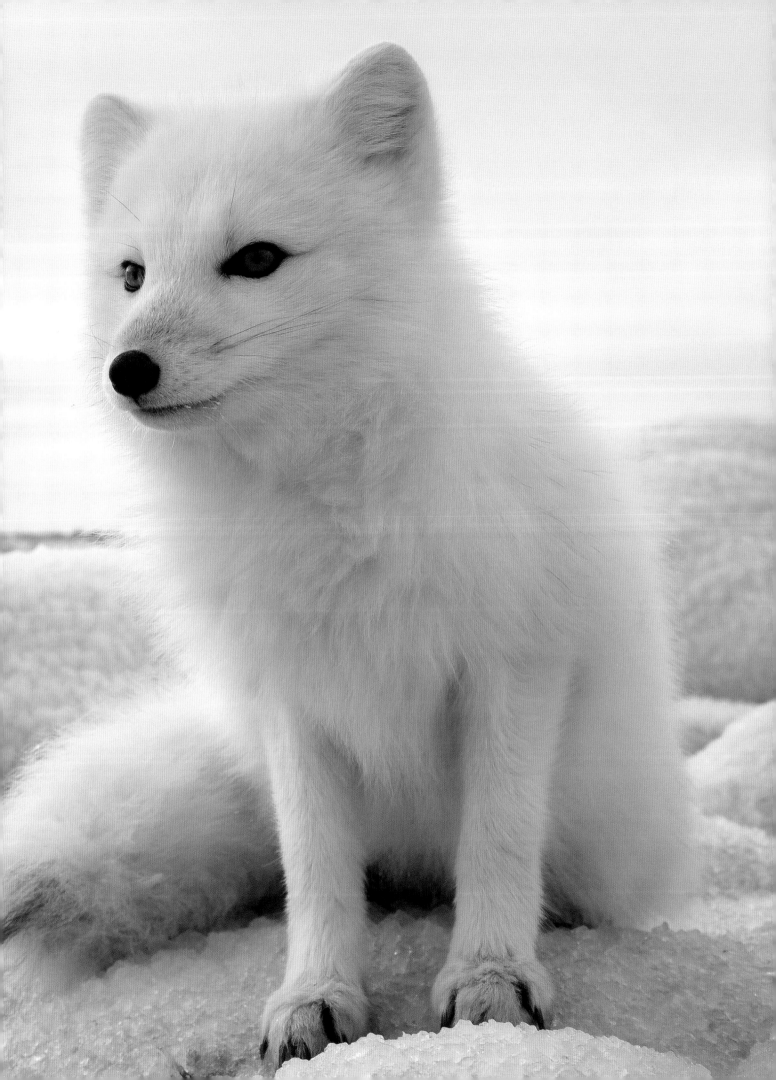

SANDWICHED BETWEEN THE Arctic Ocean to the north and the temperate forests of Eurasia and North America to the south is a vast region of frozen tundra and boreal forests that encircles the northern hemisphere at high latitudes. Both forest and tundra experience long, cold and severe winters and short, increasingly warm summers, and they are home to exceptionally tough plants and animals that are adapted to survive in extreme environmental conditions, from freezing to frazzling. Temperature here can swing wildly. On 20 June 2020, for example, the Russian town of Verkhoyansk recorded a summer high of 37.8°C, the hottest temperature ever recorded in the Arctic, and this in a town that is one of the coldest permanently inhabited places in the world, with a world record low temperature of minus 67.8°C. Local people consider it to be the northern 'pole of cold', a claim it shares with Oymyakon about 630 kilometres away. Both towns are located in the northern extreme of the Siberian taiga where sub-Arctic conditions prevail, but where winter air temperatures can be far colder than at the North Pole.

BELOW In the Far East of Russia, a male Amur leopard patrols his ridge-top territory overlooking the Ussuri taiga.

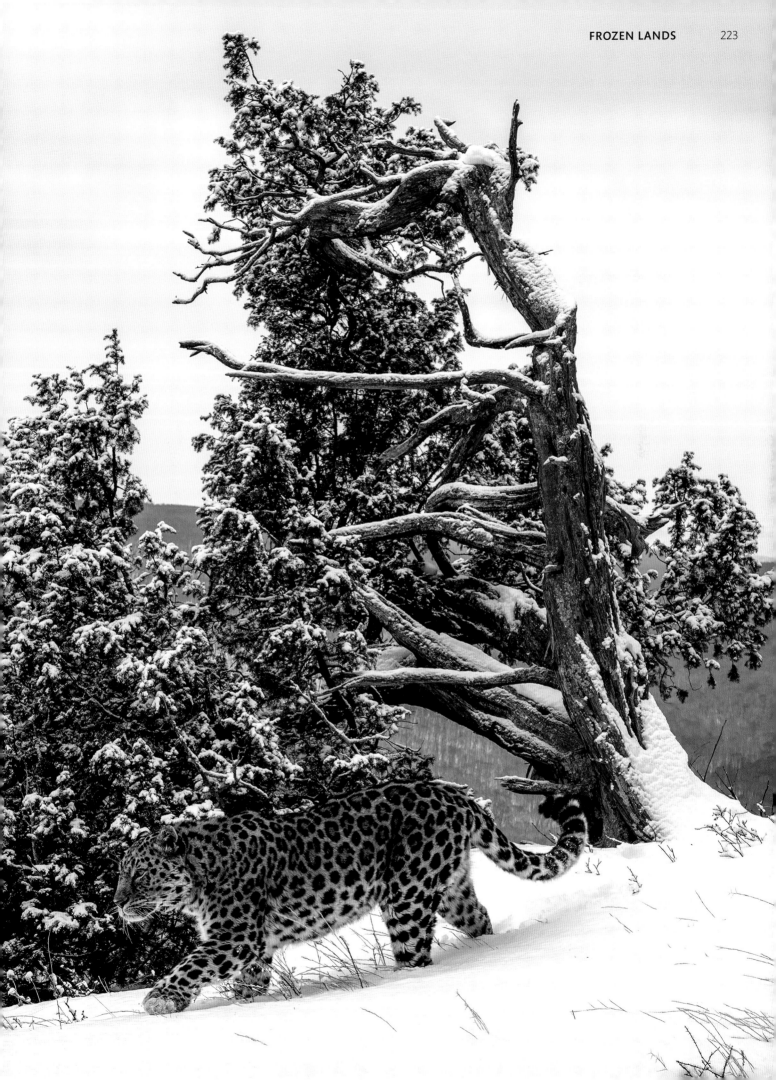

Tundra and Taiga

The more northerly zone of land – the Arctic tundra – borders the Arctic Ocean and, in winter, when the average air temperature is minus 34°C, snow blankets the frozen ground and darkness rules for three months. Even so, annual precipitation is surprisingly scant, little more than 380 millimetres, which puts it on a par with the Sonoran Desert in a damp year, with two-thirds falling as summer rain and the rest as winter snow, so the tundra is something of a polar desert.

The thin tundra soil is acidic, poor in nutrients, and drains badly. Vast swathes of the tundra are underlain by permafrost, which is permanently frozen to as little as a metre or as much as 1,500 metres below the surface. It is deepest in places like the northern Lena and Yana river basins in Siberia; in fact, huge areas of northern Russia have permafrost, the rest being in Canada, Alaska, Greenland, and northern Europe, and it's been that way since the last ice age.

At high latitudes, the consistent low temperatures throughout the year mean there are few trees, only dwarf willows that grow to a height of 15 centimetres at most, making them among the world's shortest woody plants – and the tallest trees on the tundra. There are also hardy dwarf shrubs, sedges, grasses, mosses, liverworts and lichens. In summer, though, when the temperature rises up to 12°C and the snow clears, numerous species of wildflower bloom and even pollinating insects abound. All the plants have shallow roots and so grow in the topmost 'active layer', which freezes and thaws, the rest of the soil being frozen solid all year round. They gather together in clumps to resist cold temperatures, and many are low-growing cushions, an adaptation to the relentless winds.

The tundra's animal populations oscillate with the seasons. There is an influx of migrants in summer and a mass exodus before winter. Permanent residents are adapted to survive in the cold temperatures, with thick feathers or fur and an insulating layer of subcutaneous fat. They breed and raise their young rapidly in spring and summer, so their offspring have the

best start in life before winter sets in. Some opt out of winter altogether and hibernate.

The boreal forest or taiga, on the other hand, is all trees – vast tracts of coniferous forest, to the south of the tundra, that stretch from Alaska, across Canada and northern Europe to Siberia. It is the largest terrestrial biome on the planet, yet, for wildlife, it is one of the least diverse. Cone-bearing conifers or evergreens dominate – firs, pines and spruces – and they exclude many other plants, although boggy areas can have broad-leaved trees, such as oak, birch, willow and alder.

The cold, snowy winters and mild, wet summers favour the conifers. Drought during winter, when the water in the soil is frozen and unavailable, is a bigger problem for trees than the cold. Most have antifreeze in their sap anyway, as well as ice nucleators. These molecules, or in some cases entire bacteria, draw liquid water from the tree's cells, concentrating the sugars so

ABOVE A meeting of the seasons in Alaska's Denali National Park.

OVERLEAF The headwaters of the Lena River and surrounding taiga in Siberia, northern Russia, in summer.

the fluid inside has a lower freezing point. Evergreens have needle-shaped leaves that lose little water, and they do not shed their leaves in the autumn and so have no need to grow them in spring, an energy-saving strategy. They are also coloured dark green to absorb the maximum amount of solar energy. The flaring branches and pointed tops are a simple adaptation that causes snow to slip off rather than build up and break branches.

Northern forest animals have similar environmental challenges and are adapted in similar ways to those on the tundra, except they have the advantage of trees to nest in, hide behind and exploit. Many of the herbivores take advantage of the superabundance of seeds that the conifers provide, and further up the food chain some of the carnivores are large and suitably ferocious as befits such a dramatic landscape. But, come the winter, many opt for hibernation or sleep through the worst of the weather; and a few, as you'll read later, actually freeze almost solid.

The Hunt Is On

ABOVE A super-pack of 25 wolves searches for wood bison in Wood Buffalo National Park, northern Canada.

A seemingly endless stark snow-covered terrain looks devoid of life at first, but the eye is suddenly caught by a dark spot that moves, followed by another and then another, until there are many dog-like shapes loping across the plain. A super-pack of 25 wolves is searching for an animal so big and powerful that no other North American predator would dare try to take it down – the North American bison or buffalo.

They are in Canada's Wood Buffalo National Park in northeast Alberta and southern Northwest Territories, where vast tracts of boreal forest and undisturbed grass and sedge meadows sustain the world's largest population of wood bison, a northern cousin of the more familiar bison of the Great Plains. Wood bison are big, up to 3.5 metres long, 2 metres tall at the shoulder, and weighing 1,179 kilograms, making them bigger and chunkier than the plains bison and therefore the largest and heaviest animal in North America. Their considerable mass gives them an advantage in these northern climes. The body produces more heat and forms a larger

frame on which to store fat, and the thick fur is such a good insulator that falling snow does not melt on the bison's back: good to have when the winter temperature sometimes drops to minus 40°C.

The super-pack is thought to be an extended family, in which the young and old depend largely on the most experienced trackers, the lead male and female. They decide when and what to hunt. The wolves try to stay relatively close to the bison, rather than roaming too far, but the hunting grounds are so extensive that a pack might still have to travel great distances to relocate a herd and carry out a hunt.

The wolves pick up the bisons' trail by the smell they leave on the crushed snow, and when a herd is in sight, the wolves weigh up their options. They instinctively look for calves and, failing that, identify the old and weak; somehow, they spot tiny giveaway movements, which we fail to see but the wolves detect. Scientists watching wolves, though, have identified three factors that make a hunt successful: speed, footing and obstruction.

Both species are well matched for speed: top speed for wolves is about

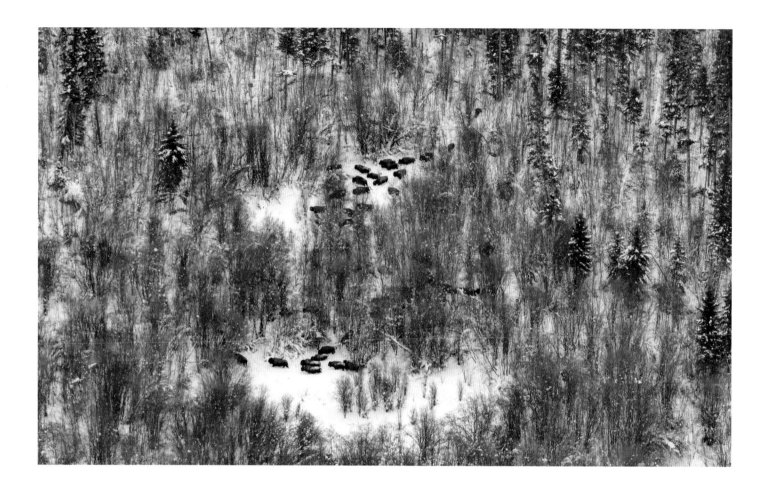

ABOVE A herd of wood
bison hides from wolves
in a small stand of trees.

38 mph, and 34 mph for bison, but bison have greater stamina, so, if the hunt is in an open area with firm ground, the bison can outrun the wolves. Summer and early winter hunts are, therefore, less successful. In winter, deep, soft snow can be an obstruction for bison, giving wolves the advantage. In late February and early March, an icy crust forms on top of the snow. The wolves are light enough to be able to run on the top, whereas the bison break through it and are slowed down. If the snow is hard-packed and icy throughout, the bison have good footing, and can escape. Footing, however, can be a bison's downfall, as tripping on undergrowth can have the pack on your back in seconds, and a trip for a wolf means the prey escapes. In woodland, trees and bushes tend to get in the way, although bison can barge their way through, leaving the wolves behind.

There are usually about five or six 'killers' in the pack. They take the risks and bring down the bison. Among the rest are the younger wolves, present for the food and to learn the ropes – and learn they must. Adult wood bison are large and powerful adversaries, and, if a hunt goes wrong, there can be serious injuries. Some wolves die from being stomped, gored or kicked by bison; the kick alone is capable of delivering a lethal blow. Lucky wolves get away with a limp, but several wolves have been found with broken jaws, and they probably died of starvation: with no means to capture and consume prey, it's game over, so the wolves are very wary of flailing hooves.

The pack starts its hunt in a very laidback way, despite probably not

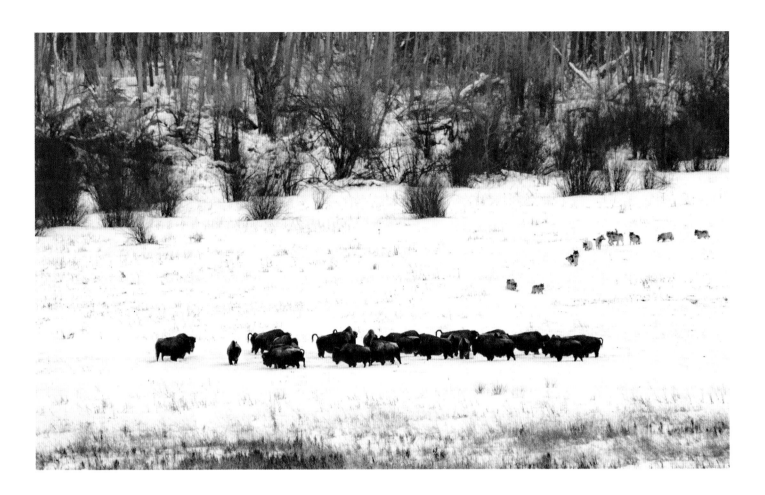

ABOVE **The wolf pack plays a 'waiting game', as the bison close ranks.**

having fed for maybe five or six days. They lope around the herd, which might well match them in number. Then, they stand and simply stare. The bison respond by huddling together in a defensive phalanx, their horns facing outwards. One young bull might make a mock charge, and, realising its mistake, quickly re-join the group. The wolves barely move. If the herd has no obvious calves present, the wolves have no choice: they must take down an adult or a juvenile, and the only way they can do that is to tire one out, so they trigger a stampede.

Startled by the wolves' sudden movement, the herd takes off, the leading wolves on the heels of the tail-enders. One bison is grabbed by the tail but is kicked for his trouble. A second wolf tries, and is lucky to keep his jaw intact, and then the bison turn into a thicket. Here, the prey has the advantage. They can bulldoze their way through the bushes and small trees, and, as the foliage springs back into place, the wolves struggle to keep up. They change tactics, and switch to a game of hide-and-seek.

Now, the task is to separate a smaller group from the rest of the herd. In among the undergrowth, the wolves lose contact, but then a bison snaps a twig. Acting alone, one of the wolves flushes a handful of bison into the open. The chase is on again, but this time there are twice as many wolves as bison, although the early spark is missing. Both predator and prey are exhausted. The wolves eat snow. They need to hydrate, and then suddenly a couple of younger bison lose their nerve and make a bolt for it. Without the protection of the herd,

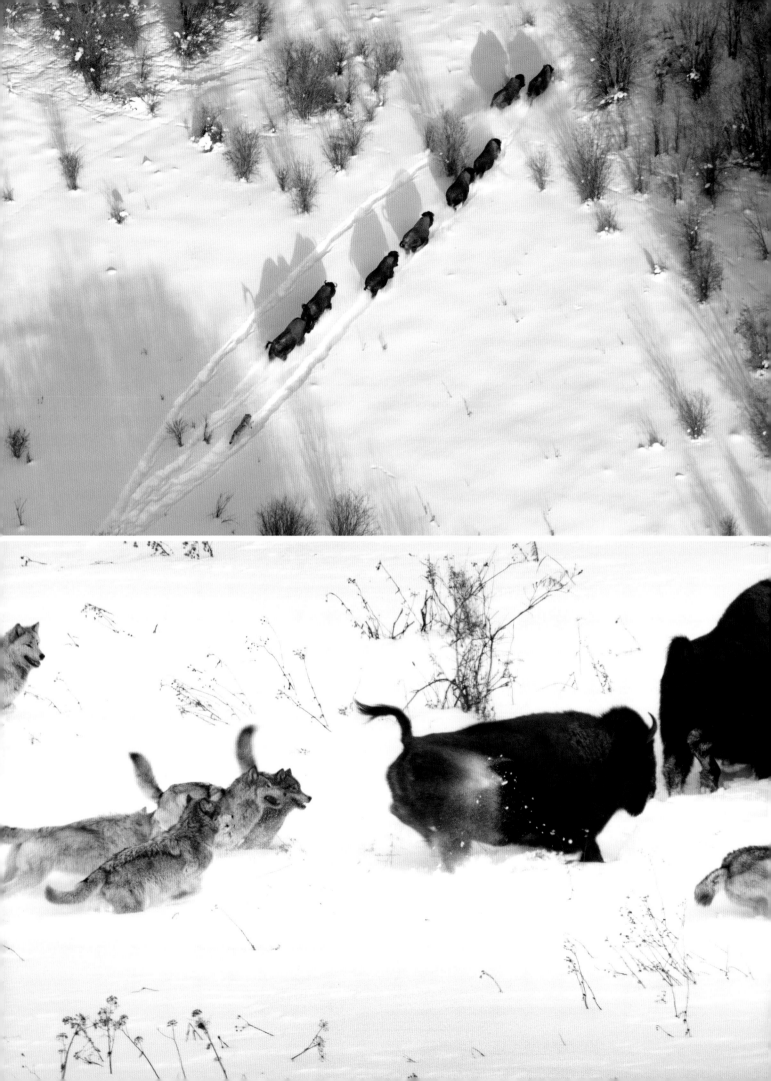

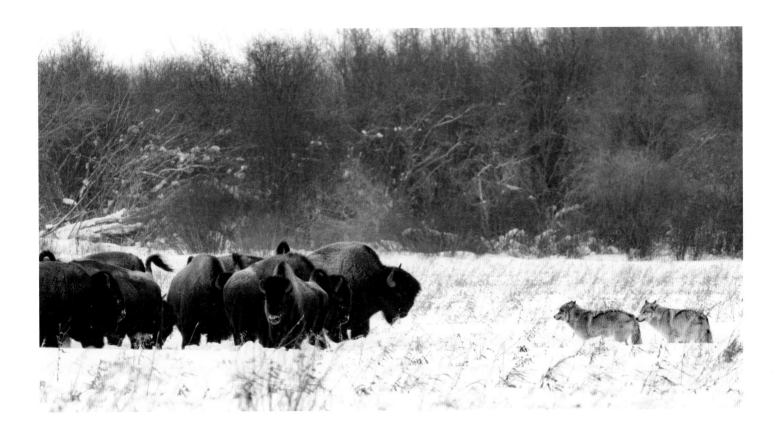

OPPOSITE AND ABOVE
The wolves work out how
to stampede the bison,
giving them a chance
to isolate an individual
from the herd.

the wolves separate one and are quickly on it. Grabbing legs, they eventually bring down the struggling beast, but they still have to avoid the kicks. It is now only a matter of time. By working together in this hostile environment, the super-pack is able to eat well tonight.

The problem for the bison is that they are at a disadvantage in deep snow, and not just in terms of movement – with food plants buried deep, they can be malnourished in late winter. They do, though, have back-up systems. They can slow their metabolism so that food moves slower through the gut, and they can absorb more nutrients, but this means they cannot move so fast, and they have less energy, especially when bogged down by the heavy snow. It makes them more susceptible to successful wolf attacks during February and March than at any other time in the year; and, with so many mouths to feed, a pack of this size must hunt successfully every three or four days to survive. Just in case, the wolves too have a plan B: they will return and gnaw on the cadavers of previous kills and pin down the occasional rabbit or hare if hunting opportunities are limited. The park is a tough area in which to hunt, and wolves here live no longer than six to eight years, compared to 20 years in captivity, but wolves have been here a long time, and the predator–prey relationship between wolves and wood bison has continued unbroken over thousands of years.

OUT IN THE COLD
NORTHERN CANADA

BELOW The expedition's helicopter, with camera pod hanging from the front, drops off the film crew on the ground, prior to filming a wolf hunt.

'There's no discussion: Canada's Wood Buffalo National Park is vast,' reflects assistant producer Will Lawson. 'With an area larger than the size of Switzerland, simply covering the ground to find our characters, let alone film them, was always going to be a logistical challenge. To make matters worse, the wolves are incredibly mobile, often travelling 16 kilometres or more in a day and twice that when pursuing bison. It meant we had to use a spotter plane and helicopter but, to make the sequence really special, we needed to film not only from above, but also from wolf and bison eye level. It wasn't until we reached the location that it dawned on me: this would be easier said than done!'

The production team's intention was twofold. One crew would be filming from the air in a helicopter. Set to one side of its nose was a camera with a very long focal-length lens attached to a gyro-stabilised mount. This would eliminate any shake and so capture rock-steady close-up images while it flew some distance away from the animals. Aerial cameraman was Jamie McPherson.

'Our helicopter pilot', recalls Jamie, 'was one of the best I've ever worked with, an incredibly skilled pilot. You'd think that shooting from a helicopter is easy: you just fly around the animal, but actually you have to be incredibly careful. We worked downwind and tried not to influence the behaviour and not scare the wolves or the bison.'

A second crew on the ground planned to spend as much time with the wolves and bison as possible. In an ideal world, the helicopter would put down

ABOVE The production team used a spotter plane to cover the vast area covered by the bison and wolves. It burned less fuel than the helicopter, so the helicopter was only deployed when there was something to film. It was all part of the team's effort to lower its carbon footprint.

a kilometre or two away from the action, and the crew would very quickly and quietly trek in. To Will, it all seemed pretty simple… at least, at first.

'When wildlife cameraman Justin Maguire and I were dropped in position, it was a baptism of snow. The helicopter only semi-lands – not wanting the skids to sink too far into the snow – so it was a race to unload the kit as the rotors whirled overhead, and then to strap down or lie on as much of it as possible, so nothing got swept into the blades. The aerial team then took off and the helicopter's blizzard-like downdraught blasted you to smithereens with crystalline snow. Only as its rhythmic beats receded into the distance did we feel it was safe to put up our heads. But, after that adrenaline rush, you're left in the vast, quiet and seemingly peaceful landscape.'

The contrast struck Justin too.

'One moment you're inside this warm, noisy helicopter, flying over a vast seemingly inhospitable snow-covered terrain, and the next you're dropped off in the middle of it, and you're hit suddenly by the absolute quiet and stillness. Your senses come alive again – the coolness of the air, the crisp crunch of snow – and you become more aware of movements in the landscape and to wind direction and scents, and your place within it all.

You notice every tree, broken branch, piece of frozen ground, snow bank. Each step or sudden move could give away your position, and you begin to understand what the life of the animal you're about to film is actually like. It's this immersion in the wilderness that is the highlight of being a wildlife cameraman.'

But first the crew on the ground had to find the wildlife, and that meant trekking through the snow, along with a fair bit of kit. The unpredictable weather and being 50–80 kilometres from base meant that each time the helicopter dropped off the ground team, they needed to be self-sufficient for a few days as a pickup was not guaranteed. Each of the crew had 60 kilograms of tent, sleeping bags, rations, firelighters, first aid, spare clothes and camera equipment all strapped to sledges that had to be dragged across the rough, snow-covered ground.

'If you've never ventured onto deep virgin snow wearing snowshoes, while pulling a heavy sled,' says Will, 'then I can only describe it – to put it nicely – as "hard". In our case the top 5 centimetres was crust, and the dream was not to break it and so glide effortlessly over the smooth surface. In reality, on nearly every step, we broke through and sunk up to our knees. It was completely exhausting. I had to try to keep up with Justin, but he was like a machine, striding out across the snow. Eventually, I caught up and we edged closer to the wolves.'

In order to stand any chance of success, the film crew had to rely on the local knowledge of spotter plane pilot Matthew Erhardt. He maintained a

BELOW With such a large area to cover, a helicopter was the only viable way to keep up with the action, dropping the ground crew ahead of the hunt.

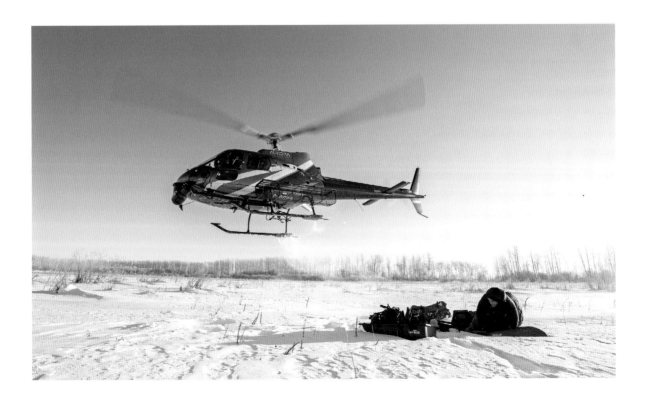

ABOVE **The deep snow slows the wood bison considerably, as they sink right in. The lighter wolves can run on the frozen surface.**

bird's-eye view and radioed out to give updates to both the film crews. The message 'No change in the wolves, you're on track' was the encouragement the crews needed, especially those on the ground. Even then, the footage was far from in the can.

'Having taken an hour to snowshoe 1,500 metres, Justin and I were on track and picking a final approach when the radio quietly squawked, "Guys, the wolves are getting up and stretching." We quickly changed our approach to try and get ahead of where they might start moving and, after a few more minutes of accelerated grunting and sled wrestling, we were only about 100 metres away. Another squawk announced: "Guys, you better be quick. The whole pack is up and moving. You're going the right way but they're not hanging around."'

Ten minutes later, the pack had moved the best part of 3 kilometres, and Will and Justin were left hot and very bothered in their trail. It had taken them an hour and a lot of sweat to do just half of the distance. Justin had been there before.

'Working on the ground and hauling kit is very challenging at these extreme-cold temperatures. Pulling a sled and carrying a pack of equipment at minus 25°C or below in thick snow quickly becomes tiring work, and the risk, in fact, is getting too hot and beginning to sweat. Long hikes like these

are often followed by hours of sitting very still, and a sweaty damp body is a disaster for the hours of sitting still. Managing your body temperature and clothing layers becomes a fine art. Spare dry socks tucked in an inside coat pocket are a simple delight!'

Over the next few days, the team tried to pre-empt the direction the wolves were heading and drop the ground crew ahead of them. They also tried to sneak up on them when they were preoccupied with the bison, but all approaches had varying levels of disappointment. Jamie knew exactly what they had to keep looking for.

'To find wolves, you look for tightly packed bison. A herd does not want to run away as this is when the wolves have a chance to bring them down. The wolves will sit by a herd for hours or even days waiting for a chance to get them running. They make short runs trying to spook the herd, but on our last morning, before we had to head out of the park, we finally found a tightly bunched herd and, sure enough, the wolves were there, but this time they were not sleeping, but circling. Then, the bison suddenly made a break for it.'

Will realised they had a real window of opportunity.

'I was in the spotter plane, and we had seen the wolf pack harassing the bison. The helicopter scrambled with ground and aerial teams aboard and raced to the location. Making a snap decision, we dropped the ground team as close to the action as was safe, then took off again to attempt to film the hunt from the air. The ground team could only prepare the kit, sit and wait.

'I remember watching and taking in the scene as it unfolded far below me – it was everything we'd waited nearly a month to witness. The wolves had got the bison on the run, and the process of singling out a target had begun. The wolf tag team and bison cut through dense willows like they were grass. All the while both species galloped through the deep snow relentlessly: how many miles they covered in that chase I don't know, but the speed and unwavering endurance of both species was quite frankly terrifying. I tried to imagine the sounds of panting wolves and snorting bison moving with the effort I now knew was required. It was astonishing. It made me realise that for both predator and prey adapting to and surviving this frozen world wasn't just about thick fur and finding food; it was also about power, endurance, strategy and more.

'As I sat, awe-struck, the action was ebbing and flowing across a huge area. Slowly but surely, the wolves gained the upper hand, running in the trail of a lone bison. When it became exhausted, the wolves took hold and anchored it to the spot.

'At the end of the hunt, there was almost no trace of the bison – just horns and a fur-laden patch of snow remained – and the well-fed wolf pack moved off and out of sight. We picked up the ground crew, flew back to base, packed up our kit, and flew home the same day. Talk about down to the wire!'

Foxes at 3 O'Clock High

To the north of the wolves' territory is the tundra. In winter, it is a very exposed and hostile place to be, yet there are animals that have found ways to survive even here. Super cute, but also super tough, is the Arctic fox, undoubtedly a chionophile: an animal adapted to thrive in ice-cold winter conditions. Curled up and resting in the snow with a thick white tail covering its nose and eyes, the fox could easily be overlooked, its pure white fur blending in so well with the snowy background.

The fur is not only a useful disguise, but it is also incredibly warm: 20,000 hairs per square centimetre compared to 200 on an average human head. The fox is also relatively small compared to, say, a red fox, and it has small ears and short legs, so it has a low surface-area-to-volume ratio, which loses less heat. The blood vessels in its well-insulated legs and fur-covered feet work as a countercurrent heat exchange system. The artery and vein in each leg are close together so the warm blood in the artery transfers its heat to the vein and is not lost through the soles of the feet. It means, of

BELOW By cocking its head, an Arctic fox can locate the precise position of any sounds made by Arctic lemmings under the snow.

course, the fox has permanently cold feet, but maybe that's a small price to pay for having a warm body.

Coupled with this is an ability to lower its metabolic rate by something in the region of 25 per cent compared to in summer so, when curled up in the snow or in its snow den, it ticks over, using considerably less energy, a useful adaptation when food in the dark days of winter is hard to come by. At some point, though, it has to find something to eat.

In winter, there's not a lot of food on top of the snow, except maybe the frozen carcasses of dead animals, but underneath there is a surprising amount of activity. This is the domain of tiny lemmings. Despite their size – no bigger than a hamster – and their need for fresh moss and other greens, these lemmings don't hibernate. They can remain active throughout the winter because they live in a labyrinth of tunnels they create between the ground and deep snow. Insulated by the snowy blanket, they can be warm and cosy, even though it's minus something ridiculous outside. Their plant food is readily available on the floor of the tunnel, so they have no need to venture out, which means they're not easy to catch.

BELOW Lemmings occupy long tunnels beneath the snow. The floor of the tunnel has the vegetation on which they can feed even in winter.

ABOVE Having located
the sound of a lemming's
footfall or a giveaway
squeak, the fox dives
head and front feet first
into the snow.

For a start, a lemming tunnel can be as long as 15 metres, and the little rodents could be anywhere along it. Pinpointing them would be difficult if it weren't for the fact that they just don't know when it's time to be quiet. The fox has extremely sensitive hearing that is tuned in to the high-frequency squeaks of lemmings and the pitter-patter of their tiny feet, even when they are a metre under the snow. And, having located a disturbance, the Arctic fox then does the most extraordinary thing: it leaps high into the air and dives down headfirst, hitting the snow with its front feet and pointed snout; and if that fails, it does it again, and again, until it finally grabs and hoists out a lemming from its hideaway.

The depth and quality of snow is critical. Foxes are less likely to catch a lemming under hard, deep snow, although foxes that dig rather than dive might have more success. Lemmings, though, are not a given. During the winter, Arctic foxes have been known to travel enormous distances across the tundra and on the frozen Arctic Ocean in their relentless search for food, as one young female did in 2018.

ABOVE If at first it doesn't succeed, the fox will try, try, try again. It might dive into the snow many times during the day before it is successful.

In March that year, the fox was tagged by scientists in Spitzbergen, in the Svalbard Archipelago to the north of the Norwegian mainland, and by July, they had tracked her across the Arctic to Canada's Ellesmere Island. She was leaving the place where she'd been born and then heading out to find a suitable place to call 'home'. Overall, she travelled a staggering 4,415 kilometres, one of the longest dispersal events ever recorded in the Arctic, and she did not hang about. She covered on average about 45 kilometres a day, although on one single day walking across the ice sheet in northern Greenland, she travelled 155 kilometres, the fastest movement rate recorded for this species… and that was not all.

The young fox came from a family of coastal dwellers that do not usually catch lemmings. They rely directly on the Arctic Ocean for their food, sometimes scavenging on polar bear kills. When she reached Ellesmere Island, however, she switched ecosystems and diet. She began to catch lemmings – a remarkable story of tenacity and adaptability, and a fascinating bit of science.

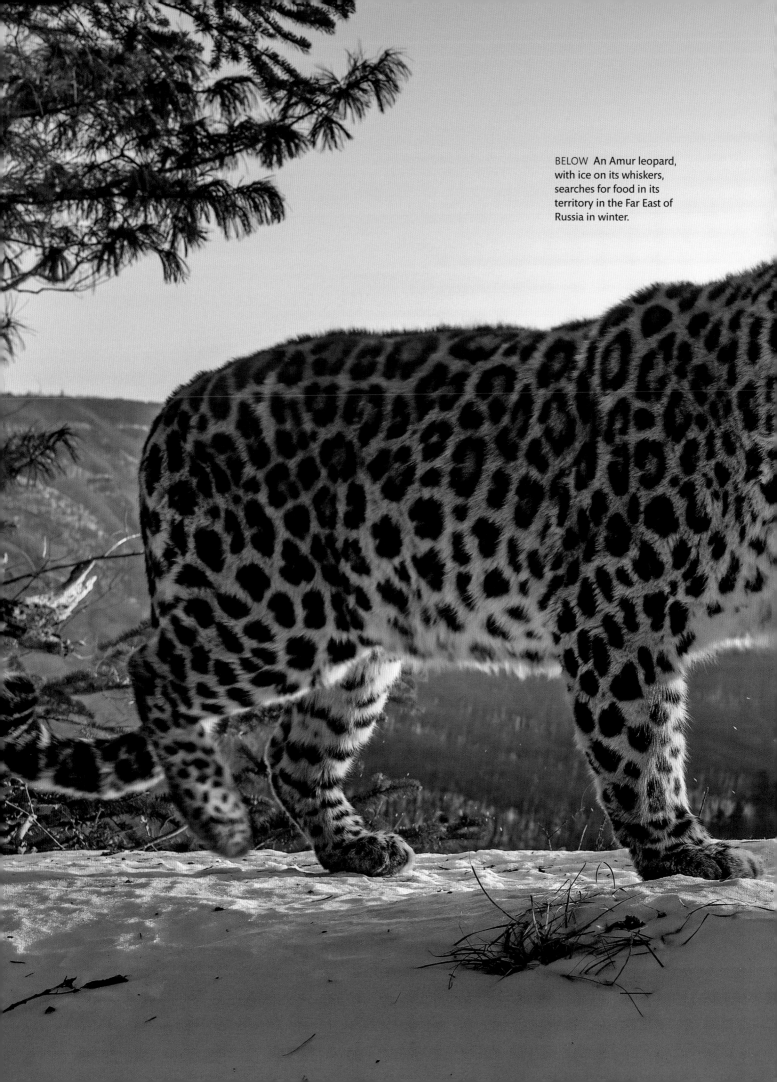

BELOW An Amur leopard, with ice on its whiskers, searches for food in its territory in the Far East of Russia in winter.

Two Cats, One Forest

To the south of the tundra lies the Great Northern Forest – a belt of coniferous forests that circles the Earth in the cold sub-Arctic region. In North America they are also known as the boreal forests and in Russia, the taiga, and living in the Far East of Russia is a predator of the forest that, when not bringing up cubs, is something of a loner – the Amur leopard.

Recognised by its large size, thick winter fur – paler than that of other leopard subspecies with large widely spaced, thick-rimmed black rosettes – and a large furry tail, it is built for the cold. Its large paws are like snowshoes so it can walk in the snow without sinking in too far, yet it is surprisingly

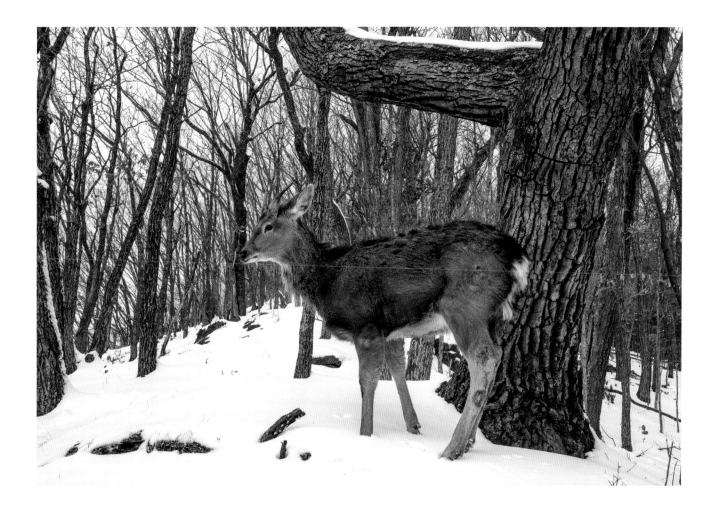

ABOVE Amur leopards and Amur tigers compete for the forest's population of deer, their main prey in winter.

agile, credited with an ability to leap about 6 metres horizontally and 3 metres vertically and to run at speeds up to 37 mph.

This subspecies of leopard, though, is exceedingly rare and extremely shy and cautious, but one place it can be found is the Land of the Leopard National Park at Primorsky Krai, a transition zone between the conifer forests in the north and the broad-leaved forests to the south. The park nestles between the border with China, marked by the Ussuri River, and the shores of the Japanese Sea, isolated from the rest of the world by high mountains and steep valleys – a true wilderness.

The Land of the Leopard is also one of the richest hotspots in all of Russia for biodiversity, with vast rocky uplands and flat-topped hills on which grows a mosaic of trees – black birch, Amur fir, poplar, Siberian spruce, Manchurian linden, ash, Mongolian oak, broad-leaved Manchurian walnut, and enormously tall cedars, each giant with its own microclimate. Its forests teem with life, including such rare predators as the yellow-throated marten, leopard cat, Asian black bear, and that giant of the cat world, the Amur or Siberian tiger.

In early winter, blanketed with snow, the forest may look deserted, but there are many animals scratching a living, such as the several species of deer, and even though the forest is bordering the southern edge of the taiga, the temperature here can drop to minus 20°C. This cold weather, as you might expect, claims the lives of those too frail to cope. One animal's misfortune, though, can be another's gain. As often as not, the first animals at a carcass are crows, but, crows being crows, they fail to keep quiet about their find. They are typically chatty, and caw incessantly, their calls alerting other meat eaters, including the Amur leopard.

Silently, almost ghostlike, the leopard creeps out of the forest, pauses, and looks around suspiciously, before walking slowly and deliberately to the food and sniffing it, just like domestic cats do. It is cautious probably because, while walking and scent marking, it might have come across signs – a tree with large scratch marks over 2 metres above the ground and the distinctive odour of another big cat – that a tiger's territory overlaps with its own, and the noisy crows could well have attracted the bigger and

BELOW The body of a stag, having succumbed to the cold, is a feeding opportunity for leopards, but they have to watch out for tigers, which could kill them.

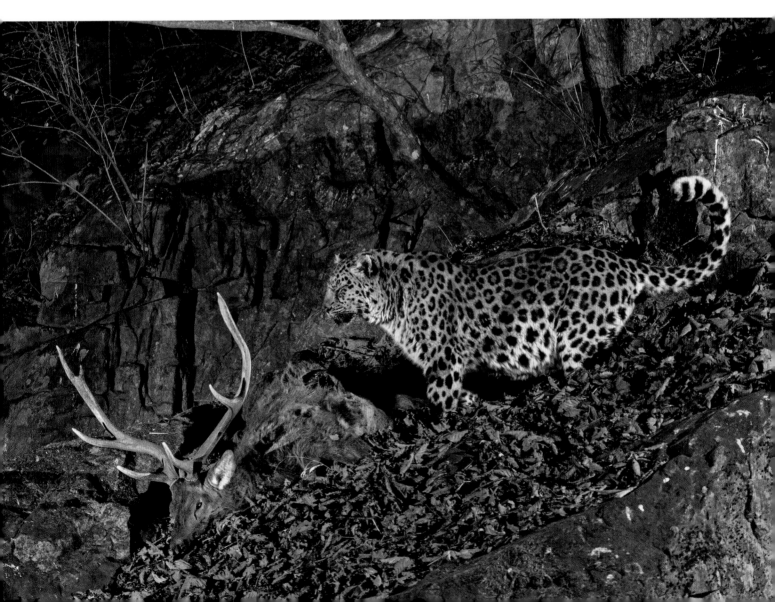

OPPOSITE The Amur or Siberian tiger is the apex predator in these forests.

more powerful cat to the same place. However, this may be one of the few places on Earth where the two species share the same forest and walk the same trails, but there is one thing they won't share – food.

The leopard more usually hunts deer for itself, bringing down prey on average three times a month, but scavenging is less energy-intensive: big cat convenience food. It pulls delicately at the fur, the meat underneath having frozen almost solid, maybe one reason why the birds need a helping hand, but the leopard is nervous due to their constant crowing. There really is the danger that they summon the larger cat. The leopard pauses, looks around, then quietly slopes off from whence it came.

That Amur leopards are still present here is a miracle in itself, as this animal is living at the extreme northern edge of its range, where there are not many leopards left. The Amur leopard is listed as critically endangered on the IUCN Red List. With populations devastated by poaching for the cat's fur and bones, individuals killed for raiding deer farms involved in the antler velvet trade, and its habitat destroyed by deforestation, there are estimated to be close to 120 individuals in the Land of the Leopard National Park, plus an unknown few in China, making it one of the rarest cats on Earth. At the turn of the century there were just 35, so the setting up of the national park to protect them is a real plus. Conservation efforts here have been so successful that Amur leopards (and tigers) are now finding territories over the border in China's Hunchun National Nature Reserve, once part of their historic range. It is hoped they will start to breed there too.

However, while Amur leopards are not yet out of the woods despite the conservation work, at one time they were not only more common, but also more widespread. They could be found living in the southernmost parts of the Russian Far East, northeastern China and much of the Korea Peninsula, and they turned up in some surprising locations. During the 19th century, in what is now South Korea, Amur leopards co-existed alongside people in the city of Seoul. Daytime hiding places were abandoned palaces inside the walled city and they fed on stray dogs, a pattern of behaviour repeated in villages and towns all over the Korean Peninsula, and it is thought they had been doing so since at least the 15th century. Then, things changed. The cats were no longer welcome, and local hunting was allowed to eradicate them. They survived in remote mountains, but they were extirpated on the peninsula by the 1970s. Today, they are only found in the wild in these small protected areas on the China–Russia border.

Although Amur leopards and tigers suffered badly during and after the Russian Revolution and during the fall of the Soviet Union, both species are now nurtured, and the hunting of their prey is regulated. Against all the odds, both have now been allowed to live in these secretive snow-covered forests.

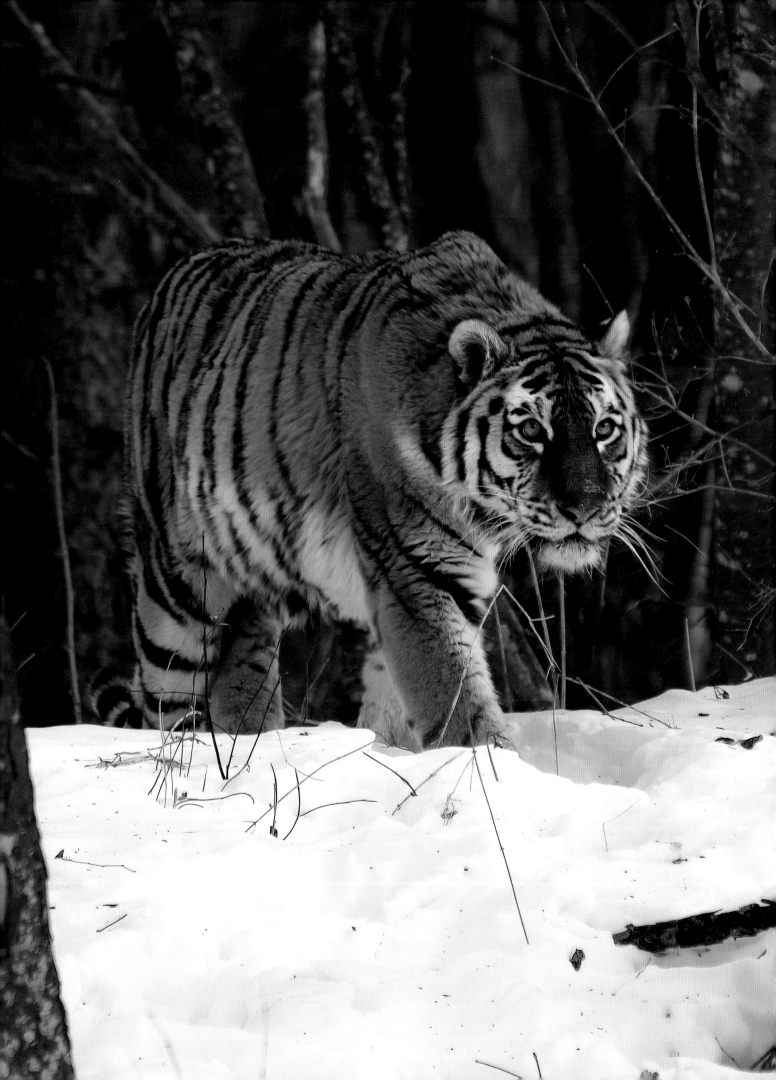

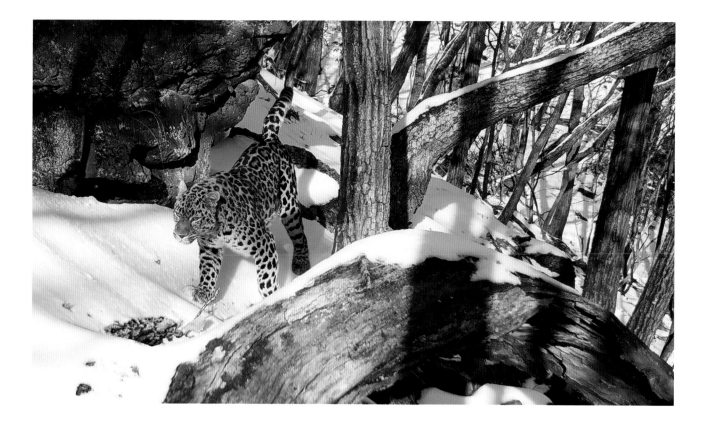

OUT IN THE COLD
PRIMORSKY KRAI, RUSSIA

Working with a local guide and tapping in to his knowledge of the Land of the Leopard National Park, our production team identified a site where leopards might be living. It was then down to Russian wildlife photographer Sergey Gorshkov to find and photograph the cat, something easier said than done.

'Our leopards are cautious,' says Sergey, 'so it's virtually impossible to see one in the wild unless, of course, it wants to be seen. It prefers to observe you surreptitiously from a distance without betraying its position.'

So, to get pictures of such a secretive cat, Sergey deployed camera traps. These are cameras triggered by an animal's presence; in effect, it takes its own picture, but knowing precisely where to place them is key.

'Hills with rocky slopes are the best places to look for leopards. Amur leopard trails generally run along the edges of high plateaus and ridges with a large number of crags. Leopards favour steep, uneven slopes, so they avoid unexpected encounters with tigers that tend to walk through the hollows and river valleys below. Both dislike walking in deep snow. During the winter, they frequent the south faces of hills with less snow, which their prey – deer and wild boar – also prefer.'

ABOVE The leopard follows a regular trail through the forest.

OPPOSITE The tiger uses the same trail as the leopard. Both scent-mark the route, so they both probably know that the other is present in the same area.

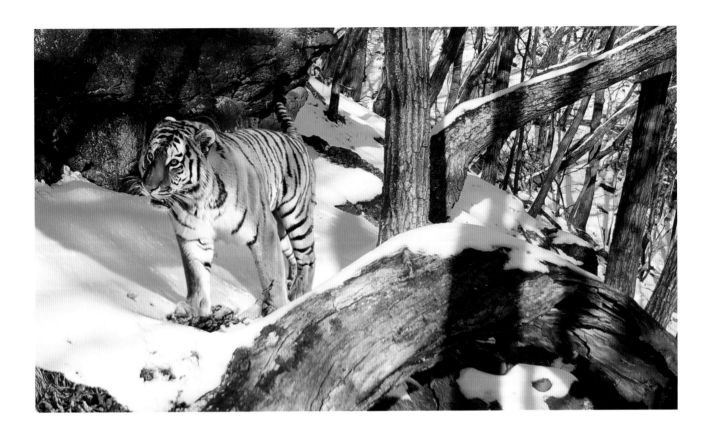

After much searching and constantly looking for tell-tale signs, such as a scratched tree or footprints on the ground, Sergey came to a cliff-edge site with a view out over the Ussuri taiga, where he was sure a leopard must walk. He set up the camera, and waited, visiting the site every three months to check the camera.

'In the end, the camera stood there for 729 days, but it mostly took shots of deer, particularly in summer, because the wind provided some relief from the midges and mosquitoes. Around once a month, leopards came too, but none of the shots was ideal. Then, in February 2021, I went back to check my camera traps and finally got the reward – an Amur leopard walking in freshly fallen snow through the line of sensors, captured perfect against the backdrop of a snow-covered Far Eastern taiga valley. It felt like a late Christmas present!'

And there was another: by staking out the trail, Sergey was able to obtain pictures of first a leopard and then a tiger not only using exactly the same path, but also placing their feet in roughly the same places, as the compacted snow of a footprint makes it easier to walk in deep snow. Capturing such images of two of the world's rarest big cats living in the same part of the forest is quite remarkable, and a huge credit to the team and their local support.

Frozen Alive

ABOVE **In midwinter, the turtle hatchlings are almost frozen solid, but not entirely. Only the fluids between cells freeze. The cells themselves are unaffected.**

MIDDLE **In spring, the young turtles begin to thaw.**

OPPOSITE **When the hatchlings emerge from the nest, the first thing they do is hide.**

Winter can throw up some really strange stories, and the behaviour of an animal that inhabits ponds, lakes and slow-flowing rivers in Canada's northern forests almost beggars belief. It's the painted turtle, and it ranges from the Great Plains in the south to the boreal forest in the north. That a freshwater turtle could be living so far north, however, is remarkable in itself; after all, as a 'cold-blooded' animal unable to regulate its internal temperature, it needs the sun to be energised. Although there's plenty in summer, there's not a lot in a northern winter, but it can survive here by opting out when the water temperature of its pond drops below 15°C.

Just before winter closes down the forest, the adults burrow into bottom sediments and, when the water freezes over, they are able to remain there in a state of torpor, without breathing, for several months. A small amount of oxygen can pass through the skin, but the reality is that the animal must survive in an environment with little or no oxygen. It does this by reducing the metabolic processes within its cells, and also uses the buffering capacity of its shell and skeleton to neutralise the large amounts of lactic acid that build up. With these mechanisms, the turtle can survive for three to four months at 3°C with no oxygen. It's the most extreme anoxia-tolerant living tetrapod, and studies of its physiology could help us understand how to protect our hearts and brains from low-oxygen damage. Turtle hatchlings are even more remarkable, and they behave in a very different way during their first year of life.

Although they hatch out in September, they remain in their nest chambers on land, and are buried beneath sand and snow throughout the entire winter. Temperatures can drop to minus 10°C, but the hatchlings seem

unperturbed. Some of them super-cool, which means the temperature of the water in their cells can drop to below its freezing point without forming ice crystals. They achieve this by eating soil and eggshell which provide them with ice nucleators – just like the trees. It's the first thing they do when they hatch, and the cryo-protectants they ingest prevent the water inside their cells from freezing and causing damage. Only the water outside the cells freezes, so they do not freeze solid. Even so, about 60 per cent of the animal is frozen, including the brain and the heart. In this state, the baby turtles show no signs of muscle movement, no heartbeat, and therefore no blood flow. It is remarkable that they stay alive, but they can only do so if it is icy cold. The hatchlings' mother provides each one with a packed lunch of yolk, which must last until spring. If there are too many warm spells during the winter, it can cause the hatchlings to thaw, triggering an increase in their metabolism, and so the yolk will be used up too quickly; so, for this reason, painted turtle hatchlings are potential casualties of climate change.

If winter is 'normal', the slower metabolism enables them to emerge at the best time in spring when conditions are favourable for feeding and growth. As the nest thaws, taking anything between 12 and 48 hours, the hatchlings thaw too. At about 4°C, they can begin to move their limbs and by 10°C start to move around, and the first thing they do is hide. Many predators would relish a baby turtle, but eventually, when the coast is clear, they'll emerge into the sunlight for the very first time, several months after they first hatched. If they avoid all the dangers that crop up in a turtle's life, they might live until they're 50 years old, and at each crucial stage in its life cycle the painted freshwater turtle does something quite remarkable and unexpected. What a way to live in the cryosphere!

The Snow Queen

The tundra in winter is undoubtedly not a comfortable place to be. It is dark for much of the time, hard-packed snow and ice cover the ground, and even the upper layer of soil is permanently frozen. Hidden in a hole under the ground, however, lies an unexpected resident: a Lapland bumblebee queen. She will have hibernated there for close to nine months, out of the way of the worst of the weather, during which her body is all but frozen. So harsh are the conditions that about 50 per cent of the population are thought to perish but, in mid-June, she is one of the first spring insects to appear, even when there is snow still on the ground.

The trigger to get a Lapland queen moving is the rising air temperature, but her emergence and her first flight, which can be in near-freezing conditions, is all down to her large flight muscles and being able to 'shiver'. Put simply, the muscles pulling the wings up tense against those that pull the wings down so the wings don't move. By vibrating these muscles in this way, the bee is able to bring her body temperature up to its minimum flight temperature of 30°C, and even as high as 38°C – comparable to a human body temperature – and she can do this in just six minutes. To retain that heat she has a thicker 'fur' than most other bees, trapping more than 50 per cent of the heat that otherwise would be lost. In this way, she can be on the wing, flapping them at a staggering 200 times a second.

The queen's first job is to find a nest site, such as an old burrow previously occupied by a tundra vole or lemming. It is about 10 centimetres under

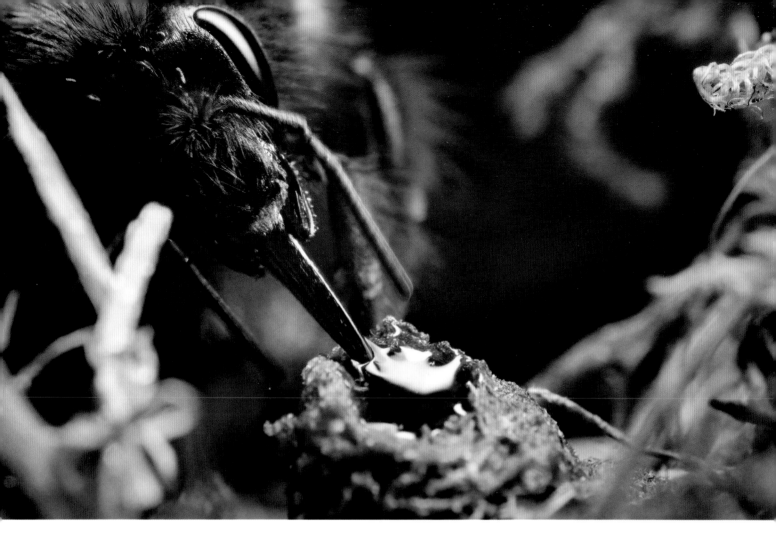

the ground and at the end of a 1-metre-long sinuous tunnel. This is her summer base, from where she can go foraging. By being on the wing so early, she is able to take advantage of the first Arctic flowers to appear as the snow melts, collecting pollen from louseworts, avens, willow catkins and saxifrages. She also feeds from any flowers with plentiful supplies of nectar because nectar is what makes her tick.

The bumblebee stores nectar in her crop, sometimes known as the 'honey stomach', which is also her fuel tank. Not only does she take nectar back to the nest, but also there's a valve that enables some to drip into her own digestive system, which she uses to fly. A full tank gives her 40 minutes in the air, but to fill it up requires a lot of effort. The flowers she visits may contain as little as 0.001 millilitres of nectar, and to fill up she'll need about 0.06 millilitres, which means she has to suck nectar from 60 or so flowers, but visit more than 100 as they'll not all have nectar readily available. And then she has to return to her nest, which might be 5 kilometres away.

She'll fly in all weathers, even in drizzle and light snow, and if the wind gets up, say, higher than 20 mph, which it frequently does, she will fly lower than usual, less than 2 metres above the ground. During high winds, blizzards and lashing rain, she sits it out, but as soon as things settle down she can continue her foraging and maybe warm up her developing offspring as she flies. While heat for flying is stored in her thorax, the Arctic queen bee can also transfer heat to her abdomen, where her eggs are developing

inside. In this way, she can pre-incubate her eggs and save precious time – at least, that's the theory, although it has yet to be proven.

In the meantime, she has to create her entire kingdom from scratch, and her initial job is to get the nest ready for the first batch of workers. For this, she forms a tiny ball of pollen, food for her larvae, and a single wax cell that she fills with nectar, fuel for when the first workers emerge. She lays a clutch of half a dozen or more eggs in the ball ready for incubation, but there's a fundamental problem: much of the ground beneath the nest is frozen, so somehow the queen bee has to keep the nest and her eggs warm in order for them to develop. The answer is to insulate the nest well, say, with material left behind by the previous owners, and then shiver. The queen maintains a nest temperature of 25–30°C, again by vibrating her flight muscles. She then uses her abdomen to incubate her eggs, much like a bird, moving the muscles of her body to help keep them warm. Inevitably, during the 15 to 30 minutes that she goes foraging for nectar, the temperature of the nest drops by about 7°C so, for the next few weeks, this single parent works around the clock, torn between gathering enough nectar to fill her honey pot with keeping her brood from freezing to death. If she mistimes it, all her

BELOW Bumblebee queens fly in most conditions, but the smaller workers sit it out in bad weather.

ABOVE Rather than a barren landscape, in spring and summer the Arctic tundra comes alive with carpets of flowers.

work will be in vain. Often as not, however, the queen's dedication to her incubation duties mean that her brood of eggs do, indeed, develop into tiny silver worker bees, just as the tundra is losing the last of its snow and yet more flowers are blooming.

By this time, the first workers have the combined shivering capacity of many bees, with the nest ticking over at a steady 35°C for the rest of the summer. They forage, expand the nest, clean up, and look after the next batch, with Arctic nests generally having no more than two batches of workers each year.

These sterile females are smaller and less hardy than the queen. They get going at a higher minimum temperature and stop flying when it drizzles. The governing factor is the amount of nectar the bee can store in its crop. The larger queen has more nectar so she can perform in a greater range of wind and weather conditions. Later in the summer, which can be as short as two or three months for the most northerly Arctic queens, she produces a third batch of eggs which hatches out as drones and fertile females that are potential queens or gynes (queens without a nest) for the following year, but alas, only one gyne per colony is likely to survive. Nevertheless, the synchrony of the seasonal timings that this little bee achieves is very impressive, not least that it can survive frozen throughout the long winter, then emerge and create new life in just a matter of weeks during the very short spring and summer.

Throughout her life, the Arctic bumblebee queen is built to survive in a harsh and unforgiving environment like the tundra, so when things get out of kilter and the environment heats up this insect can be in trouble. During heatwaves, which have become increasingly frequent in the Arctic in recent years, the bee does the strangest thing: it falls on its back and its legs spasm. It'll remain like this for three or four minutes, after which 50 per cent of bees

die. Heat can also affect the nest; higher than usual temperatures mean that the workers must fan more with their wings to keep the temperature down, and they are therefore not foraging. Less well-fed colonies are more susceptible to heat stress, so things can quickly spiral out of control and the entire colony perish. For now, this is not a pan-Arctic problem. Some parts have yet to experience heatwaves, but other parts do. On the day of the summer solstice in 2021, ground temperatures (rather than air temperature) in Siberia reached a sizzling 48°C, an increase on the previous year, so this could be a trend. It makes life for Arctic bumblebees very uncomfortable indeed, and the queen is unlikely to be alone with her unease because, under the feet of the Arctic's wildlife, the ground is crumbling.

OUT IN THE COLD
SWEDISH LAPLAND

In northern Sweden, our production team filmed the Lapland bumblebee queen in and around her nest for the very first time. Finding a tiny bee in the vastness of the tundra was one thing, but finding her underground nest was quite another, so it was an exciting moment when Dutch wildlife photographer Joris van Alphen came across a nest. Directing the sequence was Yoland Bosiger.

'Filming inside the queen's little nest was a real struggle. It was pitch black and needed to be so in order that the queen felt safe and undisturbed as she tended to her eggs. To stand any chance, the film crew worked hand-in-hand with scientists who studied the bees and used new specialist low-light cameras to see what was, in effect, the invisible. However, the footage was so revealing that it led to the entire crew being quoted as co-authors in a subsequent scientific paper.'

RIGHT According to a study of insect pollinators in Swedish Lapland, bumblebees, more so than other flying insects, are key pollinators on the Arctic tundra.

That Sinking Feeling

Since the end of the last ice age, much of the tundra's frozen ground is held together by frozen water and is known as permafrost; but large areas of permafrost have started to thaw out, and ice that used not to melt is now melting. Permafrost might seem simply a pile of frozen dirt in a remote part of the globe, so you could well be thinking, 'Why should I be worried what happens to it?' Well, consider this: the Arctic permafrost region is 1.8 times the size of Europe – 18 million square kilometres – and locked away in it is twice as much carbon as in the atmosphere or, to put it another way, the equivalent of about 150 years' worth of current fossil-fuel emissions. If it thaws, the organic matter of dead plants thaws too, and this is decomposed by microorganisms, releasing large quantities of potent greenhouse gases – carbon dioxide and methane, together with nitrous oxide recently identified from thawing permafrost in Russia. As this seeps into the atmosphere, it causes the planet to warm up even more than it is already.

It is not universal. In some parts of the Arctic, such as northern Sweden, carbon emissions have actually declined from the relatively thin permafrost layers. Here, the thawed soil dries out and both vegetation and microbial life changes, which reduces the amount of escaping greenhouse gases. Generally, though, where and when there is a thaw in deep permafrost, greenhouse gases

BELOW In spring, while the wildflowers were blooming, the slump being filmed in Arctic Canada was already eroding.

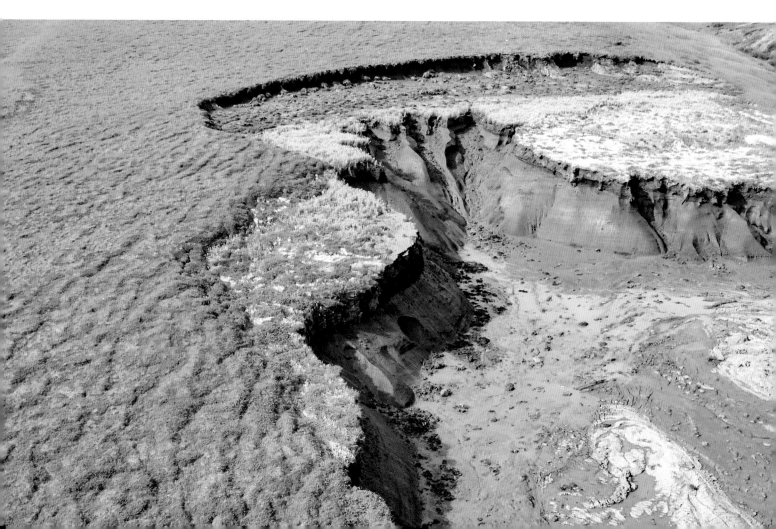

are released, and the scary thing is that the big thaw is already happening, and it is due to a general increase in temperatures across the Arctic, the rate of warming beyond any natural cycle of warming and cooling. At one time, it was thought that the most northerly tracts of Arctic tundra would escape thawing, but research is showing otherwise. Some of the most northerly areas of the Alaskan and Canadian Arctic are already showing signs that the top layer of permafrost is starting to thaw, even though the temperature deeper down is still minus 14°C. At Deadhorse, on the North Slope of Alaska bordering the Arctic Ocean, for example, the ground temperature of the uppermost layers of permafrost averaged minus 8°C in 1988, but today the figure is minus 2°C. Elsewhere, the average is exceeding zero, therefore above the melting point of ice.

Time-lapse pictures show the impact of this at a place in the Canadian Arctic where the soil is crumbling away and 20-metre-high landslides cascade down, leaving an enormous scar in the landscape. Known technically as a 'slump', the sped-up pictures show how fast it expands during the course of a single summer, and how the soil, lubricated by the melted ice, flows rapidly as liquid mud.

Slumps can occur naturally, when there have been big changes of climate, such as the glacial and interglacial periods associated with the ice age, but these changes occurred over thousands of years. Even so, in more recent times, there are natural cycles of warming and cooling that can trigger

BELOW By the end of summer, substantial portions of the permafrost cliffs had collapsed and been washed away.

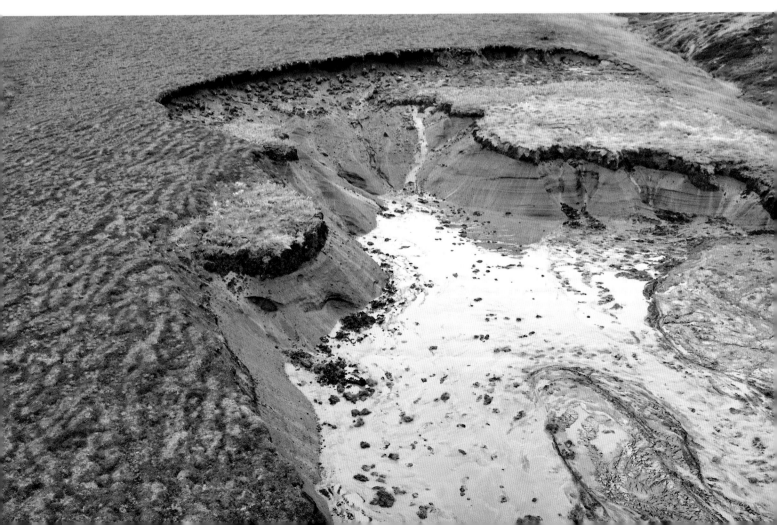

or stabilise slumps over periods of 30–40 years. During the most recent cycle, borehole measurements over the past 40 years have shown that the permafrost has been warming gradually and constantly. The problem now is that, with climate change, warm waves are warmer, which is leading to slumps becoming unstable, even though they were stable in previous warm spells. It means, aside from the impact on the tundra environment and its wildlife, the thaw is likely to negatively impact vital Arctic infrastructure, such as roads, railways, buildings and airports.

The biggest slump in the world – a mega-slump – is in the Russian taiga. Known as the Batagaika crater, it is a kilometre-long gash in the ground, about 70 metres deep, and growing at an average rate of about 10 metres per year, but which increases to 30 metres in warmer years. Local people know it as the 'doorway to the underworld', and it was originally triggered by deforestation, but now they are very much aware of why it continues to occur: the crater is about 90 kilometres from Verkhoyansk, where those record high temperatures occurred in 2020. Add to this the intensity and scale of wildfires across Siberia, such as those in the summers of 2014 and 2019, and even more areas have slump potential.

One of the unexpected knock-on effects is a reawakening of disease-causing microbes, as pathogens, such as anthrax, are nudged out of their dormant state and are killing off caribou, musk oxen and nesting birds in a few remote areas. Another is that slumps are occurring at the edge of the Arctic Ocean where permafrost below the seabed is thawing, creating deep sinkholes as big as city blocks in the sea floor.

Scientists are also concerned that we are starting to reach key 'tipping points'. One tipping point is that, between 2003 and 2017, the permafrost released far more carbon into the atmosphere than global vegetation absorbs, indicating the Arctic permafrost could be shifting from being a 'carbon store' to a 'carbon source', and that a positive feedback mechanism may be under way. Carbon emissions from the permafrost lead to warming that, in turn, thaws more permafrost, which leads to more warming, a self-perpetuating process.

The projections make for uneasy reading. It's thought that by 2100 one of two scenarios will play out: if we can limit global warming to well below 2°C, we can expect something like 25–30 per cent of surface permafrost (3–4 metres deep) to disappear; but, if fossil-fuel emissions continue at the current rate, 70 per cent of the near-surface permafrost is likely to thaw. Taking the Arctic region as a whole, it's been estimated that 10 per cent of surface permafrost has already gone.

RIGHT The slump, which was filmed throughout the summer, was a just a small section of a huge gash in the landscape.

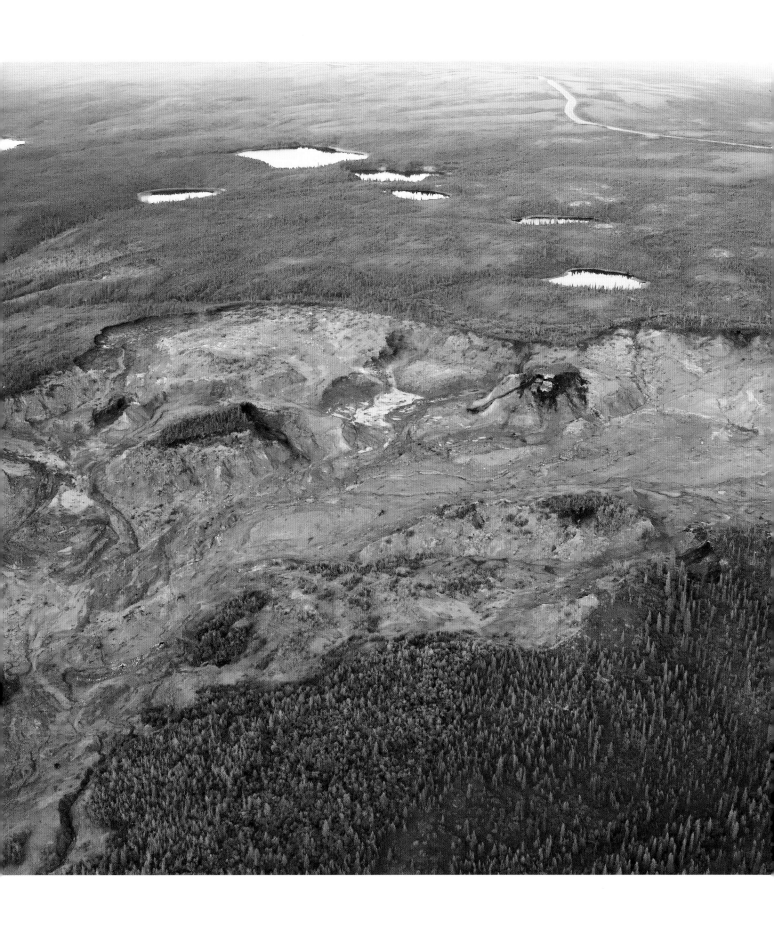

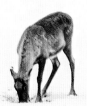

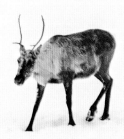

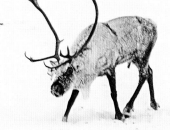

The Grand Trek

One animal on which the warming Arctic is having a profound impact is a subspecies of the North American caribou. These high-latitude deer live in the wilderness areas of Alaska, Yukon and the Northwest Territories and every summer, as they have done for thousands of years, several distinct herds leave their winter homes in the south, where they feed mainly on reindeer moss, to embark on epic migrations. Not all caribou migrate. Some herds living in the boreal forest stay put all year, but those that head north follow ancient pathways. Sometimes their footfalls are permanently etched into the ground, and their treks are some of the longest migrations that any land mammal undertakes, their numbers astounding.

There are close to 218,000 individuals in one herd alone – the Porcupine herd, named for the Porcupine River that flows through its range – and their destination is the broad coastal plain in northeast Alaska, known as the Arctic National Wildlife Refuge. The distance, as the crow flies, is about 650 kilometres between winter and summer pastures, although their zigzag course might mean an annual round trip of up to 4,800 kilometres.

ABOVE Individuals of the Porcupine herd travel through The Yukon in northern Canada. Both male and female caribou grow antlers, the mature males having the largest and most elaborate ones.

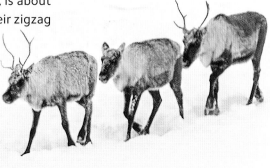

They will have spent the winter south of Alaska's Brooks Range, and in spring, just after the snow starts to melt, they set off for the north, timing their arrival on the tundra to coincide with the birth of the calves – all 40,000 of them – which means the females were travelling when they were heavily pregnant. Following not far behind them are the males and yearlings, so when they re-join the herd, there's quite a crowd.

The parents graze the pastures of newly sprouted cotton grass and other sedges, which are especially nutritious round about calving time, which is just as well as the calves must consume sufficient milk for them to be strong enough to make the return trip in the autumn. Everything is timed to the new growth, but scientists studying trends across the Arctic tundra are concerned that climate change is causing the seasons to be unreliable. One seasonal shift is that, in warmer years, tundra plants may erupt earlier in the year, so they could be past their best by the time the caribou arrive. If this continues, the result could be malnutrition, fewer calves being born and fewer surviving. But that's not all.

At the same time, mosquitoes are on the wing, synchronising their mass emergence with the arrival of the caribou. In response, the caribou move to the windier coastal areas or high up on mountain slopes to get away from them. It's something they've had to deal with for centuries but, as the climate warms, there are concerns that insects will breed earlier and reach plague proportions just as the caribou need to feed and rest in the tundra. In getting away from them, the caribou are not eating

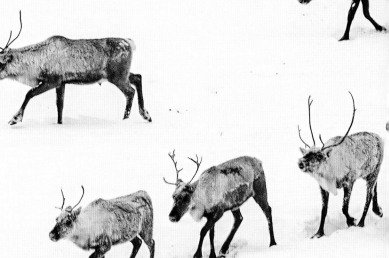

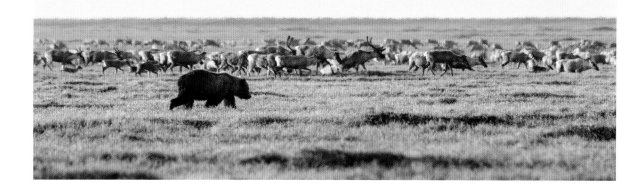

ABOVE A grizzly bear searches the caribou herd for young and helpless calves.

OPPOSITE TOP Caribou calves must be up and moving with the herd directly after they are born, or they get left behind.

OPPOSITE BOTTOM The herds cross many rivers on their annual treks north and south. Many are shallow enough to wade across, but if necessary, caribou are good swimmers. Their fur has hollow hairs for buoyancy and they have wide hooves for propulsion.

OVERLEAF A group of caribou from the Porcupine herd migrates across North Slope, Alaska.

properly and therefore not fattening up to help them through the winter. It also means milk supplies for calves could be reduced. It is just one of many changes that are having an impact on young caribou.

When crossing rivers on their trek to the coast or to high ground, a weakened calf can be separated from its mother and even washed away. If it doesn't find her again, its life will be exceptionally short, for waiting in the wings are grizzlies. Grizzly bears stake out river crossings. Even though they are as fleet-footed as a greyhound over short distances, they would be unlikely to pin down an adult caribou, but the sad truth is that, like a newborn musk ox, an exhausted and defenceless caribou calf is easy pickings.

And, if all that's not enough, with rain more likely to replace snow during the Arctic winter, it could be catastrophic for caribou. Rain falling on existing snow cover would mean a huge increase in surface ice, making it impossible for caribou to forage for their food underneath. It's just another not very obvious but highly significant event that could have enormous implications for the future of Arctic wildlife on the tundra and in the adjoining boreal forests.

Life in the Arctic depends on the annual cycle of the seasons, but it also depends on having huge areas of protected land, particularly in the key wildlife areas. In Alaska, for example, the Arctic National Wildlife Refuge is one of the least disturbed ecosystems on Earth, giving it global significance for wildlife and science, but it is also thought to hold considerable reserves of oil and gas, which makes it vulnerable to development. As many herds of caribou across the Arctic are declining, it is becoming clear to the scientists studying them that it is more important than ever to maintain and protect biodiverse areas like these, now and into the future. *Frozen Planet II* producer, Jane Atkins, adds:

'Having filmed in the Arctic from the depths of winter to the height of summer, you really get a sense of how critically important the short summer season is for all wildlife. From the tiny bumblebees busily pollinating the carpets of flowers across the tundra to the thousands of caribou and their tiny calves migrating, it's clear this Arctic ecosystem is interlinked, and that, if the great caribou herds reduce in number, as they have in many places across the Arctic, this will have a huge impact on the frozen lands in the extreme north of our planet.'

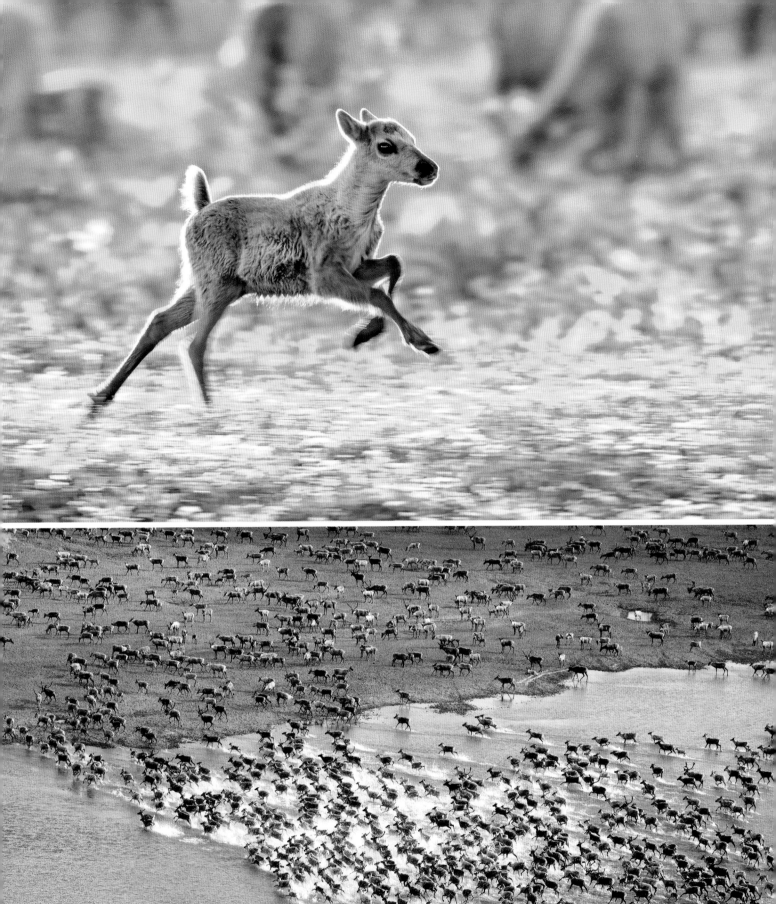

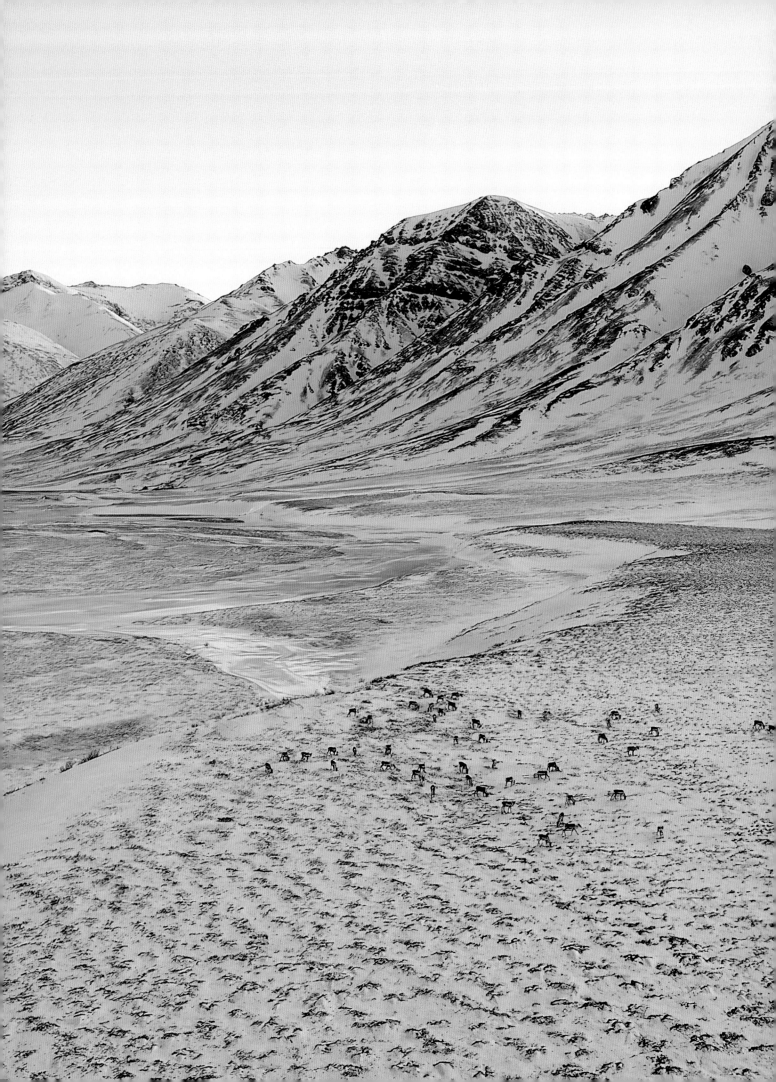

OUR FROZEN PLANET

OPPOSITE An Antarctic fur seal is joined by king penguins on the beach at St Andrew's Bay, South Georgia.

ANIMALS SURVIVE AND even thrive in the most inhospitable regions of our planet, where ice dominates and the cold could pervade every part of their bodies if it were not for the process of natural selection. The animals that live within the cryosphere exist because their ancestors acquired traits, such as layers of insulating blubber beneath their skin or antifreeze proteins in their blood, that have enabled them to live in such an alien environment. Those that did not fell by the wayside, the survivors passing on these advantages to their offspring. It is a process that generally takes thousands, if not millions of years to accomplish, but today the planet itself is evolving so rapidly that there is a big question mark over whether these cold-tolerant living organisms can become adapted quickly enough to keep pace with the current rate of change. Here, we meet some of the scientists who are on the front line, and they all share the same sentiment – a sense of urgency.

Greenland Ice Sheet

ABOVE Turquoise rivers of meltwater flow across the surface of the Greenland ice sheet.

The greatest challenge that the plants and animals of the cryosphere must face today is global warming, and nowhere are its effects more obvious and more troubling than in Greenland. About two-thirds of the island lies within the Arctic Circle, and its most northerly point is less than 800 kilometres from the North Pole. In winter, it is generally icy cold, but during summer, when temperatures increase right across the Arctic, the temperature on the island rises too. And the current trend of longer and hotter summers triggers a chain reaction that has dire consequences for people living 11,500 kilometres away on the other side of the world. To some extent, their future depends on Greenland's ice.

The Greenland ice sheet is the world's second largest ice sheet, and it covers nearly 80 per cent of the world's largest island. It has an average thickness of more than 1.5 kilometres, and parts of it are estimated to be over a million years old. The entire mass is something like 2.9 billion cubic kilometres of ice, a figure which at first sight might be meaningless to you and me, but actually represents more than all the other glaciers and ice fields combined, outside of Antarctica. Coastal mountains hem in the ice, but it can still move towards the sea in more than 300 glaciers that flow down through glacial valleys.

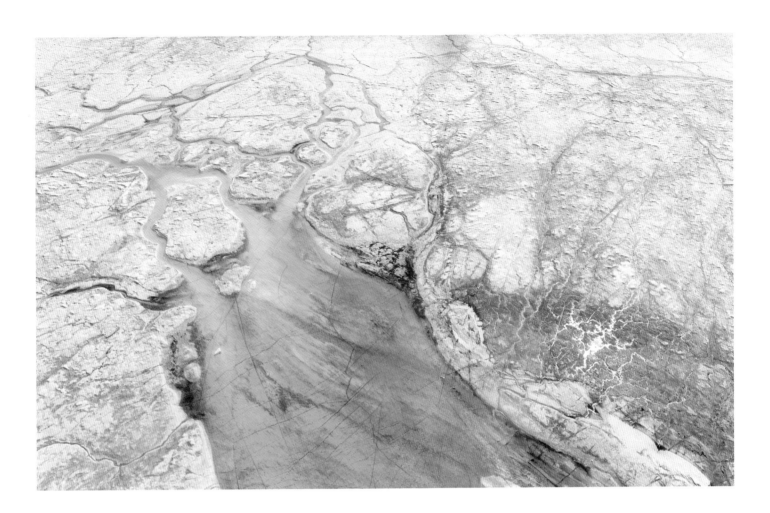

ABOVE Meltwater rivers fill lakes, their weight causing the ice to crack.

The 'normal' annual cycle of events is relatively simple to describe. It snows from September until spring, when temperatures are usually way below freezing, so more snow and ice accumulate than melt. In late spring, the air temperature increases, and so throughout the summer more snow and ice melt than are produced until the end of August. It varies, of course, from year to year, but the pattern of ice sheet and glacier formation is fairly consistent. The powdery snow is turned into crystalline snow, known as 'névé', and that which survives from one year to the next is re-crystallised as 'firn'. Then, over many years, the snow is compacted into dense ice by the weight of snow falling on top of it. In summer, some of it melts. This is normal, but the melt has increased significantly in recent years.

An early sign that all is not well in Greenland was the appearance on satellite pictures of spectacular patches of aquamarine on the stark white surface of the ice sheet. They start as ribbons of meltwater that crisscross the surface, and these rivulets flow into rivers which carve through the ice, feeding huge sapphire lakes over 8 kilometres across. The water looks blue because blue light is not scattered, and the water's purity, together with the white reflective background, intensifies the colour. They are striking to look at, some say beautiful, but the reality is they're portents of doom. Normally, the ice would reflect sunlight, but the darker colour of the pools absorbs more energy from the sun, and so increases the rate of melting. It

is a state of affairs that has alarmed polar scientists, and so the Greenland ice sheet is under intense scrutiny.

One of the scientists taking a close look is glaciologist Alun Hubbard, of UiT The Arctic University of Norway, and he has been looking at how the water flows across and through the ice sheet. Standing beside a raging torrent, flowing with the ferocity of a white-water river, he searches for places where the water plunges down from the surface to the bedrock below the ice.

'It's not a wide channel, but it's deep,' he says, 'so water is bombing through at hundreds of tonnes per second. These rivers don't look that big from satellites, but down here the sheer quantity of water shifting through the system is mind-blowing.'

In fact, the weight of all this water concentrated in huge lakes and fast-flowing rivers puts huge pressure on the ice below. Eventually, the stress causes ice quakes that tear cracks through the ice, known as 'hydrofracture events', and thousands of tonnes of water plunge down to more than a kilometre below the surface – potentially the world's highest waterfalls. Another glacial feature is the moulin, a sinkhole in the glacier up to 10 metres across, which also funnels surface meltwater to the base of the glacier, and, while the film crew were with him, Alun located a moulin in the process of being formed. It was a first for him, and the first time it has ever been filmed.

'You've got this massive river, and the water is finding the path of least resistance, sculpting a passageway. The mass of water actually generates heat by friction, introducing warmer water into the ice sheet itself, creating a shaft that goes deep into the ice.'

And to find out where all this water is going, Alun lowers himself into recently dried-up moulins and, in doing so, has discovered that they are not simple, vertical shafts.

'The water is heading off horizontally as well as vertically, so the system is complex, and the channels interlinked. It's more like the roots of a tree, with relatively warm water spreading throughout and fracturing the ice sheet far more quickly than a simple shaft.'

The result is that the water lubricates the underside of the glacier causing it to flow more rapidly over the land beneath it, and *Frozen Planet II* time-lapse videos, which compress many days of recording into just a few minutes of a moving glacier in western Greenland, show how the ice speeds along relentlessly. Eventually, the glacier runs out of land and pushes out over the sea. With the ice unsupported, it can do only one thing: it cracks and collapses into the ocean.

'There is a constant supply of huge icebergs being calved from the front of the ice sheet,' says Alun, 'so it's quite an intimidating place to be hanging out. It is a natural process, but what we've been seeing in the past 20 years is more melt and considerably more icebergs calving off.'

And to establish the amount of ice being lost to the ocean, Alun has been putting out his own time-lapse cameras. The results are telling.

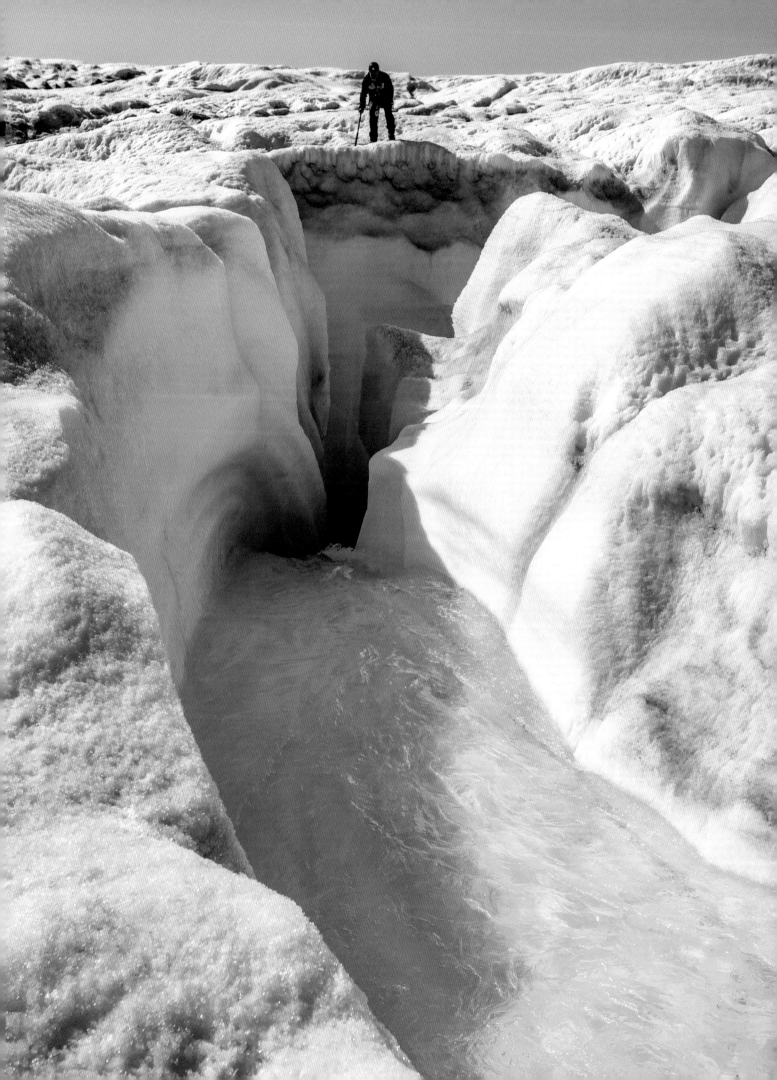

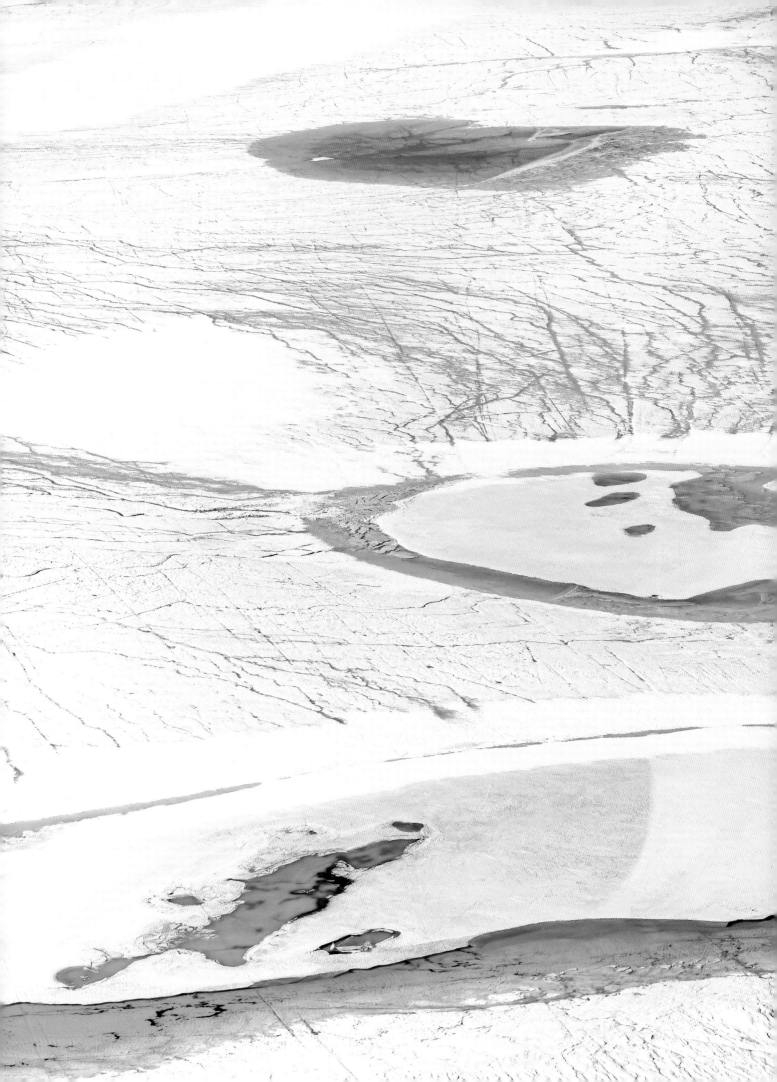

'We can see that the ice at the front can be moving in excess of 20 metres a day, which is fast, and when you think that an ice front can be maybe 6 kilometres wide and 500 metres deep, that's a huge quantity of ice discharged straight into the ocean.'

During a year, hundreds of gigatons of ice fall from Greenland's 178 major glaciers, calving icebergs up to 168 metres (almost as tall as the Washington Monument obelisk), the height above sea level of a record-breaking iceberg spotted in Greenland's Melville Bay from a US Coast Guard icebreaker in 1957. It was the tallest that's ever been recorded in the North Atlantic, and bear in mind this can be as little as one-eighth of the total height; another seven-eighths are below the surface.

Icebergs from glaciers on Greenland's west coast drift southwards through the Davis Strait and then via the Labrador Sea into the North Atlantic. One such iceberg was the infamous block of ice that sank the RMS *Titanic* in 1912. Of the 15,000 to 30,000 icebergs that calve from Greenland's glaciers only 1 per cent actually reach as far south as the *Titanic*'s course, so it really was a freak accident, and they still occur today, despite regular iceberg patrols. In March 2002, for instance, a shrimp trawler – the BCM *Atlantic* – hit a small iceberg, called a 'bergy bit', off the coast of Labrador, sinking the vessel. All the crew were saved. The hazard from icebergs, though, is not what really concerns people currently.

The clear reason for the catastrophic loss of ice is revealed in data from a permanent weather station Alun placed on a small rocky island in the bay of the Store Glacier. He took our film crew there on 31 July 2019.

'We put this weather station here in 2010, and the hottest temperature it recorded was just two days ago. It was 22.37°C, and that is very hot for Greenland. The ice sheet cannot sustain the onslaught of such hot weather year in and year out. When I first started working here, I thought the impact of climate change would be over

centuries or millennia, but now I'm absolutely confident that there's going to be at least a foot of global sea level rise in the next 80 years from this ice sheet alone.'

Confirming Alun's observations, the Danish Meteorological Institute recently announced that temperatures on Greenland were on average 10°C hotter than usual during the summer of 2021, and glaciers had lost double the average amount of ice.

The problem is that climate change caused by anthropogenic emissions of greenhouse gases, especially carbon dioxide, is having a profound impact on the region; something highlighted by what might seem a small thing, but which has huge implications for the future, and it was totally unexpected.

On 14 August 2021, rain fell at the US National Science Foundation's Summit Station located on the highest point of the Greenland ice sheet. It was the 'third time in less than a decade and the latest date in the year on record', according to NASA's National Snow and Ice Data Center, and this in a place 3,216 metres above sea level where the average annual temperature is minus 30°C and record-breaking low temperatures have occurred. Right here, the air temperature in midwinter plummeted to a northern hemisphere all-time low of minus 69.6°C. It was recorded at an automated weather station in the centre of Greenland on 22 December 1991. It eclipsed the previous record holders, Russian weather stations in Verkhoyansk and Oymyakon, which recorded minus 67.8°C in 1892 and 1933 respectively. On 14 August, however, the summer air temperature here rose above freezing for several hours, a very rare event, but one that scientists believe will become more common in the future. In fact, researchers at the University of Manitoba have predicted that, if there is no change in the rate of global warming and we head towards a global 3°C rise and not the 1.5°C agreed following the Paris Accord, by the end of the century the Arctic will be dominated by rainfall rather than snowfall, especially in autumn and winter.

To ram home the point, at the end of 2021, Greenland's winter temperatures rose unexpectedly too. In the capital Nuuk on 20 December, the mercury hit 13°C, when the seasonal average is minus 5.3°C, and on the same day it was 8.3°C at Qaanaaq in the north, where the average for this time of year is minus 20.1°C. The elevated temperatures were thought to be due to a natural weather phenomenon known as the 'foehn effect'. Foehn winds are dry, warm, down-slope movements of air, generally on the lee slopes of mountains. They are not uncommon in Greenland but are usually local. For foehn winds to sweep across most of the west coast and part of the east coast at the same time, as they did on 20 December, is very unusual indeed.

The result of this shift in climate is that many of Greenland's glaciers are already melting faster, travelling more rapidly on their lubricated bases, and calving icebergs at an increasing rate. A study of satellite data, by an international team of 89 scientists – known as the Ice Sheet Mass Balance Inter-comparison Exercise (IMBIE) and published in the journal *Nature* in

2019 – revealed that, since 1992, about 4 trillion tonnes of ice from the Greenland ice sheet had spilled into the ocean, which has caused roughly a centimetre rise in global sea level. Over the next millennium, this could translate into something even greater.

If the entire mass of ice in the Greenland ice sheet should melt, the global sea level could rise by about 7.3 metres, and one of the issues we face in our warming world is that the ice sheet is actually melting at a faster rate than it did in pre-industrial times. Overall, more ice is melting than is being replaced, so annually there is a net loss. It has been estimated that the Greenland ice sheet has lost more ice in the past decade than it did during the previous century. Project that into the future and the devastation is unthinkable. Already, people living in island nations, such as Kiribati in the Pacific, where most of the land is just 2 metres above sea level, are facing the death of their homeland and the prospect of having to be resettled elsewhere in the world. Looking further ahead, low-lying cities, such as Miami and New Orleans, could also disappear beneath waves. That's how important the future of the Greenland ice sheet is in a warming world.

BELOW These vast turquoise lakes, seen from space, were the first hints that something was not right with the Greenland ice sheet.

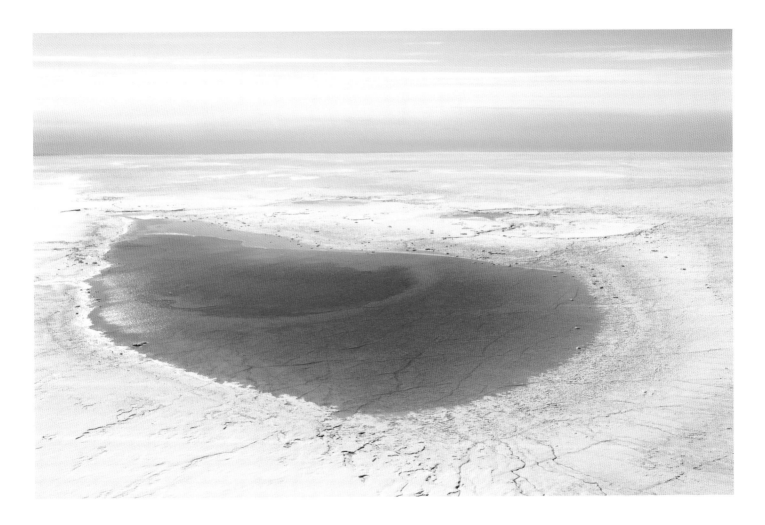

OUT IN THE COLD
STORE GLACIER, GREENLAND

Filming calving events on the west coast of Greenland, using drones, was camerawoman Helen Hobin, and, like almost all the shoots for the series, it was not without its problems.

'For weeks our little crew camped beside Store Glacier, watching for any signs that a glacier was about to calve, and it quickly became an obsession. With 24 hours of sunlight and a constant cacophony of creaks, groans and cracks from the ice, it was nearly impossible to switch off, despite working in shifts. When you were lying in your sleeping bag attempting to rest, the slightest bang would echo across the landscape and you'd find yourself torn between leaving your cocoon and investigating what was happening, so it was easy to go a bit mad on this shoot. The sun never set, the mosquitoes only eased off for a few hours around 2am each day, and sleep was but a fleeting moment.

'Our director, Sacha Thorpe, frequently sat hunched with binoculars glued to his eyes. Because light travels faster than sound, often by the time you heard the thundering crack of ice separating, it had already hit the

BELOW The production team camped out opposite the mouth of Greenland's Store Glacier, waiting patiently for icebergs to calve.

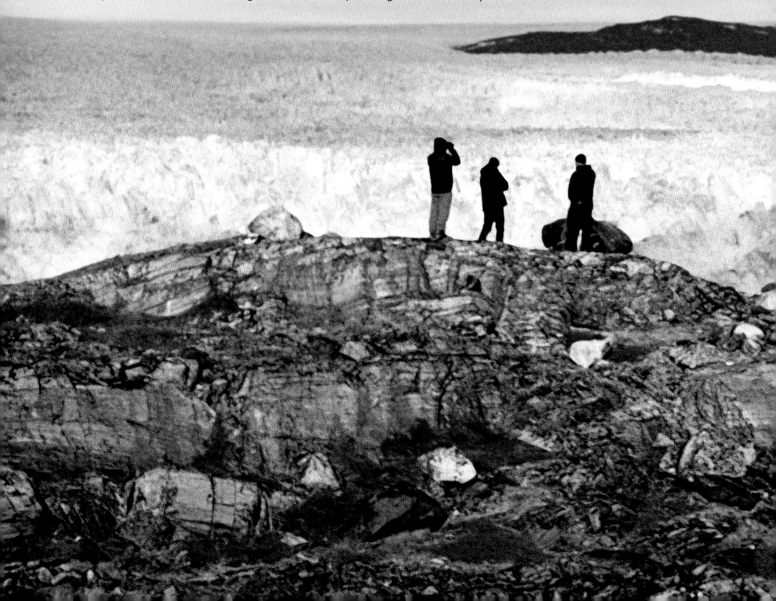

water. As the drone batteries only last a short time, and much of it is taken up by actually flying to and from the glacier front, it was a risky game to choose the best moment to take off. Fly too early and you're forced to bring the aircraft back just as everything starts. Fly too late and by the time you get out there, there's nothing to see. And once you actually have the drone in position near the ice front, the little aircraft is surrounded by hazards. Ice can surge up without any warning from below the surface, breaching like a whale, silent to us until it's already beginning to fall back down. Falling ice not only creates a tremendous splash, but it can also cause huge waves to roll towards a low-flying drone. Being hit from above by a calving iceberg could drop the aircraft in seconds, and then there's the powerful katabatic winds rolling off the vast expanse of ice.

'When the timing worked, however, it was an extraordinary feeling. I remember watching part of the front begin to crack, and instinctively curving the drone around to follow a particular piece. It detached and almost sank, only to rise out of the water constantly reforming its shape, a growing icy spike reaching higher and higher until it was catching the sunlight. Then it rolled and tumbled and reformed again.'

Landing on Thin Ice

ABOVE James Grecian searches for harp seal pups that rest on the ice off the east coast of Canada.

ABOVE RIGHT The research team's helicopter lands on the sea ice, but it must be a minimum thickness of 30 centimetres to support its weight.

While the Greenland ice sheet is composed of frozen freshwater, covering the Arctic Ocean is a floating platform of sea ice, which increases in area and volume in winter, but decreases in summer. In recent years, however, the extent of summer sea ice has dropped to less than half the area covered in the 1980s, yet it is the freezing and melting cycle of this ice that is important to all of the Arctic's wildlife, including those cute but vulnerable harp seal pups we met in Chapter 2. Their very survival depends on their early days on the ice, but with the summer thaw coming increasingly earlier, they are being spilled into the sea before they are ready, with huge losses in some areas. Monitoring how they are coping is marine ecologist James Grecian, based at Durham University.

James is one of a team of researchers examining the impact of climate change on ecosystems in the Arctic, and our film crew accompanied him on a helicopter flight over the ice-covered Gulf of St Lawrence on the east coast of Canada. He was searching for harp seal pups on the edge of the fragmenting pack ice. As one of the most numerous seals in the North Atlantic, the harp seal is a key player in the region, and highly vulnerable to changes in sea ice conditions.

Putting down tentatively and hovering just a few centimetres above the ice, one researcher jumped out and checked its thickness before the machine could put down. It had to be at least 30 centimetres thick to be safe.

'It's a dangerous and inhospitable place, but it's perfect for these seals,' reflects James, 'and harp seals are a really interesting species to study because they're so closely tied to the sea ice. Without the sea ice, they'd have nowhere to breed or to raise their young, and they'd have nowhere to forage.'

The team are on the ice to fit young seals with small GPS transmitters.

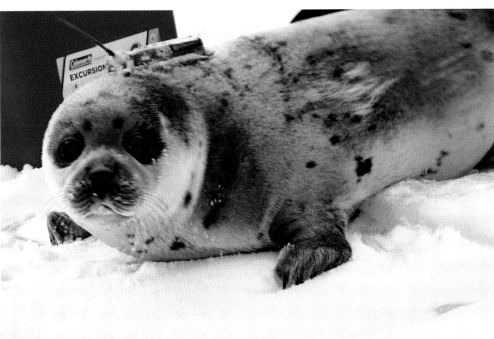

ABOVE RIGHT A harp seal pup has a GPS transmitter glued to his head so scientists can track his movements during his first year. The device drops off after his next moult.

The ones they are searching for are already survivors, six-week-old pups resting where the ice has endured long enough for each of them to have moulted its white coat and grown a grey one in its place. By monitoring their first year, the research team has already discovered that young seals in two parts of the Arctic – the Gulf of St Lawrence and the Greenland Sea – travel for over 3,500 kilometres northwards to Baffin Bay, the northern Barents Sea and other parts of the Arctic Ocean, following similar routes to those recorded for their parents. Pups from the two locations, however, show different diving behaviour.

While diving is similar for the first 25 days, probably as they develop the ability to hold their breath and to dive deep for extended periods, the two populations diverge as they begin to forage. Young seals in the Greenland Sea have access to sea ice for several months, so they perform shorter and shallower dives at the edge of the sea ice. The ice in the Gulf of St Lawrence, by contrast, retreats much earlier and, rather than chase it, the seals learn to dive in an ice-free environment. On the positive side, this suggests some degree of flexibility in their early foraging behaviour, but, in the long term, the edge of the sea ice is where the fish on which they feed are concentrated. Summer sea ice, though, could disappear entirely as soon as 2035, so are these seals going to be able to adapt to this mega-change? This is something James and his colleagues are beginning to find out.

'The Arctic is changing more quickly than ever before. We're already seeing years when there's no sea ice, and the harp seal mums give birth in the water and the pups drown straightaway. I think one of the issues with climate change is that it's really difficult to see. It's quite easy to look out in the ocean and see bits of plastic, and you can make a difference by not dumping it there; but in the case of the harp seals, it's really quite simple: if we lose the sea ice, we lose the harp seals. It's likely that we won't see harp seals in 50 to 100 years' time.'

Earth's Albedo

While it is engaging to learn how the wildlife of the cryosphere is adapted to live on or under the ice or in places blanketed by snow, it is worth taking a moment to reflect on one of the less well-known consequences of its absence. Ice and snow – whether they are in the Arctic Ocean, on the Antarctic mainland, in mountains, or elsewhere – are critical ingredients in mediating the Earth's climate. These vast white surfaces reflect the sun's energy away from the Earth. It is part of the planet's cooling system, a natural phenomenon known as 'albedo'.

The sun's energy is the principal driver of weather and climate on our planet, so the amount that is absorbed by the atmosphere, oceans and land or reflected back, into space has a profound effect on how the global climate is likely to change in the future. Under 'normal' conditions, about one-third is reflected away and, since the 1970s, the Earth's average albedo has been calculated as 0.3, meaning 30 per cent of solar energy is reflected away. Factors that influence it include ice and snow cover, land surface cover, clouds, and airborne particles or aerosols, say, from volcanic eruptions, forest fires, dust storms or manmade pollution. If the entire planet were to be covered in ice, for example, the albedo would rise to 0.84, meaning 84 per cent of the sun's energy would bounce back into space. If it were covered by dark, dense forests, the albedo would be about 0.14, which means most of the warmth would would be absorbed. Since the 2000s, there have been concerns that the Earth's albedo may be declining, and one area where this is particularly noticeable is in the Arctic, where the disappearing sea ice is hastening its decline.

The northern hemisphere is absorbing more solar energy than elsewhere, according to NASA, especially along the outer margins of the Arctic Ocean. With dark sea replacing white ice and permafrost melting, more solar energy is being absorbed and less being reflected back into space, the so-called 'Arctic amplification'. Between 1979 and 2011, the Arctic region albedo dropped from 52 per cent to 48 per cent. This might not seem a huge decline, but scientists consider it 'quite large'. It is, according to NASA, 'one-fourth as large as the heating caused by increasing atmospheric CO_2 concentrations during the same period'. It is also a self-perpetuating system: more solar energy being absorbed leads to an increase in snow and ice loss in the Arctic, and this increase means that even more solar energy is absorbed by the ocean and tundra, and so it goes on until the cycle is broken. For the Arctic's wildlife, it is a catastrophe already unwinding. Eventually, harp and hooded seals will have no ice on which to haul out during their breeding season, and polar bears will lose the ice platform from which they hunt.

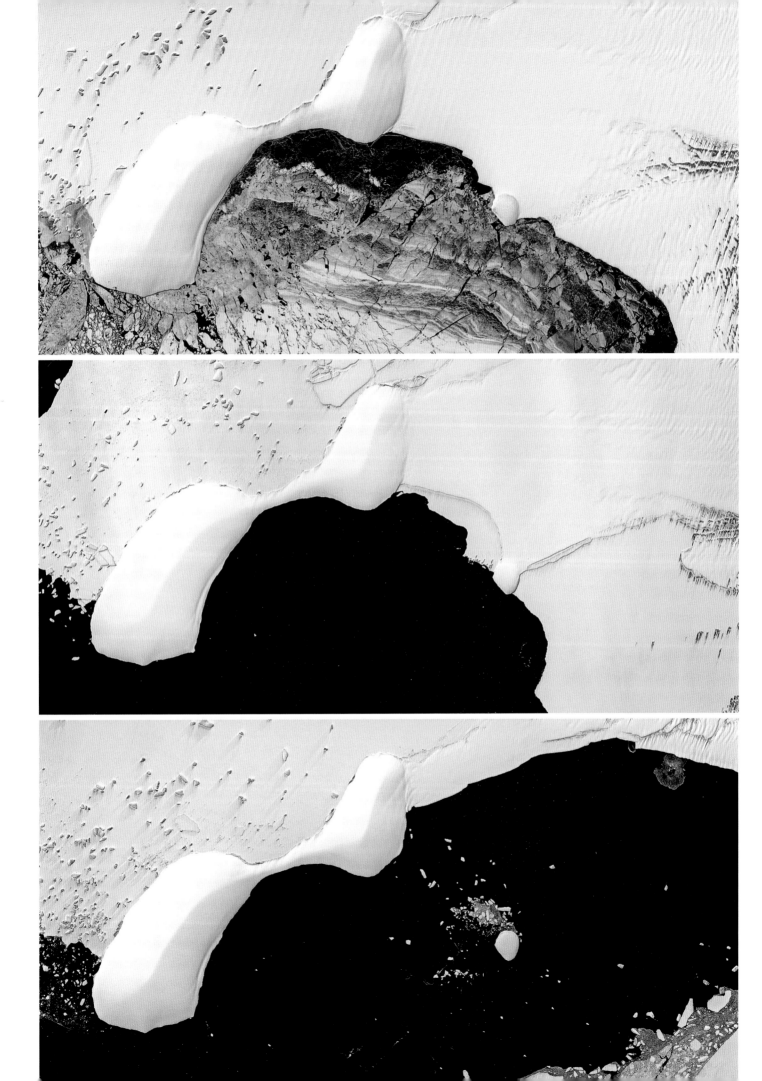

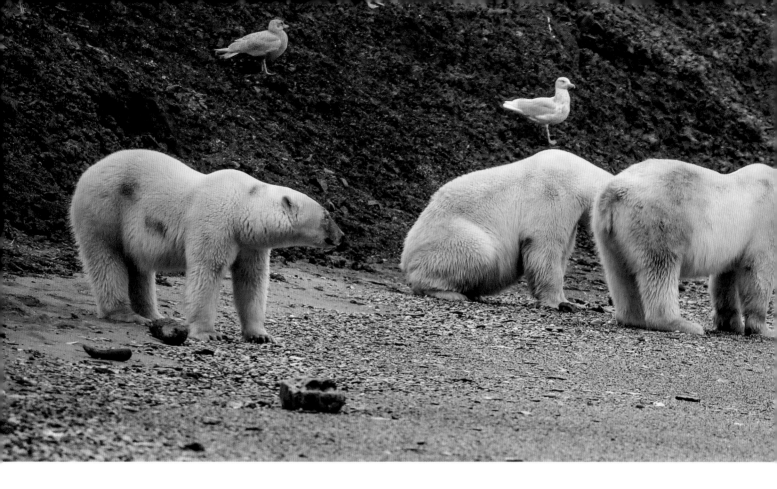

Solitary No More

One place the knock-on effects of the loss of sea ice are clearly visible is Russia's Wrangel Island in summer. Here, polar bears are coming ashore in unprecedented numbers in a desperate search for food. They represent a large part of the population that would normally be hunting on the ice in the Chukchi, East Siberian and Beaufort seas, and they come to Wrangel during summer and remain until the sea freezes over in winter. Some find food on the island's beaches – a whale carcass or a dead walrus – while others head inland to find whatever they can. Apart from resident rangers, a few visiting scientists, and the occasional boat-load of tourists, the place is virtually uninhabited, so wildlife is undisturbed. One of the Wrangel Island State Nature Reserve rangers is Gennadiy Fedorov.

'Wrangel is a unique place,' he says, 'and bears are part of this landscape. They're powerful predators, and we are food for them, so I don't try to become friends with any of them. I need to be prepared that they might approach at any time.'

Gennadiy repels any bears that might come searching for food by covering his makeshift wooden shack with planks through which are driven numerous 6-inch nails facing outwards. It seems to work, but each summer, he's not usually alone. An important part of Gennadiy's job is working with visiting polar bear scientists to establish just how many bears are coming to the island each year and from where. One of them is quantitative ecologist Eric Regehr, of the Polar Science Center at the University of Washington. He has been developing ways to estimate animal abundance, as well as

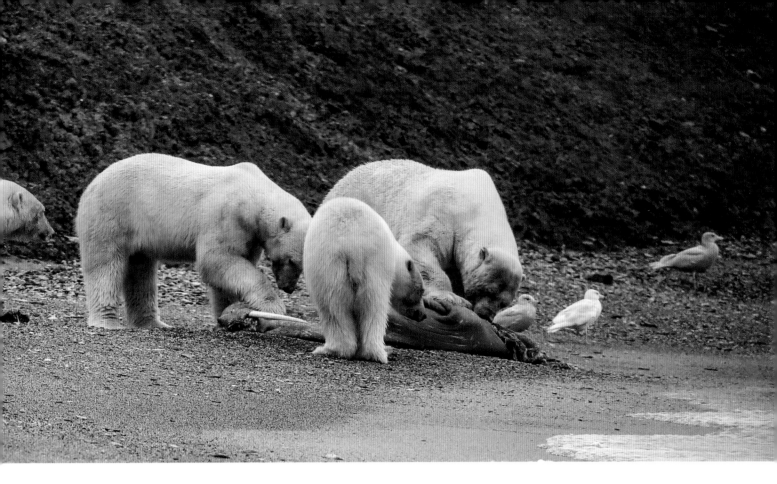

ABOVE A group of polar bears tucks into a walrus carcass on the beach at Wrangel Island – one of the few occasions when many polar bears are seen together in one spot.

rates of survival and reproduction, while recognising humans as a key part of ecosystems. He and his Russian co-workers have been closely monitoring the bears and, in view of the loss of summer sea ice, they are trying to establish whether the bears are adapting to life on land.

'They are intelligent animals,' he reminds us, 'but there's simply no food on land that can compare with the blubber-rich seals that the bears eat on the sea ice.'

Eric's studies reveal Wrangel's bears seem well fed and healthy, at least for now, but this is just one subpopulation of polar bears on the move, so it raises one big question and that's to establish exactly from where the bears originate. Are they local bears or do they travel from some distance away? To find an answer, Eric has been using a sampling technique called a 'hair trap', a box with the floor coated with an attractive-smelling liquid and wire brushes on the inside walls. The bears pick up the smell and put their paw or head into the trap where the brushes catch a few pieces of hair. These can be analysed for their DNA, and so each bear can be recognised as an individual.

'We don't know specifically where the bears on Wrangel come from. Some may come from populations yet to be studied, for example, so the hair trap might help us understand which population these bears are a part of.'

The sheer numbers arriving at Wrangel, though, are staggering. Even though Eric has been studying polar bears for close to 20 years, the number turning up in recent years has taken him by surprise.

'The density of bears is unlike anything I've ever seen before. The past two years, we've seen about 500 bears, and my sense is that's just a fraction of how many are here.'

The warming climate is having an unexpected impact on those bears and their prey, the walruses, as wildlife cameraman John Aitchison discovered during his time on the island.

'From our viewpoint on the top of a cliff, we could see rocks were falling onto the beach below. A lot of the island is composed of loose stuff glued together by ice – permafrost – and this was thawing, and one day a big chunk fell and killed a number of walruses. On another occasion, a huge chunk came down and crashed into the water. The bears on the beach swam out to sea and didn't turn back. They were having none of it: they just kept on going and were heading possibly to a neighbouring island or to the mainland 140 kilometres away.'

Apart from rocks landing on their heads, the walruses were compromised in other ways too, as John found out when talking to the visiting scientists.

'Without the ice, the increasing number of storms produce bigger waves, and the walruses, especially the young ones, are washed back out to sea, where they become exhausted and drown, and this was less common in the

BELOW Large male bears get first access to the food. Younger male bears and females have to wait, or risk being attacked, and so a queue quickly forms.

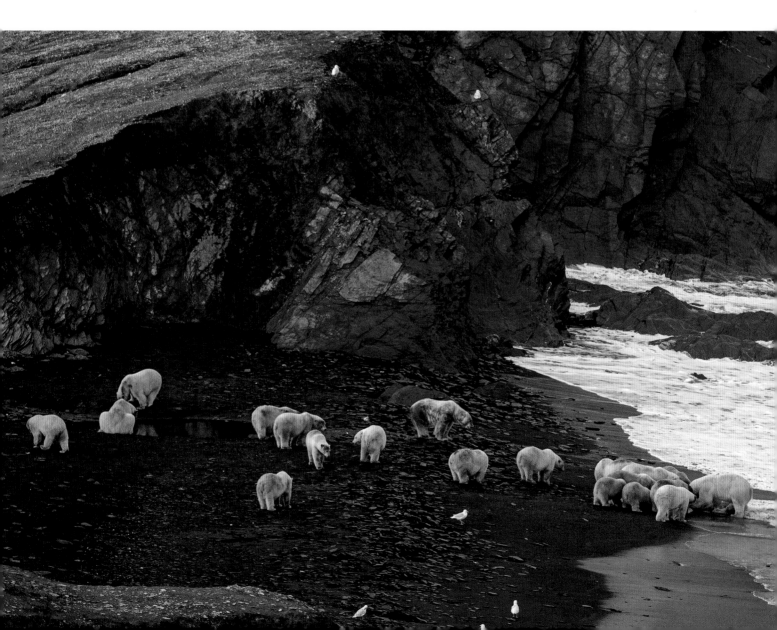

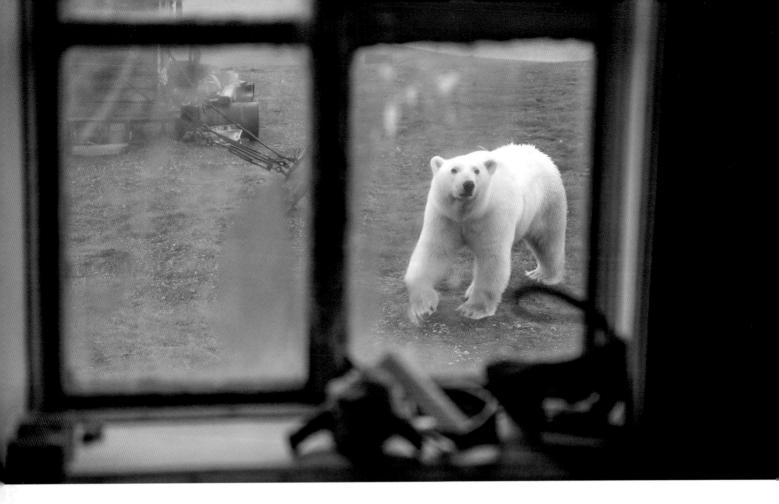

ABOVE A hungry polar bear checks out a hut on Wrangel Island, a constant danger for scientists and rangers alike.

past. Also, the shallow seas around the island and all the way to the mainland enable walruses to forage for clams on the seabed, but, being shallow, the sea warms up more, has less oxygen, and becomes acidic because it absorbs more carbon dioxide, and that's a problem for bivalve molluscs, principal food for walruses, because their shells weaken. So, in the short term, the bears have a glut of walruses on which to feast, but in the longer term, the walruses might not come to Wrangel. If and when that happens, the future will be bleak for the region's polar bears.'

And it is not only on Wrangel that these kinds of changes are obvious. All across northern Russia, polar bears are invading human coastal communities. In 2019, for example, 56 thin and hungry bears descended on Ryrkaypiy in northeast Russia, entering the communal areas of apartment blocks, trying to break into any other inhabited area and scavenging on rubbish tips. In the past, one or two bears might visit the village from Cape Schmidt, a couple of kilometres away, but now there are so many coming each summer that the authorities have considered resettling the 700 villagers elsewhere. It is all part of the changes that Eric Regehr is seeing in the Arctic.

'The sea ice in this part of the world has changed dramatically in the past 30 years, and one of the main things we expect to see is a change in the movements and distribution of bears. Polar bears are going to appear in places they never were before, and they're going to disappear from the places where they were previously. World climate change is something most people hear about on the news, but here in the north it's a reality.'

Loss of Traditions

The Inuit of northern Greenland are well aware of that reality, and none more so than the people of Qaanaaq, one of the most northerly settlements on Earth. Located at the northwest tip of Greenland, the people living there experience almost continuous darkness in winter and 24-hour sunlight between April and August. Air temperatures can reach record lows of minus 58°C in midwinter and highs of 20°C in midsummer, which means for most of the year the sea is covered with sea ice, a vital platform from which the Inuit can hunt seals and walruses. They head out onto the ice with heavy sleds pulled by dogs; in fact, there are more dogs than people in town. In summer, a brief window of open water enables them to take to small boats and tackle whales, beluga and narwhals, the hunt sanctioned by the International Whaling Commission as part of the Aboriginal Subsistence Whaling quota. The sea ice in winter – and the sea in summer – is their highway, and nothing from the hunt goes to waste. It provides food, fur, leather, and additional sources of income for the community from crafts, such as the carving of narwhal and walrus tusks. It is a traditional way of life that has endured since the area was first settled over 4,000 years ago, each generation passing on the skills and knowledge to the next. Now, however, as Aleqatsiaq Peary, a local hunter from Uummannaq, tells us, the place is changing rapidly, especially the state of the ice.

'Traditions are important for our people, and we are proud of who we are. We rely on the sea ice to hunt, and using dogs is the safest way to travel, but this year the sea ice has a lot of water scattered about and it's breaking up quickly, so we have to trust our dogs. Somehow they know when we are approaching thin ice, so, when they stop, we cannot travel any further. There is nothing we can do but to go back.'

The return journey, though, can be just as dangerous, with the sleds bouncing across the leads and almost turning over, tipping the hunter into the frigid water. It means that this season's hunt for seals is over, with no prospect of another for several months, when the sea hopefully freezes once again.

For Qaanaaq's 650 residents, change is not necessarily a new thing. Houses have heating, there's a convenience store, street lighting and a children's play area; the children even play soccer in the street. But the loss of sea ice may mean embracing a future that is very different from their traditional past.

'When the sea ice is gone it will affect everything on this Earth,' says Aleqatsiaq. 'If the world is changing, then we must change with it, but for us, it has been going too fast.'

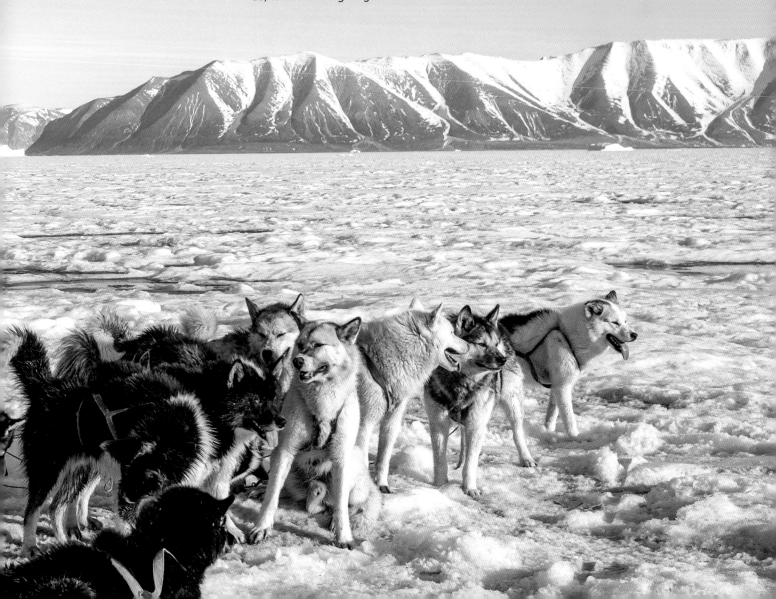

Extreme Weather

The unusual conditions experienced by the Inuit are not confined to northern lands. All over the world, people are being hit by exceptional weather and its aftermath: unusually powerful thunderstorms, bomb cyclones, typhoons, hurricanes, tornadoes, devastating floods, landslides, mudslides, avalanches, dust storms, scorching heatwaves, heat domes, and wildfires, all events that, about 50 years ago, climatologists had predicted would occur more frequently and would worsen as a result of global warming. A study at Yale University has even predicted that hurricanes and typhoons will not be confined to the tropics and subtropics but will move northwards and southwards in their respective hemispheres and expand into mid-latitudes. And, during 2021, Finnish researchers recorded twice as many lightning strikes in the High Arctic than in the previous nine years combined; and this in a region which is usually not suitable for lightning. Thunderstorms require convective moist air, which typically has been lacking in the Arctic, but rising temperatures and the loss of sea ice means that more water is evaporating into the atmosphere and condensing to form thunderclouds.

In fact, 2021, a year of extreme weather, gave a hint of what is to come: July was the hottest month ever; torrential rain and devastating floods hit Germany, the UK, New South Wales, China, India and Nepal; a series of the most powerful tornadoes in US history swept across Kentucky, Arkansas, Missouri and Tennessee; record-breaking snowfall and low temperatures blanketed Madrid; and the year culminated in a Christmas heatwave in Alaska's Kodiak Archipelago, where the mercury rose to 19.4°C, the highest December reading ever recorded in the state. Records like these are generally broken by a degree or two, but this event was almost seven degrees warmer than the previous state record. This was followed by heavy rains, but then temperatures plummeted and everything froze, what the local authorities dubbed 'Icemageddon'. Scientists believe this kind of unpredictable weather with wild swings is a direct consequence of a warming climate.

Some events are so extensive that they can be seen even from space, and watching them from the International Space Station (ISS), which is orbiting the Earth every 90 minutes, was NASA astronaut Jessica U. Meir.

'One of the interesting things about the view from up here is the perspective you get because you are 250 miles from the Earth's surface. You can begin to see larger-scale geographical phenomena in ways you

OPPOSITE During unusually hot weather wildfires rage across the taiga and tundra of Siberia.

can't experience on the ground. You're used to thinking about the planet by looking at a map or globe, and you see the manmade borders between countries, and you might think that's how the world actually looks, but when you look down from here you realise that we are truly all in this together. As a whole, we are not recognising the impact we are having and the fact that we need to do something, and everybody needs to play a role. We are having an incredible effect on our planet, and it's something we cannot deny. Right there, I'm looking down on several wildfires. We're flying over Europe, and there are fires down there right now.'

An increase in the frequency of wildfires worldwide is a very obvious sign that something is seriously wrong with our planet. In the USA, data from the National Interagency Fire Center indicates, not unexpectedly, that the greatest acreage burned by wildfires coincides with the warmest years on record, especially in western parts of the United States, such as California, Oregon, Washington and Colorado. Most fires are in spring and summer, with a peak in the past during August. Today, the peak is earlier in July, and fires are beginning to spring up at all times of the year, like the Colorado fires in December 2021. Similarly, the number and intensity of wildfires have been increasing in places as widespread as Greece, Turkey, Spain, Brazil, Indonesia, China, Canada, southern Africa, Australia and the UK.

However, while lives and property are at risk from these kinds of fires, the most disturbing from a global perspective must be the so-called 'zombie fires' in the Arctic. In the summer of 2019, great swathes of the boreal forest and peatlands went up in flames. Warm air rising in the Arctic sucked in hot air and produced drier conditions further south, creating a tinderbox. Over 100 long-lived fires burned during June and July, most in Siberia and Alaska. Even though the fires were thought to have been extinguished by the time winter arrived, they flared up again the following spring, hence their nickname. Huge quantities of black carbon particles or soot also filled the skies, and there is evidence to suggest that it accelerated the melting of ice. The dark soot readily absorbs sunlight, and when it falls on top of the ice, it darkens the surface, so less sunlight is reflected away, trapping more heat in the atmosphere.

In June 2019, the Arctic fires also spewed an estimated 50 megatons of carbon dioxide into the atmosphere – the equivalent of Sweden's total annual emissions, and more than the past eight Junes combined. The reason is that many of the fires raged through deposits of peat. Warming Arctic temperatures had caused the peat from the permafrost to dry out and it proved to be highly combustible. The fires were then started simply by lightning strikes, and burned longer than the forest fires. And, as lightning is likely to increase in frequency in the Arctic, fires could increase too. Such peat fires are also likely to cause more slumps, and this could result in the release of an even more potent greenhouse gas – methane.

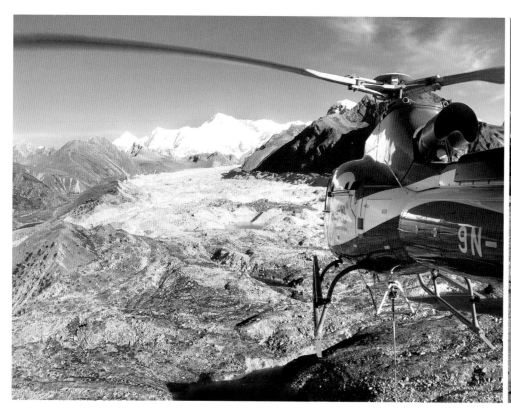

Glacial Meltwater

ABOVE Hamish Pritchard's helicopter flies over the Ngozumpa Glacier.

ABOVE RIGHT Hamish's radar array for measuring the thickness of ice of remote glaciers is slung below the helicopter, here on a survey approaching the icefall on the Khumbu Glacier, a neighbour of Ngozumpa, which flows down southwestwards from Mount Everest.

While the focus for climate change scientists has been mainly in polar regions, other parts of the cryosphere are showing similar trends, and none more so than the 'third pole' – the Himalayas – one of the largest bodies of frozen water outside of the Arctic and Antarctic. This remote and inhospitable place is a source of the most precious resource on Earth – water for drinking and crop irrigation. More than a billion people depend on water from the mountains, yet scientists have no idea just how much water mountain glaciers hold. British glaciologist Hamish Pritchard, of the British Antarctic Survey, is trying to find out.

'We know that these glaciers are losing about half a metre of ice a year. What we don't know is how much ice is left. If we knew that, we could predict how long the water supply will last.'

When our film crew caught up with Hamish, he was at the Ngozumpa Glacier in the Nepalese Himalayas, the country's longest glacier. He was about to deploy an airborne radar survey platform slung beneath a helicopter.

'The radar sends out radio waves that bounce back from the bottom of the glacier, so we get to work out the thickness of the ice. It's experimental and nothing like it exists, but we're hoping it will solve the problem of getting data from these remote mountains.

ABOVE RIGHT The radar array in action close to the Sherpa town of Namche Bazaar.

'The data for this glacier looks pretty clear. It's about 150 metres thick, so at the current rate of melting, the section we surveyed will last for maybe 200 to 300 years. But there are many more glaciers that are much smaller, with much thinner ice. With the melt rates increasing, the ice will be lost much more quickly.

'And what happens when these glaciers disappear? Many people live in arid and semi-arid areas where they depend critically on the meltwater supply from these mountains to get through the summer months. It's the world's most water-intensive economy. A number of rivers cross borders and then flow through countries, such as India, Pakistan, Afghanistan and China. If their water resources are under stress, those societies are under stress. There could be the displacement of many millions of people. One of the big risks of losing this ice is that tensions could rise, with the risk of conflict, and that is a frightening prospect.

'Children born today will see these scenarios playing out. They will live with the consequences of which emissions strategy we choose to follow. I think for decades now we've known that these sorts of changes are happening, but there are tipping points, beyond which we cannot go back. If we manage to reduce emissions, so the warming is less in summers and less ice is lost, then we buy ourselves time and ensure a water supply for hundreds of millions of people downstream.'

The Doomsday Glacier

BELOW A team of
scientists from the ITGC
sets up camp on the ice of
Thwaites Glacier.

A glacier that is greatly troubling the scientific community is not in one of the world's great mountain chains, but in the Antarctic. Located in West Antarctica, in what visiting scientists have described as 'the place in the world that's the hardest to get to', Thwaites Glacier is about the size of Florida or Great Britain, and is listed as the widest glacier in the world. Although its rate of flow has doubled during the past 30 years, its bulk is held back by a platform of ice that pushes out over the sea, itself anchored by a seamount. This ice shelf restrains the glacier from flowing even faster, so it is vital that it remains intact. Recent observations, however, show that cracks and crevices, some as long as 10 kilometres, are appearing in the ice shelf, and there is a real danger that it will break away, unleashing vast quantities of ice from the interior of Antarctica and spilling it into the ocean. The shelf itself is unusual as ice shelves go and has been described by Anna Wahlin of the University of Gothenburg as 'like a jumble of icebergs that have been pressed together, so it's not a solid piece of ice like other ice shelves'. It could 'break into hundreds of fractures like a damaged car windshield'.

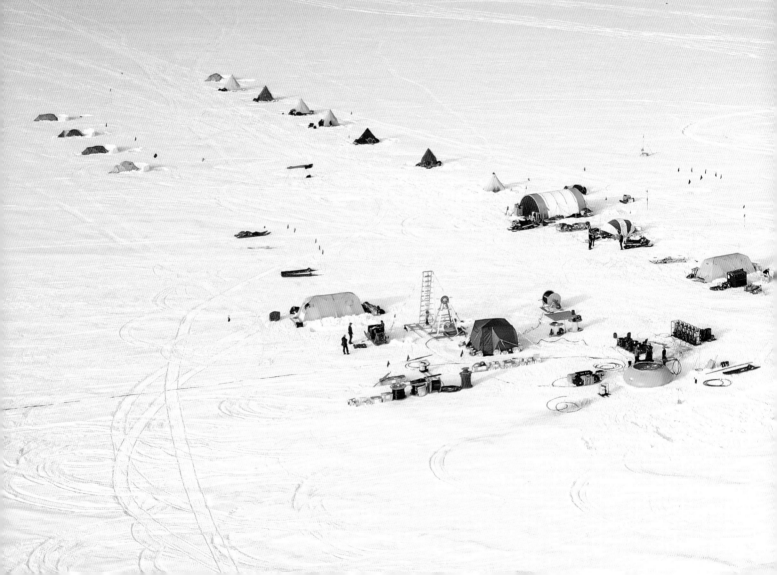

If this ice shelf and the glacier behind it should collapse, it has the potential to raise sea levels globally by at least 65 centimetres. To put this into perspective, global sea levels have risen by roughly 20 centimetres since 1900, and already coastal communities in low-lying lands are being forced from their homes by flooding and salt contamination of agricultural land, so a further 65 centimetres would be catastrophic. Looking into the future, though, there could be worse to come. Should Thwaites collapse, it could trigger other neighbouring glaciers of the West Antarctic Ice Sheet to go too, raising sea levels not by centimetres, but metres.

While most glaciers are affected by changes in air temperature, scientists studying Thwaites believe that the warmth affecting this glacier is coming from below. To find out whether this is the case, an international group of scientists in the International Thwaites Glacier Collaboration (ITGC) is studying the glacier closely. One of them is Sridhar Anandakrishnan, a glaciologist and geophysicist at Pennsylvania State University.

'Across the glaciological community, we've identified that sea level rise from Antarctica is the most pressing question of the next decades, and we, as a collaborating group, have come together to try and understand it, and governments have also come together, because it's important.'

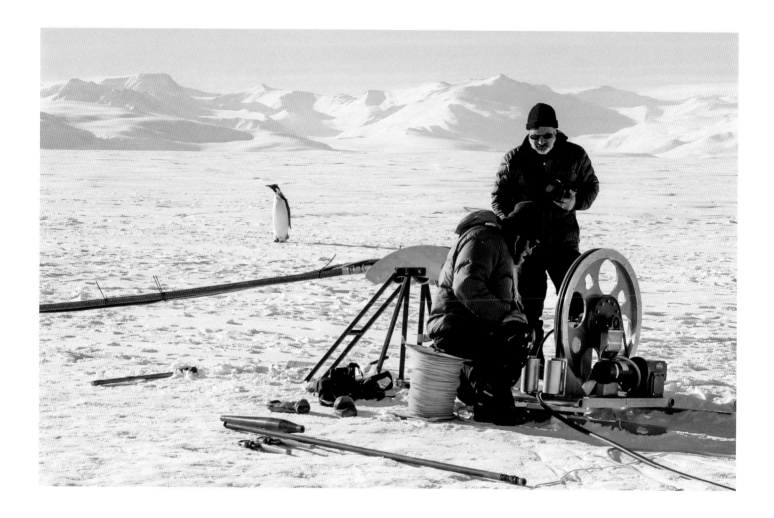

ABOVE An inquisitive
emperor penguin checks
out what all the fuss is about.

To try to comprehend what is going on, Sridhar and his colleagues brave the erratic weather conditions in West Antarctica to put their instruments on and within the ice.

'Without getting out on the ice you can't measure things underneath it,' he says. 'Those kinds of things can't be done from space, or by drones or aircraft flying over it. You actually have to go and put your instruments on the ice.'

And by boring down 600 metres to where the ice and rock meet, they have already found that, as they predicted, there is warm water under Thwaites. It is about 2°C above the freezing point of seawater, which in polar regions is about minus 1.8°C, and the tides are causing the shelf to rise and fall so it pumps that warmer water directly under the ice sheet itself. These may be disturbing revelations, but it is only by gathering all the facts that science will be able to make accurate forecasts about the future we face from a melting Antarctica. As Sridhar points out, it is not a local problem.

'There are places all over the world where people live within 1 metre of the ocean, and as soon as a glacier puts water into the ocean, the water

ABOVE **The ITGC underwater robot Icefin is shaped like a torpedo. It is used to explore the underside of the ice.**

rises all over the world. This is a global problem, and the amount of water that Antarctica contains is huge.'

With the water equivalent to a 3.2-metre rise in sea level contained in the West Antarctic Ice Sheet alone, and a staggering 57 metres of sea level rise from ice melt of the entire southern polar region, urgent questions are pending: how much of it and how fast will it actually melt, and to what extent can we slow it down? Scientists have identified that warm water is eroding many of West Antarctica's glaciers, but there is a particular concern about Thwaites. Hopefully, the new data from the ITGC will provide a new perspective on the processes taking place, so they can predict future change with more certainty. For the moment, though, that future change is predicted by these scientists to occur within a short period of time, maybe decades, when there is a real danger that Thwaites will eventually collapse, with all the consequences that its demise implies. It will be a huge moment for humanity… and not in a good way.

Index

Acknowledgements

Firstly we would like to thank Michael Bright, for his hard work and dedication in shaping this book of the television series, and Laura Barwick for her expert eye in choosing the very best imagery to accompany it.

Working in the cold regions of Earth is not for the faint-hearted and we are deeply indebted to all of those involved in finding and filming the stories reflected in these pages. From the long list of scientists and experts who gave their time to share rare and 'new' stories from these remote and changing lands, to the team of dedicated field guides, government bodies and scientific institutions who welcomed us on location – even in the midst of a global pandemic!

Our dedicated camera and sound teams literally travelled to the 'ends of the Earth' at a time when isolation periods were lengthy – adding to the already logistically complicated and long shoots that were required to capture these stories. Their safety in working in these inherently risky lands was ensured by safety consultants, dive advisors and a raft of captains, crews and guides, specialists at operating on and around mountains, snow and sea ice.

Finally we would like to thank the fabulous production team for their passion, resilience and dedication over the four-and-a-half years it took to do justice to the incredible and changing worlds that make up our Frozen Planet.

Mark Brownlow and Elizabeth White

PRODUCTION TEAM
Sir David Attenborough

Jack Bootle

Alan Neal
Alex Lanchester
Alex Ponniah
Alexandra Fennell
Ashley Noulty
Beth Cullen
Caroline Cox
Claire Aston
Daniel Turner
Dave Cox
Ellie Pinnock
Elliot Jones
Emily Duggan
Emily Humphrey
Emily Thurgood
Emma Fry
Erin McFadden
Estelle Ngoumtsa
Gillian Taylor
Helen Bishop
Hiro Harazawa
James Reed
Jane Atkins
Jane Greenford
Jodie Allt
Joe Treddenick
Jon Cox
Judy Roberts
Karmen Summers
Kate Horvath
Kathryn Jeffs
Laura Bartley
Libby Prins
Louis Hunt
Louise Caola
Matt Allen
Miraca Walker
Orla Doherty
Polly Billam
Poppy Riddle
Premdeep Gill
Rachel Scott
Rachel Wickes

Sacha Thorpe
Sally Cryer
Sarah Conner
Sarah Titcombe
Stephen Parker
Toby Cresswell
Usha Amin
Will Lawson
Yoland Bosiger

CAMERA TEAM
Alex Vail
Andrew Thompson
Barrie Britton
Batgerel Battulga
Ben Goertzen
Benjamin Sadd
Bertie Gregory
Brandon Sargeant
Chen Xiaoyu
Dan Beecham
David Baillie
David Reichert
Dawson Dunning
Declan Burley
Erik Lapied
Erika Tirén
Espen Rekdal
Ester De Roij
Florian Ledoux
Florian Schulz
Garath Whyte
Gavin Thurston
Graham Mcfarlane
Grant Baldwin
Grigory Tsidulko
Gustavo Vladivia
Hector Skevington-Postles
Helen Hobin
Howard Bourne
Hugh Miller
Hugo Kitching
Inge Wegge
Jamie Mcpherson
Jesse Wilkinson
Joel Heath
John Aitchison
John Brown
Joris van Alphen

Josh Wallace
Justin Hofman
Justin Lewis
Justin Maguire
Marcelo Villegas
Marco Andreini
Mark Carroll
Mark Payne-Gill
Mark Smith
Mathieu Dumond
Matt Hobbs
Max Kobl
Max Lowe
Michael Male
Mr Pei Jingde
Nick Widdop
Olly Jelley
Owen Carter
Pete McCowen
Peter Cayless
Raphael Boudreault-Simard
Raymond Besant
Ricky Kilabuk
Robert Hollingworth
Roger Munns
Rolf Steinmann
Rowan Aitchison
Ryan Atkinson
Sam Lewis
Sam Lowe-Anker
Sam Meyrick
Scott Mouat
Sergey Gorshkov
Simon De Glanville
Stuart Dunn
Ted Giffords
Toby Strong
Tom Beldam
Tom Ross
Wu Yuan Qi
Zachary Moxley

SOUND RECORDISTS
Andrew Yarme
Darryl Czuchra
Freddie Claire
Phil Streather

FILM EDITORS
Adam Coates
Andy Netley
Angela Maddick
Bobby Sheikh
Danny McGuire
Dave Pearce
David Warner
Emily Davies
Gary Skipton
Harriet Hoare
Joe Pedder
Matt Meech
Nigel Buck
Owen Porter
Pete Brownlee
Robbie Garlands
Robin Lewis
Sarah Bright

MUSIC
Adam Lukas
Anže Rozman
Bleeding Fingers
Greg Rappaport
Hans Zimmer
Jake Schaefer
James Everingham
Marsha Bowe
Natasha Pullin
Nichola Dowers
Russell Emanuel
Steven Kofsky
Tyson Lozensky

POST PRODUCTION
Films at 59
Miles Hall
Shelley Stott

ONLINE EDITORS
Ben Kersey
Chris Gunningham
Franz Ketterer
James Aitkin
Martin Ralph
Shaun Littlewood
Wesley Hibberd

DUBBING EDITORS
Wounded Buffalo Sound Studios
Hannah Gregory
Kate Hopkins
Tim Owens

DUBBING MIXER
Graham Wild

COLOURISTS
Adam Inglis
Simon Bland

GRAPHIC DESIGN
Moonraker VFX
Blake Liang-Smith
Emma Kolasinska
Lukasz Grzelak
Olly Hagar
Ryan McGrath
Tom Downes

BBC STUDIOS DISTRIBUTION
Louise Muhlauer
Mark Reynolds
Monica Hayes
Patricia Fearnley

WITH SPECIAL THANKS
Abigail Lees
Abisko Scientific Research Station
Adam Gaudreau
Adrian Luckman
Alejandro Bello
Aleqatsiaq Peary
Alexander Batalov
Alexander Gruzdev
Alexandra Prasolova
Alexey Chugunov
Alfred Wegener Institute
Alison Fawcett
Alistair Hopper
Alona Serotetto
Alun Hubbard
Andrés Barbosa Alcón

Anja Frost
Anne Junglbut
Antarctic Logistics Centre International
Anton Overballe
Arctic Kingdom
Arctic National Wildlife Refuge, Alaska
Ari Friedlander
Arnaud Tarroux
Arran Laird
Athena Dinar
Australian Antarctic Division
Baptiste Martinet
Basile Longchamp
BBC Engineering
Benjamin Metzger
Beringia National Park, Russia
Bill Fraser
Bjørne Kvernmo
Brent Young
Brian Anderson
British Antarctic Survey
Bruce Hobson
Canadian High Arctic Research Station
Captain & crew, MY *Gamechanger*
Captain & crew, RV *Investigator*
Captain & crew, RV *Polarstern*
Caspar McKeever
Charlotte D'Olier
China Conservation and Research Center for the Giant Panda
China State Forestry and Grassland Administration
China Wildlife Conservation Association
Chris Lane
Chris Webster

Clare Warren
Claudio Bustos
Colin Jackson
Comité Polar Español
Craig Buckland
CSIRO Marine
 National Facility
Dale Andersen
Danish Meteorological
 Institute
Danny Kleinenz
Darren Tracey
David Ainley
David Goodger
David Suqslak
Department of
 Fisheries and
 Oceans Canada
Derren Fox
Dhananjay Regmi
Diego Araya
Dimitri Evrard
Dina Matyukhina
Dion Poncet & crew,
 MY *Golden Fleece*
Dolgormaa Namsrai
Dominique Fauteux
Donna Gomes
Doug Allen
Douglas Hardy
Dylan Taylor
Ed King
Ejercito De Tierra,
 Base Gabriel De
 Castilla
Elaine Hood
Emil Herrera-Schulz
Eric Regehr
Erling Nordøy
Eugina De Marco
Eurasian Linguistic
 Services Ltd
European Space
 Agency
Florian Stammler
Fortress Mountain
 Resort, Alberta,
 Canada
Garry Stenson
Gavin Newman
Gennadiy Fedorov
Geoff Schellens
Geoff York
Gerhard Bohrmann
Government of South
 Georgia and the
 South Sandwich
 Islands
Governor of Svalbard
Graeme Elliot
Gran Paradiso
 National Park
Gwich'in Tribal
 Council
Hamish Pritchard
Heather Liwanag
Helen Cherullo
Henry Mix
Heritage Expeditions
Hiroo Saso
Holly Wallace
Huw Griffiths
Igaja Alataq
International

Thwaites Glacier
 Collaboration
Irene Giorgini
Ivan Rakov
Jade Xia
Jake Soplanda
Jakob Markussen
James Balog
James Fulcher
James Grecian
Jamie Coleman
Jan Stipala
Jason Roberts
Jaume Forcada
Jay Rotella
Jefferson Beck
Jennifer Duff
Jennifer Jackson
Jessica U. Meir
Jim DeWitte
Jim Guerrero
Joanna Weeks
John Bryans
John Durban
Jon Tyler
Jonny Keeling
Jordan James
Jordan Schaeffer
Juan Carlos
Julia Mishina
Julian Hector
Juliette Hennequin
Justin Hofman
Justine Allan
Kadmiel Maseyk
Karina Moreton
Katey Walter Anthony
Kath Walker
Katie Hall
Katrin Linse
Keith Larson
Kieran Baxter
Kimberly Przybyla
Kostya
Krista
Land of the Leopard
 National Park
Leigh Hickmott
Lindsay Steinbauer
Lucy Hawkes
Marcus Shirley
Maria Norman
Marianne Marcoux
Marisa Luisa Sanchez
 Montes
Marjolaine Verret
Mark Brandon
Mark Elbroch
Martin Collins
MARUM, University
 of Bremen
Mathilde Poirier
Matt Thoft
Matthew Witt
Michael Barratt
Michael Double
Michael Gooseff
Michael Korostelyov
Michael Meredith
Mikael Härd
Mikhail Andreev
Mikili Kristiansen
Miles Ecclestone
Miranda Dyson

Mittimatalik HTO
Nadescha Zwerschke
NASA
Natural History
 Museum of Denmark
National Science
 Foundation
Nathan Russ
Neil Brock
New Zealand
 Department of
 Conservation/*Te
 Papa Atawhai*
Nigel Adams
Nigel Hussey
Nikolai Agapov
Nisar Malik
Northwest Territories
 Film Commission
Northwest Territories
 Geological Survey
Norwegian
 Polar Institute,
 Norwegian
 Antarctic Research
 Expedition 2017-
 2018
Olga Shpak
Open University
Oskar Strøm
Owl Research
 Institute
Pangnirtung HTO
Patrick Baker
Patrick Evans
Patrick Jacobsen
Patrick Makin
Paul Lawrence
Petr Sonin
Phil Hanke
Phil Stone
Philip Trathan
Pierre Rasmont
Polar Bears
 International
Polar Regions
 Department,
 UK Foreign and
 Commonwealth
 Office
PolarX
POLOG
Poul Ipsen
Qillaq Kristiansen
Rhonda Pitoniak
Richard Gill
Richard Phillips
Ricky Kilabuk
Rob Frost
Rob Robbins
Robert Sila
Robert Utting
Roberto Donoso
Rodney Russ
Rodrigo Moraga
Roza Laptander
Ru Mahoney
Russell James
Sally Peterson
Sanikiluaq HTA
Sarah Fortune
Sebastien Deschamps
Sergei Melnik
Shigeyuki Izumiyama

Silas Petersen
Simon Knox
Sivuqaq Community
 of St Lawrence
 Island
Sivuqaq Incorporated
 of Gambell
Sofus Alataq
Sridhar
 Anandakrishnan
Stas Zakharov
Stefan Jacobsen
Steffen Olsen
Steve Cole
Steve Ferguson
Steve Rupp
Stig Henningsen
Su Pennington
Sue Aikens
Svetlana Artemeya
Takayo Soma
Tawani Foundation
Te Rūnaka o
 Makaawhi
Terra Mater Studios
 GmbH
Theo Ikummaq
Thomas Mock
Tiago Bartolomeu
Tim Fogg
Timothy Bürgler
Tom Horton
Tom & Sonya
 Campion
Tom Thurston
Tommy Franzen
Tony Oney
Tore Haug
Trottier Family
 Foundation
Ukpeaġvik Iñupiat
 Corporation
United States
 Antarctic Program
University of
 Cambridge
University of Mons
Valentin Beneitez
Valentine Kass
Vernon Chu
Viktor Bardyuk
VisionHawk Films
Volker Ratmeyer
Wolong National
 Nature Reserve
 Administration
 Bureau
Wood Buffalo
 National Park
Wrangel Island State
 Nature Reserve
Yang Hongjia

1

BBC Books, an imprint of Ebury Publishing
20 Vauxhall Bridge Road,
London SW1V 2SA

BBC Books is part of the Penguin Random House
group of companies whose addresses can be
found at global.penguinrandomhouse.com

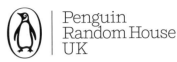

© Mark Brownlow and Elizabeth White 2022

Mark Brownlow and Elizabeth White have
asserted their right to be identified as the
authors of this Work in accordance with the
Copyright, Designs and Patents Act 1988

This book is published to accompany the
television series entitled *Frozen Planet II*,
first broadcast on BBC One in 2022.

Executive producer: Mark Brownlow
Series producer: Elizabeth White

First published by BBC Books in 2022

www.penguin.co.uk

A CIP catalogue record for this book is
available from the British Library

ISBN 9781785946578

Publishing director: Albert DePetrillo
Project editor: Bethany Wright
Picture research: Laura Barwick
Image grading: Stephen Johnson,
www.copyrightimage.com
Design: Bobby Birchall, Bobby&Co

Printed and bound in Italy by Printer Trento

Penguin Random House is committed to a
sustainable future for our business, our readers
and our planet. This book is made from Forest
Stewardship Council® certified paper.

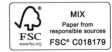

Picture credits

1 Alex Lanchester; **2–3** Florian Ledoux; **4–5** Danny Green/naturepl.com

Frozen Worlds

6–7 Wild Wonders of Europe/Munier/naturepl.com; **8–9** florianschulz.org; **10–11** Guy Edwardes/naturepl.com; **12** Yoland Bosiger; **13** Stefan Christmann/naturepl.com; **14–15** Casper McKeever; **15** Stefan Christmann/naturepl.com; **16–17** Yoland Bosiger; **18–19** Alex Vail; **20–22** BBC Studios; **22–3** Juliette Hennequin; **23** BBC Studios; **24–5** Juliette Hennequin; **27** Tim Flach; **28–9** BBC Studios; **30** Juliette Hennequin; **31** Yoland Bosiger; **32–3** guvendemir/Getty; **34–5** Ashley Cooper/naturepl.com; **36–7** Valeriy Maleev/naturepl.com; **38–40** Pete Cayless; **41–3** Sergey Gorshkov; **44–5** Matthias Breiter/Minden/naturepl.com; **46–7** BBC Studios; **48–9** florianschulz.org; **50** Sylvain Cordier/naturepl.com; **51** BBC Studios; **52–3** Sylvain Cordier/naturepl.com; **54** Tony Wu/naturepl.com; **55–58t** BBC Studios; **58b** Tony Wu/naturepl.com

Frozen Ocean

60–69 Florian Ledoux; **70–73** BBC Studios; **74–5** Nansen Weber/Weber Arctic; **76–8** Justin Hofman; **78–9** BBC Studios; **79** Daisy Gilardini; **80** BBC Studios; **81–3** Justin Hofman; **84** BBC Studios; **85** Christophe Courteau/naturepl.com; **86** BBC Studios; **87** Alexander Benedik; **89–91** John Aitchison; **92–3** Florian Ledoux; **94** BBC Studios; **95** Florian Ledoux; **96–7** Barrie Britton; **98–9** Daisy Gilardini; **100–101** Olly Jelley; **102** Sam Merek; **103–106** Olly Jelley; **106–7** Grigory Tsidulko; **107** Sergey Gorshkov

Frozen Peaks

108–9 Delpixel/Shutterstock; **110–11** HPS/Alamy; **112–13** Freddie Claire; **114** BBC Studios; **115** Freddie Claire; **116** Jan Stipala; **117–18** Freddie Claire; **119** Jan Stipala; **120–21** Laurent Geslin/naturepl.com; **121–2** David Pattyn/naturepl.com; **120** BIOSPHOTO/Alamy; **124–5** Olly Jelley; **127** Danny Green/naturepl.com; **128–9** Yukihiro Fukuda/naturepl.com; **130** Kirill Skorobogatko/Shutterstock; **132–3** BBC Studios; **132** Matt Hobbs; **134** Hunter Baar; **135–137** BBC Studios; **138–9** Shane P. White/Minden/naturepl.com; **140–43** Tui De Roy/Roving Tortoise Photos; **144–5** Ingo Arndt/Minden/naturepl.com; **146–7** John Aitchison; **148–9** Helen Hobin; **151** Diego Araya; **152–158** BBC Studios; **159** Andrew Gasson/Alamy; **160–61** Juan Carlos Munoz/naturepl.com

Frozen South

162–3 Ole Jorgen Liodden/naturepl.com; **164–5** Stefan Christmann/naturepl.com; **166–7** Florian Ledoux; **168–9** Stefan Christmann/naturepl.com; **170–71** Vicki Beaver/Alamy; **171** Orla Doherty; **173t** Ben Cranke/naturepl.com; **173b** Daisy Gilardini; **174–5** Klein & Hubert/naturepl.com; **176–9** Ben Cranke/naturepl.com; **180–81** Rachel Wicks; **182** BBC Studios; **183** Rachel Wicks; **185** Justin Hofman/Alamy; **186** Martin Collins/BAS; **187–9** BBC Studios; **190** Lyn Irvine; **191t** Paula Olson, courtesy International Whaling Commission; **191b** BBC Studios; **192** Stefan Christmann/naturepl.com; **193–5** Justin Hofman; **196** Yoland Bosiger; **196–9** Justin Hofman; **200–201** Pete McCowen; **201–3** BBC Studios; **204** Florian Ledoux; **205** Pete McCowen; **206** John Eastcott and Yva Momatiuk/Minden/naturepl.com; **208** BBC Studios; **209** Brent Stephenson/naturepl.com; **210–11, 213t** George Steinmetz; **213b** Dale T. Andersen; **214–15** George Steinmetz; **216–19** Dale T. Andersen

Frozen Lands

220–21 Matthias Breiter/Minden/naturepl.com; **222–3** Sergey Gorshkov; **224–5** Matthias Breiter/Minden/naturepl.com; **226–27** Fortunato Gatto; **228–9** Olga Kamenskaya/naturepl.com; **230–35** BBC Studios; **236–9** Howard Bourne; **240–42** BBC Studios; **243** Olly Jelley; **244–49** Sergey Gorshkov; **251** Vladimir Medvedev/naturepl.com; **252–3** Sergey Gorshkov; **254–65** BBC Studios; **266–77** Peter Mather/Minden/naturepl.com; **268** BBC Studios/Florian Schulz; **269** florianschulz.org; **270–71** Peter Mather/Minden/naturepl.com

Our Frozen Planet

272–3 Jordi Chias/naturepl.com; **274–5** Ben Cranke/naturepl.com; **276–9** Andrew Yarme; **280– 81** Florian Ledoux; **283** BBC Studios; **284–5** Olly Jelley; **286–7** BBC Studios; **289** NASA/Joshua Stevens, using Landsat data from the US Geological Survey, and ICESat-2 data from the National Snow & Ice Data Center; **290–91** John Aitchison; **292–3** Sergey Gorshkov; **294–5** Benjamin Sadd; **296–7** Contains modified Copernicus Sentinel data [2020], processed by Pierre Markuse; **299** Anton Petrus/Getty; **300** BBC Studios; **300–301** Hamish Pritchard; **301** Ed King; **302–3** Jemma Cox; **304** Dale Pomraning; **305** Jemma Cox

endpaper *front* Florian Ledoux; **endpaper** *back* David Allernand/naturepl.com